# WORK SIGHTS

A volume in the series
Science/Technology/Culture

Edited by
Carolyn Thomas
Siva Vaidhyanathan

# WORK SIGHTS

The Visual Culture of Industry in
Nineteenth-Century America

VANESSA MEIKLE SCHULMAN

University of Massachusetts Press   AMHERST AND BOSTON

ISBN 978-1-62534-195-2 (paper); 194-5 (hardcover)

Designed by Dennis Anderson
Set in Minion Pro by House of Equations, Inc.
Printed and bound by Sheridan Books Inc.

Library of Congress Cataloging-in-Publication Data

Names: Schulman, Vanessa Meikle, 1981– author.
Title: Work sights : the visual culture of industry in nineteenth-century America /
    Vanessa Meikle Schulman.
Description: Amherst and Boston : University of Massachusetts Press, 2015. |
    Series: Science/Technology/Culture | Includes bibliographical references and
    index.
Identifiers: LCCN 2015030475 | ISBN 9781625341952 (pbk. : alk. paper) | ISBN
    9781625341945 (hardcover : alk. paper)
Subjects: LCSH: Art and industry—United States—History—19th century. | Art
    and technology—United States—History—19th century. | Art and
    society—United States—History—19th century. | Industries in art. |
    Technology in art. | National characteristics, American, in art.
Classification: LCC N72.I53 S38 2015 | DDC 709.7309/034—dc23
LC record available at http://lccn.loc.gov/2015030475

British Library Cataloguing-in-Publication Data
A catalogue record for this book is available from the British Library.

*For my parents.*

# Contents

# Acknowledgments

THE RESEARCH and composition of this book were long and complex processes with contributions from colleagues, friends, and helpers distributed over a wide geographical area. Some of them may never know they are thanked in these pages, which seems fitting given the subject of this book and its emphasis on the inter-reliance of vast, often invisible networks. Nevertheless, in ways large and small, they have ensured the success of this project through emotional, financial, and intellectual support, through advice, criticism, and friendship.

First and foremost, thanks are due to Cécile Whiting, who shepherded this project through its first incarnation and has continued to act as a valued and trusted mentor over the past decade. Other Americanists in a variety of fields have read portions of this manuscript or discussed the project with me in ways ranging from casual conversations or e-mail queries to in-depth critiques. I would like to thank Nancy Anderson, Joshua Brown, Bridget Cooks, Alice Fahs, Joy Kasson, Catherine Liu, Jeff Meikle, Kirstin Ringelberg, Jennifer Roberts, Edward Slavishak, Sally Stein, Jon Wiener, and Amy Wood.

Thanks are also due to the University of Massachusetts Press. The Science/Technology/Culture series editors, Carolyn de la Peña and Siva Vaidhyanathan, believed in this project and helped bring it to the attention of the press. My editor, Clark Dougan, has helped immeasurably to strengthen the book and ensure that it appears in its ideal form. In addition, Miles Orvell and an anonymous reviewer offered invaluable suggestions for refining the book's argument. I hope that I have done justice to the insightful comments and critiques they provided on their reading of the manuscript. Mary Bellino, Carol Betsch, and the production team at the press were thorough and helpful at all stages of this process, and

Margaret Hogan provided an inimitable and much-needed eye for detail as she copyedited the text. Thanks for all their hard work, without which this finished product would not exist.

A book cannot be written without considerable financial and administrative support. Completion of this project was made possible by generous funding from the University of California, Irvine (UCI); Illinois State University (ISU); and the Text and Academic Authors Association. While a Ph.D. candidate in the Visual Studies Program at UCI, I received several fellowships from the Graduate Division and the School of Humanities that supported the research and writing of this book when it was still a dissertation. Since becoming an assistant professor at ISU, I have enjoyed generous support from the College of Fine Arts, the School of Art, and the office of Research and Sponsored Programs, which provided funding for the licensing of images. Thanks are due to Dean James Major, Assistant Dean for Research Laurie Merriman, and School of Art Director Michael Wille for their contributions to the funding of this publication. In addition, I want to thank Tony Crowley for selecting my project as a winner of the Gwen and Ted Crowley Grant for ISU School of Art faculty. I was also chosen as a recipient of a Text and Academic Authors Association Publication Grant, which helped cover many of the necessary permissions fees. In addition to financial support, I have been grateful for administrative and research support from several institutions and individuals. Steve Good at the Thomas Moran Catalog Raisonné Project, Dennis Sears at the Rare Books and Manuscripts Library at the University of Illinois, and Sarah Dick at Milner Library at Illinois State University have helped me to secure information about historical images and reproduce them responsibly. Staff, administrators, and librarians from the Boston Public Library, Columbia University's Butler Library, the Powell Library at UCLA, the Washington County Museum of Fine Arts, and Harvard University's Widener Library have enabled my research process to run smoothly.

Working in academia means you are never short of brilliant friends and colleagues. I have appreciated being part of several academic communities over the past decade, most of which had no direct part in this book but nevertheless had a positive impact on me and my work. Here's to my colleagues, friends, grad students, fellow grad students, and fellow travelers across the country—in Illinois: Barry Blinderman, Angie Bonnell, Lea Cline, Andreas Fischer, Elisabeth Friedman, Chris Hagen, Jo Hart, Arthur Iorio, Melissa Johnson, Kathleen Lonbom, Kendra Paitz, Laura Primozic, Dylan Welch, Mike Wille, and Amy Wood; in North Carolina: Evan Gatti, Robert Mayhew, Kirstin Ringelberg, and Richard Liebhart; in

Boston: Maggie Cao, Alex and Tal Gourevitch, Lili Mugnier, Jenne Powers, Linwood Rumney, Verity Smith, Bonnie Talbert, and Scott Votel; and in southern California: Mark Cunningham, Eva Friedberg, Krystal Hauseur, Garnet Hertz, Ginger Hill, Laura Holzman, Kelly Kirshtner, Lee Laskin, Natalie Phillips, Tina Rivers, Sean Rowe, Tim Seiber, Sami Siegelbaum, Mary Trent, and Nicole Woods.

Finally, my family has been a constant source of support throughout this process. From an early age, my parents encouraged my intellectual curiosity, and they are always far prouder of my accomplishments than I am. I owe them the greatest debt of gratitude for giving me an inquiring mind and fostering the desire to keep learning and asking questions. The rest of my family and my wonderful in-laws are also a source of love and moral support. My son, Byron, is already asking the hard questions—keep it up, kid! Lastly (and mostly) my husband, Alex, has provided the emotional support, love, and humor that I needed to see this project through.

# WORK SIGHTS

# Introduction

## Behold the Lightning Chained and Bound

IN 1876, an unknown scribe at the popular newspaper *Harper's Weekly* welcomed all the nations of the world to the Centennial Exposition in Philadelphia's Fairmount Park with a bit of verse celebrating the achievements of the modernizing United States. The poem stresses the relative youth of the country but also its technological exceptionalism:

> Behold our lands, their wide extent; and yet from sea to sea
> Our steeds of fire on paths of steel sweep on triumphantly.
> Behold the lightning chained and bound, whose flash can well reveal
> Each impulse at the nation's heart that guides the common weal.
> And threaded by the silver streams traced out by man's own hand,
> The produce of our prairies wide flows forth to all the land.
> A thousand cities fleck the plain; their towers and steeples high,
> They shimmer in the glittering sun, and point toward the sky.
> Our ships ride on the swelling wave, and each one as it goes
> Reveals the story of the wealth with which our land o'erflows.[1]

The Centennial was only one of the most prominent sites where American technological ingenuity was celebrated during the 1850s through 1880s. In visual culture, from rarefied painting exhibitions to illustrations in weekly 10-cent magazines, viewers were exposed to a variety of images that represented, and reflected on, American factories, railways, cities, and shipping centers: the technological systems that *Harper's* praised so bombastically in rhyme. These images helped viewers make sense of often

disorienting new developments that shaped both industry and daily life. The Centennial poem was written to commemorate a spectacular national event specifically designed to showcase American progress in all its forms, but more often viewers experienced representations of industry, labor, and technological systems in the course of their everyday lives. The visual realm was saturated with thousands of images of industry in the years from 1857 through 1887.[2] The purpose of this study is to ask why: to ascertain some of the meanings these images held for their viewers, to explore how artists working in divergent visual media helped to shape American ideas about technology, and to consider hidden chains of association, teasing out how an image's visual armature creates rhetorical positions within a larger culture of debate and representation.

Understanding certain elements of the Centennial can help us think through these ideas in a preliminary fashion. The poem quoted above encapsulates technological systems in rhyme. It presents the United States as powerful, innovative, and unified. Rather than sectional conflict, the Centennial stressed peace, prosperity, and mechanical ingenuity, especially "the lightning chained and bound" in the form of the Corliss engine, designed and built by the Providence-based engineer George H. Corliss. Located in Machinery Hall, the Corliss engine was the centerpiece of the entire exhibition, a dramatic enactment of national unity and technological power. No article on the fair was complete without some impressions of the Corliss, and those who were able to visit the opening ceremony watched in awe as President Ulysses S. Grant set the giant machinery in motion. The Corliss engine served a three-pronged function at the Centennial Exposition. As an American invention showcased at a fair celebrating national technological development, it served as a potent symbol for the concord of the post–Civil War United States. As the machine that powered the other displays in the hall, it was at the heart of a miniature technological system of complex interconnectivity. And as a large and extremely powerful machine designed as a spectacle for an enormous number of visitors, it awoke contemporary fears about the destructive power of technology.[3]

The intersection of these three functions is a primary focus of this book, which attempts to make sense of the overlapping and often contradictory messages that visual images conveyed about the roles of technology and industry in nineteenth-century American society. Radical changes to American life brought about by technical and managerial innovations forever altered life in the United States and redefined what it meant to be a citizen who mattered. Images of industry and progress were multifaceted visual productions that could be filled with fanfare or fear, celebration or

condemnation, all at the same time. Highlighting the strains of progressivism and anti-modernism that coexisted uneasily throughout the century, these images reflected guarded optimism about the potential of American progress.[4] But they did not merely respond to change; the images, especially those created for mass distribution, were intended to manufacture a consensus about the roles of technology and industrial capitalism in the modern United States. Visual artists captured change in dramatic, often humorous, and frequently insightful ways.

Images brought these changes home, literally, to those who saw them in the pages of magazines and newspapers. During these years, *Harper's Weekly* alone published nearly a thousand images of labor, technology, industry, and machinery, which means that approximately every other week over three decades, viewers were reminded of the centrality of modernization to their lives. Beyond this single publication, it is impossible to deny the saturation of these images. Millions of Americans visited regional, national, and international expositions designed to showcase products and machinery; there they bought souvenir brochures and postcards, stereograph slides and sheet music. Even painting, which held an elevated and sometimes separate role in American visual culture, was more broadly disseminated through chromolithographs and engravings in gift books, magazines, and newspapers. Among those were reproductions of *Forging the Shaft* by John Ferguson Weir, *The Strike* by Robert Koehler, and *The Ironworkers' Noontime* by Thomas Pollock Anshutz, rare but crucial examples of American paintings that dealt with the topic of industry. Although the Civil War might be the century's defining event, technology was its definitive theme. Understanding the roles these images played in shaping responses to that theme can help us refocus our picture of American life during these years, a life saturated with visual reminders of the radical changes that constantly altered the fabric of daily existence and redefined the meanings of nationhood.

Images of technological systems allowed Americans to conceptualize the nation and their place within it. Seeing work, witnessing technological advances, observing modern factories in action: viewers used these images to take an active role in understanding their national, local, and personal stakes in the growing industries of the United States. And yet, behind the systemic, rational qualities of technology and industry lurked something essentially unknowable, strange, and irrational. Even images or objects that were intended to showcase a progressive positivism and patriotic fervor could be viewed through an alternate lens, that of the potentially destructive and uncontrollable power of technology. This book is

an attempt to understand how these complex and contradictory responses to technical and industrial change shaped a vast and diverse visual realm over a period of three decades.

## Technological Systems in Tension

This study covers the years 1857 through 1887, a brief but turbulent thirty-year period that saw the rapid expansion of rail and telegraph networks; the rise of powerful, centralized corporations; and the creation of specialized facilities for the mechanized production and distribution of products for national and international consumption. I categorize such changes broadly as the large-scale development and maintenance of "technological systems." The historian of technology Thomas Parke Hughes coined this phrase in the 1980s to describe two phenomena: most basically, the actual physical networks required to maintain the function of an industry or technology, and, more abstractly, an understanding of the technological underpinnings of a society as interconnected and contingent.[5] All elements of a system are to some degree dependent on the proper operation of each of its component parts, creating some systems so large and complex that they cannot easily be mapped or comprehended. In her 1997 book *A Social History of American Technology,* Ruth Schwartz Cowan expanded on the theory of technological systems, arguing that people undergoing the transition between preindustrial and industrialized modes of production become increasingly reliant on other people who may be hundreds of miles away, "linked together in large, complex networks that are, at one and the same time, both physical and social."[6] Industrialization reorganizes society in potentially upsetting ways, replacing localized networks with transcontinental systems of telegraph wires, train lines, or manufacturing schemes. This book examines in depth the confusion, excitement, and innovation of one such period of transition.

I do not propose a radical break. These developments were part of a lengthy and sustained process of industrial development dating back to the late eighteenth century, but I believe that in the 1850s, two related phenomena allowed for the increasing acceleration of change: the publication of popular illustrated weekly periodicals such as *Frank Leslie's Illustrated Newspaper* (1855) and *Harper's Weekly* (1857), and, also in 1857, the first attempts to lay a suboceanic transatlantic telegraph cable that would be the initial step in an international network of rapid communication. These two elements combined to create a world more saturated with inexpensive and readily available information and images. They shaped and participated in

the expanding networks of communication, distribution, and standardization that helped to forge a managerial nation in the late nineteenth century. In addition, the growth of instantaneous international communication and mechanized publishing of mass periodicals influenced the ways many people thought about interconnectivity—whether or not those people's lives immediately changed as a result. No single narrative can tell the story of how the visual realm negotiated these changes, for artists, like the public, responded with ambivalence.

Some scholars have used the term "revolutions," suggesting rupture rather than continuity, to refer to nineteenth-century developments in transportation and communication.[7] While I take a more gradualist perspective consonant with recent scholarship in the history of industry, it is crucial to understand that the changes occurring in these years did vastly alter certain everyday experiences. The increasing expansion of the railroad system, which worked with and relied on the telegraph in many ways, made transportation and communication more rapid, efficient, and accessible. In turn, these innovations enabled the development of quasi-assembly line techniques, strategic management in factories and other locations of production, and rapid, efficient distribution of finished products to larger, more dispersed groups of consumers across the globe. These changes affected those at all levels of society, from the privileged group of overseers that became America's first industrial managers, to the industrial laborers who had to adjust to new, speedier, and more impersonal modes of production, to consumers of all classes who found themselves moving away from local networks of production toward huge international business structures. Many commodities now reached their consumers through a diffuse process of production: from a farm, forest, or mine, through the factory, across weblike distribution networks, and eventually into the home. Although these systems were neither unitary nor seamless, by the 1880s they covered a vast area of land, and both companies and governments were working to make them more unified and consistent.[8]

By 1887, which I have chosen as the concluding point of this study, government was more actively working to curtail unrestrained private industry and to codify a set of rules that would cover everything from worker safety in railroads and factories to long-distance transportation of goods. The standardization of the railroad track gauge, discussed in chapter 1, occurred in 1886 as a federal initiative to encourage rapid transportation between states; the following year, Congress passed the Interstate Commerce Act of 1887. These two events suggest a closing or restriction of the open, almost carnivalesque, world of industry and technology that

existed earlier in the century. It is tempting to think of this increasingly restricted, rationalized worldview as an endpoint in a narrative of progress leading to an ultimate managerial outcome. Instead, I believe that in the post–Civil War era, specific social, technological, and economic conditions strongly rewarded managerial structures and ways of thinking, but that such modes were neither inevitable nor immutable. Throughout the thirty years examined in this study, multiple narratives about American art and American industry coexisted, and many of those narratives persisted, albeit in changed forms, into the twentieth century.

The story of technological systems, especially as presented visually to the public in the nineteenth-century United States, is one of oscillating orderliness and irrationality, of systems that shift between appearing clear and logical or mysterious and obscure. Was technology something magical and frightening, beyond the capacity of a layman to understand, operated by fairies, sprites, and demons? Was it a rational and completely logical means of organizing and shaping the world? Or was it something in between? The answers to these questions often depended not merely on the personal beliefs of an image's creator but on the rung of the American art world he occupied. At the heart of this book are two central tensions: one between a managerial ethos and a desire to see the poetry, magic, and strangeness of technology, and one between the pro-business aims of paid-per-illustration popular periodicals and the greater freedom afforded "fine" artists who were not plagued by editorial demands or deadlines. Often, though not always, these two tensions map onto one another, with illustrators focusing on precise details, facts, and processes while painters allowed industry greater room for doubt, strangeness, and even mysticism. In many ways, this comes down to differences in the intended communicative functions of different forms of imagery, tensions between the audiences, goals, and discursive spaces of "high" and "popular" images.

*Visual Systems in Tension*

While recent historians of art and visual culture have challenged traditional hierarchies of artistic quality and relevance, it is important at the outset to note that this book deals both with paintings and with more ephemeral productions of visual culture, mostly in the form of magazine illustrations. The process of weaving together print culture and the high art of painters such as Thomas Moran, John Ferguson Weir, and Thomas Pollock Anshutz, all of whom I discuss at some length, can raise problematic questions about the status of various forms of visual production

during the nineteenth century. I include painting alongside illustration because I believe that, despite these art forms' very different positions in nineteenth-century America, the boundaries between them are more porous than one might expect.[9] In addition, the different goals and needs of artists working in varied fields contributed to the ways they chose to interpret technological and industrial progress in their work.

The artists included in this book held a variety of positions in nineteenth-century artistic culture. Some illustrators, like Charles Graham, had little or no formal training, while others, such as Thomas Nast and A. R. Waud, took classes at the National Academy of Design or the Art Students' League. Regardless of their educational backgrounds, most popular illustrators spent their careers under deadline from art directors and editors, though painters, including John White Alexander, Winslow Homer, and Edwin Austin Abbey, sometimes got their starts as sketch artists, paid by the page. And the painters discussed here were by no means a homogeneous or elitist group, despite the greater cultural prestige of their works. Weir published widely in middlebrow American journals, while Moran worked under contract with railroad companies on several voyages to the West. Artists and illustrators sometimes inhabited the same spaces—the Tenth Street Studio in New York often housed both—and sometimes even the same conceptual spaces, despite the cultural hierarchies that governed their subject matter, audiences, and reception. Although I operate under the assumption that illustrations are equally as important and meaningful as large-scale oil paintings for achieving an understanding of nineteenth-century visual culture's varied responses to industry, it would be historically inaccurate merely to lump all these images together as if they had equal value in their original context. They did not. And yet, through cross-examination of a variety of visual media, I believe we can reach a fuller understanding of the astounding *presence* that pictures of industry held in nineteenth-century American life. Considering all these works of art in a single volume can, I believe, greatly enrich and expand our understanding of how central this imagery was within a broad field of visual culture.

In addition, the tension and interaction between high and popular art may help to clarify the simultaneous interplay between the irrational, strange side of technology and its orderly, rational aspect. While the two sets of categories do not map exactly onto one another, considering the function, distribution, and cultural role of paintings as opposed to illustrations, it becomes clear that fine artists had much greater room for experimentation, play, and doubt, while illustrators, working under the dictates of often pro-business magazines, were usually encouraged to

depict industrial change with a more positive slant. Weir and Moran, the painters profiled in chapters 2 and 4, were trained with a Romantic conception about the role of the artist as a figure who displays (and creates) wild states of emotion and turmoil. They shared an emotive ethos based on heightening the experiential qualities of art through key categories of nineteenth-century aesthetic theory, the sublime and the picturesque. Illustrators, by contrast, were usually not encouraged to convey aesthetic sensations but to communicate with viewers in ways that were clear and straightforward. While most frequently this communication lent itself to a form of representation that was highly factual, as discussed in chapter 5, occasionally the communicative goal of magazines was to entertain or shock. Therefore these illustrations could not convey only a single message about industry, because the periodicals themselves were designed to appeal to a number of audiences and provide a number of functions at one time. Envisioning themselves as hybrids of education, culture, news, humor, and scandal, illustrated periodicals of necessity used widely differing techniques, sometimes even within the same volume, to provoke conflicting responses from their audiences. Still, though it is impossible to pin down the categories of high and popular imagery as falling in line with specific responses to technology, it is possible to suggest that the art world had reasons to privilege a dark, unruly understanding of technology while illustrators were encouraged to depict it in a more celebratory fashion. And unlike oil paintings, which were viewed in person only by small numbers of elite individuals, each week periodical illustrations traveled across the country and reached millions of viewers, articulating popular responses to technological and industrial change.

## Periodical Illustration as a Visual System

In the press, viewers were given the opportunity to see the full extent of technological systems from the comfort of their parlors. Images in mass circulation magazines helped them envisage the technological changes that increasingly structured their lives. "A subscription to a mainstream magazine," writes Cecelia Tichi of the early twentieth century, "was a guarantee that the reader would be made constantly aware of the national and worldwide presence of machines."[10] What Tichi argues of the period from 1890 to 1930 was already becoming a reality in the earliest years of illustrated magazine publication, though on a smaller scale. It is nearly impossible to open a copy of some of the major illustrated periodicals of midcentury—magazines ranging from the popular, melodramatic sensi-

bility of *Frank Leslie's Illustrated Newspaper* to the highbrow literary aspirations of *Harper's New Monthly Magazine*—without being powerfully reminded of the ever-present existence of technological systems. The illustrated periodicals that arose in the 1850s, also including *Harper's Weekly, Scientific American,* and *Vanity Fair,* expanded the accessibility of visual materials and shifted popular notions of visuality. With their dedication to in-depth pictorial journalism, these publications contributed to a rich and complex culture of images that was available to a larger segment of American society than ever before.

While it would be a mistake to describe this era as "more visual" than earlier periods in American history, the rapid growth of illustrated periodicals in the immediate antebellum period had important consequences for popular and visual culture throughout the rest of the century. Such magazines created a readership that quickly became accustomed to seeing or experiencing the news in certain ways, and also helped to shape notions of a unified (if not quite uniform) national audience for visual culture.[11] Print culture also gave viewers privileged access to a wide variety of images that would otherwise be unavailable to them, and news illustrations could reach vast audiences. Although accurate circulation numbers for this era are difficult to obtain, around 1860 both *Frank Leslie's* and *Harper's Weekly* had circulations of around 100,000 copies per issue. If, as publishers estimated, five people read each copy that was circulated, the two magazines combined to reach around 1 million people a week.[12] In addition to broadening the audience for imagery, periodical illustrations also allowed viewers to "travel" to sites that would otherwise be beyond the bounds of possibility. In the pages of the press, viewers could fly over (or dive beneath) oceans, travel to faraway cities, and experience cultures foreign to them—whether exploring Africa or visiting Lower Manhattan's Italian tenement dwellers.

The audiences for these publications remain largely an unknown quantity to present scholars, who agree that the lack of subscriber lists for nineteenth-century periodicals hampers our knowledge of who, precisely, was reading them. While it is evident that the monthly magazines such as *Scribner's* (later *The Century*) or *Harper's Monthly* were outside the price range of most working families, weekly illustrated newspapers like *Harper's Weekly* and *Frank Leslie's* would have been more affordable. It is generally accepted that middle-class families made up the largest share of readership for most of the illustrated periodicals, but there may also have been a significant upper-working-class readership that found the middlebrow ethos and genteel cultural values of these publications

aspirational. Barbara Sicherman, Mark J. Noonan, and David Paul Nord present arguments in favor of working-class readership for such magazines. Noonan suggests "grass-roots distribution" of the more expensive monthlies to working class families, while Nord finds that in 1890–91, 77 percent of working-class families spent discretionary income on reading material, though precisely what that reading material consisted of was not recorded.[13] We can therefore posit a readership that may have been somewhat economically and geographically diverse but was most likely limited to those who shared the magazine editors' values of gentility and "uplift."[14]

Until the late 1880s, most of the images in these periodicals were created using the technique of wood engraving, a medium that was particularly well suited to precise depictions, whether of urban panoramas or factory machinery. A relief process, wood engraving was similar to woodcut, a technique in which areas were cut away leaving a raised design that would print as black. Wood engraving, however, differed from woodcut because engravers used a burin on blocks cut from end-grain, which could give much more precise and detailed designs.[15] Rather than simply gouging out unprinted areas, wood engravers could use the burin and other engraving tools to slice, stipple, and incise with great accuracy and delicacy. The engraving could then be set on a page with type and the whole page electrotyped for mass printing. The process of wood engraving also allowed for speed unmatched by other reproductive media at the time. In *Frank Leslie's,* for the first time in the United States, pictorial news was available as soon as a few days—and no longer than two weeks—after an event.[16] In addition to speed, publishers of wood engravings tried to emphasize their authenticity and accuracy. Paradoxically, despite their clearly hand-drawn character, magazine editors claimed that wood engravings gave viewers direct access to "truth." Even though wood-engraved images were almost always created in an office in New York, far removed from the sites where news took place, magazines used many strategies to emphasize their realness. Making bold claims of topicality and timeliness, *Harper's* and *Leslie's* rhetorically underscored their relation to truth by including words like "accurate" and "authentic" in image captions.[17] Magazine illustrators were by no means regarded as mere scribblers or unimaginative draftsmen, though. A designer of wood engravings was also "a *poet*," his labor "purely an intellectual process, and it requires intellectual qualities of the highest order."[18]

Wood engraving was directly challenged in the 1880s by the adoption of inexpensive halftone printing for the reproduction of photographs and original artworks. It was cheaper than wood engraving, did not require

engraving's intensive skilled labor, and could directly translate an original into a mass-printable form. As the print scholar William M. Ivins, Jr., argued, any non-photomechanical translation of a pictorial statement into a new medium inadvertently transforms the pictorial syntax of the original.[19] This argument is essentially teleological and presupposes that the fidelity of halftone engraving would ensure that it almost immediately superseded a less direct mode of representation such as wood engraving. This, however, did not occur. Later challenges to Ivins from Neil Harris and Gerry Beegan suggest that late-nineteenth-century publishers made complex decisions about what types of reproduction were suitable for an image, given both its subject matter and its original medium, a structure that Harris describes as "categories of appropriateness."[20]

It is therefore not surprising that despite the affordability of halftone and its ability to give a truly direct reproduction, magazines adopted it slowly, continuing to print a mixture of media into the late 1890s. When compared with early halftone reproductions, wood engravings are superior in clarity, detail, and contrast. The rise of photographic news reportage in the late 1880s challenged newsmagazines' myths of objectivity and accuracy, but wood engravings were still the primary way most Americans visually experienced news in the nineteenth century.[21] The longevity of wood engraving in the face of photomechanical reproductive technologies suggests that it possessed desirable qualities. Because it was *not* indexical, engraving could be used to portray dreams, nightmares, and events that could not yet be photographed, such as train crashes. In addition to freezing time, engravings could play with expectations of space, challenging the strict orthogonal perspective required by photography and understood as traditional to painting. This flexibility allowed artists to experiment with the irrational side of technology or to manipulate space and temporality to create greater "factual" legibility in representations of industrial commodity production. The format of wood engraving enabled the contradictory representation of technological systems as simultaneously controlled and understandable, mysterious and unknowable. Taken together, paintings and engravings of this period show a wide-ranging engagement with the question of technological systems in the nineteenth-century United States. Visual production was a crucial part of a larger cultural discussion surrounding industrialization and its changes, allowing viewers to become active participants in the management and control of technological systems. But it also introduced them to the powerful, sometimes overwhelming, qualities of sublime technology. The Corliss engine, with which I began this introduction, sparked just such a contradictory

reaction in nineteenth-century viewers and served as a focus for the tensions discussed throughout this book.

### Reading the Corliss Engine

Within this milieu of multifaceted change, the 1876 Centennial Exposition stood as an important site for symbolic national rebuilding. The celebration of one hundred years of national unity tended to gloss over what many commentators euphemistically referred to as the "late conflict." The fair was an important opportunity to display the manufactures and machinery of South and North together, and to trumpet the strength and vitality of the renewed Union to an international audience. As one Georgia newspaper put it, the Centennial was a place to "perfect the bonds of fellowship and fraternity, and cause North and South, East and West, to strike hands, and stand shoulder to shoulder in all time to come."[22] The visual culture of the fair triumphantly masked lingering political tensions in a haze of rosy nationalistic propaganda, turning technology into a marvelous spectacle of American achievement and dominance with the fabulous Corliss engine as its prime mover and symbol. Nearly one-fifth of the total U.S. population visited the Centennial Exhibition during its six-month duration; an even larger number would have been exposed to representations of the engine in press illustrations, souvenir books, or prints.[23] Representations of the Corliss forcefully presented the engine as a product of American technological and political might. During the fair's opening ceremony, President Grant and a visiting foreign dignitary, Emperor Dom Pedro of Brazil, set the engine in motion. In his lengthy speech of welcome, Grant invited visitors to marvel at the achievements of a country that only one hundred years before had been a nation of farmers, now "rivaling older and more advanced nations in law, medicine, and theology, in science, literature, philosophy, and the fine arts."[24] For his audience, the spectacle of Grant's body, elevated above the crowd on a platform level with the engine, melded American technology with American politics.

Theodore R. Davis's illustration for *Harper's Weekly* embeds the Corliss in an international context stressing America's connections with the rest of the world (fig. 1). The novelist and journalist William Dean Howells patriotically wrote that in Machinery Hall, "one thinks only of the glorious triumphs of skill and invention. . . . All that Great Britain and Germany have sent is insignificant in amount when compared with our own contributions; the superior elegance, aptness, and ingenuity of our machinery is observable at a glance. Yes, it is still in these things of iron and steel that

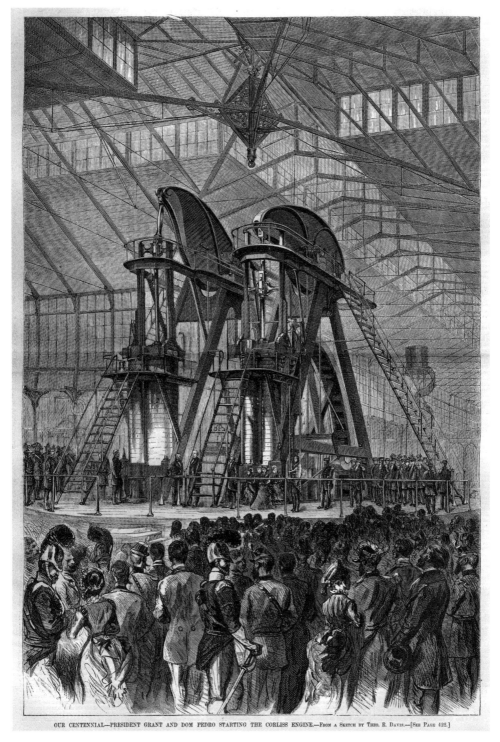

OUR CENTENNIAL—PRESIDENT GRANT AND DOM PEDRO STARTING THE CORLISS ENGINE.—From a Sketch by Theo. R. Davis.—[See Page 422.]

Figure 1.    Theodore R. Davis (American, 1840–94). "Our Centennial—President Grant and Dom Pedro Starting the Corliss Engine," *Harper's Weekly*, May 27, 1876, 421. Wood engraving, 14 x 9¼ in.

the national genius most freely speaks."[25] Understanding the people who came to witness the festivities impacts the way we interpret the Corliss's meanings. The crowd in Davis's image provides a cross section of fairgoers, both American and foreign, similar to the mob described in the image's accompanying article: "There was a picturesque commingling of nationalities and costumes never before witnessed in this country—Japanese and Chinese side by side with Europeans and Americans, French and Spanish officers in full uniform, Norwegians, Swedes, Germans, Congressmen, Senators, broad-brimmed Quakers, and fashionably attired ladies."[26] Another spectator commented on the veritable Babel of languages to be overheard, "from our own familiar and vigorous Anglo-Saxon to the guttural of our barbaric Aboriginese, or the sing-song jargon of the 'heathen Chinese.'"[27] The foreground of Davis's engraving reveals some "fashionably attired ladies," almost all paired with foreign military officers, perhaps those "French and Spanish officers in full uniform" described above. In its June 3 issue, *Scientific American* depicted a different, though equally diverse, cross section of the crowd, including the Chinese Americans noted in eyewitness accounts. Both periodicals featured a variety of domestic and foreign visitors gathered to witness the crowning technical achievement of the United States, which had arisen as one of the primary political and technological forces of the industrialized world.

Architecturally, the engine itself was designed to impress. One Arkansas traveler marveled at the Corliss as "one of the most perfect pieces of mechanism ever made."[28] The initial reaction was often mute admiration. For instance, Howells recalled first being rendered speechless and then noticing the machine as "an athlete of steel and iron with not a superfluous ounce of metal on it."[29] Howells's lack of technical knowledge actually enhanced his experience of viewing the Corliss; from a layman's point of view, the machinery stood out as a wedding of impressive might and ruthless efficiency. One contemporary observer, an engineer and inventor, however, argued that he could have produced an equally powerful engine on a much smaller scale. Evoking the nineteenth-century vogue for managerial order, Charles T. Porter commented on the inefficiency of Corliss's machine. He argued that a single-cylinder engine of less than half the size of the Corliss would "exert more power than is afforded by this monster and would run with far greater economy."[30] Porter, though critical, was cognizant of the importance of visual impact on spectators. He noted that the Corliss engine's impact did not derive from its *actual* efficiency; rather, it communicated to viewers a sense of power and spectacle. He referred to the engine as "the most attractive single exhibit ever

shown anywhere."[31] A twentieth-century scholar, John Arvid Hertzman, later made a similar argument about the aesthetics of the Corliss; he suggested that the machine was specifically designed to give an *impression* of harmonious efficacy, whether or not the symmetrical dual pistons were actually the best design from an engineering standpoint.[32]

In addition to its role as a symbol of American unity and dominance, and its spectacular design, the Corliss engine was also a site of sublime experience. The sublime, discussed in detail in chapter 2, arose as an important category of aesthetic viewing during the eighteenth century. The sublime foregrounded an experience of simultaneous awe and fear, together creating a sensation of thrilling and heightened perception. In the American context, the sublime increasingly became associated with the experience of viewing technological marvels rather than natural phenomena. Indeed, in the United States, it is difficult to separate national pride or patriotism from spectacular technology. Nineteenth-century audiences became accustomed to reading ideas of American nationalism in technological vistas, an experience that stressed a democratic, group mode of viewing. Instead of heightening individual subjectivity, David E. Nye argues, the American technological sublime produced a group identity and a "belief in national greatness."[33] One visitor to the fair, author Bayard Taylor, referred to the Corliss engine as "the sublime of mechanical power"; other viewers agreed that its massiveness and strength were both impressive and terrifying, though it was difficult for news illustrations accurately to express the true qualities of the engine.[34] It was challenging for artists to suggest the awe provoked by the Corliss engine when translating these impressions into two dimensions; few were as successful as Davis, who heightened the machine in relation to the viewer and gave the engine what the art historian Marianne Doezema described as a "heroic vantage point."[35]

Early American technological booster Jacob Bigelow claimed that exploiting technology had "given the mind the advantage over the body."[36] When considering Davis's depiction of the Corliss, however, the explicit relationship of mastery seems qualified, if not reversed. The avatar of technology, the massive steam engine groaning into life, dwarfs its supposed masters, the men of state on the podium before it. Machines take the dominant position. This powerful image of technological strength played into contemporary fears about what could happen when man's ability to harness nature broke down. The most successful images of the Corliss expressed this tension, providing viewers with a way to relive the fair, to remember how it felt to look up at the engine whose "mighty walking-beams

plunge their pistons downward, [whose] enormous fly-wheel revolves with a hoarded power that makes all tremble."[37] Many viewers even used language loaded with occultism to try and describe the awesome impressions of the experience. As the historian Henry Nash Smith noted, this response was typical for viewers of the Corliss and of steam-powered machinery more generally. He suggested that such imagery partakes of "a supernatural quality, which often . . . is given a sinister aspect by references to 'monsters' and 'demons' . . . suggesting dark subterranean forces beneath the brisk ideology of enlightenment."[38] The varied responses to the Corliss reinforce Smith's argument. An author in the September 1876 issue of the *Atlantic Monthly* compared the displays in Machinery Hall to "intelligent brutes" and "will-o'-the-wisps," and argued that "there is something at once sublime and infernal in the spectacle."[39] Howells referred to the Corliss as a "slave" and a "prodigious Afreet," referencing a character type from Arabic mythology, a jinn with magical and often evil powers. In this case, the engine was an unruly subordinate who "could crush [the operator] past all semblance of humanity with his lightest touch."[40] Although Howells noted that fear of the engine was not his overwhelming impression, the image of a restive slave who toiled on sufferance and easily had the strength to crush its master was not always reconcilable with positive national feelings. The reference to a slave obliquely called up the past specter of slave revolts and tied the technological sublime to overlapping fears of blackness and disunity.[41]

One observer from Georgia also noted the engine's fearful ability to dominate its human controllers, even to take on a mysterious life of its own: "Somehow we have caught the idea that this mammoth power is endowed with more than ordinary intelligence."[42] The anthropomorphosis of the engine persisted in another author's suggestion that the Corliss was so overpowering that "a young girl among the assistants was apparently overcome by it."[43] In the most sinister of these accounts, the Corliss became more than just a specter of artificially intelligent machine life. The Georgian correspondent went on to describe the engine as a spectacle of marvelous autogenesis, writing that it seemed spontaneously to have grown, or evolved, from raw minerals *under its own motive force*. He stated, "Why not give to the metals and materials of this vast power [the engine] the same progressive principle from its crude ores that Darwin gives to the animal creation from the mamal and molusk germs?"[44] While in *Appleton's Magazine*, William H. Rideing could write that the Corliss was evidence of "man's power over matter," others insisted on the uncontrollable nature of the machine.[45] The engine's phenomenal spectacle thus had its ominous

side, a side that could revive unwanted specters of the past or call into question man's power over the world. As with all manifestations of the sublime, the thrill and majesty of the sight is tempered with an undercurrent of fear and uncertainty, a frisson of danger.

Machinery was thus strange, unknown, wearying, even dangerous. Consider a final quotation from the *Atlantic Monthly*: "Machines ... make no boast, but silently perform their task before your eyes; the mode in which it is effected is a mystery; the spools, shuttles, spindles, are there, so is the raw material; one sees the means and the result, but the process is invisible and inscrutable as are those of Nature."[46] The raw material is evident to us; so is the result, the products. But in so many cases of encounters with technology during this period, the process is mysterious, invisible, unknowable. The Corliss engine contained within it a power both transcendent and transgressive, one that could overturn the neat dichotomy of mind over machine expressed by Bigelow earlier in the century.

## A Narrative of Tensions

As is evident from this discussion of the Corliss engine, many responses to technology and industry could coexist, even within a single example. Throughout this book, I attempt to bring order to the huge amounts of source material by organizing it along both chronological and thematic lines. Stretching from early telegraphic technology to Progressive principles for organizing both labor and life, the narrative works its way through the nineteenth century. While the progression may seem to privilege a linear historical narrative—that is, a teleological march toward increasing managerial domination—I believe that in the long view, this interpretation proves illusory. While it may have seemed that way to observers during the nineteenth century, the managerial revolution was not a harbinger of a perfectly rationalized American society. Instead, what I believe is captured here is a snapshot of one era in a larger, and much messier, narrative of American economic, technological, and industrial development. The post–Civil War period moved toward greater "incorporation" and regulation for a variety of reasons—economic, political, social, and cultural—yet this was only part of a larger story of continuous expansion and contraction, playfulness and seriousness, nervousness and confidence that mark the ever-changing relationships Americans have with their contemporary technologies.[47]

The narrative of this book begins in an antebellum atmosphere of change and possibility. In chapters 1 and 2, I explore some of the ways that

artists showed industry and technological systems as strange, uncanny, mysterious, or threatening. The first chapter explores the response, primarily in press illustrations, to two main systemic expansions occurring in the 1850s and 1860s: the creation of a submarine telegraph connection to the United Kingdom and the completion of the transcontinental railroad in 1869. Both these events sparked artistic responses that couched technological systems as something beyond understanding, something magical and strange. The second chapter also deals with this theme as it appears in the painter John Ferguson Weir's two major canvases depicting industry at the West Point Iron and Cannon Foundry in upstate New York. I argue that Weir's paintings were part of an outpouring of nineteenth-century interest in alchemy as a metaphor for transformation and change, something that was increasingly important to explore in light of troubling and often disorienting industrial and technical development.

In chapters 3 and 4, I look at ways that technological systems were imagined as increasingly national in character in the decades following the Civil War. Chapter 3 considers how Reconstruction was conceptualized as a form of labor that would piece the shattered nation back together. Additionally, I examine how emergent southern industries were depicted in northern periodicals. This chapter posits industry and hard work as national values that contributed to the reunification of the country. In chapter 4, I look at the way the reunified nation was linked together by often invisible systems, examining Thomas Moran's 1880 painting *Lower Manhattan from Communipaw, New Jersey* in the context of the international trade in sugar. This chapter examines the ways that artists struggled to come to terms with changing meanings of traditional aesthetic categories—such as the picturesque—in their depictions of industrial cities. It also shows how one industry, sugar harvesting and refining, was connected with many other systems: from the collateral industries of the trade, to the national network of transportation, to expansionist tactics in the western United States and the Caribbean.

Finally, the last two chapters examine the rise of an organizational culture as the nation drew closer to the rationalizing principles of the Progressive Era. Chapter 5 explores the emergence of a new mode of viewing that I have conceptualized as the "managerial eye." The managerial eye arose simultaneously with the implementation of managerial capitalism in many key industries in the United States. These illustrations position the viewer as an overseeing figure who can take in, at a glance, many diverse steps involved in a commodity's production. These images gave viewers—no matter their social standing—a fantasy of control over and

à la Pinkerton-eye?

knowledge about the manufacture of everyday commodities. Finally, chapter 6 addresses the importance of systems in the social realm. The representation of factories, schools, prisons, and workhouses underscored the newly important issue of social organization. Images urged viewers to interpret these institutions as sites for the training of future citizens, who were also conceived of as future laborers. Whether artists were focusing on the importance of pedagogy or the rehabilitation of criminals, social systems were shown as a means of organizing and controlling U.S. society and bringing certain members of that society into a productive capacity through labor.

In the conclusion, I consider the rise of halftone illustrations, which put an end to the era of wood engraving and made most of the images discussed in this book obsolete. Considering why wood engraving remained dominant for almost a decade after the invention of a relatively inexpensive photomechanical means of reproduction, I look back on the wood-engraved periodical illustrations of the nineteenth century. Their particular form of visual communication and their central cultural position as hybrid items of entertainment, news, boosterism, and middle-class cultural dissemination made them ideal vehicles to communicate a blend of high and popular ideas to their readership. During the same years, the rise of avant-garde modernist art movements in the United States made the images of industry by Weir and Moran seem outdated. Exploring conventions of sublimity and picturesqueness inherited from the eighteenth century, by the time of their deaths in 1926, their paintings appeared tame and undramatic compared with works by Charles Demuth, Charles Sheeler, Joseph Stella, and Paul Strand. The conclusion, however, argues that the images discussed in this book were crucial forbears of twentieth-century art and major contributors to a continuing, shared American vision of technological achievement and national identity.

# Chapter 1

# Between Materiality and Magic

Representing the Railroad and the Telegraph

WHEN *Harper's Weekly* began production in 1857, the United States stood on the threshold of a new age as a team of engineers strove to lay a submarine telegraph cable between North America and the United Kingdom. By 1886, the cartoonist Thomas Nast could joke that the country was so overrun with telegraph wires that new lines would have to be laid through middle-class drawing rooms (fig. 2). An apparently small change—the ubiquity of the telegraph system—parallels in microcosm the transformations in the structure of daily life in the United States during this thirty-year period. With the emergence of telegraphic communications in 1844 and the explosion of mass market illustrated newspapers just a decade later, America found its daily life increasingly enmeshed in a technical web constituted by almost instantaneous communication and inexpensive, rapid access to vividly reported current events.[1] Added to the already expansive and quickly growing railroad system, these technologies allowed the creation of a shared vision of the nation structured by ideas of interconnection and standardization. Although changes reached the eastern seaboard cities more quickly than outlying towns and rural communities, the national press nevertheless worked to enforce an ideal of one nation, under technology.

Through the portrayal of two main technological systems—the railroad and the telegraph—artists attempted to construct a visual map of the

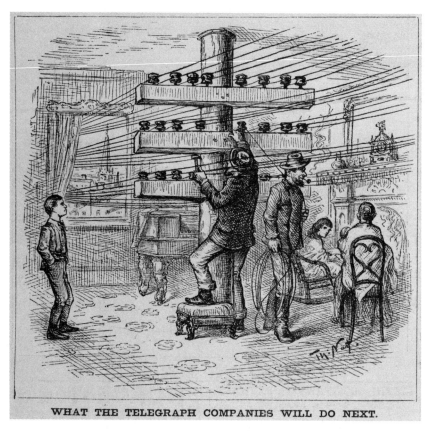

**WHAT THE TELEGRAPH COMPANIES WILL DO NEXT.**

Figure 2.    Thomas Nast (American, 1840–1902). "What the Telegraph Companies Will Do Next," *Harper's Weekly*, January 9, 1886, 32. Process line engraving or wood engraving, 5 x 5 in.

ways in which systems produced nation; these two systems in particular provided key points around which the technological and ideological unification of the country could center. These new technologies, however, so helpful in structuring commerce, speeding travel, and accelerating communication, also created anxiety among observers, who described them with a mixture of wonder and apprehension. The steam engine's "firewings" and the telegraph's ability to "forestall the flight of Time" unsettled and even alarmed some observers.[2] As the historian Barbara Young Welke writes, "fright and shock were by-products of the industrial era."[3] Artists tried to bridge this tension by developing multiple strategies to help viewers work through the disorientation such changes might bring. Often under the direction of editors (in the case of illustrators) or patrons ranging from the U.S. government to railroad companies, the artists discussed in

this chapter grappled with the best methods for representing new technologies in ways their viewers could readily understand.

This chapter focuses on how visual artists depicted two key events in the technological development of the United States: the attempts to lay a transatlantic telegraph cable between the United States and United Kingdom and the 1869 "wedding of the rails," when the transcontinental railroad was completed at Promontory Summit, Utah. The methods artists, illustrators, and photographers developed to document these events demonstrate a compelling tension in nineteenth-century visual culture. Visualizations of the railroad and telegraph oscillated between control and mystification, picturing systems in ways that were simultaneously concrete and journalistic or enigmatic and ambiguous. I examine this friction by analyzing images that helped viewers to mentally picture how these networks spread across the country: some attempted to explain these systems to viewers rationally, while others used metaphor and allegory to make systems legible in a different way. This tension demonstrates viewers' simultaneous desire to receive factual accounts of changes to their daily lives and to see these disruptive changes in ways that were already familiar to them.

The development of the railroad and telegraphic systems in particular transformed the ways Americans experienced both transportation and communication. The railroad, developed beginning in the late 1820s, constitutes America's earliest major technological system.[4] It is also one of the few nineteenth-century systems whose infrastructure is, at least partially, extant in our contemporary moment. Its visibility and familiarity to us today are problematic, however; they make it more difficult for us to view this technology through nineteenth-century eyes and to see how strange and occasionally frightening it could be. The other system explored in this chapter, the telegraph, is more foreign to most readers, though its early claims to instantaneous transmission, international connection, and standardization of information may sound surprisingly contemporary.

Once implemented, the telegraph and the railroad quickly became indispensable for the maintenance of a nationalized social-technical apparatus of production and communication. Together, they transformed many elements of the nineteenth-century United States, enabling changes to the structure of everyday life such as rapid and comfortable travel, clear and speedy communication, and standardization of goods, services, and even time.[5] But the emergence of modern systems, which provide so many benefits, can also radically alter or restructure traditional life in unforeseen ways. Observers talked about both systems as more wonderful than fiction, more spectacular than the human mind could devise. Recalling his

first breathtaking sight of a locomotive in 1828, Ebenezer Hiram Stedman wrote that a "Flying Maching . . . woold not cause one half the Excitement [of] that Rail Road," while Alexander Jones, the first general agent of the Associated Press, noted in his 1852 history of the telegraph that "no romance—no tales of fiction excel in wonder" the power of electricity.[6] Both authors framed the new technologies as a kind of science fiction—but if the technologies themselves were beyond human imagining, so must their consequences be. On the whole, while people reacted with excitement to both the railroad and the telegraph, uneasiness at their potential for unsettling power remained. Artists absorbed these hopes and fears, and helped to create and perpetuate them through visual means.

Because the average American understood new technologies only poorly, artists worked to resolve a key question: How to represent the complex technics of the railroad and telegraph in ways that were visually comprehensible to their audiences? The telegraph had a physical manifestation—miles of wires strung high above roads and railways—but also a more abstract quality that was difficult to grasp both conceptually and visually. The idea of transmitting a message through those wires as a series of electrical impulses mystified many observers. As Alexander Jones complained, "It is difficult for any one to give a clear and popular idea of the manner in which electric telegraphs are really worked. . . . The public see posts erected, and wires stretched on them."[7] But, he continued, the same public failed to understand the functionality of those concrete manifestations of the telegraphic system. Because its operation was essentially intangible, the telegraph differed from the railroad in a crucial way: it was much harder to illustrate in a comprehensible manner, as Jones recognized. In addition, because its apparatus was stationary and its actual function occurred at the microscopic level, the telegraph could not be represented dynamically in the same way the railroad could; unlike rushing railroad cars, telegraphic messages could not be shown in motion, speeding across the continent.

These limitations led artists to search for modes of representation that could make the telegraph's "magic" comprehensible to viewers with no technical background and that could animate telegraphic technology in a visually exciting manner. While the railroad's technical operation was also beyond the understanding of most everyday Americans, its tracks, cars, and stations comprised a system that travelers could inhabit physically. Thus, in some ways it seemed more comprehensible to many viewers than the telegraph. Despite these differences, however, both technologies proved difficult to represent. Artists could not agree on a standard mode

of depiction. Instead, pictures of the railroad and telegraph demonstrate a variety of representational approaches emphasizing the ways these crucial systems helped to produce the idea of a unified and technologically progressive nation.

Artists and illustrators walked a line between two key modes of representation when imaging these systems, oscillating between clarification and obscurity, between elucidating the connections forged by new systems and cloaking those links in the language of symbolism or myth.[8] Using either of these modes—or a combination of the two—artists showed viewers that their daily lives were implicated in overarching technological systems, stressing interconnectedness, organization, and nationhood. Viewers gained new information about technologies that, concretely or abstractly, connected them to a massive American extended family, united by systems. As one observer wrote in 1844, telegraphic technology had the power to "knit our people in closer relations of union and brotherhood," continuing on to ask, "Will not the telegraph literally render our people one family?"[9] As a technical wonder in its own right, and a primary technology that enabled the spread of popular print culture, the telegraph was a means of enacting greater national unity through the emerging form of the mass market illustrated press.

Benedict Anderson, most notably, has focused on the ways in which the spread of print capitalism enables the imagining of national identities through shared language and the tacit agreement to accept the news as a simultaneously experienced fiction of community.[10] Trish Loughran has challenged Anderson's theory of identity formation by suggesting that, in the U.S. context, the advent of an apparently unified national press actually caused increasing sectionalism.[11] While Loughran's arguments are compelling, Anderson's formulation nevertheless remains crucial for understanding the ways in which technological systems produce nation, if we consider the crystallization of national identity as part of a process of modernization that focuses on organization and rationality. Anderson's powerful description of the emergence of the modern worldview directly relates to nineteenth-century artists' attempts to understand, even control, the vagaries of telegraphic and locomotive technology. Periodical illustrators, in particular, struggled to effect just such a "transformation of . . . contingency into meaning," as Anderson describes in relation to the early modern secularization of European culture.[12] That is, the process of representing early systems as enmeshed in American identity was also an attempt to make sense of those systems, their contingency, and their occasionally frightening elements. Some representations of the railroad

and telegraph appropriated the language of Enlightenment rationalism, which Anderson notes as requisite for the formation of modern national identities; others seemed, however, to embrace the "contingency" of the irrational as a means of coping with the sometimes mysterious and even destructive power of these technologies.

Visual representations covered a spectrum from cartoons that posited technology as the work of fairies or magicians to comprehensive maps, charts, and checklists that claimed to grant viewers rational knowledge about the operation of systems. These different visual approaches gave viewers a set of tools with which to evaluate the dramatic changes they saw occurring around them. While some viewers embraced the informational impulse by devouring the maps and statistics that periodicals offered, others relied on a familiar vocabulary of allegory and myth to soften the intense changes brought about by the advent of modernity.

## Railroad

The railroad, as a locus for both hopes and fears about technology, is one of the best-documented technological systems in the United States. Beginning in the 1830s, its development and spread affected almost all areas of transportation, communication, and manufacturing. Because of its interconnectedness and ability to cover large areas while shortening travel times, the railroad, as the art historian Sue Rainey notes, "provided a way of expanding one's mental image of the country . . . a means of conceptualizing distances and locations of cities and geographical features."[13] Railroad supporters envisioned how the new technology might develop not only the "mental image of the country" but also the commercial and symbolic possibilities of the new nation.[14]

Early railroad boosters joined their voices to antebellum commentators who believed that the expansion of industry was a manifestation of Jeffersonian ideals congruent with the republic's goals of self-reliance and productivity.[15] Charles Caldwell, a professor of medicine, lauded the positive influences of railroads in an 1832 article in the *New-England Magazine*. Anticipating the idea of technological systems, Caldwell envisioned the future of the United States: "Throughout one of the most extensive empires of the world, every section is studded with cars, bearing hundreds of thousands of well dressed and gay inhabitants, and uncomputed millions of wealth, in the form of merchandize; and the whole is conveying to different points, with surpassing grace and majesty of movement, and the fleetness of the antelope, at the top of its speed."[16] Caldwell argued

that technology, specifically in the form of the railroad, had the potential strongly and irrevocably to unite and empower the nation. His evocation of a bustling and prosperous future made possible by the expansion of railroad lines echoes Rainey's insistence that the railroad allowed Americans to conceptualize a mental map of the country. Caldwell evoked both an actual map—a nationally interconnected railroad system—and a conceptual map—mentally positioning the United States as a center for international trade and transportation.

During the antebellum years, painters in the United States lent their brushes to the national conversation about the benefits of the railroad. Artistic representation of the railroad system, which was always tied up with westward growth, was fraught with concerns about national unity, identity, imperialism, and American technological prowess.[17] Artists maintained a conflicted relationship to development, "believing simultaneously in the benefits of inevitable progress . . . and in the goodness of a quasi-religious conception of nature."[18] Painters in particular found themselves addressing this tension through images of the railroad that aestheticized the idea of technological and geographical advancement. Thus the railroad could maintain a successful symbiotic relationship with the perfection of nature while still conforming to the mandate of Manifest Destiny.[19] Images of isolated train cars, such as *Starrucca Viaduct, Pennsylvania* by Jasper Francis Cropsey, depict bucolic scenes in which rural observers mark the passing of a miniscule train, which is usually located in the far background (fig. 3). In Cropsey's image, the train passes over the titular viaduct, delineated with precision but visually wedded to the surrounding natural environment in a typical expression of the Hudson River School style. The peace of the scene is not markedly disrupted by the intrusion of this machine; the puffs of steam from the locomotive are barely more prominent than the wisps of smoke escaping from the cottages below the stone arches. Cropsey naturalizes the machine and harmonizes it with the land, softening the impact of the railroad by choosing a point at which the line curves in harmony with the hillside and using the viaduct itself as a bridging device between foreground and background.[20]

The composition seems to replicate, almost literally, Leo Marx's evocation of the American ideal of "a society of the *middle landscape,* a rural nation exhibiting a happy balance of art and nature."[21] In Marx's seminal rethinking of the American pastoral ideal in terms of the tenuous balance between nature and the machine, such paintings as Cropsey's may be understood as balancing acts—or bridges. This literal bridge—Starrucca Viaduct—was, however, emphatically *not* assimilable into such

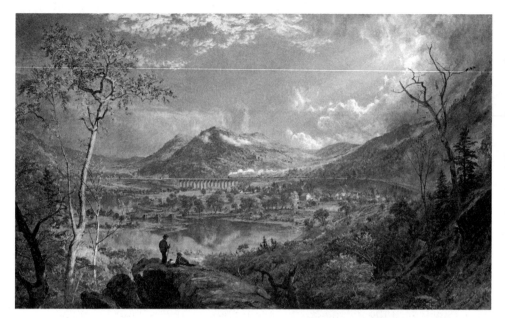

Figure 3.   Jasper Francis Cropsey (American, 1823–1900). *Starrucca Viaduct, Pennsylvania,* 1865.
Oil on canvas, 22⅜ x 36⅜ in. (56.8 x 92.4 cm). Toledo Museum of Art (Toledo, Ohio).
Purchased with funds from the Florence Scott Libbey Bequest in Memory of Her Father,
Maurice A. Scott, 1947.58. Photo credit: Photography Incorporated, Toledo.

an idealized landscape; it was a clearly manmade construction that physi-
cally altered the surrounding area with "21,259 cubic yards of masonry,
brick and concrete."[22] Like most large railway bridges, it was built with
the intention of spanning a river valley, suggesting the need to speed com-
merce to the other side. At the time of its building in 1848, the viaduct
was a powerful symbol of the unrivaled domination of the railroad in
American commercial interests, the most "stupendous construction" on
"the grandest railroad yet undertaken, or constructed."[23]

Almost two decades after the bridge's opening, a reviewer of Cropsey's
painting reinforced the idea of the bridge as a permanent, manmade in-
tervention into the landscape: "Had a thousand years elapsed since its
construction, and the work fallen into disuse and ruin, all man would be
moved by its majesty and grace."[24] In this estimation, the viaduct might
crumble but would never fall—would not be subject to the ravages of ero-
sion that shaped the rest of the landscape. *Harper's Monthly* reinforced this
with its attention to the dynamic human and technological intervention
needed to insert this seemingly harmonious element into the landscape:
"There is probably no road in the world that . . . can present to the traveler

such a succession of triumphs of art over the formidable obstacles which nature has, at almost every step, raised against the iron-clad intruders."[25] The peaceful surface of *Starrucca Viaduct*'s "middle ground" belies the violence inherent in this account of the railway's construction. Far from evoking the delicate balance between nature and technology suggested by Marx's analysis of American railroad art, Cropsey's composition may imply a more complex and troubling encroachment of the machine into the landscape.

At other times, this violent undercurrent to the locomotive's reputation came more obviously to the surface, as observers emphasized the forceful nature of railroad expansion. Appearing frequently in pro-business journals, celebrations of the railroad used a hypersexualized language to praise the mechanisms of westward expansion. Although originally meant to be clearly positive, today we can read a degree of violence and chauvinism in their chosen rhetoric. In 1876, for example, a writer in *Scribner's Monthly*, A. C. Wheeler, wrote, "Commerce . . . still travels the Santa Fé trail—but it is now an iron trail . . . one of the finest and fastest trails in the country, and it pierces Colorado in the center, and must sooner or later become the great feeder, no less than the developer, of the immense domain on the south-west, now known by every Wall street man to be bursting with mineral wealth."[26] Wheeler was but one of many contemporaries who noted that the encroachment of the railroad allowed for the exploitation of the West. In this example, Wheeler used two typical rhetorical strategies of the time—a sexualized description of national expansion and a teleological understanding of technological development.[27] Here the railroad violently "pierces" Colorado in order to take advantage of the ripe, fecund West, "bursting" like a womb with "mineral wealth." Further, Wheeler suggested that technological expansion allows for continually increasing exploitation of resources, which, in their turn, leads to further innovations and improvements. The progress of technological systems is thus both linear and exponential. In this formulation, the system of the railroad is never complete; rather, it is ongoing, absorbing new resources into the growing prosperity of the imagined nation.

*Spanning the Continent*

Because the railroad was such a potent figure for national expansion and commerce, both professional illustrators and fine artists used it as a metaphorical conduit spanning a massive continent. This was most evident in representations of the 1869 completion of the transcontinental line,

when the Union and Central Pacific Railroads were united at Promontory Summit, Utah. Technological boosters had suggested the desirability of such a line beginning in the 1830s; in 1848, one author posited the hope that a transcontinental railroad "would make the commerce of all the world tributary to us, and make us its carriers . . . would open the wilderness to cultivation, production, and usefulness, with the best means of transit, of connexion and intercourse with all the world . . . carrying from ocean to ocean a belt of population, educated to our habits and to our institutions, which would spread its influence over the habitable globe."[28] Although they would wait more than two decades after this hopeful pronouncement, American observers eventually witnessed the line's completion, an event that sparked an atmosphere of unqualified celebration. The press, the railroad companies, and individual artists used the "Golden Spike" ceremony, when the lines from east and west finally met, to posit the railroad as a symbol of economic progress and national accord. Most of these visual celebrations were sponsored by industry or intended as widely reproducible visual documents that could convince a viewership from the working class to the elite of the fitness of American progress. These images work powerfully to define what it meant to be part of a modern, industrialized America linked by a nationalized system of rail lines, a country, as the economist Henry George put it, "netted with iron tracks."[29]

Representations of the event focused on two primary indicators of national identity: race and technological dominance. These categories interacted in a variety of visual modes but with a consistent focus on the mutual reinforcement of white racial superiority and technical mastery. *Harper's Weekly* celebrated with a busy scene of east-meets-west that blatantly encodes technology as the province of native-born, white Americans (fig. 4). The pro-business Harper Company was a strong supporter of the expansion this moment symbolized and clearly desired to convince its middle-class and upwardly mobile audience of the fitness of Anglo-American control over the railroad and, through it, the West.[30] In the central image, a group of workmen cheers as a locomotive engine puffs around the bend, telegraph wire strung along the tracks. The visual trope of the "vanishing American" appears in the band of Native Americans witnessing the onrushing train.[31] Surrounding this idealized though visually realistic scene, a multitude of allegorical figures creates a vivid human border that frames an issue explored only superficially in the center: the convergence of race and technology. At the base of the image, a white male with his hand on a globe and a Chinese man represent "west" and "east," with the scene of naval commerce between them suggesting the recent

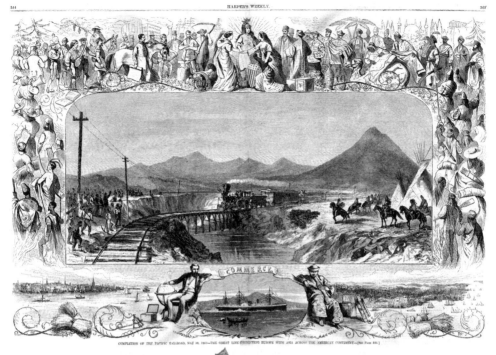

Figure 4.    "Completion of the Pacific Railroad, May 10, 1869—The Great Link Connecting Europe with Asia across the American Continent," *Harper's Weekly,* May 29, 1869, 344–45. Wood engraving, 14 x 20 in. Reproduced by permission from HarpWeek.

forceful opening of the Chinese ports by the Western powers. In addition to this explicit reference to Western economic imperialism, the teeming figures in the border reinforce a racialized idea of modernity. Centered at the top of the image, Columbia, personification of the United States, smiles as she invites two female figures—a "crowned head" of Europe and an Asiatic princess—to clasp hands in a symbolic joining. At Columbia's feet kneels a dark-skinned woman with bare breasts who is *not* invited to join the handshake. Although she is not in chains, her supplicatory position mirrors a well-known abolitionist image showing a kneeling female slave. Thus in the marriage of regions and races implied by the completion of the railroad, those of African descent are, like the Native Americans in the central scene, relegated to a state of powerlessness in the face of European American techno-hegemony.[32]

This racialized hierarchy is confirmed in the rest of the border, which attempts to place all peoples and cultures of the world into strict

relationships of superiority and inferiority. To the left of the central alle-
gorical grouping, male figures symbolizing agriculture, labor, and capital
stand in a modern landscape of factories, warehouses, and steamships.
They are accompanied by historical figures and contemporary "types,"
including a Union soldier, a cowboy, and Western European immigrants in
regional costume. To Columbia's right, "Eastern" ethnicities are on parade,
with the lightest-skinned in closest proximity to the center. Their backdrop
is distinctly premodern, containing leafy palms and cypresses, minarets,
pagodas, and a sketchy outline of the Parthenon. In the lower registers of
this border, Africans carry elephant tusks on the left, while indigenous
South American peoples are shown in the lower right. Compositionally,
the image's border is structured around current ideas about racial develop-
ment.[33] By placing Columbia at the top and races purportedly embodying
"lower" stages of development at the bottom, the image implies that with
the completion of the transcontinental line, the United States sits at the
pinnacle of historical, evolutionary, and technological achievement.

This composition resonates with contemporary accounts of the event,
which reinforced the technological dominance and social control of Anglo-
Americans. Describing the laying of the final rails, Henry T. Williams
wrote, "The Union Pacific people brought up their pair of rails, and the
work of placing them was done by Europeans. The Central Pacific people
then laid their pair of rails, the labor being performed by Mongolians [Chi-
nese]. The foremen, in both cases, were Americans. Here, near the center
of the great American Continent, were representatives of Asia, Europe and
America—America directing and controlling."[34] Williams's description
posits the event as a high point of American dominance over all other
races, nations, or continents, a dominance specifically enacted through
superior control over technology. Even immigrant European workmen
are described as inferior, not yet assimilated as "Americans" despite their
crucial role in bringing about this great achievement. Williams suggested,
like Harper's, that the wedding of the rails united the country but that only
certain members of the nation were qualified to be a part of that symbolic
unification.

Other contemporary illustrations and photographs reinforced the
completion of the transcontinental railroad—the driving of the "Golden
Spike"—as an important unifying event that made massive systemic ex-
pansion possible. Andrew J. Russell, a staff photographer for the Union
Pacific Railroad, was one of only three photographers present to record the
iconic moment when the two train engineers shook hands as their engines
met nose to nose (fig. 5).[35] Clearly the mandate of these photographers was

to represent their employers, the railroad companies, in a positive light, so this photograph, like *Harper's Weekly*'s massive tableau, reinforces the dominance of Anglo-Saxon culture and technological know-how. This time, the position of white Americans at the apex of achievement is suggested not by placing the United States at the top of an implied schema of racial evolution but through exclusion of nonwhites entirely. Russell's photograph carefully avoids capturing a likeness of any of the thousands of Chinese laborers whose work was so crucial to the construction of the railroad. Instead, as Jennifer L. Roberts notes, the photograph works spatially to reinforce an ideology of linear history and technological determinism; its ranks of carefully arranged spectators and strict perspectival recession into space underscore the event as one of "punctuality," an imagined notch on a timeline of U.S. progress.[36]

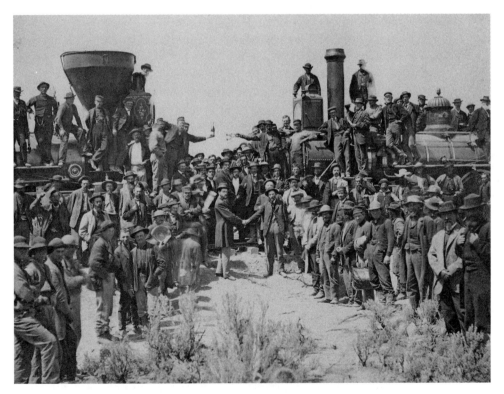

Figure 5.    Andrew J. Russell (American, 1829–1902). *East and West Shaking Hands at Laying Last Rail*, 1869. Photographic print, 28.2 x 35.5 cm. Photographs taken during construction of the Union Pacific Railroad (1865–69). Yale Collection of Western Americana, Beinecke Rare Book and Manuscript Library.

The dual meaning of "punctuality" also references the ways in which the railroad helped to reorganize and restructure time as something regular and standardized.[37] Roberts writes that the "optical armature of Russell's photograph . . . helped to make the geopolitical operations at work in the Golden Spike ceremony—centering and consummating the American nation—seem as 'natural' as vision itself."[38] In other words, Russell's composition centers the collective eyes of an entire nation on this event, claiming it as a significant moment of nation-building and naturalizing specific ideas about technology's role in that process. Richard V. Francaviglia adds that the composition of Russell's photograph, which is accurately oriented to the compass points (that is, east is to the right and west to the left in the photograph), serves as "a cartographic metaphor for both the meeting of the rails and the mapping of westward expansion."[39] The moment of celebration (and its representation) was carefully managed, designed to strike a wide viewership with an indelible impression of American technological achievement, westward thrust, and national unity.

The composition of Russell's image influenced several other depictions of the event, including Thomas Hill's *The Last Spike* (1881), a painting containing a mind-numbing variety of characters and social types. Commissioned by Governor Leland Stanford of California, *The Last Spike* is a history painting containing seventy portraits of specific individuals who were important to the wedding of the rails. Despite its painterly singularity, however, the composition of *The Last Spike* clearly takes inspiration from the photographs of the event by Russell and his contemporaries Alfred A. Hart and Charles R. Savage, which by 1881 had been reproduced in numerous sources as both wood engravings and stereoscopic view cards.[40] In this case, then, the "high art" version of the scene actually owes much to popular forms; Hill's massive canvas is a dramatic re-envisioning of an image that may already have saturated the popular consciousness. The artist made a concerted effort to have reproductions of it, with supportive information, published for a broader audience; *The Last Spike* joined the ranks of celebratory images of this event that achieved some measure of popular circulation.[41] Despite its horizontal format, the image is punctuated with a series of strong verticals, emphasizing a sense of rhythmic, repeated, and continually unfolding westward movement embodied by the telegraph with its uniformly spaced poles.

In fact, the relationship between the telegraph and the railroad was especially potent in the wedding of the rails, for a telegraph wire placed on the head of the Golden Spike allowed observers to attend the event vicariously: the hammer's blows on the spike's head registered as telegraphic

impulses that were transmitted throughout the country. No less illustrious an observer than General William Tecumseh Sherman recalled how he sat in Washington, DC, listening to "the mystic taps of the telegraphic battery announcing the nailing of the last spike in the great Pacific road."[42] Images helped complete the picture those tinny, faraway taps conjured in the minds of the rapt American public. As a group, representations of the event helped familiarize viewers with this crucial link in national and international systems.

While these images reinforced white American dominance over the new technology, the role of the Chinese in the railroad's construction complicated this picture. Around twelve thousand Chinese men participated in the construction of the railroad; as has been noted, official depictions of the meeting of the rails attempted to gloss over this fact by excluding or downplaying Chinese contributions. While the Central Pacific Railroad's superintendent of construction, Charles Crocker, was complimentary of the effort and reliability of the Chinese, other contemporary observers were not so sanguine. Crocker claimed that Chinese laborers "prove nearly equal to white men in the amount of labor they perform, and are much more reliable," but his admiration carried with it tinges of paternalism.[43] Most others were less appreciative; though Governor Stanford later praised the industriousness of the Chinese, he had run partially on a platform of Chinese exclusion.[44] More common than Stanford's grudging acceptance was the observation of Albert D. Richardson in his travelogue *Beyond the Mississippi:* "The rugged mountains looked like stupendous ant-hills. They swarmed with Celestials, shoveling, wheeling, carting, drilling and blasting rocks and earth."[45] Richardson's phrasing implies that the Chinese are no better than insects and thus symbolically unclean—not an uncommon belief at the time.[46]

Fears of growing Chinese immigration were explicitly associated with the completion of the transcontinental line; no sooner had the railroad been finished in May 1869 than the national press began publishing anti-Chinese editorial cartoons. Prior to May, the Chinese presence had been practically invisible in newspapers, but in the following four months, *Harper's* and *Leslie's* between them printed ten cartoons questioning Chinese immigration. The most belligerently anti-Chinese cartoons tended to occupy the back pages of the journals, a space traditionally reserved for humor, political caricatures, or opinionated visual interpretations of recent news. The tendency of these cartoons to show the Chinese in caricatured, exaggerated, or fearmongering ways was likely exacerbated by their placement with the magazines' humorous and sometimes crude "back matter."[47]

One example, "The Chinese Puzzle," explicitly worked to activate fears about the macabre possibilities of technology when placed in the hands of the racially "unfit" (fig. 6). The cartoon shows a massive Chinese specter straddling the West Coast, ready to crush the impotent Uncle Sam. The grotesque and sinister features of the Chinese man, described in the caption as a "demon," lend an inhuman, brutish quality to the figure. The cartoon reinterprets "The Fisherman and the Genie," a story from *The Arabian Nights,* as a dark fantasy of race and technology.

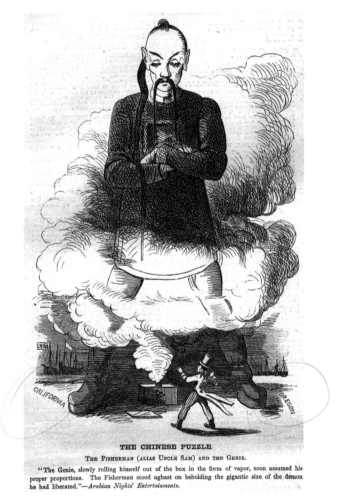

THE CHINESE PUZZLE.

THE FISHERMAN (ALIAS UNCLE SAM) AND THE GENIE.

"The Genie, slowly rolling himself out of the box in the form of vapor, soon assumed his proper proportions.  The Fisherman stood aghast on beholding the gigantic size of the demon he had liberated."—*Arabian Nights' Entertainments.*

Figure 6.   "The Chinese Puzzle: The Fisherman (alias Uncle Sam) and the Genie," *Harper's Weekly,* September 4, 1869, 576. Wood engraving, 8 x 4¾ in.

By connecting the Chinese "threat" with a myth from Arabic folklore, this artist made bold connections touching on race, technology, and fears about dark forces underlying the rational surface of nineteenth-century society. Conflating Arab, Chinese, and African, the cartoon creates an Orientalist hallucination of technology run amok—a technology that is, by inference, like a freed slave: powerful and vengeful. In "The Fisherman and the Genie," a poor fisherman pulls in his net to find a heavy copper vase containing a genie who threatens to kill him. In a translation by British clergyman Edward Forster, reprinted in the United States in 1868, the two have the following exchange: " 'And for what reason, pray, will you kill me?' answered the fisherman: 'have you already forgotten that I have set you at liberty?' 'I remember it very well,' returned he; 'but that shall not prevent my destroying thee.' ... 'But in what,' added the other, 'have I offended you? Is it thus you wish to recompense me for the good I have done you?' " The genie then describes how he was enslaved because he would not follow an "oath of fidelity and submission" to King Solomon. After four hundred years of enslavement, during which he at first swore to reward whoever set him free, the genie eventually built up an insurmountable hatred for mankind: "Enraged, at last, for being so long a prisoner, I abjured mercy, and swore to kill whoever should in future release me."[48] To a reader in 1868, this story could not help but read as a parallel to the recent emancipation of the American slaves and a fear that, despite the "good I have done you," four centuries of slavery were easy neither to forgive nor to forget. In "The Chinese Puzzle," the freed slaves are compared to the newly arrived Chinese laborers who made the transcontinental railroad possible: both have submitted to labor under the control of a white master, but it is an uneasy alliance.

## Gothic Hopes and Fears

Across nineteenth-century media in the United States, expressions of "the gothic" in its various meanings consistently paired race and technology with ideas of darkness, eeriness, and lack of control. While Leslie Fiedler in *Love and Death in the American Novel* first characterized American gothic as haunted by psychological and racial trauma, recent scholars have proposed a nuanced interpretation of the American gothic as a category that also deals with ontological fears about hybridity and self-knowledge.[49] Within the unstable category of the gothic, race still remains a primary term, but it is no longer black and white. In "The Chinese Puzzle," the threat is represented as a multivalent, Orientalized figure: the Chinese are

conflated with the Arabic "Orient" through reference to "The Fisherman and the Genie," which itself can be read as a metaphor for the trade in African slaves. As Justin D. Edwards argues, the gothic cannot be separated from the political nor can it be freed from the pervasive fear of a "racially mixed and so-called mongrel society," which the coming of the Chinese, no less than the emancipation of the slaves, promised (or threatened) to create.[50]

To the fear of racial mixing was added the fear of technology. Both new technologies and nonwhite races threatened to prove more dangerous than useful. In their quest to find and exploit cheap labor, American "fishermen" feared they had liberated an unknown and angry "genie" in the persons of thousands of Chinese immigrant workers. The link between dark gothic threats, monstrous nonwhite bodies, and sinister uncontrollable machinery goes back at least to Mary Shelley's *Frankenstein,* in which a monster created through the use of new technologies wreaks vengeance on its well-meaning creator.[51] The monster's physical characteristics, such as its size, power, and dark skin, tied it to contemporary English debates about emancipation, and its journey to educate itself—and subsequent repudiation of Enlightenment tenets—was connected with eighteenth- and nineteenth-century theories of racial development and intellectual capacity. The monster's violent revenge against Victor Frankenstein at the end of the novel is simultaneously a reprisal by a brutalized, subject, nonwhite slave and a malfunction of a hitherto unknown, and poorly controlled, machine.[52] *Frankenstein, as* H. L. Malchow argues, emphasizes parallel fears of unrestrained racial violence and rogue technology. While these references tied technological spectacle to overlapping fears of blackness, death, and disunity, other depictions of the railroad also struggled with the tension between rationality and terror, the useful and the destructive elements of technology, though not always in explicitly racialized terms.[53]

Macabre images of the railroad—speeding trains driven by skeletal figures of death or threatening, bestial locomotive monsters—peaked in the late 1850s and early 1860s, years coinciding with the highest rates of per capita railroad-related mortality and multiple-fatality accidents in the United States.[54] The lack of regulation on America's railroads was tied to the haphazard manner in which they had developed, with private companies, not the federal government, controlling the implementation of most security precautions.[55] Most visual and textual sources in the popular media blamed accidents on operator error; for instance, *Harper's Weekly* referred to the "frightful daily massacres" of rail travel, blaming "carelessness in conductors, employés, and directors."[56] In fact, passengers or in-

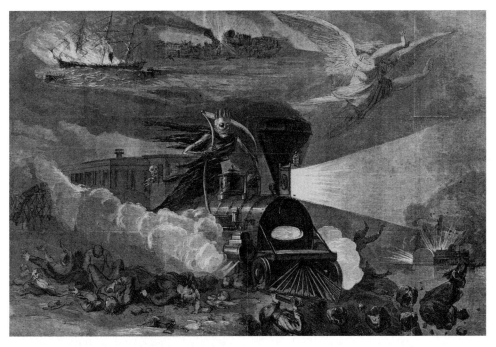

Figure 7.    "The Horrors of Travel," *Harper's Weekly,* September 23, 1865, 600.
Wood engraving, 9½ x 14 in.

frastructural failures were at fault in most fatalities.[57] Whatever the causes, the perceived danger of rail travel was exaggerated by the press, literature, and the arts; as the literary scholar Matthew Beaumont writes, "The experience of train travel in all its aspects refused to be contained . . . by stable narrative perspectives. Instead, entering into the field of representation in dream-like or phantasmagoric forms, it tended to unsettle or derange Realist conventions."[58] Rail accidents had been a popular subject of news illustration since the emergence of the weekly papers in the previous decade. In their role as hybrid vendors of news, culture, and sensation, illustrated periodicals including *Harper's Weekly, Frank Leslie's,* and *Vanity Fair* apparently found that the depiction of catastrophic rail travel appealed to audiences' sense of the precariousness of modern life.[59]

One particularly gruesome example, *Harper's Weekly*'s full-page "The Horrors of Travel," partakes of this phantasmagoric escapism, picturing the railroad as a macabre technology of devastation and violence (fig. 7). A contemporary reimagining of Benjamin West's outlandish fantasy of the end of days, *Death on the Pale Horse* (two versions, 1796 and 1817), "The Horrors of Travel" places death not on a white steed but straddling

the engine of a speeding locomotive that crushes fallen bodies under its wheels as it prepares to rush headlong over a rocky cliff. The figures of death and his henchman, a skeletal engineer in the locomotive's cab, seem to grin with wanton glee as they watch the slaughter of men, women, and children who appear to have been flung from the train; one man hangs onto the collapsing rails as the screeching steel wheels come close to obliterating him. The locomotive's headlamp, which should throw light into the darkness, fizzles out, creating gloomy shadows; the surplus of steam spewing from the engine both obscures the train's mechanisms and seems to scald the already agonized bodies of the survivors. This representation of "the constant and peculiar peril which surrounds travel in this country" utilizes a visual rhetoric of terror, grotesque slaughter, and uncontrollable technology.[60] This and other similar images were construed as a major category within the American gothic: bringing the violence of railroad travel to the fore, they work to negate the celebratory nationalist fantasies of positive railroad imagery. As Teresa A. Goddu writes, "The gothic disrupts the dream world of national myth with the nightmares of history."[61] Such gruesome images of the railroad's power would seem to erase the triumphalist visions of continental domination proposed in celebratory images of unification. And yet both continued to coexist within the pages of national newsmagazines.

Such conflicted responses to technology—torn between pride and fear—were not unusual. The historian Henry Nash Smith suggested that viewers tended to "regard steam power as a supernatural force kept only precariously under human control."[62] The varied visual responses to the railroad system reinforce this argument. While the railroad tended to be represented in a way that rationally underscored the dominance of white, native-born Americans, it also contained an underlying potential for disaster that made it fearsome. This duality was also clearly present in the representation of the telegraph system, a technology that increasingly contributed to the world's rationalization and standardization but that could not easily be understood or depicted.

*Telegraph*

Like the mixed responses to the railroad, representations of the telegraph demonstrate a wide variety of visual reactions to technological systems. Different, and occasionally contradictory, genres of representation—including history painting, news reportage, maps, political cartoons, and allegorical images—were applied to the series of events surround-

ing the attempts to lay a transatlantic telegraph cable. Probably because of its abstract quality, artists frequently used a mythological vocabulary that bordered on the fanciful to represent the telegraph. It also, however, inspired rational, straightforward representations; it is the variety of approaches to the telegraph that suggests a sense of tension. The telegraph was like a tabula rasa on which artists and their viewers could project different reactions to the sublime network that allowed their words to speed through wires in code and be deciphered on the other end. Samuel F. B. Morse's original long-distance telegraphic message—"What hath God wrought?"—demonstrates the awe and potential fear that surrounded this technology when it was first developed.[63] Even more than the railroad, the telegraph promised an exciting, though potentially "dislocating," revolution.[64] The hopes and fears surrounding the telegraph subjected it to a variety of interpretations: some represented it as orderly and rational, while others focused on the invisible sublime of a communication network that spanned the country and the globe.

The construction of telegraph lines occurred alongside railroad development and was an important factor in Americans' concept of expansive technology. The telegraph had the potential to revolutionize both business and foreign relations, and reactions to its emergence were generally positive and hopeful. In the United States, it was developed by the painter and inventor Samuel Morse and his partner, Alfred Vail, during the 1830s and early 1840s. Morse was one of several inventors concurrently striving to develop a speedy method of communication between major cities; his technology prevailed because of its claim to "instantaneous communication" while other proposed methods relied on a complicated and labor-intensive system of semaphores.[65]

Early commentary on the telegraph emphasized its essentially systemic nature while using a nonscientific, even mystical, vocabulary. These two reactions were not necessarily opposed to one another, as the literary scholar Paul Gilmore writes, calling electricity a "nearly spiritual force" that simultaneously evoked mysterious unknown powers *and* "rendered mind . . . physical in the form of 'nerves' or wires criss-crossing and creating both the individual and the national 'body.'"[66] Gilmore's insistence on the at once spiritual and systemic natures of the telegraph mirrors contemporary attempts to describe this bewildering new technology.

Nineteenth-century commentators evoked this contradictory language—of both spirit and system—in print. The spiritualist approach celebrated the telegraph's ability to divorce thought from the prison of materiality, asking, "For what is the end to be accomplished [by telegraphic

communication], but the most spiritual ever possible? Not the modification or transportation of matter, but the transmission of thought."[67] Others saw the telegraph as precisely the opposite: a triumph of man's control over the material world and a means of effecting practical innovations in commerce and other fields, such as "the speedy transition of news" or the ability of "the merchant of New York . . . to communicate with his agent in London, and receive an answer the same hour!"[68] Paradoxically, these two poles could converge in a single response, as in an 1854 travel memoir by British clergyman Henry Caswall, in which the author praised the "sublimity" of "this almost magic system [that] is consolidating the vast American continent."[69] With similar enthusiasm, the technical and agricultural journal *Cincinnatus* described the telegraph: "Our minds can not cease to marvel at the sublime achievements of the Electric Telegraph. *Wiry,* weird, wonderful—it stands before us incomprehensible; spelling the very lightnings of heaven into the English language. . . . Giving to the globe a nervous system, and making a whispering gallery of the world!"[70] Caswall and *Cincinnatus* both combined the magical and systemic elements of the telegraph; they understood it as a technological improvement but seemed unwilling to let go of all that was miraculous, astonishing, and "weird" about its operation. Still, despite this, they continually stressed its identity as a system, a means of "consolidating" the continent through a uniform structure of complete interconnectedness. The telegraph as the "nervous system" of the American body politic was responsible for relaying messages across the continent, keeping all parts functioning in tandem through synaptic electrical impulses.

### Spanning the Globe

The transatlantic telegraph planned by Cyrus W. Field and his Atlantic Telegraph Company promised to expand this system beyond the nation's borders by laying down the "great nerve that was to pass from continent to continent."[71] By the mid-1850s, Field was at the head of a group of inventors and industrialists endeavoring to construct a submarine telegraph to the United Kingdom. The group included Morse, the painter Daniel Huntington, and the businessmen and financiers Peter Cooper, Wilson G. Hunt, Marshall O. Roberts, and Moses Taylor.[72] Hoping, as the British journalist W. H. Russell wrote, that it would "be within the limits of human resources to let down a line into the watery void, and to connect the Old World with the New," Field's group laid the first, briefly successful transatlantic cable in 1858.[73] Both Britain and the United States hoped for the

connection as a means to promote peace and international cooperation, but a lasting cable was not installed until 1866.

Perhaps because telegraphic technology was not well understood by the general public, in early representations artists used a visual vocabulary that would already be familiar to many viewers: the language of allegory borrowed from European history painting. Constantino Brumidi's murals for the U.S. Capitol used mythological references to stress the political power offered by a transatlantic cable. Brumidi broached the topic of the telegraph in his rotunda fresco, *The Apotheosis of Washington,* which combines figures from classical mythology and American history to represent different categories of American achievement including "Science," "Commerce," and "Mechanics." In the "Marine" portion of the composition, Venus, a goddess born from sea foam, is shown accompanying Neptune's chariot and holding the transatlantic cable, which coils behind her and is picked up by cherubs (fig. 8). Some of this iconography is taken directly from European painting, but through inclusion of the telegraph, Brumidi created a hybrid form of representation that celebrated science through the use of familiar mythological figures. He spectacularly displayed this new visual form at the political heart of the American nation just at the moment that the cable was finally being laid successfully.[74]

Many observers did not like the fact that the Italian-born Brumidi received this commission—Walt Whitman, for instance, deemed the *Apotheosis* "by far the richest and gayest, most un-American" work of art he could imagine—but others believed the artist did unique justice to his subjects by creating a new form of American history painting capable of dealing with modern developments.[75] One reviewer stressed the fitness of Brumidi's approach of combining symbolic and realistic content: "Men may criticize the mingling of mythological figures and symbols with the great triumphs of art and science of our day . . . but what picture of the magnitude and dignity of this one of Brumidi can be made impressive, interesting, or beautiful without mythological figures and devices?"[76] In this dramatic piece of public art, allegory was a familiar and also an extraordinarily potent way for Brumidi to heroize and legitimate American scientific endeavors and to give visual expression to ideas of cooperation and communication between Europe and North America. The recognizable figures of Venus and Neptune integrated telegraphic technology into a familiar, European-influenced visual field, but with a twist—that of American technological determinism. Like the photograph of the wedding of the rails, this image naturalizes and legitimates technology's role as a core American value. The prestige of Brumidi's painting was reinforced not

Figure 8.  Constantino Brumidi (Italian, 1805–80). *The Apotheosis of Washington: Marine,* 1865.
Fresco, 4,664 sq. ft. U.S. Capitol Building, Washington, DC. Photo credit: Architect of
the Capitol.

only through its placement in the Capitol rotunda but also through the
application of the visual techniques of Grand Manner history painting,
clearly believed by some viewers to be the most suitable technique for
conveying big, allegorical concepts such as national unity and innovation.

No doubt recognizing the different audience and reduced scale required
to translate this visual idiom into a popular periodical, illustrators used a
toned-down version of Brumidi's aesthetic to communicate with viewers
about the mysterious workings of the telegraph. Rather than the grand
political resonance of the Capitol murals, periodical illustrations spoke
with more visual directness to their audiences, though they, too, some-
times used allegorical depictions of the telegraph. Such endeavors could
serve to raise the tone of the publications and flatter their readership by
expecting that they were familiar with mythological and literary allusions.

An 1858 issue of *Harper's Weekly* features a cover image of "The Atlantic Telegraph" celebrating the successful laying of a cable from Valentia Bay, Ireland, to Trinity Bay, Newfoundland (fig. 9). That cable was to break almost exactly two months later and was not relaid for another year. Nonetheless, in the month after the placing of the cable, magazines celebrated with poems, images of the cable's installation, and news coverage of the parades and pageants staged in its honor; never did an event "more truly electrify a nation," as Cyrus Field's brother Henry later punningly wrote in his history of the Atlantic cable.[77] This image couches difficult-to-understand technology in the guise of supernatural magic. Two sickly looking angels carry a laurel branch of victory over the cable, which nestles solidly against the ocean floor. Above their heads, stars lead them on their path across the ocean to the far coast, labeled "United States," despite the fact that the actual landing place of the cable was in Canada, an arrangement which allowed the shortest possible length of the cable to be underwater. As the art historian Marianne Doezema notes, this image adopts allegorical figures in order to celebrate and exalt American technological

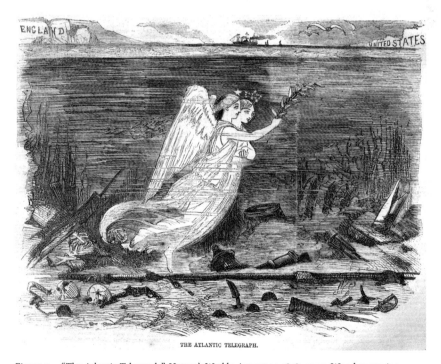

THE ATLANTIC TELEGRAPH.

Figure 9.   "The Atlantic Telegraph," *Harper's Weekly,* August 14, 1858, cover. Wood engraving, 6½ x 8½ in.

achievement.[78] Several details of the image, however, trouble this purely positive reading.

Although the picture is intended as a celebratory one, the ocean floor actually depicts a macabre gothic landscape. The engraving contains an almost frightening undercurrent, suggesting that the reverse of the upbeat allegorical scenes is a disturbing magical realm of technology which cannot be controlled or understood by mere mortals. The ground is strewn with the wreckage of ships, including casks, lanterns, anchors, a cutlass, a broken mast, and cannon shot. At the left, even more chilling, are two skulls, one with a bullet hole in the forehead and one next to a shackle and ball. These may speak of anything from ordinary shipwrecks to piracy and the slave trade, which, as has been previously noted, was an often unspoken undercurrent of American gothic representation. In fact, this landscape is surprisingly similar to that vividly evoked by Henry Field as he related the survey of the ocean floor undertaken by Matthew Fontaine Maury, a Navy oceanographer who studied the cable's proposed underwater route. Field wrote, "The divers came up only with tales of riches and ruin, of gold and gems and dead men's bones that lay mingled together on the deep sea floor. Was the bottom of the sea all like this? Was it a vast realm of death, the sepulchre of the world? No man could tell us . . . no eye of science had yet penetrated those awful depths."[79] The whitened bones of the *Harper's* engraving and of Field's imagining lend this eerie underwater kingdom a strange otherworldliness, as if sprung from *The Tempest*: "Full fathom five thy father lies; / Of his bones are coral made; / Those are pearls that were his eyes: / Nothing of him that doth fade / But doth suffer a sea-change / Into something rich and strange. / Sea-nymphs hourly ring his knell."[80] The connection is subtle but far from unprecedented.

*The Tempest* has frequently been interpreted as an allegory about the discovery of America or the New World more generally.[81] Recent interpretations of the play add to our understanding of the work as a fantasy of white racial control over the "savages" of the New World and a parable about the unruliness of slaves, personified in the figure of Caliban. B. J. Sokol suggests that *The Tempest* is, additionally, a play about the limitations of technical knowledge, a text that walks a tense line between "magical" thinking and "more rational modes of pursuing knowledge," precisely the tension that appears in nineteenth-century depictions of the telegraph.[82] I am not the first observer who has linked the telegraph with Shakespeare's play; in 1856, the journal *Cincinnatus* praised the technology as "a messenger more fleet than the 'delicate Ariel' of Prospero's art and Caliban's isle!"[83] The reference to Caliban also reignites the underlying connection

between race and technology: both were dark, unruly "slaves" who could easily overpower their masters.[84] Dr. Dionysius Lardner, an Irish science writer, evocatively tied the telegraph back to the Orientalist specters of "The Chinese Puzzle," writing of electricity's power that "compared with all such realities, the illusions of oriental romance grow pale . . . the feats of Aladdin are tame and dull; and the slaves of the lamp yield precedence to the spirits which preside over the battery and the boiler."[85] Thus this image could, for contemporary viewers, contain a chain of references that tied the transatlantic cable to the Atlantic slave trade, the Anglo-American literary past, and the supernatural, whether valiant and celebratory or dark and vaguely threatening. The sea nymphs in this illustration, heralding the arrival of a new technology, preside over a watery realm, surveying all those shipwrecked items that have an afterlife of strange beauty under the waves.

## Facts and Figures

While mythological images could deflect anxieties about a poorly comprehended technology, some representations of the transatlantic cable were more straightforward. Like Russell's photograph of the railroad, they reinforced American technological dominance through visual realism. There was certainly no dearth of more factual reporting on the cable's progress, and the same magazines that sensationalized the Atlantic cable project also sought to educate the public on the possibilities of its implementation. In one case, the telegraph was submitted to a cartographic impulse that sought to visualize its possibilities through mapping. An 1865 diagram of the proposed "telegraphic systems for encircling the entire globe" shows the technology as a thick black cord wrapped around the midsection of the earth.[86] Although nearly half of the pictured cables had yet to be constructed successfully, the map demonstrates the desire to bring the entire world under telegraphic control. This ring around the globe would have a constricting function, collapsing distances and providing rapid communication between different countries and regions. American control over the network was implied, and would be echoed four years later by Secretary of State Hamilton Fish, who stated to twenty-three ally nations that the United States's "central position in the communication of the world entitled" its leading role in "this movement for the common benefit of the commerce and civilization of all."[87] The proposed cable ran south from Siberia and across China, connecting the western United States with East and South Asia, areas with which the United States was keen to establish trade relations. Improved communication was an important initial step in

the development of those geopolitical regions in which America held an interest. The potential telegraphic control exercised by the United States is visualized as an expansive, ordered, and well-controlled technological system.

In the same year, *Harper's Weekly* printed a double-page spread by Edwin Forbes that helped to underscore the geopolitical implications of the transatlantic telegraph. "The Atlantic Telegraph Cable" uses primarily factual, realistic representations to stress the union of the United States and Great Britain and to celebrate American invention (fig. 10). Surrounding an exciting central scene of the Great Eastern steamship laying down cable in a thunderstorm, various vignettes reinforce ideas of American technological ingenuity and international cooperation. The central image is flanked by portraits of two important American scientific men—Benjamin Franklin, whose experimentation with the conduction of electricity led to the invention of the cable, and Morse, who developed both the telegraph and the code used to relay its messages. The telegraph had been described to the House Committee on Commerce as the "offspring of American genius," referring specifically to the efforts of these two men, one of which fed off the other's discoveries.[88] At the base of the image, a coat of arms combines emblems of the United States and Ireland—the cable's embarkation point—surrounded by tools of science, cartography, manufacturing, and agriculture. These symbolic attributes emphasize the occupations devoted to the laying of the cable and those that will profit from its completion. In the background, railroads and farms alike are shown benefiting from the implementation of the telegraph, suggesting the breadth of American technology and production. The two lower corners show comfortable domestic scenes of President Andrew Johnson and Queen Victoria, each reading the news relayed from the other's continent, reinforcing the message of international collaboration.

Despite the apparently journalistic elements of most of these images, the composition is topped by a medallion of Cyrus Field and the quotation, "I'll put a girdle round the earth in forty minutes." The line is spoken by Puck in Shakespeare's *A Midsummer Night's Dream*.[89] Regardless of the other "realistic" qualities of the image, then, the quotation reinscribes the telegraph with pseudo-magical properties by equating its possibilities with the mythical sprite Robin Goodfellow. In fact, this line was commonly associated with the telegraph's quasi-magical powers; noting that telegraphic communication had outstripped even Puck's marvelous speed, Dionysius Lardner quipped, "To have encircled [the earth] in a second, would have seemed too monstrous, even for Robin Goodfellow."[90]

This single image thus combines portraiture, news images, and geographic realism with a lingering taste of fairy magic to provide a summary of all that the cable stood for. Overall, this powerful collection of images features the United States as the developers of a revolutionary technology and demonstrates the many areas in which the expansion of this technological system would have an important impact. It cannot, however, entirely let go of the impulse to depict the telegraph as something mysterious, almost magical.

The images surrounding the three main attempts at laying a transatlantic cable between 1858 and 1866 demonstrate the power and importance of technological systems and show a number of different strategies artists developed to present these systems to viewers in ways that were comprehensible and informative. The telegraph most clearly encapsulated the tension inherent in the representation of technological systems: a tension between the desire to clarify and quantify those systems and the urge to represent them using a language of allegory or the supernatural.

## Coda: Looking Backward

In the 1880s, the railroad and telegraph continued to serve as examples of how systems helped to create an image of the ideal nation. Still, as the technologies became more familiar, artists had to shift their representations to deal with new realities. After the fading of the Hudson River School, later nineteenth-century painters increasingly excised the railroad from scenes of the American landscape, and as history painting and allegory waned in prestige after the Civil War, Brumidi's approach to the telegraph appeared more and more outdated. No significant new painterly representations of these technologies appeared in the 1880s. Nevertheless, periodicals continued their attention to the two systems, but with new emphases, particularly regarding the telegraph. While the railroad continued to be a powerful symbol for national unity forged through technology, the representation of the telegraph in the popular press shifted almost entirely to provide comic relief—and to define Americanness through exclusion. If the railroad was used symbolically to show the United States as a technotopia that embraced a variety of races and regional identities, understanding (or misunderstanding) the telegraph became a way to pinpoint who was (or was not) a properly "modern" American.

In 1886, the United States adopted a single gauge or track width for all railroad lines throughout the country to spur interstate and interregional commerce. This event, though by no means as publicized as the

Figure 10. Edwin Forbes (American, 1839–95). "The Atlantic Telegraph Cable," *Harper's Weekly,*
August 12, 1865, 504–5. Wood engraving, 14 x 20 in.

THE STERN OF THE GREAT EASTERN.

"EARTH IN FORTY MINUTES."

R. J. MORSE.

Queen VICTORIA reading the news from AMERICA.

[SEE PAGE 502.]

1869 wedding of the rails, was a logical time for Thomas Nast to show-case sectional and racial reunification in "Our Standard (Gauge) Adopted All over the Union" (fig. 11). Because of the uneven history of railroad development—which took place over a period of about fifty years and was implemented by numerous private companies—the width of railroad tracks was not standardized.[91] This meant that cars built for southern railroads were not compatible with northern routes, making travel and commerce between the two regions inefficient. The use of a standard width connected the entire nation on one giant, interchangeable railway system. Nast repre-sented the 3.5-inch difference between the South's wide-gauge tracks and the North's narrower width as an almost unbridgeable gulf, crossed at last.

"Our Standard" is replete with meanings. What at first appears to be an image that simply replays the spatial and compositional dynamics of the Golden Spike is revealed on closer glance as an allegory for national unity through technology. While a cheering crowd looks on, the train "Union" puffs into the station, ridden by Hermes, patron deity of commerce. On the right, a bourgeois Northern mercantile character holds one side of the American flag while a southern gentleman holds the other to the left. Behind this erect figure, an African American laborer gives his hammer a final swing to push the rails into position. This man wears the symbolic uniform of a skilled laborer; however, his stooped position and hidden face rob him of any active agency. He stands in for the "thousands of workmen," mainly African Americans, who performed the southern standardization, changing the gauge of thousands of miles of track in just a few days.[92] A celebratory banner above the engine proclaims "The Last Spike of Our Commercial Union," explicitly referencing the *economic* gains expected and hearkening back to that earlier "last spike" that promised absolute *geographical* unity. The American flag, or "standard," stretched between male representations of North and South, gives the image another layer of meaning: it is labeled with the width of the new standard gauge ("Four Feet; Nine Inches") and forms the bond between the two men.[93] By choos-ing to adopt this track width, the South symbolically opts for union (and *the* Union) over continued difference and separation. North and South are unified for the common commercial good under the impetus of technol-ogy. The standardization of the railroads was an event of national tech-nological and commercial significance, but it also represented a symbolic reunification that was realized in concrete, infrastructural terms. By finally agreeing to adopt the standard gauge, the South made sure that it was included in the increasingly dominant web of American technological systems.

By this time, the wonderment that had greeted early telegraph technology had worn off; instead of being a supernatural element that collapsed space and time, the telegraph had come to seem a normal part of everyday life. Understanding of the telegraph was an important part of being a technologically savvy American. Instead of being a powerful symbol of American technological dominance, the telegraph was viewed, at best, as

Figure 11.   Thomas Nast. "Our Standard (Gauge) Adopted All over the Union," *Harper's Weekly,* June 5, 1886, 364. Wood engraving, 11¾ x 9½ in.

a useful benefit to contemporary life and, at worst, as a positive nuisance. Satirical images such as Nast's "What the Telegraph Companies Will Do Next" show a city so congested with telegraph lines that workers are forced to run new cables through the drawing room of a middle-class home (see fig. 2). After the drama and excitement of the Atlantic cable adventure, magazine depictions of telegraphic technology more frequently made fun of those who still failed to understand the purpose of those networks of cable. A degree of technological knowledge was required to be a true "American"; instead of suggesting that most people could never understand the weird workings of the magical telegraph, images now defined citizenship *through* technology, suggesting that understanding this system was an important requisite for national identity.

An example from the 1880s harshly mocks those who were still mystified by telegraphic communication. In "The Telegraph Spider" by Peter Newell, an Irish immigrant stares in uncomprehending wonder at the network of wires over his head (fig. 12). He muses, "Spoider-web across the sthreet, and a spoider in it. But shure I didn't know the varmints were so big in America." The man's stereotyped profile and accent set him apart as Irish. His lack of understanding that the "web" is part of the telegraph network and the "spoider" is a workman shimmying up the pole mark him as a member of a group considered separate from "true" Americans at the time.[94] His mispronunciations and misunderstandings mark the subject as an unfit citizen, one who lacks comprehension of the modern world and its systems. The cartoon's racist assumption is not only seen in the stereotyped representation and use of language; more importantly, it claims that Irish Americans failed to understand the technological side of the telegraph, placing them forever in a marginal relationship to the development of the United States.

Over time, the representation of these two key systems evolved according to changing conceptions of what was important for creating a national identity. While the railroad continued to be shown as a symbolic agent of national unity, the telegraph's initial technological impressiveness dulled over time. Its sublimity was superseded by other, equally magical systems such as the electric grid and the telephone, and it came to seem a normal part of life, to such an extent that those who failed to interact with this system in the proper manner were mocked mercilessly as unfit to be members of the new, technologized nation. If the representation of technological systems—and the systems themselves—helped to produce an idea of national identity, that identity was infinitely malleable, ranging from the

**THE TELEGRAPH SPIDER.**

NEW ARRIVAL. "Spoider-web across the sthreet, and a spoider in it. But shure I didn't know the varmints were so big in America."

Figure 12.   Peter Newell (American, 1862–1924). "The Telegraph Spider," *Harper's Weekly*, November 12, 1881, 768. Wood engraving, 4½ x 4½ in.

inclusiveness and optimism of "Our Standard" to the exclusionary, ethnic definition proposed in "The Telegraph Spider."

The essential tension underlying the depiction of technological systems did not disappear as those systems became more familiar to viewers; instead, these conflicts between clarity and obscurity, fact and myth, subtly shifted to reflect the new realities of an increasingly diverse and industrialized nation. Although the popular periodicals continued to view themselves as hybrids of entertainment, news, and education, the pro-business affiliation of the Harper Company, in particular, increasingly led

to celebratory, positive depictions of industry. On the other hand, artists who were on the whole freer from the constraints of patronage or editorial control seemed to embrace more ambiguous, personal representations of technology. The work of John Ferguson Weir in particular shows that the celebration of industry may have been a starting point for artwork that ended up exploring darker and more disturbing undercurrents of the technological realm.

# "Where Vulcan Is the Presiding Genius"

John Ferguson Weir, Metallurgy, and the Alchemical Sublime

JOHN FERGUSON WEIR'S *The Gun Foundry* (1864–66) and its companion piece, *Forging the Shaft* (1866–68; figs. 13 and 14), completed within two years of one another, are some of the only industrial interiors painted in the United States before the twentieth century. In subject matter, composition, and use of tenebrism, these two paintings departed markedly from contemporary American norms, as noted by an 1868 reviewer who lamented that sites "where Vulcan is the presiding genius" were "not more frequently depicted" in American painting.[1] Although most scholars claim the pairing as examples of heroic industry or celebrations of the North's technological success, I argue that the images have a more complicated relationship to the question of labor. Existing contemporaneously with the growing American focus on technological systems, Weir's industrial works constituted an alternative to the increasing rationalization of American society. His canvases displayed vivid and almost violent acts of work and partook of the then prevalent undercurrent of irrationality in American technological culture. These paintings of an iron foundry explore the frightening and magical side of American industry, turning away from a documentary impulse and rehabilitating a hidden language: that of alchemy, a premodern scientific belief system

Figure 13. John Ferguson Weir (American, 1841–1926). *The Gun Foundry,* 1864–66. Oil on canvas, 46½ x 62 in. Putnam History Museum, Cold Spring, New York.

Figure 14. John Ferguson Weir. *Forging the Shaft,* 1874–77 (second version; original 1866–68). Oil on canvas, 52 x 72¼ in. The Metropolitan Museum of Art. Purchase, Lyman G. Bloomingdale Gift, 1901. www.metmuseum.org.

whose history and vocabulary were deeply embedded in American culture and aesthetics.

In these paintings, the spectator is forcefully presented with burly men toiling in the red-orange glow of molten metal. The compositions are both curiously intimate, bringing the viewer startlingly close to fiery loci of raw power, and infinitely vast, set in cavernous, echoing cathedrals of industry. Such oscillation between binary opposites also functions to activate contemporary notions about categories such as gender, selfhood, and work. The inability of Weir's paintings to resolve these poles is part of what makes the scenes alchemical: they depend on a fusion and confusion of categories rather than exclusionary binaries. Weir's exploration of supposedly rigid dichotomies such as leisure and labor, self and other, pushes the boundaries between those opposites and performs an alchemical procedure in which binary elements are synthesized. *The Gun Foundry* and *Forging the Shaft* are also undeniably sublime in their focus on high contrast, vibrant, almost jarring effects of light, and the power of massive technologies. These images forcefully convey an impression of a chaotic and obscure, but ultimately transcendent, realm of industry. While the paintings confound the viewer who tries to "read" their narratives, they provide a thrilling sensory and visual experience to the attuned spectator. It is the indeterminacy and complexity of these compositions that has led me to posit the aesthetic category of the "alchemical sublime." A corollary to more traditional definitions of the American technological sublime, this category adds a metaphysical dimension tinged with metaphors of rebirth and transformation taken from the language of alchemy.

Weir's canvases reference alchemy as a means for addressing larger questions of change and transformation prompted by the shifts in American life discussed throughout this book. Showing the magical process of iron production filtered through a Romantic artistic practice, Weir created an emotional and personal pair of paintings that spoke to his own uncertainties about artistic education, inspiration, and the human capacity for spiritual growth and development. Shying away from a rigidly informative perspective on industry, he instead used brushwork, lighting, and compositional choices that intentionally imbued the paintings with an air of mystery. By looking at Weir's paintings, his writings on art, and the context in which he came of age as an artist, it is clear that his images of the iron industry engaged with metaphors of process, purity, and transformation to become exemplars of the alchemical sublime.

## Emergence of an American Adept

John Ferguson Weir was part of a large family of artists, one of several sons of the history painter Robert Walter Weir, a drawing instructor at the West Point Military Academy.[2] J. F. Weir's artistic training was primarily informal, undertaken at home under the instruction of his father. John did not travel to Europe until 1869, after the completion of both his major metallurgic pieces, and did not undergo any formal training while there. Therefore he represented part of an intermediate generation of American artists who came of age after the British Royal Academy ceased to be the primary instructional resource for Americans abroad, and prior to the ascendancy of Paris and Munich in the postwar years. His first major work, *An Artist's Studio* (fig. 15), won him acceptance as an Associate of the National Academy of Design (NAD) in May 1864; he was elected as a full Academician two years later based on the success of *The Gun Foundry*. Despite practicing in a range of styles and subject matter, Weir's reputation

Figure 15.   John Ferguson Weir. *An Artist's Studio,* 1864. Oil on canvas, 25½ x 30½ in. Los Angeles County Museum of Art. Gift of Jo Ann and Julian Ganz, Jr. www.lacma.org.

was made on the basis of these dramatic industrial works, both of which he showed at the NAD and abroad. Not only were the canvases widely exhibited and reviewed but *Forging the Shaft* even appeared as a front page engraving in *Frank Leslie's Illustrated Newspaper* in 1869, bringing his work to a more diverse audience.[3]

Despite his relative obscurity today, and the fact that he never again produced works of the renown or magnitude of these two industrial canvases, Weir was something of an art celebrity in the late nineteenth century. In 1869, he attained a teaching post at the Yale School of Fine Arts, where he remained for most of his life, retiring in 1913. During these forty years, in addition to his teaching career, Weir published widely on artistic and religious topics. While his own artistic education was based strongly on European precedents, Weir championed what he believed to be the native character of American art, protesting against mere slavish imitation of European fashions. He urged American artists to find their subject matter and inspiration at home, channeling "those instincts which spring out of our own peculiar conditions of life."[4] Such "peculiar conditions" in Weir's own life probably prompted his interest in the metalworking operations at the West Point Iron and Cannon Foundry in Cold Spring, New York, a site near where Weir grew up that would have represented, in his mind, a uniquely American subject. The foundry was opened in 1818 by the politician and technological booster Gouverneur Kemble, a friend of the Weir family, and by the time Weir rose to artistic maturity in the early 1860s was being used almost entirely by the Union Army for the production of cannon and missiles, as seen in *The Gun Foundry*, which depicts the most exciting moment in the forging of a cannon barrel.

The painting teems with active, laboring bodies: at least sixteen different workers are visible in the composition, only two of whom appear to be at rest. In the left foreground, a mustached, shirtless worker leads the viewer into the composition. Seated on the barrel of a cannon, he turns toward the central action; the glow of the intense heat outlines his head and musculature, while his back is lost in shadow. To his immediate right, six straining workers struggle to tip the massive cauldron filled with almost white-hot metal into the upright cannon mold, placed vertically in a deep trench dug into the floor of the shop. A man with his leather apron held up over his head to protect his face leans down over the trench. An eighth man prods the molten iron with his rabble (a rod used to separate impurities) to keep contaminated elements away from the pouring spout. Astoundingly, none of these laborers wears protective gloves, and only one shields his face, though they are mere feet from the boiling crucible.

All have burly physiques but seem frozen in their poses, despite the dynamic character of the scene as a whole. The final foreground figure, perched atop a cannon barrel in the center of the canvas, holds chains that control the movements of the gantry, which is cranked by at least four other workers, who are clearly straining from effort. In the far background, one man is bathed in red from the glow of the fire he stokes. He seems a lone and inscrutable figure, dwarfed by the huge space and the cavernous, high-beamed ceiling, his shadow enormous and looming on the wall behind. I interpret this sole laborer as a self-portrait of Weir, a claim to which I will return later. Taken together, these elements make a canvas filled with details but lacking an overall narrative; crammed with mysterious objects and actions, the scene has an air of uncertainty, gloom, even danger. The setting is one of sublimity, with its molten metal, bright light, high ceiling, and dwarfed human figures.

After the war, the foundry continued to operate but retooled for peacetime manufacturing, producing locomotives and steamships as shown in *Forging the Shaft,* a composition that repeats many of the visual and thematic elements of its pendant. The version now owned by the Metropolitan Museum of Art is a replica that Weir painted during 1874–77, after the original was destroyed by fire while on display at the Derby Athenaeum in 1869. Weir evidently considered the painting so important that he wished to re-create it, and photographs of the 1868 original suggest that the Metropolitan Museum version is an almost exact copy. The painting shows eight foundrymen plunging a massive propeller shaft into the scorching furnace out of which vibrant yellow tongues of flame whirl violently. The interior is recognizable as the same featured in *The Gun Foundry,* and Weir treats it in similarly dramatic fashion: the only source of light is the blazing metal itself, a mesmerizing bar of pure yellow-orange that dimly illuminates the soaring rafters and massive machinery of the forge's interior. Weir shows similar interest in the drastically extended shadows and effects of light that outline and emphasize the brawny physiques of the laborers. The rhythmic repetition of the workers' tensed, extended legs along the length of the shaft give the canvas a greater feeling of organization and focus than its partner. Some of the detritus that litters the floor in *The Gun Foundry* has been excluded here, allowing a tighter and less cluttered focus on the central action. From the prior work, Weir retains the seated worker in the foreground, here bookended by an older standing laborer, probably an overseer. And, I believe, the artist includes a more direct self-portrait, in the figure of a young, hatless man with a mustache located almost exactly in the center of the canvas, his face

framed from below by the brightly illuminated, foreshortened arm of a bearded worker.

Weir spent a great deal of time in and around the West Point Foundry in 1864 and 1865 preparing to compose these pieces. In sketchbooks and small oils he documented the interior of the foundry and important machines such as the steam hammer and the crucible (fig. 16). His sketches are strange, eerie compositions devoid of human figures, making the interior of the foundry with its discarded molds, finished cannon, and machine parts seem still, deserted, and ruinous. It is not difficult to make a connection to Giovanni Batista Piranesi's series of etchings *Carceri d'invenzione* (*Imaginary Prisons,* usually referred to simply as the *Carceri*), with their vast ceilings, high walkways, tortuous looking machinery, and coils of ropes and chains that seem to echo the cranes and gantries of an industrial interior but are fundamentally empty and uninhabitable (fig. 17).[5] Likewise, without the workmen, Weir's interior scenes of the foundry seem to depict an empty, dead space. Even at this early stage, the strange indeterminacy that characterizes the final paintings is evident. Like Piranesi's silent and inoperative spaces, Weir's foundry seems to *try* but fail to tell us something concrete about ironworking.

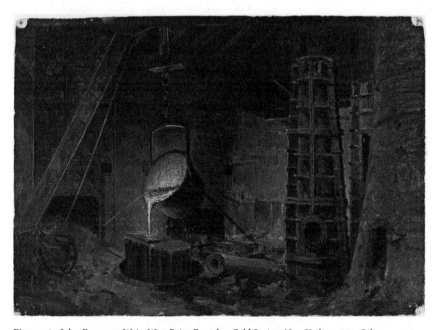

Figure 16. John Ferguson Weir. *West Point Foundry, Cold Spring, New York,* c. 1864. Oil on canvas, mounted on board, 13⅞ x 9⅝ in. Yale University Art Gallery.

Figure 17.   Giovanni Batista Piranesi (Italian, 1720–78). *Carceri*, Plate XI, 1761 (later stage). Etching, 40.5 x 54.5 cm. © Trustees of the British Museum.

How did nineteenth-century viewers and how do modern scholars read the visual and connotative meanings of these unusual scenes? The dates of creation have ensured that these two canvases are almost always discussed in the context of the Civil War and the political turmoil surrounding that conflict. Because of the industries chosen—armaments manufacture in *The Gun Foundry* and peaceful maritime production in *Forging the Shaft*—scholars have read the works as embodiments of the twinned concepts of war and peace.[6] This interpretation is almost certainly one of the major contemporary readings they received; for instance, in 1867 the *New York Mail* noted that the two paintings juxtaposed "the brazen terrors of War" with "the strength and majesty of Peace."[7] While the "war and peace" message is a viable interpretation of the pair, I argue that Weir's compositions took viewers beyond this iconographical reading to ask deeper questions about the meaning of labor, whether industrial or artistic.

Contemporary viewers noted that the compositions spoke to the un-knowable, irrational elements of technology. A review of *The Gun Foundry* from its first showing at the 1866 NAD exhibition demonstrates that view-ers reacted to its drama with a physical intensity: "If he will pause long enough in quiet receptivity before 'The Gun Foundery' by J. F. Weir, the massive drawing of the work, the grand intermingling of fire-light from the molten metal with the light from the roof and the floating fumes of the furnaces, a distinctness of details amid the fumy obscurity, the masterly centering of all expectation upon the pouring of the fiery and spluttering metal into the mold, in a word, the dramatic intensity of the scene and the occasion, will hold him spell-bound and breathless."[8] This reviewer highlighted the spectacular and indeterminate characteristics of his con-frontation with the piece.

In 1868, a reviewer from the *New York Herald* similarly focused on the sensory qualities of *Forging the Shaft,* in an impression filled with sublime adjectives: "The brilliant light radiates from the heated metal, bringing out into bold relief the bronzed, swarthy faces of the workmen, the huge, ponderous machinery and massive, shapeless heaps of unborn power, intensifying the heavy black shadows which fill the corners of the pic-ture."[9] Both contemporary reactions demonstrate that for many viewers, observing these paintings involved an almost physical reaction that went beyond mere aesthetic interpretation. Modern art historians, by contrast, have given these experiential responses relatively little consideration. The canvases offered a palpable thrill that engendered excitement and "breath-less" admiration; in their focus on the heat and skill of metallurgy, they provided a metaphor of sublime alchemical discovery.

In writing about the pieces, Weir addressed the desire to evoke an ir-rational, awesome side of industry. In 1866, as he contemplated making *Forging the Shaft,* he commented, "And I sometimes sit before my picture thinking how much finer I will have the next, how mysterious I will make it, how less of labour and more of mind, I will show. And endeavor to make it just the very spookiest place that ever was, with Ghouls for men, and sudden gleams of light, as if it was in Pandemonium, and mischief was brewing in the furnace."[10] Weir's stated goal, to make his work "mys-terious," denies the viewer the possibility of attaining concrete knowledge about cannon founding or shipbuilding, the industries depicted. Instead, *The Gun Foundry* and *Forging the Shaft* function as sites of indeterminacy, where hopes and fears about the transformative power of technology could be explored. Weir's paintings and other midcentury works showing the

drama and danger of metallurgy partake of the hybrid visual and cultural language of the alchemical sublime, a visual discourse that combined strands of alchemical theory, sublime viewing, and American technological exceptionalism.

## Sublime America

Nineteenth-century American aesthetic doctrines gave increasing prominence to philosophies of viewing that arose from a European vogue for the sublime theorized in treatises such as Edmund Burke's *A Philosophical Enquiry into the Origin of Our Ideas of the Sublime and Beautiful* (1757) and Immanuel Kant's *The Critique of Judgment* (1790).[11] Burke's concept of the sublime, which offered an experience of simultaneous awe and terror, referred primarily to the physiological effects of experiencing the violence, power, and vastness of nature. Burke included as key characteristics of the sublime "astonishment . . . that state of the soul, in which all its motions are suspended, with some degree of horror," "obscurity" or darkness, power, and overwhelming size.[12] Major scholars of American studies, including Perry Miller, Leo Marx, John F. Kasson, and David E. Nye, have chronicled how the eighteenth-century European vocabulary of sublimity was adapted in the United States, focusing primarily on Burke's sensational understanding of sublime effects. In making the transatlantic voyage, they argue, Burke's theory shifted from the appreciation of natural wonders to the majesty of American technological achievements. This "technological sublime," as coined by Miller, applied the sublime's physiological effects to the appreciation of American marvels of engineering and construction.[13] The vast power of sublimity, coupled with American patriotism and the celebration of "native" mechanical expertise, offered a populist sense of inclusion that centered around ideas of a national community.[14]

In general, formulations of sublime vision based on Burke suggest a passive mode of reception in which the viewer experiences a primarily physical response to sublime encounters. I want to posit sublime viewing as a more active form of vision based on the theories of Kant, whose influence on American aesthetics has been underemphasized. Kant's analysis of sublime phenomena in *The Critique of Judgment* turns explicitly from the physical sensations and sights described by Burke, noting that "nothing, therefore, which can be called an object of the senses" may be considered sublime. Rather, "it is the state of mind produced by a certain representation with which the reflective Judgment is occupied, and not the Object, that is to be called sublime."[15] In Kant's thesis, the sublime is a kind of

ontological pain created by the recognition of our inability to comprehend infinity.

The influence of Kant in America has been downplayed by an over-reliance on Burke's more clearly aesthetic theories, though Weir's own rec-ollections suggest that educated Americans, himself included, were read-ing and grappling with Kantian definitions of a priori epistemology. In his position at Yale, Weir became friendly with the metaphysicist Noah Porter, author of *The Human Intellect* (1868); heard lectures by the philosopher James McCosh, who wrote on *The Intuitions of the Mind* (1860); and read the Swedenborgian treatise *Substance and Shadow* (1863) by the theologian Henry James, Sr.[16] Within these works, Weir's colleagues, friends, and acquaintances among the American intellectual elite worked through aes-thetic and perceptual questions inherited from eighteenth-century Euro-pean philosophy. Attempting to understand the meaning of the sublime in the nineteenth-century American context, we must consider the centrality of both Burke and Kant. Thus our understanding of sublimity must move beyond mere visual contemplation and consider the sublime as a category that causes a restlessness or oscillation. This vibration between polarized categories or dualities, what Kant described as "a quickly alternating at-traction towards, and repulsion from, the same Object," is also a crucial part of alchemical theory.[17]

The alchemical sublime combines the doctrine of transmutation with an expanded understanding of the nature of sublimity; the two realms already share some terminology. Marek Kulisz notes that sublimity and alchemy, for instance, share a reliance on one of Burke's key terms, "ob-scurity," writing that alchemy was "sunk in obscurity, or more precisely obscurities of all kinds; very often to such an extent that one can say with-out much exaggeration that in many instances it represented nothing but obscurity."[18] Nye touches on the historical link to alchemy in his discus-sion of the word "sublime" as it was used by medieval scholars, as a verb meaning "to act upon a substance so as to produce a refined product." Nye adds, "It was common to call the process of converting a substance into a vapor by heating it and then cooling it down to a refined product 'sublimation.'"[19] In particular, alchemists used the process of subliming or sublimation as a technique for distilling raw materials in the effort to reach a higher state of purity.

An ancient Near Eastern science that claimed the power to transform base materials into gold, alchemy flowered throughout the medieval and early modern periods in Europe and gave rise to many of the innovations of the scientific revolution. Despite its modern reputation as a haven for

crackpots and charlatans, alchemy was an important precursor of modern chemistry, with a similar focus on the transformation or reaction of materials.[20] Alchemists worked from a teleological understanding, believing that metals followed a strict trajectory of development. All gold, they claimed, had once been lead and had passed through a series of transformations that increasingly purified and refined its content. Alchemy would, ideally, develop a set of chemical processes to speed up the maturation and produce gold on an accelerated timeline.[21] Using this idea of transformation as a metaphor, I posit that the alchemical sublime of the nineteenth century deals with the intertwined threads of metallurgic production, artistic inspiration, and spiritual renewal, all forms of producing new meanings through a process of radical change.

### Alchemical America

The alchemical sublime may be seen as an extension of the American technological sublime, one that wedded the spiritual operations of Kantian ideas to the more concrete and nationalistic adaptations of Burke's theories. American interest in alchemical processes was part of a larger discourse that stretched back to the colonial era. In fact, seventeenth-century American society included prominent practitioners of alchemy such as Governor John Winthrop, Jr., of Connecticut. Winthrop and other "Christian alchemists" saw alchemy as a multifaceted science that embraced spiritual, economic, and political goals. Beyond a mere quest for riches, it was also a philosophy that sought self-discovery and the revelation of arcane truths about life, death, and the spirit. Modern scholars of alchemy generally agree that the attainment of great wealth was a secondary concern for many practitioners; the ultimate goal was eternal life, a concept that medieval alchemists took both literally and metaphorically.[22]

Walter W. Woodward's recent study shows that Winthrop's alchemical theories of governance demonstrated both material and spiritual motives. By exercising political control over the establishment and expansion of colonies in the New World, Winthrop and his fellow alchemists metaphorically effected "the gradual transformation of base matter, *materia prima*, into *materia ultima*, the purest form of matter."[23] In this case, the *materia ultima* constituted a new and better society, that "City upon a Hill" that Winthrop's father had envisioned in 1630. This famous sermon of Winthrop the Elder, "A Model of Christian Charity," exhorted the Puritan settlers of Massachusetts to work cooperatively, behave charitably, and worship vigorously, but it also established Christian society as a crucible

of spiritual transformation through the catalyst of "Love": "Now when this quality is thus formed in the souls of men, it works like the Spirit upon the dry bones . . . and knits them into one body again in Christ, whereby a man is become again a living soul."[24] This spiritual rebirth was an important component of the alchemical process, one that paralleled the story of Christ with its phases of death (putrefaction or *nigredo*) and eventual revivification (reddening or *rubedo*). The Paracelsan alchemy practiced by Winthrop the Younger and other early-modern Christian alchemists asserted that divine revelation could be achieved by thorough examination of the properties and material operations of natural resources.

As part of John Winthrop, Jr.'s "projects of transformation" in the New World, he established a network of mining, refining, and metalworking operations throughout New England, beginning in 1645 with the New England Ironworks in Braintree, Massachusetts.[25] America's first practical alchemist was also an enthusiastic technological booster of the metallurgic trades. Like Weir two centuries later, Winthrop was a deeply religious Christian who "viewed God as an active agent in the alchemical quest."[26] At the moment of its founding as an Anglo-American, Christian society, then, America was seen as the crucible for a social experiment in transformation through both spiritual and economic channels. The alchemical language suffusing Winthrop's governance lingered and became a hidden foundation of American thought.[27]

The symbols, language, and history of alchemy continued to circulate as a form of secret communication within American society into the nineteenth century. While references to alchemy appeared in popular magazines, where curious readers could be titillated with exposés of Winthrop's alchemical beliefs or jokey explanations of the elixir of life, readers could also find serious essays about the development of alchemy into modern chemistry.[28] Such articles included a *Harper's Monthly* piece by Dr. Henry Draper in which he used alchemy to construct a prehistory for contemporary pharmaceuticals. Alchemical discoveries, Draper argued, "lie at the bottom of modern chemistry, and are the basis of our daily comforts and present medication."[29] Draper's father, John William Draper, was a prominent chemist who had included his young son as an assistant in his photographic laboratory, experimenting with a chemical process that was sometimes referred to as a kind of alchemical wizardry.[30]

In this atmosphere of scientific experimentation and radical change, alchemy was also used more as a metaphor than as a historical foundation of American technology. Alchemy's message of rebirth and purification remained relevant to nineteenth-century society, both before and

after the Civil War. In the early nineteenth century, alchemy was used in the visual and literary arts as a metaphor for progress, spiritual birth, or rebirth. Prominent cultural figures such as the author Nathaniel Hawthorne and the history painter Washington Allston embraced alchemy as a metaphor for the process of artistic generation.[31] Familiar with Allston's work, Weir once referred to him as "a true missionary, or evangelist of art," one of the few who brought American painting closer to "that elevated plane which can only be attained by larger sympathies and deeper convictions."[32] Weir was well aware of Allston's Romantic orientation and probably also knew about his membership in the brotherhood of pansophic Freemasons, which according to David Bjelajac infused Allston's works with visual fantasies of a secret, exalted fraternity of artistic knowledge.[33] In addition to these messages of hidden meaning and transformation, alchemy challenged assumptions about the relation of certain apparently binary categories, such as male and female, life and death, matter and spirit; these binaries appear in Weir's work in addition to the contrasts of war and peace, labor and leisure. The interaction and cross-pollination of these categories was commonly manifested in a traditional iconographic symbol of alchemy, the smith or metalworker.

## The Alchemical Forge

Indeed, the smith was one of the most crucial symbols in alchemical literature, a figure highlighting alchemy's connection with metallurgy. Often this was invoked using mythological means: Vulcan, Roman god of fire, stood in for the alchemical adept or master.[34] Representations of Vulcan's forge, with either implicit or explicit reference to his relationship with his wife, the goddess Venus, activated a series of key opposites, as Klaus Türk writes: "The figure of the smith is formed around typical binary codes: man-woman, ugly-beautiful, war-love, rational-erotic, work-art, exclusion-belonging; all against the background of a labor of material-metamorphosis."[35] These ancient binary understandings of the metalworker's forge symbolize the uniting of the "two principles," a central tenet of alchemy.[36] The art historian Michael Fried argues that rather than being mutually exclusive, however, these binary categories overlap and intertwine in images of metalworking, specifically in the German painter Adolph von Menzel's The Rolling Mill, the closest European counterpart to Weir's pair of canvases (fig. 18). Fried's claim that masculine and feminine, ethos and eros, *combine* to form new meanings is a simplified description of the chemical wedding, which Lyndy Abraham describes as "the trium-

Figure 18.  Adolph von Menzel (German, 1815–1905). *The Rolling Mill (Steel Mill)*, 1872–75. Oil on canvas, 158 x 254 cm. Gemäldegalerie, Berlin. Photo credit: Erich Lessing / Art Resource, NY.

phant moment of chemical combination where such opposite states and qualities . . . are reconciled of their differences and united."[37]

In Weir's paired canvases, moreover, a key binary has already been mentioned: the "war and peace" interpretation common to both nineteenth-century viewers and modern scholars. In the context of alchemical binaries, the iconographic contrast between *The Gun Foundry* and *Forging the Shaft* becomes part of their implicit meaning. The viewer is asked to use the pair of paintings to consider the relationship between these two apparently opposed categories. Visually, the images contain more similarities than differences—whether for wartime or peacetime use, iron comes from the same forge. Products for both peace and war have embedded within them a dangerous process of struggle with intractable natural materials. Weir's pairing of the images may suggest multiple meanings: the reunification of the country after the devastation of the Civil War, for instance, as a moment of alchemical synthesis. But note also that the state of peace has no fixed meaning unless it is contrasted with the state of war. In this context, it seems it must have been imperative for Weir to repaint *Forging the Shaft* after its destruction in 1869.

Weir's alchemy of binaries is compounded and sharpened by his metallurgic subject matter, with its legacy of metaphorical connections to alchemical discovery. Some of Weir's models, particularly the works of the eighteenth-century British painter Joseph Wright of Derby, were directly connected to the mysteries of alchemy. Weir was well educated in European art history, and his collection of prints included works by Wright and the French painter François Bonhommé, a closer contemporary of Weir who specialized in industrial scenes.[38] Wright painted at least five different canvases of blacksmithing in the 1770s and additionally stands out because of his parallel interests in alchemy, science, and metallurgy. Richard Earlom's mezzotints of Wright's ironworking scenes were distributed throughout the Anglo-American world and would have been familiar to Weir. One example, Wright's *An Iron Forge*, though depicting artisanal blacksmithing rather than industrial metalworking, suggests visual parallels with Weir in the sharp raking light of the forge and the strongly muscled bodies of the male workers (fig. 19). Wright also created several canvases depicting scientific experimentation and was connected with the Lunar Society, an intellectual circle interested in natural science and esoterica. Members of the group included the artist Philippe Jacques de Loutherbourg and the scientist Joseph Whitehurst, whose theories dealt with the idea of "subterraneous fire," a conception of the earth's molten core as a crucible of alchemical sublimation. Art historians have suggested that Wright's industrial scenes, along with Loutherbourg's apocalyptic vision of English industry, *Coalbrookdale by Night* (1801), connected the ideas of subterraneous fire and alchemical creation with the modern milieu of metalworking.[39] Wright's specific focus on iron forges in these protoindustrial, but also sublime, paintings clearly influenced Weir.

It was not only in the realm of painting that such references were made, however; the connection between alchemical magic and modern metallurgy can be seen in images of iron and steel workers that appeared in the pages of the nineteenth-century press. One of the most dramatic of these is an English example, W. B. Murray's "The New Steam-Hammer at Woolwich Arsenal, England," originally published in the London *Graphic* in July 1874 and reprinted in *Harper's Weekly* less than a month later (fig. 20). The scene depicts the moment when, "with a scream the monster rises, and with a roar he comes down, driving up all those tons of twisted iron into a compact breech or trunnion-piece," or when "this 'hammer of Thor' comes thundering down, mashing the hot iron into shape as easily as if it were crimson dough, squirting jets of scarlet and yellow yeast."[40] The titular steam hammer may be seen in the background, but the focal point

is the plug of iron, illuminating the entire scene with a light that almost sears the eyes. Murray brings the action forcibly into our space: the left side of the image itself appears to be on fire, the flames ready to consume the scene, reinforcing its exciting sublimity. The reference to the iron as yeasty dough strengthens the connection with alchemy: the concept of yeast fermentation was a medieval analogy for the natural processes of transformation that alchemy sought to replicate through chemical means. Sparks rise from the iron as from the sputtering fires of Vulcan's forge, reiterating the underlying link between alchemy and metallurgy and forcefully recalling creation through transmutation. And the workers stand in

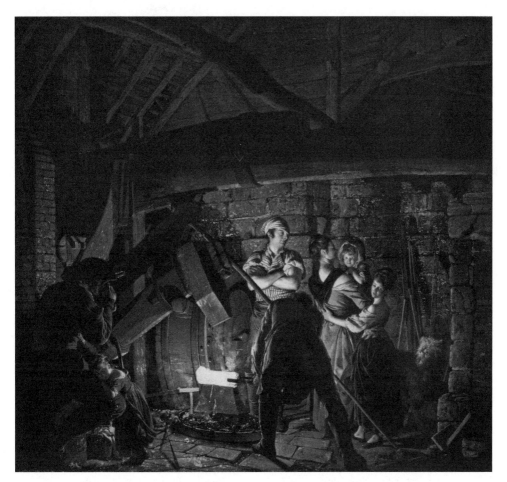

Figure 19. Joseph Wright of Derby (English, 1734–97). *An Iron Forge,* 1772. Oil on canvas, 121.3 x 132 cm. © Tate, London 2015.

THE NEW STEAM-HAMMER AT WOOLWICH ARSENAL, ENGLAND.

Figure 20. W. B. Murray (English, active 1870s–80s). "The New Steam-Hammer at Woolwich
Arsenal, England," *Harper's Weekly,* August 1, 1874, 646–47. (Reprinted from
*The Graphic,* July 11, 1874.) Wood engraving, 12 x 20 in. Reproduced by permission
from HarpWeek.

for alchemist figures—tending the fire, keeping the transformative process
under control, their knowledge holds danger in check while accomplishing
a radical act of production.

## Transmitting Knowledge

Shared bodies of knowledge were central to the continuation of alchemical
practice, and one prominent American painting of the previous generation
makes plain a connection between this transmission and the metallurgic
trades. John Neagle's portrait of a Philadelphia smith, *Pat Lyon at the Forge,*
paved the way for Weir's dramatic representations of the alchemical sub-
lime forty years later (fig. 21). In 1798, Anglo-American blacksmith Pat
Lyon was wrongly accused of bank robbery and spent three months in
the Walnut Street Prison. His portrait, painted in two versions in 1827
and 1829, commemorates this early obstacle to Lyon's eventual success as
a wealthy engineer. Many authors have noted Lyon's desire to be portrayed
not "as a gentleman—to which character I have no pretension" but rather

Figure 21. John Neagle (American, 1796–1865). *Pat Lyon at the Forge,* 1829. Oil on canvas, 94½ x 68½ in. (240 x 174 cm). Acc. no. 1842.1. Courtesy of the Pennsylvania Academy of the Fine Arts, Philadelphia. Gift of the Lyon Family.

"at work at my anvil, with my sleeves rolled up and a leather apron on."[41] Lyon, however, appears in this portrait neither as the humble smith he was in 1798, nor as the society gentleman he had become in the late 1820s, but rather as a hybrid figure encoded with various markers of transformation. Melissa Dabakis has noticed the fine metal buckles on Lyon's shoes, and Laura Rigal suggests that despite the forge setting, Lyon is represented at rest.[42] I would add that Lyon's immaculate white shirt and leather apron—unpatched and apparently untouched by the fire's heat—signify a man of leisure who has been transformed from his former "crude" state.

Pat Lyon, according to the prejudices of his day, began his career as a "base" material. Through skilled processes of metallurgy, alchemy takes such lowly matter rapidly through the necessary stages for purification. Pat Lyon also attained "nobility" through metallurgy, by means of his skill with refining and transforming metals. Neagle's portrait shows the finished product of an alchemical transformation, a man who retained traces of all the stages he had passed through on his journey through different echelons of Philadelphia society. The young apprentice marks an earlier stage of his own development; his tools—most prominently his anvil and hammer—lie around him, and the fire or crucible just behind his shoulder denotes the transformation that is, even within this painting, ongoing. Lyon's connection with arcane knowledge is further underscored by the inclusion of a paper containing a proof of the Pythagorean Theorem, visible in the lower right corner of the 1829 version. Pythagoras, a central figure in the genealogy of both Freemasonry and alchemy, was credited with "originating and disseminating the idea of secret brotherhoods bonded by the love of wisdom."[43] Lyon's Masonic identity tied him historically with other seekers after knowledge and probably connected him to Neagle, his fellow Freemason, who may have included the theorem as a way of advertising to other likeminded clients.[44]

The inclusion of Lyon's apprentice Jamie McGinley adds another message to the composition. Rigal argues that the painting is connected to major shifts in the workforce occurring during the first decades of the nineteenth century, in which shops were becoming closed to journeyman apprentices, craft education was becoming less common, and many industries were beginning to transition to larger, unskilled workforces through the adoption of mechanization. De-skilling restructured the relationship between business owners and laborers not as one between teacher and student but rather as one between employer and employee.[45] Thus this image may decry the passing away of a system of knowledge shared between older and younger men as it had been practiced by Lyon and McGinley. These

two men constitute another "father-son" pair—in addition to the Weirs and the Winthrops—involved in the passing of privileged information. A further such partnership occurs in the lower right-hand corner of *The Gun Foundry:* the older, seated man is Gouverneur Kemble, the founder of the West Point Foundry, accompanied by Robert Parker Parrott, the director of the foundry at the time of the painting. Kemble was a pioneering industrialist whose knowledge of ironworking technique and organizational skills had allowed the foundry to prosper for almost half a century; Parrott, Kemble's much younger brother-in-law, based the production of his innovative Parrott Guns on the foundation laid by his older mentor. Weir depicted them in the work at least partially as patrons—Parrott purchased the completed painting—but also as symbolic representatives of the generational transmission of knowledge.

Alchemy was a discipline that was only available to a select brotherhood of men, its constant secrecy and eternal reproduction ensured by the adept-apprentice relationship. Like the labor of skilled craftsmen, the techniques and foundations of the discipline had to be passed down to newly inducted practitioners by an older expert. By its very nature, this process could be sublime; in the ancient *Hermetica,* the great alchemical teacher Hermes Trismegistus recalled his own master-pupil relationship with Poimandres: "He looked me in the face for such a long time that I trembled at his appearance. . . . I was terrified, out of my wits."[46] The relationship between these two figures replicated the alchemical process itself, as the adept sought to reproduce both himself and his body of knowledge in the younger man. Neagle's image thus calls for the preservation of the reciprocal master-apprentice relationship.

Weir's long life was intimately tied up with this basic principle of generational knowledge. As a young man learning painting and drawing from his father, he described himself as "busy with my apprenticeship in art."[47] During his tenure as director of the Yale School of the Fine Arts, Weir was, in his turn, responsible for training at least two generations of American artists. While Weir's curriculum was methodical and progressively organized, his views on art instruction suggested that each artist should move beyond mere technical facility to pursue a more elevated path through self-examination and spiritual inspiration. The student, Weir wrote, "should be left to follow the bent of his individual inclinations . . . rather than force upon him prescribed disciplinary studies." Such overly strict curricula were an "attempt to circumscribe genius with a strait-jacket."[48] The primary goal of a young artist, Weir argued, should be to find a balance between technical skill and personal creativity, one that would contribute

to the purification and elevation of the entire artistic profession. In fact, his discussion of the state of American art was almost explicitly alchemical in its focus on the synthesis of the two "hostile" poles of technique and inspiration: he argued for art as "an impassioned expression of emotional impulse addressing the moral sense through the sensibility, and finding the means for this in the visible commonplace of everyday life."[49] Weir here describes art as a means of making moral truths visible by distilling the small realities of mundane experience into a higher and more exalted form, none of which would be possible without the transmission of knowledge from older artists like Weir to his students. Part of his role as a professor was to induct these apprentices into the exalted brotherhood of art-making, replicating the master-apprentice relationship for the modern world.

### Iron into Gold

That modern world was one of increasingly structured wage labor, a system that appears embedded within Weir's works as a kind of alchemy of capitalism. The actions seen in his paintings illustrate an alchemical process, that of making "gold" from the base metal of iron. This gold exists on several levels simultaneously. The molten iron itself glows golden in both images, giving this metaphor a strikingly visual meaning. In addition, if we return to Nye's definition of sublime—"to act upon a substance so as to produce a refined product . . . by heating it and then cooling it down"—we see that these men are involved in doing just that. They are heating up the metal, purifying it, and cooling it to produce a final product more valuable than the one with which they started. Indeed, industrialists had long recognized the alchemical qualities of iron. In one English dictionary of the late eighteenth century, iron was described in terms of the ease of its transformation from baseness to purity: "It has pleased the beneficent Creator of all things to make it common to all parts of the world, and plentiful in most: for this reason it is happily of small price; but if we look upon it with an eye to its utility . . . it is found to be greatly superior, in real value, to the dearest of the other [metals]."[50] The almost pulsating glow of Weir's molten iron draws our eye again and again to the sites of this sublimation and recalls the transformative nature of the ironworking process.

The middle-class spectators at the right side of *The Gun Foundry* give a clue to another type of "gold" that is being sublimed here. As has already been mentioned, two of the figures have been identified as Gouverneur Kemble and Robert Parker Parrott. Weir, however, incorporated three additional figures: two well-dressed ladies and a Union soldier. The in-

clusion of this group powerfully creates a tension between leisure and labor and a nuancing of the very concept of labor. Weir juxtaposes the leisure of the middle-class women and the different kinds of work performed by Kemble, Parrott, and the army officer with the sweaty toil of the men involved in the iron casting. These relatively leisured spectators, as overseeing yet removed figures, are catalysts for the alchemy of capitalism, the material transmutation of base iron into golden profits. Such a quasi-mystical account of the operation of capitalism underlies Karl Marx's otherwise highly structured theories, which were gaining intellectual currency during these years.

In his writings on economics, Marx made extensive references to alchemy, positing the modern structure of wage capitalism as a system of miraculous—though, in his estimation, negative—transformations. In the modern, bourgeois era, Marx and Friedrich Engels most famously wrote, "all that is solid melts into air." Solid states inexplicably transform themselves into gases: the very definition of alchemical sublimation.[51] In *Capital* (1867), Marx described the process of commodity exchange as a "transmutation" (*Wandlung*) involving the money-commodity binary. The entire process was, he wrote, a kind of "social metabolism" (*Stoffwechsel*), a term that can be translated literally as exchange or transformation of materials. All of this seemed to be the work of some "magician" (*Hexenmeister*) who enacted and oversaw those transformations.[52] While I do not take Marx's writings as indicative of eternal structural truths, I believe they can serve as valuable primary sources for understanding nineteenth-century attitudes toward capital's operation.

Marx's writings on alienated labor, particularly the "Economic and Philosophic Manuscripts of 1844," suggest the system of capitalism as a befuddling, rather than purifying, alchemy, one in which the products of labor are achieved by processes mysterious to those who physically undertake them. The end product in this schema, as in alchemy, is gold—money earned for the exchange of commodities and services, rather than work performed for its own sake. Money, Marx wrote, is "the transformation of all human and natural properties into their contraries, the universal confounding and overturning of things," in short, an alchemical wedding that effects a transformation through competing dualities ("contraries" or *Gegenteilen*). Profit's only goal is to endlessly reproduce itself—"to do nothing but create itself"—just as an ultimate goal of alchemy was to achieve eternal life—to endlessly reproduce oneself—through the Philosopher's Stone.[53] In this sense, Weir's image and others that depict the metallurgic industries during this period were not only alchemical in their subject

matter. They also contained within them the very structures of wage capitalism's alchemical mystery. The West Point Foundry workers were participating in the transmutation of iron into *literal* gold or profit. It is the well-dressed women and their male escorts at the right of the painting who reap the golden rewards of the laborers toiling in the foundry. Weir marked a class divide by showing the ways that resting bodies watch laboring ones—and by implicating the viewer's leisurely body in this division.

Weir's body, too, intruded into the work as he sought to probe the making of art as a form of labor. In many of his writings, he likened his artistic creation to the exertion of the men he observed at work in forge and foundry. To reinforce the similarities between industrial and artistic work, Weir occasionally wrote of the difficulty of his labors, especially to his friend and fellow artist Jervis McEntee, whom he fondly referred to as "Mac." In a letter of July 22, 1867, Weir bemoaned his work on *Forging the Shaft*: "The glorious hope of getting off to Europe in the following Spring is a strong incentive to dig away hammer & tongs—(which according with my subject 'The *Forge*' may be construed literally)." The reference to blacksmithing tools as stand-ins for his own tools—brush and palette—strikes an odd note. But it seems Weir truly struggled in his work, to the extent that he felt himself oppressed by the darkness of a canvas he felt almost trapped within. In the same letter, he complained, "I sometimes wish I could crawl out of its dusky overshadowing gloom. . . . I sometimes think my task is a little harder than is generally allotted to us poor devils."[54] He continued in this vein two weeks later, again to McEntee, more explicitly comparing his work to that of the foundrymen he was painting: "I sigh for such sweet and wholesome work as you are doing, all day long in the blessed woods while I am breathing the smoke and dust of an unsightly foundry—with its eternal din forever ringing in my ears. . . . I have to fret and sweat over barbarous mechanical facts and appliances."[55] The vivid quality of this description—dated not from West Point but from Milford, Pennsylvania, where Weir was spending his summer—gives a vivid picture of torturous and labored creation. Miles from the foundry, Weir still felt himself absorbed and surrounded by its din, working to refine something successful from those sooty fires. In a national forum, the *Princeton Review*, Weir also argued that though "the painter presents an image that seems flashed upon the canvas with the ease and celerity of thought, with the vividness and truth of nature," behind this momentary impression lies "laborious, painstaking, studious inquiry."[56]

Outside observers, too, made a connection between Weir's artistic labor and the foundry work he depicted. A review of the 1866 NAD exhibition

approached *The Gun Foundry* in explicitly alchemical terms, describing fire as "the medium by which nature's tough treasures are wrought into usefulness."[57] This language suggests a transformation enacted on raw materials by industrial processes but also compares the fire of the foundry to the artist's brush—each a "medium" for creation. When it published a large engraving of *Forging the Shaft* in 1869, *Frank Leslie's* described Weir as "one of the most successful workers in the field of American art."[58] Although all artistic labor should be seen as "work," because of his choice of subject matter, Weir's role as a worker came to the forefront in his connection of art to industry.

## Art and Alchemy

Another aspect of Weir's alchemy can be found by considering the art of painting itself. Pigments from verdigris to Prussian blue had been developed through processes of serendipitous chemical experimentation that created marked transformations of materials. Cennino Cennini, the author of the technique book *The Craftsman's Handbook* (c. 1390), specifically referred to vermilion, yellow orpiment, and verdigris as products of alchemy, "prepared in a retort" (*lavorato per lambicco*).[59] The kind of experimentation that lay at the root of many Renaissance changes in art production was tied up with a vocabulary of transformation and discovery borrowed from the arcane sciences.[60] Knowledge of chemistry, Weir himself argued, was an important skill for artists, who should use experimentation to develop new media and techniques.[61] Weir used the apocryphal example of Jan van Eyck's accidental invention of oil paint—a story propagated by Giorgio Vasari in his *Lives of the Artists* (1550/1568)—as a particularly important example of this kind of innovation. While, in fact, van Eyck did not invent oil paint, his apparent interest in experimenting with chemistry led Vasari to characterize him as an artist who "took delight in alchemy" (*dilettandosi forte della archimia*).[62] An artist as well-read as Weir would have been familiar with the ways in which art and alchemy were connected through the language of chemistry, whether or not he himself engaged in such experimentation. There was also a more metaphysical connection between the disciplines, of which Weir seemed well aware.

The art historians David Bjelajac and James Elkins have focused on the ways painting, by its very nature, enacts a kind of alchemy. Bjelajac argues that paint itself, when transformed from blobs of color on a palette to a recognizable painted image, is "a kind of crystal ball for revealing gnostic truths."[63] In Elkins's more personal, poetic meditations on painting, he

suggests a similar kind of sublimation: "Alchemy is the old science of struggling with materials, and not quite understanding what is happening . . . as every painter does each day in the studio." Painting is the act of combining concrete elements (painted strokes) until "the paint ceases to be paint and turns into colored light," that is, until the paint transcends its materiality. Elkins also adds a statement that resonates with the way Weir discussed his own process: "For the alchemists as for the painters, [metamorphoses] are partly reasonable procedures that can be taught and learned, and partly intuitive, mystical methods that describe something a rational analysis cannot grasp."[64] Such metaphors were current among Weir's circle of artistic friends as well. In the early 1870s, Susan Nichols Carter wrote that Weir's friend John Frederick Kensett possessed an "artist's alchemy" to purify "every different phase of American scenery that passes through the crucible of his imagination," while Weir himself referred to the landscape painter Frederic Edwin Church as the "great alchemist."[65] Something about the ability of artists to transmute everyday subjects into great works of art resonated with a nineteenth-century conception of painting's essential nature.

Alchemy resided not only in the chemistry and the ontology of painting but also in the emotional work of artistic creation. Weir wrote in 1882 of how art-making included "much groping under faint gleams of light" until " 'new light breaks in upon him.' "[66] In his autobiography, he recalled the process of composing The Gun Foundry as sparked by a moment of clarity that came out of a confusing plenitude: "In my studio one morning I was looking over my foundry studies . . . and I was further impressed with the virile activities of that busy place; the thought of it, in looking over the studies, seemed to take strong hold of the imagination for its human interest. And one night, having already stretched a large sheet of brown paper in preparation, and spread my studies of the foundry on the walls and floor where I could see them, I began to arrange the composition of 'The Gun Foundry' in a large charcoal cartoon."[67] Weir wrote at length about his process of artistic creation, and many of his writings have a clearly metaphysical subtext. His conception of artistic labor stressed processes of inspiration and revelation, the combination of raw materials sparked by a catalytic event to effect the metamorphosis of materiality into spirit.

Elkins describes this as a crucial part of both alchemical and artistic work, "a flash of inspiration or a moment of supreme profound comprehension, more like a religious epiphany."[68] The key element of this flash is that it does not merely create new ideas out of nothing; it is, as

Elkins says, a moment of *comprehension,* not invention. Nineteenth-century America's most prominent theorist of alchemy, General Ethan Allen Hitchcock, phrased it thus: "That man has a power of *conceiving* truths which the senses cannot *perceive,* seems a mere matter of fact, about which there need be no difference of opinion. The real difficulty here is perhaps that of distinguishing *intuitions* from mere *imaginations.*"[69] This kind of language peppers Weir's correspondence with friends and family. For instance, in 1866 he confided in his fiancée, Mary French, about the "smouldering enthusiasm" he felt as he contemplated his next work, *Forging the Shaft,* feeling "as if there were a fire within, just ready for an eruption."[70] Of his working process, he also wrote to McEntee: "For my part I must confess I follow no *reasoning,* but am guided by *feeling* entirely, and seldom or never stop to analize that, to determine whether it is correct or false."[71] Much later in his career, he guided his younger brother, the Impressionist artist Julian Alden Weir, with similar advice. "There is a distinct inner voice in each of us," he wrote. "The thing is to obey it."[72] These declarations suggest that for Weir, sometimes creation was intuitive, bubbling up from inside.

### Subliming the Self

Weir's focus on the revelatory quality of art-making also played on crucial binary divisions of gender and selfhood. As we have already seen, Weir played with the relationship between such opposed concepts as war and peace and labor and leisure, through the pairing of *The Gun Foundry* and *Forging the Shaft.* Enacting a contemplative merging between categories understood as exclusive, Weir forced his audience to consider the porousness of such oppositions. In 1878, he strenuously recommended a modulated approach to life, asking his readers to "avoid those rude contrasts which only admit the extremes of black and white, without recognizing the infinite shades of half-tone that hold the finer truths and comprise the juster relations of merit in art, as in every thing else."[73] One youthful piece of writing obliquely brings Weir into view as someone whose art explored these boundaries but who was himself occasionally frightened by the power and drama of revelation. This private piece, an 1865 letter to Mary French, depicts the artist as the interpreter of strange and mysterious urges and the interior of the foundry as a hellish site of Gothic visions. While Richard S. Field and Betsy Fahlman have noted the similarity in rhythm and tone to Edgar Allan Poe's "The Raven," neither has commented much

on how the text of the letter relates to Weir's conception of his own art of painting. Although it is a drawn-out text, it is worth quoting at length, as it demonstrates the metaphysical nature of Weir's thinking:

> Let your spirit come on the wings of the wind, and let us suppose it peering down through the dark glass, from out that inky space beyond, pressing tightly against the wet glass, looking down upon my room. Seeing the bright light falling softly on my table, on my paper, on my figure bending over it. And the ghostly shadow of my form, standing stark against the wall, mocking every movement of my figure. So mysteriously tall, projected on my Study wall. . . . And the relics hanging high, arms and weapons hanging high, glisten there and catch the light, catch the flickering light and sparkle, casting grotesque shadows, mingling shadows on the wall. All these trophies and these trinkets that hang upon my study wall, in the daytime seem most friendly, friends and friendly are they all, but at night, in feeble light, dance their shadows on the wall, mingled mysteriously on the wall, almost frighten and appall. Spectre-like and queerish, very queerish are they all.[74]

Weir goes on to describe both *The Gun Foundry* and his idea for the not-yet-begun *Forging the Shaft* in similar language, full of references to the toil of the burly male workers and the mysterious, almost frightening character of the compositions. But it is this first part of the letter that is most telling. While its playful, Poe-inspired repetitions of phrases may be a sophomoric bit of literary showing off for his fiancée, the overwhelmingly claustrophobic and hellish character of the letter lends an entirely different cast.[75]

Field has argued that both *The Gun Foundry* and *Forging the Shaft* served as sexual metaphors for Weir's desire for his fiancée, and that *Forging the Shaft*'s "insistent phallicism" and *The Gun Foundry*'s "onanistic discovery" are two sides of a coin in which the artist longs to find sexual satisfaction and release through his work.[76] Particularly convincing in this analysis are later portions of Weir's letter describing the two paintings using phrases such as "roars and groans throughout the night. How it surges, how it swells," and "welding into shape the seething monster . . . till at last the thing is done."[77] These could certainly be barely cloaked references to sexual self-denial and eventual release. They could also be interpreted as explorations of male and female essences and their volatile but ultimately purifying alchemical combination: "the marriage of Sol and Luna," whose offspring is the hermaphroditic *rebis*.[78] At the pulsating center of *The Gun Foundry* is the iron crucible; in alchemy, the crucible is the vessel in which the *materia prima* is fertilized. And the plunging phallic quality of the

golden rod at the center of *Forging the Shaft* maps nicely—if a little too neatly—onto the masculine principle; one reviewer picked up on the "vital and virile force" of the composition, wording that emphasizes an ethos of manliness.[79]

Weir's focus on masculinity comes out in his letters to McEntee, complaining that "these 'Artists' are not all *men* it appears, and others are losing the little manliness they had."[80] Artists must be "men," but they must also be creators. Here Weir seeks to reappropriate the act of generation from the feminine to the masculine, in the process recalling another key binary, that of self and other. While Weir's long letter to Mary has primarily to do with the painful and occasionally frightening experience of creating a painting, it also depicts a radical act of dislocation as Weir ponders the sources and forms of his inspiration. The artist steps outside of himself as he contemplates his artworks; a shadow artist, cast on his study wall, seems to loom above him: "the ghostly shadow of my own form . . . mocking every movement of my figure." This shadow self comprises an external force that seems to have power over the composition of the paintings, creating an ontological discomfort in the artist and causing him to question his own subjectivity. Could it be this man who appears in the upper right corner of *The Gun Foundry,* illuminated in sharp orange raking light and with a monstrous shadow towering over him on the foundry wall?

To trace this element of Weir's artistic persona, it is necessary to return to his first major painting, *An Artist's Studio* (see fig. 15). This first academic success depicts Weir's father surrounded by tools of the artist's trade, such as canvases, props, and plaster casts.[81] With *An Artist's Studio,* Weir boldly asserted his suitability to be inducted into the brotherhood of the NAD, demonstrating his knowledge of contemporary art-making and art history, included in the form of the plaster casts, prints, and copies of European paintings that Weir replicated based on his father's extensive holdings. In fact, the composition, with its focus on artistic production and materials, suggests an early interest in artworks that present a meta-commentary on the process of art-making. The light within the composition seems to radiate outward from the center of the canvas, where one of his father's recent paintings, *Taking the Veil* (1863), stands on an easel, its size exaggerated as if to heroize its painter. The artist is not shown in action, however, but in contemplation, with the completed canvas of *Taking the Veil* and the tools of his artistic and teaching careers standing as markers of his creative role. The painting also shows an interest in exploring the effects of light to model the plaster casts set high on a carved wooden cabinet. But there is no identifiable light source for this illuminating beam—rather,

the statuettes stand out as unnaturally bright in the gloom of the room, presaging Weir's letter of 1865 in which all the typical accoutrements of artistic studios come alive and cast their oppressive presences into the room.

The space Weir evokes in that letter is like the shadow world of *An Artist's Studio:* a Gothic nightmare in which suits of armor used as props and disembodied limbs from plaster casts come to terrifying life. Adding to the eerie effects of the long passage quoted above, Weir wrote, "Still those awful shadows, shadows tall, upon the wall, and sundry creakings in the hall, appall, appall, fall like a pall upon my heart. . . . The human limbs in plaster cast, grotesquely gesticulate, chrystalized action, dangling hang, hang dangling from the wall."[82] This unsettling scene is repeated in a small 1862 sketch from Weir's papers showing the artist seated in his studio, surveying a grotesque panoply of casts hanging on the wall: amputated feet, arms, and hands of plaster, a spooky vision of carnage and nightmare.[83] By imbuing these inanimate objects with a disturbing sense of wakefulness, Weir probes the relationship between self and other, reality and representation, through a Romantic exploration of his own humanity. Such reflections may seem natural to the growth process of a youthful artist, but Weir never entirely abandoned this meditation. The theme reoccurred in one of the most unsettling works of his career, *His Favorite Model,* made approximately twenty years later (fig. 22).

In this enigmatic composition, an unidentified artist dances with a life-sized articulated dummy, clasping her hands in an intimate embrace. It is not a self-portrait and does not appear to represent Weir's father, brother, or any of his close group of artist friends. Set in a studio space that appears superficially similar to that of *An Artist's Studio, His Favorite Model* takes a close-cropped approach, making it difficult for the viewer to gauge what is occurring in the space as all the elements are pushed up against the picture plane. The composition plays with the concept of visual indeterminacy, confounding the viewer with a multitude of surfaces, frames, and nested representational devices evoking mirrors, screens, and fictive painted spaces. While Fahlman suggests that the "Pygmalion-like action of the figure adds a note of gentle humor to the scene," when viewed in concert with Weir's writings about his studio, the grotesquely twisted neck and visible articulations of the female mannequin evoke the uncanny tales of E. T. A. Hoffmann rather than the *Metamorphoses* of Ovid.[84] The tools of the artist's trade once again prove unpredictable and frightening, threatening to acquire a life of their own. In *His Favorite Model,* Weir continues a theme that had troubled him since the mid-1860s: where to draw the line between the inner self and the outer world. With its multiple levels of

painted, sculptural, and reflected representations, *His Favorite Model* also questions the role and purpose of art-making itself.

Like alchemy, which communicated using a language in which every term or symbol had another, deeper meaning, Weir's art relied on complex layers of signification that would be understood differently by different

Figure 22.  John Ferguson Weir. *His Favorite Model,* 188–. Oil on canvas, 25 x 19¼ in. Yale University Art Gallery. Gift of Vincent Price, B.A., 1933.

audiences. As Weir himself had written, "The public occupies itself with what is easily understood, and the best art is not always easily understood. Those things, therefore, which demand some correspondence of thought for their right reception, appeal to the individual, for it is the individual solitary who thinks."[85] Weir's paintings balance the tenets of contrasting opposites: war and peace, male and female, work and rest, self and world, representation and reality. His conception of the labor of painting as a battle within oneself to discover and portray the relationships between these opposites replicated the alchemists' spiritual quest to discover hidden truths.

*Coda: Alchemy and Revelation*

If we think about alchemy as a process of material transformation, the act of painting itself is always alchemical: it is a chemical process that, through synthesis, births a new and purer form. I believe, however, that the representation of metalwork, with its long connection to the symbolism of alchemy, imbues a painting with additional layers of alchemical meaning. In works such as Weir's that focus on oscillating binaries, the alchemical principle becomes even more central. For Weir, painting was also sublime: as he wrote, wracked by spirits, shadows, and fears, he described painting as an act exceeding rational understanding that is attended by both terror and fulfillment. Weir's canvases are embodiments of the alchemical sublime, sites of convergence.

As Mircea Eliade wrote in his book about the history and myths of alchemy, "the alchemist takes up and perfects the work of Nature, while at the same time working to 'make' himself."[86] Weir's involvement with the alchemical sublime was a lifelong process, one that undergirded all his work. In later years, Weir wrote two books on the transformative power of Christian revelation, recalling his earlier writings on the nature of artistic inspiration. In one of these, *The Way: The Nature and Means of Revelation,* Weir commented, "By whatever agencies man is enlightened in the course of nature . . . Revelation is a supernatural disclosure, apart from the means whereby man commonly acquires knowledge."[87] And this mode of revelation, which allows man to contemplate the existence of a spiritual intelligence that is superhuman, is the ultimate form of the Kantian sublime. "Nature is therefore sublime in those of its phenomena," Kant wrote, "whose intuition brings with it the Idea of its infinity. This last can only come by the inadequacy of the greatest effort of our Imagination to estimate the magnitude of an object."[88] The one object whose magnitude

is truly too great to contemplate is God. This, too, was the ultimate conclusion of the alchemical *magnum opus,* which sought revelation through philosophical and experimental, rather than artistic, means. In the final analysis, for Weir, life was the alchemist's workshop; the alchemical material was the artist himself. Beginning as a base material, man could eventually hope to resolve himself into pure spirit, pure soul: the soul, as Weir described it, "a substance so infinitely sublimated."[89]

Weir's metallurgic subject matter, his approach to the creation of art, and his spiritual beliefs in inspiration and transformation partake of the alchemical language that lingered in the American subconscious in the middle part of the nineteenth century. Weir's example is only the most prominent. The intention of this chapter is to demonstrate that a metaphorical language of alchemy, as an alternative to the acceptance of rational technological systems, suffused artistic culture at this time. A discourse of transmutation, change, and transformation adapted the traditionally arcane language of alchemical discovery to the shifting realities of modern life and the industrialized metal trades. Coming out of the crucible of the Civil War, the United States sought metaphors for the rebuilding and purifying of the American nation. While Weir worked through war and peace in large-scale metaphysical canvases, other artists dealt with the trauma of the war through the more apparently straightforward metaphor of reconstructing the country through labor.

*Chapter 3*

# Swords into Ploughshares

## Reconstruction, Reconciliation, and Labor

A POEM by Charles D. Shanly, "After the War," ran on the front page of the August 1865 issue of *Harper's New Monthly Magazine*. An almost pastoral scene appears in the accompanying wood engraving: farmer and blacksmith greet each other with smiles in the latter's modest shop (fig. 23). The handsome blacksmith, whose features bear a resemblance to the Victorian character type of the honest working man, stands at his anvil preparing to hammer a sword. Although the intervening years have added some flesh to his belly and some lines to his face, the Yankee farmer is another type well known from antebellum popular culture, including theater, literature, popular illustration, and genre painting.[1] They stand in amiable conversation as the farmer waits for the blacksmith to "shoe his horse" with a bayonet from the field of Gettysburg or "a broken fetter from the South." The two men converse in rhyme:

> THE FARMER:
> I see around your work-shop
> Stark implements of war—
> Can it be that you are forging
> Some new-born quarrel for?
> THE BLACKSMITH:
> Not so, my jovial farmer,
> The weapons that I forge
> No manly limbs shall sever,
> Draw no gore-drops, cut no gorge:

Sword I'm turning into plow-share,
Into reaping-hook the gun,
Here are bayonets by the bushel—
Shall I shoe your horse with one?[2]

This typical preindustrial working man labors at something more momentous than simply shoeing a horse, however. He is participating in the post–Civil War discourse surrounding reconciliation between North and South: getting back to business as usual but using the detritus of the devastating war as a foundation for future peace. Only four months later, this industrious worker is striving to obliterate the war's memory by beating "sword . . . into plow-share" and "bayonets by the bushel" into useful items such as horseshoes and agricultural implements. On the wall behind the blacksmith are artifacts mapping the progression from warlike to peaceful state. To the left hang several swords, to be subjected to the same process

Figure 23. "After the War," *Harper's New Monthly Magazine,* August 1865, cover. Wood engraving, 5 x 4½ in.

as the one now on his anvil, eventually adding to the array of horseshoes hanging to the right. By taking the materials of warfare and forging them into something new and useful for peacetime, he enacts a literal and symbolic repudiation of war and disunion. At the same time, getting back to work also meant getting the South *to* work, forging its smoking ruins into a newly thriving manufacturing society on the model of the North. This illustration of a humble blacksmith is part of a large group of images whose creators struggled to make sense of reunification after the war and did so through a single metaphor: work.

Putting the nation back together was difficult and sometimes unpleasant work, with the ultimate goal of bringing the country to a life of peace and prosperous commodity production. This illustration echoes a biblical quotation commonly used to sum up the postwar return to normality: "They shall beat their swords into plowshares, and their spears into pruninghooks: nation shall not lift up sword against nation, neither shall they learn war any more."[3] With its vivid imagery of an industrious shift from warlike to peaceful implements, the verse was a touchstone quoted in magazine and newspaper editorials, poems, and songs from 1865 into the 1870s.[4] The appeal of the phrase was not limited by region; one commentator wrote from the South to the *Daily National Intelligencer*: "Commercially, the cities and towns are reviving. Merchants are returning to their desks, sending circulars to their old friends, and buying and selling; and mechanics, to their benches; in fact, everybody in his place, and thousands of newcomers seeking places of employment. The farmers have commenced again to develop the resources of the earth. In truth, everybody is returning to domestic pursuits; none for war. They have really turned their swords into ploughshares."[5] Viewed in this context, the poem and image at once provoke thoughts of the stormy past and suggest the distinct possibility of regeneration through productive labor.

A similar tension underlies many of the images discussed in this chapter, images that also dealt with the question of how to work at rebuilding the nation after the tragedy of the Civil War. The problems at hand went far beyond the blacksmith's shop, however. In this chapter I consider not only the blacksmiths but also the ironworkers, cotton spinners, and engineers: the ways in which metaphors of reunification encompassed a larger field of labor and industry, grasping the technologies of peace as ways to overcome, to *work through*, the trauma of war and division. This theme appeared in several media, including political cartoons; traditional, European-style history painting; views of growing southern industrial

hubs; and imagery of southern fairs and expositions. Most, though not all, of the visual documents examined were created in the North. Although illustrations in particular circulated throughout the Union, the group of images as a whole represents a hegemonic, northern view of reconciliation. The social and economic, no less than the political, terms of Reconstruction were dictated by the North and imposed on the South in explicit ways. Because the North was also the national center of print culture, authors and illustrators based in New York, Boston, and Philadelphia had the power to shape an entire nation's views about the work of reunification.

In addition, the North's role as the most technologically advanced section of the country meant that the other regions had to accept northern-style modernization as a central tenet of U.S. identity. As the historian Richard D. Brown wrote, "Because of the Northern triumph the Northern vision of United States society became the national vision. . . . The Union victory officially established modern ideals."[6] Richard Slotkin goes further, arguing that northern victory in the Civil War caused a nationwide ideological shift toward official support of big business and managerial techniques. In fact, Slotkin writes, northern leaders viewed Reconstruction as an opportunity to treat the country itself like a massive factory in which the most desirable political skills overlapped with those of rationalized industrial management, including "conceiving and managing large enterprises, of disciplining great masses of men and organizing huge quantities of capital goods, of generating the finance capital necessary to underwrite such enterprises."[7] Images of reunification used this language to shape viewers' opinions about the "New South" and its role in national life. The documenting of these shifts was primarily carried out in the pages of the national newsmagazines, a more logical site to interrogate the rapid and shifting developments of the New South than the traditional realm of painting.

Very few fine artists contributed to the visual culture of reunification. The small number of paintings that were made on the subject tended to adhere to traditional, prewar standards of European-inspired allegorical representation; those that were clearly modernist in their orientation, such as the works of Winslow Homer, did not tend to operate in the celebratory and optimistic realm of boosterism. Therefore, probably not surprisingly, the most compelling images of this trend occurred in magazine illustrations, where artists were supported by the shared motives of their editors and the southern industries they were depicting. Where painters did enter the conversation, their works tended to hearken back to the heyday

of history painting in the antebellum years, when it was still fashionable to represent the nation through European-style allegories, often women in classical clothing. While the dominant visual focus was indeed on the development and expansion of rationalized systems, some images continued to use the language of symbol and allegory to express hopes and desires about the strength of the rebuilt nation. Unitary rhetoric masked ongoing anxieties about reunification, race, and industry using visual language often borrowed from European precedents, citing the visual culture of European powers such as France and Great Britain, and, by inference, proposing those nations as models of national identity formation and state power. The need constantly to reassure viewers of national unity suggests that the war could not be erased from the national consciousness; its specter lurked behind even the rosiest images of concord. This was why putting the country back together required such diligent application.

At the same time that artists were depicting reunification as an act of symbolic labor, the periodical press used images to educate northern readers about the work of their newly rehabilitated southern neighbors. Major periodicals touted the burgeoning industrial strength of the South, which was "discovered" by northern fact-finding missions and disseminated through journalistic series focusing on the vibrancy and variety of southern manufactures. For the most part, the tone of these articles was informational and celebratory, though they sometimes alluded to fears that southern industry might outstrip the North. Some of these trips were intended to dispel myths about the homogeneity of the South, which was in fact quite diverse in its history, peoples, landscape, industries, and natural resources.[8] Reporters and illustrators from northern magazines traveled to southern cities to amass statistics and establish goodwill with mayors and businessmen.

Using a variety of visually informative techniques, artists demonstrated how the South was becoming integrated with the rest of the nation in a web of technological production, distribution, and communication. This shared culture was undoubtedly dominated by the North and was shaped by the desires and expectations of primarily New York City–based magazine editors. The periodicals studied here, however, had genuine national appeal, despite their frequently partisan politics. Because the South could boast no comparable illustrated news periodicals, *Harper's Weekly* and *Frank Leslie's Illustrated Newspaper* had major roles in shaping national expectations about reunion. The rejuvenated country included North, South, and West as balanced—if not quite equal—players in national life.

## Reconstruction as Re-Construction

The symbolic representation of the struggle for national unity as work did not originate with the end of the war. During the conflict, the genre of political cartoons used the symbolic figure of a skilled craftsman whose job was to strengthen the Union. Such a focus continued in postwar cartoons in venues such as *Vanity Fair, Harper's,* and *Frank Leslie's.* The men shown usually practiced artisanal, rather than industrial, trades, and one of the most common was the blacksmith, already seen in the illustration to Shanly's poem. The symbol of the hardworking, muscular, and industrious blacksmith was drawn from a European allegorical language of Renaissance and Baroque painting repurposed for the modern United States. The theme of Vulcan's forge was the earliest "industrial" imagery in high art, one that also referenced the alchemical workshop.[9] In the United States, blacksmiths stood for a specifically northern idea of "free labor opposed to slavery" in the popular imagination.[10] Political cartoons in *Harper's Weekly* and *Frank Leslie's* intentionally drew on these dual inspirations to create a new hybrid. Civil War–era cartoonists combined European models of Vulcan, symbolizing power, endurance, and industriousness, with references to the free American blacksmith to create strong, legible calls for unity in the face of conflict and threatened rebellion. Because the blacksmith symbolized the dignity of free labor, he could stand in for an idealized vision of the *entire* post-slavery nation, not just the North.

During the war, the northern press was already imagining a re-forged or strengthened Union tempered in the flames of the blacksmith's shop. An 1862 cartoon from *Harper's Weekly* shows the hawklike profile of "Brother Jonathan," a youthful personification of the United States, furrowing his brow in concentration over his anvil (fig. 24). In her study of the character of Brother Jonathan, Winifred Morgan notes key characteristics that identified this figure from the 1790s onward: Jonathan was a trickster figure who liked to get the "last laugh," a rugged individualist, and a dutiful worker. Up until the Civil War, Jonathan was the most popular representation of the United States; for the common people, he "captured the potentially explosive power, fickleness, anger, wisdom, or quiet strength of America's mass population."[11] Surprisingly, Jonathan's adversary in this and other similar cartoons was not a figure of the Confederacy but an image of John Bull, marking Britain's allegiance with the southern states. By placing Jonathan against a foreign enemy, cartoonists allowed the possibility of later putting the Union back together without alienating a major part of the population.

EXASPERATION OF JOHN BULL AT THE NEWS FROM THE U. S.

John (*frothing at the Mouth*). "He won't go to smash—he won't die—he won't give up restoring the Union, though I've told him, over and over, that it is no use. What Beasts those Yankees are! Ugh!"

Figure 24. "Exasperation of John Bull at the News from the U.S.," *Harper's Weekly*, November 8, 1862, 720. Wood engraving, 5 x 7 in.

Here the usually lanky Jonathan is shown with impressively large forearms and a clearly muscular torso under a star-spangled shirt. He wears the typical leather apron of a blacksmith, but instead of his usual, tight-fitting trousers, he is clad in the loose bloomers and button-up leather gaiters of the American Zouaves, volunteer regiments who based their uniforms on those of early nineteenth-century French imperial soldiers fighting in North Africa. The Zouave regiments distinguished themselves in combat in the Civil War, and their picturesquely Orientalist uniforms were a favorite topic of war reporters.[12] Zouaves were renowned for their bravery and skill, so by appropriating a part of their typical costume, the artist reinforced Jonathan's imposing appearance.

Jonathan's power is especially impressive when compared with the morbidly obese, gouty, drink-reddened caricature of John Bull in the left panel. Both Jonathan and John Bull had emerged at the end of the eighteenth century, part of shifts in Anglo-American society that led to "a new and different sense of national consciousness . . . [that] turned increasingly to vernacular images . . . and regional traditions to create their national symbols."[13] The cartoon, which mocks the South's inability to win the war despite monetary assistance from Great Britain, distinguishes what

many in the United States considered the native physiques and traits of each country: Britain is weak, pettish, drunk, and lazy, while the North is strong, hardworking, determined, and productive. The contrast is particularly marked here, for Brother Jonathan is usually depicted as weedy but shrewd, rather than beefy.[14] The interplay between these two figures would have been familiar to readers of *Harper's Weekly* from the years before the war, when Great Britain was satirized as fat and impotent. The cartoon addressed current events but also alluded to an older relationship of antagonism between the two nations, especially as the United States began to flex its industrial and military might after the War of 1812. In antebellum literature, for example, James Kirke Paulding had spoofed the United Kingdom in his satirical fairy tale *The Diverting History of John Bull and Brother Jonathan,* in which John is characterized as miserly, belligerent, and overbearing, while Jonathan has qualities of industry, ingenuity, and strength.[15] In sum, John Bull and Brother Jonathan had a long public history of rivalry, depicted in visual, performative, and literary media dating back to the 1820s, which many viewers would have called to mind on viewing this image.[16]

But the cartoon of Brother Jonathan as a blacksmith also constituted a significant reimagining of his character and of the nation. He is shown unambiguously as a working man, raising his hammer to forge and repair a great iron ring labeled "Union" and "Constitution." John Bull complains petulantly: "He won't die—he won't give up restoring the Union, though I've told him, over and over, that it is no use." Jonathan takes no notice of John's tantrum but seems intent on his task, repairing the Union by holding it together. At his feet lie cannon, bayonets, and grape shot, ready to help him enforce his job, if necessary. His pose is Vulcanic, but his accessories are those that would be found in blacksmiths' shops in contemporary American genre paintings by artists such as Eastman Johnson. This hybrid quality gave Jonathan a fresh new appearance and a monumental symbolic significance. As a stand-in for the entire nation, Jonathan's appearance transformed his typical persona of a rural, Jeffersonian yeoman into a laboring man who could represent the changing character of the United States.[17] This cartoon suggested that the war could be won and the nation rehabilitated through the efforts of working people. The unapologetic depiction of the United States as a blacksmith suggested not only the dignity of labor but also identification with and admiration of those who worked to keep the Union together. The image's roots in both European precedents of Vulcan imagery and vernacular depictions of national spirit and industriousness placed the United States on a par with—and even

superior to—the developed, powerful empire of Great Britain. Although this image represented a coercive, rather than cooperative, approach to keeping the nation together, it still reinforced the powerful desire to forge a stronger Union.

In the postwar years, this imagery of labor was adapted to the new goal of Reconstruction and rehabilitation of the southern states. The allegorical representation of a single laboring man persisted but became more equivocal. Thomas Nast's "The Time Has Come" shows Uncle Sam, the new personification of the United States who was increasingly replacing Brother Jonathan (fig. 25). Pictured as a construction worker, he enacts a literal Re-Construction of the Union but with a darker and more cynical twist. Despite his support of the Radical Republicans throughout Reconstruction, Nast showed his exhaustion with the divisive tactics of northern politicians, who still sought to blame the South for the bloodshed of the Civil War twenty years on. His weary yet determined Uncle Sam prepares to lay sectional conflict to rest, noting that he must either "bury the bloody shirt, or the party." Nast suggests that the Republican Party is coming apart, and that its insistent negativism is damaging its credibility. It is key to note that whichever he buries, it will become part of the foundation of the "New Union," whose cornerstone waits to be maneuvered into place. No matter what, this "New Union" will be founded on sectional conflict and hatemongering between North and South—the bloody shirt is not merely to be buried and put out of sight but will become a part of the foundation, built into the fabric of a nation that was still rebuilding twenty years after the war. In that sense, this image, though on the surface it continues the tradition of optimistic wartime cartoons showing laborers forging a new Union, represents a less hopeful outlook for national harmony. The gloomy atmosphere of this cartoon and the haggard appearance of Uncle Sam suggest an older, wiser nation and perhaps a loss of innocence in the transition between the rambunctious, youthful Jonathan and the middle-aged Sam.[18] This later cartoon suggests that the nation could no longer rely on the valiant labor of preindustrial craftsmen to mend itself. Instead, other modes of representing reunion used different symbolic touchstones in an attempt to promote harmony, peace, and national progress.

## Allegories of North and South

In contrast with the popular appeal of cartoons, with their frequently broad humor, more staid allegorical depictions of the United States appeared

**THE TIME HAS COME.**

UNCLE SAM. "With this corner-stone I bury the bloody shirt, or the party. CHOOSE!"

Figure 25. Thomas Nast. "The Time Has Come," *Harper's Weekly,* July 25, 1885, 484.
Wood engraving, 6 x 4¾ in.

in traditional painting styles. Although sometimes the elevated rhetoric of these allegories made its way into the popular press—particularly in the frequently erudite political cartoons of Thomas Nast—most symbolic depictions of sectional identity and reunification were completed in the traditional medium of oil painting. Prior to the Civil War, artists developed

a visual vocabulary intended to differentiate among the various sections of the country, attributing qualities thought to inhere in the people, terrain, and character of each region. While the West was depicted as a wild and exciting land, the North was commonly known as the seat of manufacturing, and the South was represented as agrarian. Allegorical paintings from the 1850s stressed the North-South dichotomy, crystallizing a standard visual language used to signify each region's place in the national system. Immediately after the war, both painters and popular illustrators continued to use this symbolism, which clearly enforced northern dominance and industrial productive capacity. Celebratory postwar paintings stressed the continued prowess of the North, using symbols of manufacturing and commerce to contrast it with the South, apparently doomed to be stuck forever in its symbolic role as an agrarian backwater.

As the South rebuilt its transportation networks after the devastation of the war, however, the former rebel states gradually expanded their industries and followed the North's lead, with the adoption of de-skilling, labor-saving machinery; comparatively rapid transportation; and managerial strategies. Although the South's industrial development never kept pace with the North's, by the mid-1880s the southern states were producing sugar, tobacco products, textiles, furniture, and other consumer products for purchase in a nationalized marketplace. Tobacco was one of the first southern industries to be mechanized, taking off between the mid-1860s and 1880. Furniture and construction supplies were modernizing their production in the same years.[19] Cotton continued to be the major cash crop of the southern states, but innovations in labor-saving machinery now allowed textile mills to flourish there. While before the war southern cotton had been shipped to the North or the United Kingdom to be spun and worked into cloth, the expansion of southern textile mills in the postbellum period resulted in up-to-date factories with hundreds of employees.[20] Southern politicians were explicit about the need for industrial developments to challenge northern dominance. In the short-lived southern periodical The Land We Love, General David H. Hill wrote of the cotton business: "We ought to excel the North in this branch of industry; and we will be utterly inexcusable if we do not."[21] Despite many advances, until the twentieth century a majority of southern laborers continued to work in agriculture and heavy industries such as mining and logging, rather than manufacturing. But as early as 1870, when southern manufacturing production again reached its prewar levels, the North-South divide no longer adhered to a simple division between industry and agriculture.[22] Artists had to reevaluate their representations of the South, moving be-

yond this outmoded schism to embrace the complicated developments of the "New South."

Antebellum allegories of the United States tended to conform to a type exemplified by Luther Terry's *An Allegory of the North and the South*, created just three years before the outbreak of the Civil War while Terry was living and studying in Rome (fig. 26).[23] A wide-eyed Liberty draped in the American flag and topped with a Phrygian cap sits between two curvaceous daughters, each with an attribute of her region: the demurely clad North, on the right, points to an open book, while the slatternly South, at left, leans languidly on a bale of cotton. Behind the shoulders of each, the viewer sees the sources of their respective wealth and productivity—two slaves pick cotton in the South, while a serene redbrick factory and orderly clapboard "city on a hill" peek from the rolling landscape of the North. The South's side of the painting is a fascinating amalgam, with the cotton field in the background giving way to tobacco plants and an orange tree shading the toiling slaves. Terry bundles together many different forms of southern

Figure 26. Luther Terry (American, 1813–69). *An Allegory of the North and the South*, 1858. Oil on canvas, 50 x 70 in. Greenville County Museum of Art. Anonymous donor.

agriculture, disregarding accurate geography, to give a snapshot of agrarian diversity. The body of the South herself also seems hybrid, with her olive skin and kinky hair suggesting a racially mixed woman, contrasted with the auburn curls and blonde waves of Liberty and the North.

The painting clearly owes some influence to the "Four Continents" tradition of allegorical representation that flourished during the age of exploration. In these feminized personifications of the continents, difference or deviation from the norm of "Europe" was marked with stereotyped clothing and racialized physiognomy. While in Terry's painting the South's long, straight nose is of the desirable "Roman" type, her facial characteristics (small, dark eyes and black hair), as well as her relaxed pose and partial undress, mark the South as a place of sensuality and looseness.[24] The painting does not wish to alienate the South, however, but rather to corral her back into submission to Liberty. The *fasces* in Liberty's right hand was a Roman symbol of concord and strength. Earlier U.S. artists had used the *fasces* to symbolize national unity, and in Terry's painting it expresses a last hope at avoiding war.[25] Even at a time when a divisive civil war was almost certain, some artists still relied on traditional European symbols of state power and national identity to reassure viewers of solidity and centralized authority.

The sectional divisions depicted during the antebellum period in *An Allegory of the North and the South* continued to hold some resonance following the war. An Atlanta-based artist, James Moser, painted an apparently lost work, *The New South Welcoming the Nations of the Earth* (1884), which, from a contemporary description in the *Atlanta Constitution*, appears to have contained a wealth of genre detail, including bales of cotton, "modern cotton presses," the "crowded levee" of New Orleans, "Mississippi steamboats," and "high brick cotton factories," combining to celebrate the "achievements of the New South," overseen by a grinning Uncle Sam.[26] Maintaining a more traditional division between industrial North and agrarian South, Constantino Brumidi created a postwar fresco for the office of the Senate sergeant at arms, *Columbia Welcoming the South back into the Union* (1876). Using figures similar to Terry's, Brumidi presents an amicable reunion that preserves a balance between the two regions thought necessary to support the proper functioning of the reunited nation.[27]

Postwar images intended for more popular or widespread consumption continued the language of allegory but complicated and updated the symbolism that had been established before the war. Embarking on the Reconstruction era, *Frank Leslie's* published a double-page spread that repeated

the split between North and South but with modifications that heralded the South's ambitious industrial and social changes (fig. 27). The desire for a return to peace, prosperity, and sectional cooperation—whether realized in reality or only in the illustrator's imagination—is evident. The image draws some inspiration from allegorical painting, but the artist chose to do away with the more typical females and instead created an image using male citizens with whom middle-class male readers could identify. These two veterans are framed by a massive triumphal arch engraved with the seals of each state, crowned with the American eagle, and flanked by portraits of George Washington and Abraham Lincoln. The scene that is framed by the arch, headed by the word "FREEDOM," is divided by the magazine's gutter, which artificially reinforces the division between the two sides of the image. On the left, a personification of the South is recognizable by his work clothes and neckerchief, while the North is dapperly dressed, his whiskers cut in a more sophisticated manner. Nevertheless, he doffs his hat to the South as the two grasp hands over a portrait of President Andrew Johnson; the South points aloft, to "FREEDOM" and the eagle perched on the arch's keystone. The scenes behind the two figures already show more ambiguity than is evident in Terry's representation from just eight years before. In the South, we can see a bustling waterfront, a few tiny workers carrying bundles of grain, and, at the far left, a smoking factory chimney. By focusing on water transport and factory production, this artist already looked ahead to a South that participated fully in the country's manufacturing and distribution.

This rosy portrait of the South almost overshadows the North's section of the image. A factory village nestles in the low hills just to the right of Johnson's portrait; above it, a river snakes into the distance. The isolated factory village of Terry's painting, with its need for water power from the rivers of the Northeast, was already becoming an anachronism in the post–Civil War North, where wartime tooling had increased the pace of mechanization and de-skilling, leading also to more urban and coal-fed factories. Oddly then, this image represents the *North* as stuck in antebellum modes of production, while the *South* holds out a promise for the future as a center for shipping, agriculture, and manufacturing. This image suggests how the traditional representations of northern and southern regions would change in the 1870s and 1880s. The focus on rebuilding and rehabilitating the South became a major source of interest throughout these years, one that was often thought about in terms of the South's new place in the nexus of manufacturing, labor, and technological systems.

Figure 27. "Reconstruction: A Story of the Time," *Frank Leslie's Illustrated Newspaper,* February 3, 1866, 312–13. Wood engraving, 14 x 20 in.

RISE ISLAND | MASSACH | VERMONT | N.HAMPSHIRE | MAINE | M | LINNE | OREGON | CALIF. | IOWA | WISCONSIN | MISSOURI | ILLINOIS | TINSOUTH

OOM

DEC.18TH 1865

RY OF THE TIME !

*Mapping the South's Technological Systems*

This focus took place in the pages of the major northern publications and was given a variety of visual treatments, from maps and charts to scenes of civic pride and factory production. The South had no major illustrated periodicals that could rival or even challenge the hegemony of the North. Thus, the representation of the South also took on a controlling function: the North needed to document and supervise its territories and resources. At the same time, northern magazines showed interest in the growing manufacturing sectors of certain southern regions, perhaps as evidence that the South had been successfully "colonized" with an appropriate, northern idea of industrial and technical progress.

Representations of the South unfailingly featured a northern conception of how the South *should* be developing. Two maps from *Harper's Weekly*, one from during the Civil War and one from just after, demonstrate a transition from an economy based on the labor of enslaved peoples into a modernized network of rail lines and depots. Both maps are part of series profiling the southern states: the first used gradations of shading to demonstrate visually the percentage of the population that was enslaved, and the second series focused on the rehabilitation of these states and their industries after the war (figs. 28 and 29). In the series depicting slavery percentages, the counties with the highest percentage of slaves are shaded almost completely black, while the shading becomes lighter as percentages decrease. These maps visualize slavery—not the black body, but the pernicious system itself—as a creeping mass, a cancer at the heart of the South.[28] Virtuous northerners could congratulate themselves on their freedom from such a taint, admiring the pristine white North as it abutted the mottled black and gray of the Confederacy. It also reemphasized the importance of slave labor in what many northern viewers saw as an undeveloped, premodern economy.

Soon after the war, *Harper's* printed another series of maps of southern states, this time focusing on the contributions these states would make as newly reinstated members of the Union. The maps delineate not just county lines but also major towns and cities, rivers, and rail lines, and each is topped by three scenes of the state: one historical, one contemporary, and one allegorical or incorporating the state's seal. In one example, the map of Georgia, the war is expunged from the historical record; instead, the composition focuses on emancipation and the benefits it will bring through the labor of freed blacks. The narrative of Georgia history is presented as follows: Spanish explorers are shown at left establishing

Figure 28. "A Chart Map of Georgia, Showing the Percentage of Slaves in Each County," *Harper's Weekly*, December 14, 1861, cover. Wood engraving, 11¼ x 9½ in.

contact with Native Americans; in the center, a simplified version of the state seal shows a figure in Revolutionary War dress under a neoclassical structure labeled "Constitution"; at right, freed slaves toil at a busy port filled with factories, a grain elevator, steamships, and a locomotive. The right-hand scene, whose depiction of valiant, free black labor was unrealistic in the immediate postwar South, represents both an idealized present

Figure 29. "Map of Georgia," *Harper's Weekly,* May 12, 1866, 301. Wood engraving, 14 x 9½ in.

and hoped-for future in which the South's problems of race and labor are solved through northern notions of industrial progress. A report on the following page lists the population of each county and other vital statistics such as the bales of cotton produced annually, topography, principal crops, natural resources (with estimated output), major rivers, miles of railroad track and canals, and numbers of public schools.[29] All these statistics, which appeared in separate issues of the *Weekly* for many of the other former slave states, suggested the economic importance of these states for the Union, and their visual representation allowed for control over the growing network of southern technological systems. The minute details of the state report card allowed the viewer to visualize exactly where certain crops were grown and what routes various products might take to reach him. The map coupled with the description—and with the added historical and political implications of the three scenes above the map—gave the reader what felt like absolute knowledge about the state of Georgia and its utility to the Union. The idea of utility is an important one, because most notably what these maps did was to lay out the South for the northern reader, allowing him to understand how its mineral and agricultural wealth might best be exploited: in other words, why the war was fought at all, how the South could serve the North and West, and what those regions gained by sacrificing men and money to force the rebel states to return.

The recognition that the South could be an important player in the national economy had dawned fairly quickly after the war. Several southern cities were advantageously placed to be integrated within preexisting structures of transport and distribution. Only six months after the war, for instance, Richmond was already busy trying to rebuild and return to business in an attempt to exploit "the geographical position of this State . . . her contiguity to all the great Atlantic markets, and the advantages she offers, as the natural outlet to the ocean of all the pent-up wealth of the great West."[30] New Orleans, too, was seen as "the natural outlet for a large proportion of Southern trade" and "the natural gateway for the vast commerce that must at some time spring up between the United States and the Central and South American countries." Developing the network of systems that connected the growing South with the established North and with new markets in other nations, "the entire country would be enriched."[31] The historian Kevin Fox Gotham notes how New Orleans's leaders emphasized the city's important role as *both* a location with a unique, particular culture and a destination "on a global scale," whose geographical situation and diversity of industries could provide valuable links in national and international trade.[32] In a panoramic view of the city, Charles Graham

represented technological systems through a combination of bird's eye and street views (fig. 30). The composition emphasizes the city's beneficial geographical location, stressing railroads, the busy wharf on the Mississippi, and a broad road leading to Lake Pontchartrain, just visible on the horizon. This focus on the South's participation in national, not merely regional, networks of transportation was an important step in envisioning southern cities as viable parts of the Union. By using the visual vocabulary of technological systems to represent New Orleans, northern periodicals framed the South as a fully rehabilitated region boasting broad-based manufacturing and transportation connections, eligible for the same representational treatment as major cities of the North and Midwest, including New York, Boston, Chicago, and Pittsburgh.

## Progress? Representing Southern Industries

After the end of the Civil War, the Army of the Potomac undertook an inventory and valuation of seized southern goods and buildings. One of the confiscated sites was the Tredegar Iron Works in Richmond, Virginia, which had been the Confederacy's largest armory. Photographs of desolation in the postwar South by Alexander Gardner, George Barnard, and others show a land barely recognizable and uninhabitable. The Tredegar Works was one such site where ruined buildings stood in mute testament to the South's devastating losses, both human and infrastructural. The site, "always the most celebrated for the excellence and facility of production," lay unpaved and unkempt in the immediate aftermath of the war, reported *Harper's Weekly* in August 1865.[33] Two decades later, however, the *Weekly* had Charles Graham depict the Tredegar Works in full steam as a potent symbol of the phoenix-like "New South" (fig. 31). This image was part of ongoing efforts in the national press to boost southern industries after the war. The growth of southern manufacturing and infrastructure in the two decades following Appomattox was a central focus for magazine readers interested in southern technological progress.

With fiery chimneys to rival the North's industrial cities, Graham's image of Richmond's Tredegar Works relies on a confluence of visual messages. In the foreground, a middle-class couple overlooks the works from a low hill; the most dramatic part of the image is just above the space framed by their two bodies as they turn toward one another. The ironworks sit in the middle ground, their spectacular chimneys emitting violent flames and mysterious sparks, smoke that dissolves into a sky clearly rendered by a master engraver. These fires resemble alchemical scenes of the metallurgic

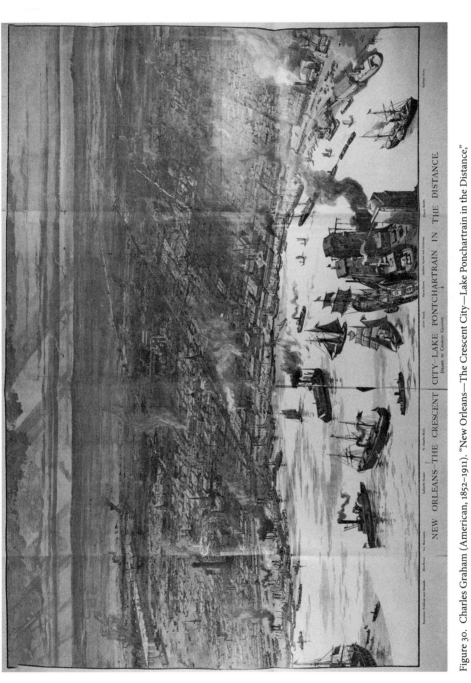

NEW ORLEANS—THE CRESCENT CITY—LAKE PONTCHARTRAIN IN THE DISTANCE
Drawn by Charles Graham

Figure 30. Charles Graham (American, 1852–1911). "New Orleans—The Crescent City—Lake Ponchartrain in the Distance," *Harper's Weekly*, December 13, 1884, supplement foldout. Wood engraving, 20 x 30 in.

SUPPLEMENT TO HARPER'S WEEKLY, JANUARY 15, 1887.

RICHMOND—THE TREDEGAR IRON-WORKS.—DRAWN BY CHARLES GRAHAM.—[SEE ARTICLE "THE INDUSTRIAL SOUTH," PAGE 42.]

Figure 31.   Charles Graham. "Richmond—The Tredegar Iron-Works," *Harper's Weekly,* January 15, 1887, supplement cover. Wood engraving, 14 x 9½ in.

industries, with their bright glow in the gloom of the night. The middle-ground train and bridge from the works across the James River reinforce the South's emergent networks of transportation systems, while the diverse strolling crowd and recently planted saplings lining the path stress an atmosphere of civic pride and renaissance. The black man at the far left of the composition, from his clothes and bundle probably identifiable as a tramp, walks significantly *away* from the scene of industry, suggesting his unwillingness to participate in the American social contract that equated work with productive citizenship. In all, the pictorial elements of this image promoted a complex message about the Tredegar Works as keyed into contemporary definitions of a productive, modern, and connected city, situated in the national matrix of technological systems.

Graham's large illustration was not an isolated image but instead formed part of a larger journalistic focus on the development of the New South. Despite continued political tensions, many northern journalists were energetic boosters who praised the great strides made by southern manufacturers and agriculturalists. The masthead of the *Harper's* supplement in which Graham's image appeared is filled by five roundels rendered like architectural relief sculptures. These vignettes trumpet the diversity of southern business, including "Manufactures," "Iron," "Tobacco," "Cotton," and "Sugar Cane." These and other industries were the focus of a large number of press illustrations and stories by literary journalists. As early as the late 1860s, northern readers were exploring the South's railways, waterways, factories, mines, and urban centers, and celebrating the successes of rebuilt facilities, some of which were already supplying their clothes, food, and furniture. Both *Harper's Weekly* and *Frank Leslie's* sent reporters to give descriptions of specific cities and factories, while *Harper's Monthly, Scientific American,* the southern industrial magazine *DeBow's Review,* and others covered southern industry in a more sporadic manner. Major northern periodicals, including *The Nation* and *Scribner's Monthly,* commissioned suites of articles on the civic, political, and industrial state of the South.[34] Illustrated series in particular were successful in bringing readers vicariously to important southern sites; the young journalist Edward King's essays for *Scribner's,* exhaustively illustrated by James Wells Champney, probably covered more ground than any other postwar series and were reprinted as a popular travel book in 1875.[35]

In 1886, *Harper's Weekly* sent a large party headed by the essayist and editorial board member Charles Dudley Warner to examine and praise "the great changes and improvements which had been made in that section of the country since the Civil War."[36] The party was invited by the

southern industrialist and entrepreneur John H. Inman and included several editorial and artistic collaborators, including Kirk Munroe, who wrote approximately half the resulting articles for the magazine. Munroe's and Warner's chatty but informational texts supplied readers with statistics, impressions, and anecdotes about specific southern regions and cities, and were almost always lavishly illustrated. The expedition benefited from the considerable artistic talents of Graham and eighteen-year-old John Durkin, an emerging artist of impressive skill. In 1912, J. Henry Harper recalled that this group found "a new and healthy life had permeated the whole frame and activity of those States, which has unquestionably made our common national life stronger and better. . . . Political differences and the friction of races were found to be yielding to the beneficent touch of healthy industrial enterprise and a fresh prosperity."[37] Industry was held up as a primary cause of successful reunion among the states.

*Harper's Weekly's* stories gave the impression of a region bursting with capital, workers, and resources. Consider, for example, Warner's description of Lynchburg, Virginia:

> An easy-going place before the war, conservative and antiquated in its business methods; the war struck out of existence most of its property, and paralyzed its industrial life. For three years it was clearing away the débris of the old civilization and laying new foundations. . . . [Now] the river slope is crowded with great warehouses and factories, large shops and handsome buildings, public and private. . . . The streets are crowded with loaded teams and thronged with life. If one wants to see what the New South is, let him get into the business whirl of this place. Everybody is at work, white and colored.[38]

Graham and Durkin both provided full-page, multi-paneled illustrations for Warner's story, Graham's giving an impression of staid civility and Durkin's showing bustling scenes of the tobacco industry. Warner also faithfully catalogued the other industries he found there: "flouring mills . . . a nail factory; a large establishment for making sashes and blinds; a furniture factory; an ice factory; a blast-furnace . . . a large bark and dye-stuff mill, an extensive and well-ordered blank-book and printing establishment."[39]

The "New South" series was probably the most concerted effort on the part of a national magazine to show its readers how the South had improved since the end of the war. In this series, southern plants for the

processing of agricultural products such as cotton (made into thread, clothing, and cottonseed oil), sugar cane (refined into granulated sugar and syrup), turpentine, and phosphates (converted into fertilizer) were getting a journalistic and apparently evenhanded treatment.[40] Illustrations like Graham's visually put southern industry on a par with production in the North. In spite of the region's uneven development, southern industrial worksites—including factories, mines, and refineries—were celebrated by the northern press as crucial components of national economic stability and growth.

### Technology and Unity at Southern Fairs

Fairs and expositions also became primary sites where the rhetoric of re-unification came into play and where the bounty of the industrializing nation could be displayed. Southern events such as the Atlanta International Cotton Exposition (1881), the New Orleans World's Industrial and Cotton Centennial (1884), and the Southern Expositions in Louisville, Kentucky (annually, 1883–1887), provided the South with chances to participate in the national spirit of reunion. These fairs offered an opportunity to represent successful reunification using the visual language of allegory. Rather than simply replicating the pomp of northern expositions, the southern fairs focused specifically on the contributions the New South could make in the realms of manufacturing, agriculture, and transportation.

The southern fairs, unlike larger national celebrations, afforded southerners their first opportunity to boast of their regional progress. Richard Nixon, secretary to the Managing Board of the 1884 New Orleans fair, wrote in the *Century* that these events provided a moment for the South to see "the gratifying result of her toil."[41] Other authors rejoiced that the fairs demonstrated the South's desire finally to do her duty as a part of the reunified nation. An author in the *Manufacturer and Builder* wrote of the pending Louisville fair in 1883 that "we heartily rejoice at this and similar evidences of enterprise from that section of our country. . . . The first great and imperative need of their section was the development of its industrial forces." The Atlanta fair of 1881 had showed, the writer continued, that "the people of the South had at length shaken off the apathy and indifference of years, and had become fully alive to the patriotic duty of developing the natural resources of their section, and of encouraging and fostering the establishment in their midst of the diversified industries that have made the North so prosperous."[42]

The idea that it was not merely desirable but *required* for the South to redeem itself through the development of manufacturing stresses how important a factor industrialization was in the imaginary of reunification. Journalists celebrated the progress made by the South in rebuilding systems destroyed by the North toward the close of the war and in developing modes of production tailored to the crops it was already growing. The Cotton Exposition lauded, in the words of one spectator, the ways southern entrepreneurs combated the "unbusiness-like and wasteful" production techniques of the antebellum period.[43] Of the New Orleans exhibition, Nixon similarly noted that southern industry had in the past been "handicapped by inferior methods and appliances," but with improved technology and an "intense desire to develop herself . . . there must come a prosperity unexcelled in history."[44] In short, both fairs trumpeted the development of southern manufactures that had been occurring steadily since the end of the war.

Fairs were also praised as sites where the problems of sectional conflict could be resolved through interaction, discussion, and profitable industrial cooperation. Thomas Nast's cartoons relating to the expositions contained some of his most positive representations of southerners. Into the late 1870s, Nast almost without fail lampooned southern characters as racist, violent, and unwilling to work toward reunion: the devious and hateful Confederate veteran, with his pointed beard, beady eyes, and angry snarl, was one of Nast's stock characters.[45] By contrast, his representations of industrial fairs contained concessions to the possibility that the South could contribute to national life, whether culturally, industrially, or politically. On the occasion of the New Orleans Cotton Centennial in 1884, he made one of his most ringing endorsements of unity in the cover illustration "On Earth Peace, Good-Will toward Men" (fig. 32). In this religiously inflected Christmas cartoon, whose title invokes the account of the birth of Christ from the gospel of Luke, Nast uses the Cotton Centennial as the setting for a joyous reunification among working men: white southerners and northerners and African Americans.[46] With the exposition building in the background, a northern worker walks happily over the threshold of a blacksmith's shop that has been decorated with mistletoe, cheerfully raising his hat in a gesture of greeting. He is faced by two men standing over an anvil—the base bearing the favorite inscription from Isaiah—who are busy beating swords into ploughshares. The freed black and southern white are shown as brothers in labor, joined by their cheery northern companion for the first time since the end of the war.

This image partakes of the spirit of the postwar southern exhibitions in its focus on unity, harmony, and cooperation. The fairs were described as places where mingling and open discussion about the past could take place without animosity between former enemies. Edward Atkinson of the *Century* wrote of the Atlanta Exhibition that it was a place where visitors could amend misapprehensions and rise above the conflicts of the past. The exhibition, he wrote, was invaluable "for the correction of errors

Figure 32.   Thomas Nast. "On Earth Peace, Good-Will toward Men," *Harper's Weekly,* December 27, 1884, cover. Wood engraving, 11 x 9 in.

of opinion on the part of citizens of the two sections of this country in regard to each other." He believed that it denoted an important shift in national consciousness when "the abolitionists of old time can here meet ex-Confederate officers of high rank, and . . . take counsel together as to the common interests and common needs of the future."[47] Nast's image holds out this hope, celebrating unity through labor as a means to address those "common needs." The smith's forge, the clothes of the men, and the slogans on the walls suggest work as one of the central ways of successfully healing the United States. "Dignity of Labor," the walls read, "Industry, Thrift, and Enterprise." President Chester Arthur is even quoted as calling for the "strengthening of the bonds of brotherhood," here envisioned as a brotherhood of working men across race and geography.[48]

However valuable this symbolic reconciliation, the key purpose of the fairs was to highlight the new machinery, managerial organization, and improved transportation that had enabled southerners to modernize. Unlike many other expositions at the time, the displays at the Atlanta International Cotton Exposition did not include many finished products, instead focusing on machinery and techniques demonstrated live by employees. Atkinson, while surprised at this irregularity, praised the unique quality of the displays, noting, "It might . . . be called an exhibition of the beginnings of new processes and for the correction of errors in old methods. . . . Might we not call it an exhibition of the potentialities of the future?"[49] This was exceptional praise considering that less than ten years earlier, the Radical Republican essayist Eugene Lawrence was still calling for the need to "raise the population of the Southern States into a higher grade of civilization."[50] The exhibition was organized rationally, including "a display of appliances used in the production of cotton, from the actual plants growing in the fields to the finished bale ready for market, and a display of textile machinery used in all the processes, from the opening of the bale up to the finished cloth."[51] The organization of the exhibition itself thus demonstrated the rational spirit of management, showing fairgoers, through displays of raw materials and machinery, the various steps necessary to go from cotton plant to finished garment. A bifurcated process, with cultivation and harvesting occurring in the South and spinning, weaving, and garment manufacture outsourced to factories in the North, became geographically unified. Processes formerly done in the North could now take place in the South due to the introduction of labor-saving machinery.

Artists' observations of this change emphasized the importance of modernity and the contrast with the past. Horace Bradley depicted a crowd of middle-class spectators looking on as two demonstrators enacted the

Figure 33.   Horace Bradley (American, 1862–96). "The Atlanta International Cotton Exposition—Spinning, Old and New Styles," *Harper's Weekly*, November 12, 1881, 756. Wood engraving, 7 x 9¼ in.

dichotomy between past and present (fig. 33). The first, an elderly woman dressed in homely garb, tends a traditional spinning wheel, while the second figure is an attractive and fashionably dressed young woman who stands controlling a bank of spools at a spinning machine so massive that it extends out of the frame to the right. Both women stand erect and alert at their tasks, but the contrast between their ages and clothing serves, just as much as the tools they use, to emphasize the break with the past granted by new technology. The choice of an older woman dressed in a conservative and outmoded manner clearly reinforces the message that the spinning wheel, symbol of home production, is a thing of the past; the future is presented as a spectacle and celebration of the possibilities of the South. This "singular contrast between the old and the new" clearly privileges the future: *Harper's Weekly* described the spinning machine as "perfect," "delicate," "noiseless," and "wonderful."[52] Bradley's presentation of this display suggests a shifting of national identity: it presents a geographical redefinition of the industrial sphere, with virtual borders redrawn to include the industrializing South.

*Coda: America as a Southern Worker*

Two months after Bradley published this image, Thomas Nast reworked it with just one of its female figures, to drive home the role of the industrialized workforce in conceptions of both the New South and the new nation (fig. 34). His dramatic cover illustration shows a young and attractive female in Phrygian cap, laurel wreath, and classical dress tending a thread spinning machine, which has clearly been copied almost directly from Bradley's composition. Above her head passes the march of time: from an exploitative white plantation owner who literally keeps his slaves under his heel ("1861") to a contemporary idyll of technological achievement ("1882") in which factories, steamboats, and railways tie the South to its northern markets. The doorway behind the young woman is ambiguous; within it, African Americans still work by hand harvesting cotton. They are presumably meant as a contrast to the crushed and debased slave above, but their labor is certainly not given the same status as that of the white woman in the foreground. This image represents the country symbolically not as a skilled worker or artisan but as a *wage laborer*. In popular media, industrial workers rarely, if ever, stood in for allegorical or symbolic concepts; when artists needed a symbolic depiction of "labor," they traditionally chose artisanal, skilled figures, not factory workers. Nast's choice to depict a female factory operative as a symbol for the industrial success of the nation as a whole (note the "U.S." monogram Nast added to the end of the machine) is surprising. It updates the tradition of using female allegories into a modern era of managerial wage capitalism and illuminates just how central modernized labor was in the imagination of post–Civil War national unity. And, in his most unorthodox move, Nast does not choose merely an industrial laborer as a symbol for the nation; he chooses a *southern* industrial laborer, a figure who, just years before, many northerners would have denied even existed.

Edward Atkinson wrote of the formerly backward South that "one of the most remarkable chapters in social and industrial history was passing almost unobserved and unrecorded," obscured by political rhetoric and minor controversies.[53] Southern progress did not go entirely unrecorded, however. The makers of images took note, and invited their viewers to do the same. On the whole, these images confronted viewers with narratives of national unity and patriotic achievement. Paintings, political cartoons, maps, and illustrations participated in a constructed account of reunification that took the triumph of technology as a central tenet of the new Union and of the rehabilitation of the South. While some im

ages continued the use of traditional allegorical imagery, others attempted to demonstrate the progress of the New South factually. The frequently statistical, objective reporting style used in many accounts of the South shows a divide beginning to appear between the visual media of high and popular arts. While fine artists, such as John Ferguson Weir, felt free to

Figure 34. Thomas Nast. "The Queen of Industry; or, The New South," *Harper's Weekly,* January 14, 1882, cover. Wood engraving, 11½ x 9½ in.

pursue individualistic and frequently magical interpretations of industry and technological systems, magazine illustrators became more strictly beholden to the calculations of profit. Particularly in the magazines with a Republican, pro-business bent, such as *Harper's Weekly,* illustrators' techniques came more and more in line with the desires of the manufacturers they depicted. In the national nexus of shipping and production, however, high artists could still be Romantics, as the career of Thomas Moran, discussed in the next chapter, shows.

*Chapter 4*

# Sugar, Shipping, and Cityscapes

Mapping Systems in Thomas Moran's *Lower Manhattan from Communipaw, New Jersey*

MANHATTAN SHIMMERS in the distance. On the middle shore, several large factories and their smokestacks loom almost in silhouette against the sky. Directly before our eyes lies a grayish wasteland of scrub grass, warehouses, and marshy inlets (fig. 35). In Thomas Moran's 1880 painting *Lower Manhattan from Communipaw, New Jersey,* these three tiers of space adhere to a typically picturesque representational system, the viewer's eye zigging and zagging from foreground to background as it lights on each area of interest. But the subject matter seems utterly foreign to Moran's typical body of work, large landscape paintings celebrating the natural beauty of the American wilderness. Why create a painting that appears to oppose everything the artist stood for? Why forsake the sublime West for a rather mundane and gritty scene of the New Jersey shore? What associations did this image call forth for its artist and its viewers? What messages about American industry did it send? The answers to these questions lead to an almost invisible network of technological systems that underlie the rather ordinary appearance of this scene. *Lower Manhattan* delves into the systems at the heart of American industrialization: railroads, shipping, and, most crucially, sugar refining. Moran's representation of the sugar refining plants of New York and New Jersey set in motion a chain of hidden associations linking the artist and his viewers to the rationalized world of

Figure 35. Thomas Moran (American, 1837–1926). *Lower Manhattan from Communipaw, New Jersey,* 1880. Oil on canvas, 25³⁄₁₆ x 45¼ in. Washington County Museum of Fine Arts, Hagerstown, Maryland.

the American manufacturing city and to an air of magic and wonder that still lingered beneath the surface.

*Lower Manhattan* depicts three tiers of space, each expressed using a different technical strategy. The foreground, which focuses on a swampy inlet housing rock quarries and a shipping depot, is constructed using a subtle but nevertheless visible matrix of small, regimented brushstrokes. Many of these, particularly the marks forming the ground and the shallows of the river, are almost exactly vertical or horizontal, creating a grid-like quality that is only evident on close inspection. The middle ground, which shows the Communipaw peninsula densely packed with factories and shipping docks, uses freer and more layered handling, allowing the paint to build up in loosely applied daubs of red, ochre, gray, and turquoise. And the background, with the island of Manhattan faintly visible to the right of the Communipaw factories, emerges vaguely but forcibly from a sky treated with creamy and pearlescent tones of gray, blue, and off-white in swirling, curled, or broad brushstrokes. A bright splash of red in the foreground draws attention to three workers who appear to be discussing a large block of stone: the man in the white shirt, taupe vest, and black hat may be a foreman, who with a single gesture directs the other workers' attention to the massive stone before them. The men inhabit an unsavory

and desolate wasteland that contrasts sharply with the shimmering, ide-
alized industrial realm across the water with its puffy clouds and thick
layering of expressive paintwork. In fact, they do not even seem to notice
the presence of the factories; they are too localized, blind to the changing
world of commerce, unaware of the invisible lines of connection humming
around them. Dozens of other figures populate this scene, too, but they are
almost illegible on the boat dock and warehouse at the right; a few dabs of
paint delineate them and their labors.

The city of New York is ghostly in the background; we see only the
outlines of three or four buildings, their silhouettes almost dematerial-
izing into the smoglike haze. The prevalence of smoke, clouds, and a hazy
sheen throughout the work may disorient the viewer at first, but a look at
modern maps can give us some idea of the overlapping planes in Moran's
painting. The viewer is standing on the swampy ground of a sheltered part
of the New Jersey shore on the north side of the Morris Canal. She is facing
almost due east across the Hudson River, with the factories of the Commu-
nipaw peninsula interposed between her and the island of Manhattan. The
southern tip of New York City lies at the right of the picture's composition;
buildings from its skyline are evident, though the factories, since closer,
stand taller and appear much more prominent.[1] Moran treats the subject
with such aestheticism that at first the many connections embedded in the
scene may not be evident to its viewers. Nevertheless, through its visual
and thematic qualities, the painting makes powerful linkages with different
geographical regions of the United States and also hints at the invisibility
and ultimate unknowability of technological systems.

This chapter examines some of Moran's beliefs and artistic practices,
the pictorial conventions of the mid to late nineteenth century, and the
specific details of the Communipaw sugar industry in order to connect
*Lower Manhattan* with larger narratives about aesthetics and industrial
systems during these years. I argue that *Lower Manhattan* is a hybrid form,
neither a straightforward look at the realities of New Jersey commerce nor
a purely "fantastic" scene of magical industry.[2] Like other images discussed
in this book, Moran's complex painting addressed the factual existence
and interconnection of technological systems while still appealing to the
picturesque or Romantic associations of its viewers. *Lower Manhattan* is
"about" the sugar industry and the shipping networks that supported it, but
it also makes claims about the beauty and fantasy possible within modern
industry. Moran's work explores the tension between the manmade and
the natural, walking a line between mundane ugliness and transcendent
beauty. His sugar refineries may be read as studies in the atmospheric

effects of smoke and steam, as examinations of the topography of a particu-
lar place, or as celebrations of American ingenuity and Manifest Destiny.
In creating a work that produces so many complex associations in viewers,
Moran participated in the contemporary uncertainty about how, visually,
to deal with industrial change and technological systems. While *Lower
Manhattan* and its subject may seem far outside the purview of an artist
known for his landscapes of mountain and canyon, I hope to demonstrate
that his brief turn to industrial scenes around 1880 was actually consistent
with several elements of Moran's artistic pedigree and philosophy.

Considering the context in which the painting was created, and look-
ing at the ways other artists portrayed the growing urban manufacturing
centers of the United States, parallels emerge between *Lower Manhattan*
and the larger realm of visual culture within which it was situated. With
the growth and expansion of urban centers, boosterist artists found ways
to express the size, location, and interrelated networks within and around
major manufacturing cities. Cities functioned in some ways like factories
writ large—the challenges of specialization and throughput were magni-
fied in the networks of rail lines, streets, rivers, and telegraph wires needed
to bring in raw materials, transport them across the city, and disseminate
products to national and international consumers. Each American indus-
trial city held within itself a microcosm of the national network of systems
while simultaneously being inextricably connected to that larger network.
In Moran's painting, viewers can trace the local systems connecting New
York and the New Jersey shore but may also see how, through the system
of sugar, these local systemic concerns were bound up with national and
international webs of commerce, often invisible to those participating at
the local level. In times of technological expansion, the world is at once
smaller, thanks to networks that speed up travel and communications,
and larger, because the goods available for purchase depend on the ex-
pending of faraway, anonymous labor.[3] The industries shown in *Lower
Manhattan* were linked to global economic and production systems. The
creeping tentacles of American imperial endeavors lay just below the sur-
face of Moran's image, its industries linked to a growing global network.
To demonstrate the invisibility yet potency of technological systems, I
examine how Moran's *Lower Manhattan* connects not only with shifts in
transportation and urban development but also with U.S. imperialism in
Latin America and the colonization of the American West. Known for his
canvases of the unspoiled wilderness, Moran seems an unlikely delineator
of technological systems. Although it is superficially divergent from his

other works, *Lower Manhattan* nevertheless retains many key elements of Moran's earlier artistic practice.

## An Artist of Contradictions

Born in 1837, Moran was a primarily self-taught painter whose family immigrated to Pennsylvania from Bolton, a cotton mill town in England, when he was seven. Although it is unlikely that Moran remembered his birthplace in such detail, his biographer Thurman Wilkins evocatively describes Bolton as "a city crowded with tall chimneys thrust against a smoke-filled sky, with dreary wastelands of furze stretching all about it."[4] Moran's informal artistic education began in Philadelphia with his apprenticeship to the engraving company Scattergood and Telfer, where he learned skills that would serve him throughout his career as an artist-illustrator. While Moran is remembered primarily as a painter, he continued working as an illustrator throughout his career and did not seem to differentiate between the prestige of painting and the popularity of print media.[5] Some scholars have credited his early training in the reproductive arts with Moran's apparent indifference to hierarchies of prestige, though he broke his apprenticeship four years short of its completion.

Another, better-documented influence on Moran's later artistic development was the growth of the aesthetic movement in America, spurred by the first U.S. publication of John Ruskin's *Modern Painters* in 1847. Moran's informal training with an American Ruskinite, James Hamilton, in Philadelphia; his presumed reading of the *Crayon* magazine, which espoused Ruskinian approaches to art and nature; and his well-documented admiration of the British artist Joseph Mallord William Turner all seem to have led to his interest in representing nature in a manner both truthful and transcendental. These influences, however, were not as straightforward as they might appear. For instance, Moran's interpretation of Turner did not toe the ideological line. Through close observation of Turner's works, Moran drew the conclusion that contemporary opinion of Turner's truthfulness to nature was mistaken. In an 1881 interview, he argued that Turner "sacrificed the literal truth of the parts to the higher truth of the whole."[6] In later years, Moran even came under criticism from Ruskin himself, who wrote several letters advising the artist how he might mend his ways and return to proper aestheticism.[7]

Art historians also give much credit to the influence of the *Crayon* on Moran's philosophical development. A journal of the arts edited by

William James Stillman and John Durand, the son of the artist Asher Brown Durand, the *Crayon* lionized the ideal of truth to nature through the study of flora, fauna, and geology, and promoted a transcendental-religious relationship to the sublime perfection of the American land. As such, it embraced Ruskinian ideals and would appear to be at odds with commerce and industry. Given the *Crayon*'s influence on the young Moran, it would appear surprising that he later developed an artistic inter-est in American manufacturing. The most common views toward industry voiced by *Crayon* contributors *were* negative. For instance, in 1857, one author produced an angry screed against what he saw as the inappropriate commercialism of U.S. society. This pessimistic view presented industry and commerce as threats to the physical and moral health of the nation: "Commerce is an idol with modern communities. . . . It is well known to be a huge complex machinery, greased by deception and propped up by chicanery; a thing without a soul, under whose crushing footsteps lie buried the ruins of many brave men, whose pure natures would not yield to its degradation."[8] Despite his romanticized ideals of a "pure" or essential mankind, the author's use of a machine metaphor to critique manufactur-ing interests shows that even contributors to a journal devoted to aestheti-cism were starting to read the world through a mechanistic lens.

The *Crayon* did even occasionally advocate for certain forms of con-sumer production as a means of self-reliance and independence from Europe. Stillman and Durand suggested that the country could not do without industry but could use the language of art to turn consumer prod-ucts into "something beautiful, and graceful, and harmonious."[9] While biographers have stressed Moran's philosophical adherence to *Crayon*-ism and Ruskinian theory, in the American context such theories were hy-brid, not unitary, and were certainly not unilaterally opposed to industrial development. Presupposition that Moran's interest in the *Crayon* would automatically cause him to reject industry leads to a dead end. Moran's approach to modern life was more flexible and forward-looking than most art historians give him credit for.

Moran's famous affinity for the wild and unsettled spaces of the West was also not without its contradictions. Although it is true that his paint-ings of Yellowstone directly influenced the congressional decision to found the National Park System, Moran's motives in traveling to the West were far from purely aesthetic. Before he had even set foot west of the Mississippi, Moran was contracted to illustrate western scenes for *Scribner's Magazine*, images he based purely on his imagination and his youthful penchant for western travelogues and adventure stories. His best-known imagery was

the result of several important trips to the West under the auspices of government and private survey parties. The first survey Moran joined was the U.S. Geological Survey of 1871, led by Ferdinand V. Hayden. Moran's place in the excursion was subsidized by assistance from Jay Cooke of the Northern Pacific Railroad, making Moran's presence explicitly commercialized from the beginning. Far from being a voyage of aesthetic discovery of the pristine wilderness, Moran's interactions with the American landscape were, from the outset, tied up with industrial interests and the expansionist ideology of Manifest Destiny.[10]

In his early thirties, Moran finally gained widespread fame for his grandiose and detailed representations of western landscapes, based on sketches made during these trips and photographs by Moran's friends and colleagues William Henry Jackson and Timothy H. O'Sullivan. Moran's best-known trilogy of western landscapes were all painted after returning from survey parties and included *The Grand Cañon of the Yellowstone* (1872), *The Chasm of the Colorado* (1873–74), and *The Mountain of the Holy Cross* (1875). Critics acclaimed these three massive works, and the first two were purchased almost immediately for the Senate chamber of the U.S. Capitol. The first to be sold, *The Grand Cañon of the Yellowstone*, went for $10,000, an unbelievably high price for a work by a relatively unknown autodidact who existed at this point on the fringes of the artistic mainstream.[11] One possible reason for Moran's almost immediate success with this new material was the unifying significance of western scenery. Following the bloody struggle of the Civil War, interest in the West rose because it allowed Americans to unify under the symbolism of a region left relatively untouched by the conflict.[12] In addition, the huge scale of canvases by Moran and Albert Bierstadt seemed to mirror the outsized natural landmarks of the West. Such size sought, in the words of Barbara Novak, to "satisfy the myth of a bigger, newer America."[13] Thus, through subject matter and scale, Moran's massive scenes represented not only hopes for future national unity but also a new style, which marked his work as substantially different from the predominantly East Coast imagery of the Hudson River School artists. The renowned editor Richard Watson Gilder called *The Grand Cañon* "a 'new departure' in art . . . something altogether fresh and daring."[14] Four years later, Gilder recalled this and other images of Moran's first Yellowstone trip, marveling that they "revealed a new wonderland" in their treatment of the West.[15]

With his first mature successes, as with his early training, the canonical narrative of Moran's career stresses aesthetic harmony and adherence to ideals of unspoiled and pure nature. The narrative of the West that was

spread through popular venues—travelogues, reproductions of Moran's paintings and sketches, and other imaginative evocations of the frontier—however, actually stressed many areas of affinity between the western wilderness and the more settled and industrialized regions of the country. The interpenetration of nature and culture found in *Lower Manhattan* first appeared in Moran's western landscapes. Visual images and popular essays on western travel constructed city and wilderness as two elements in a relationship of reciprocity.

For instance, the art historian Joni Louise Kinsey links Moran's depictions of geological formations to arches and towers, structures with important metaphorical associations: the arch was an emblem of classical civilization and the tower was a newly emergent urban form.[16] Interest in classical ruins predated Moran's journeys west, as seen in his early painting *Among the Ruins—There He Lingered* (1856). This enthusiasm resurfaced with his discovery that natural formations could vie with the great ruins of European civilization in their grandeur and ability to force the viewer to contemplate the terrible passage of time, both human and geological.[17] One review compared the cliffs in *The Grand Cañon* to cathedral spires, noting that wind and erosion "produced the most fantastic groups of wild and beautiful bluffs, buttresses and pinnacles, all bearing more or less resemblance to human architecture."[18] Moran likened the unspoiled natural world to historic ruins, forging a link between nature and artifice, wilderness and civilization.

More jarringly, Moran's scenes of steam-spewing geysers and violent canyon squalls suggested that the natural world could be just as dangerous, frightening, and likely to cause anxious neurasthenia as any sojourn on the loudest and most rackety of factory floors. Moran depicted geysers and factories using similar color schemes and treatments of light and cloud: we have only to compare Moran's *The Castle Geyser, Fire Hole Basin* with *Lower Manhattan* to note the similarity of the gushing steam (fig. 36). The white-gray steam above the sugar refineries of Communipaw blends with the clouds, shimmering like the light playing in the spray of the geyser at Fire Hole Basin. While Anne Morand argues that Moran's "images of sugar refineries, their chimneys belching smoke, form an iconographic counterpoint to the pristine wilderness," industry and nature had more in common than at first appeared.[19] Not only does Moran's visual treatment of the factories fit stylistically with some of his earlier representations of western scenery but nineteenth-century writers even made explicit connections between the geysers of the West and the industrial realm.

Figure 36. Thomas Moran. *The Castle Geyser, Fire Hole Basin*, 1872. Watercolor, 7½ x 11 in. (19.1 x 27.9 cm). Blackmore Set, no. 15. Gilcrease Museum, Tulsa, Oklahoma.

Steam, whether naturally expelled from the rocks or forced up through tall factory chimneys, was an important metaphor for the conquering thrust across the continent of steam technologies. An 1872 article by the survey leader F. V. Hayden notes of an erupting geyser, "the steam poured out in immense masses, rising in clouds a thousand feet or more in height."[20] Hayden wrote more explicitly of the intense sound and confusion of the geyser's eruption in a later article, telling the reader to "imagine a gigantic pot with a thunder-storm in its stomach, and to the noises of elemental war, add the shrieking of steam pipes and you will have a faint idea of it."[21] S. Weir Mitchell, a well-known neurologist and author, experienced similar bursts of unsettling noise and noted an even more explicit connection to industry when he wrote of the eruption of Old Faithful. It expelled "the exhaust of a steam-engine, and near it from the earth [came] the rattle and crash and buzz and whirring of a cotton-mill."[22] The thunderous and disturbing quality of these impressions suggests an imagined parity between geysers and factories that subtly emerges in Moran's

work. Such mechanistic metaphors seem at odds with our view of Moran the Ruskin-reading *Crayon* acolyte. It is evident, however, that not only Moran but also the culture at large had little problem reconciling the natural and the manmade, even in the vast lands of the West. This interest in machines, factories, and steam may have been one way of expressing the dogma of American exceptionalism using the material that best fit that ideology—the spectacular size and grandeur of the West. But satisfyingly "American" artistic material could be found throughout the continent, as several disgruntled critics argued in their battle to overcome the artistic stranglehold of Europe.

## *Toward an "American" Paradigm*

During the 1870s and 1880s, artists in the United States were struggling to find a new and uniquely "American" paradigm to counteract the influence of European art, which U.S. critics often characterized as feminized. Art critics called for canvases representing a supposedly shared national character, a new way of understanding how the nation could or should be imagined. As J. M. Mancini stresses, "Americans *were* insecure about their culture" in the post–Civil War period, and this emerged in an aggressively heightened rhetoric of American masculinity.[23] For instance, in a *Princeton Review* essay of 1878, John Ferguson Weir called for a manly American art to overcome the "pretty little superficial elaborations" by imitators of European styles that "filled the public eye and gratified the popular taste."[24] Weir did not disclose specific subjects to pursue, though some critics did explicitly argue that the nation could be represented best by the contemporary landscape of factories and smokestacks. One such enthusiast was the journalist and artist William Mackay Laffan, who wrote in 1879 that "there shall be more joy over one honest and sincere American horse-pond, over one truthful and dirty tenement, over one unaffected sugar-refinery, or over one vulgar but unostentatious coal-wharf, than there shall be over . . . all the rest of the holy conventionalities and orthodox bosh that have gone to gladden the heart of the auctioneer and deprave American artists."[25]

Laffan championed traits of sincerity and truthfulness over the "bosh" produced by artists wishing to emulate Europeans. Laffan was a friend of Moran and his wife, Mary, from at least 1879 onward, when all three were members of an informal group of New York–based artists, the Tile Club.[26] Laffan's mention of sugar refineries suggests that in his outline of desirable subject matter for distinctly American art, he may have been thinking

explicitly of *After a Thaw—Communipaw Ferry.* This was a small 1879 work on the same subject Moran would address with greater complexity in *Lower Manhattan* the following year. *After a Thaw* inspired a critic at the *New York Sun* to praise Moran as a rare specimen of those artists who were both brave and truthful enough to turn away from European subjects: "Unfortunately the chief ambition of artists has long been for Brittany skies or Mediterranean waters, and few have had the vocation to look about them at home and near them." Such local subject matter, the reviewer continued, could not help but produce the "truest and worthiest" of compositions, and patriots should be thankful "for every instance of which that is produced by an American artist." His list of potentially desirable subjects, longer and more detailed than Laffan's, called for works showcasing "the factories, the great chimney stacks, the piles of mere brick and mortar, the roofs and sheds, the railroads, the wharves and ships, the whole apparatus of daily, uneventful toil . . . these things that smoke and emit the dull monotone of labor."[27] Such a call was not truly answered until the early twentieth century, though Moran came as close as any to satisfying it.

All these critics supported a nationalistic approach to art, which would discover valiant, new, and typically "American" subject matter that could set artistic production in the United States apart from that in Europe. By specifically coding U.S. art as masculine, these authors set up a heroic paradigm for American painters, which could be achieved by focusing on social realism, industry, and the excitement and grit of the urban setting. It was on this subject that Moran somewhat uncharacteristically commented later in life, writing in 1902 that Americans "seem to devote themselves to imitations of foreign masters" instead of "seeking their subjects and inspiration in their own land and applying their technical skill in the production of works national in character." As to the future of American art, Moran continued, "Before America can pretend to a position in the world of art it will have to prove it through a characteristic nationality in its art, and our artists can do this only by painting their own country."[28]

It was in this atmosphere of artistic nationalism that Moran turned away from painting the wilds of the West to an almost obsessive, though brief, period spent sketching and painting the industrialized area around America's greatest metropolis, not far from where Moran had his studio. In 1870, the Moran family had relocated from Philadelphia to Newark, New Jersey. Although it took almost ten years after moving for him to pay much artistic attention to his surroundings, from 1879 through 1884 Moran created oils, watercolors, etchings, and sketches of the factories and sugar

refineries of New Jersey and New York City, with a focus on the manufac-
turing town of Communipaw. *After a Thaw* was his first oil on the subject,
and reviewers applauded it enthusiastically when it was first shown at the
National Academy of Design (NAD) in 1879. In contrast with his failed
historical landscape *Ponce de Leon in Florida,* displayed just across the
room at the NAD, critics professed great enthusiasm for *After a Thaw* with
its local character and lack of pretense or bombast. Perhaps prompted by
the overall rejection of *Ponce de Leon,* the last hurrah of large-scale Ameri-
can history painting, Moran's style became more understated, delicate,
and harmonious just as he began experimenting with industrial imagery.
Like *After a Thaw,* critics gave *Lower Manhattan* positive reviews, such as
one that praised its "mystery of smoke and steam."[29] Reviewers enjoyed
the works but struggled to make sense of how Moran transformed such
unappealing material as "oozy flats near Brooklyn" into a composition of
quiet beauty and grandeur.[30]

Biographers and art historians have not done a convincing job of ex-
plaining why Moran should turn to this subject matter, tending to ignore
or gloss over his brief focus on industry. Moran himself did not leave much
of a paper trail, merely commenting that these works demonstrated his
interest in creative experimentation: "My pictures vary so much that even
artists who are good judges do not recognize them from year to year. Two
years ago I sent to the National Academy Exhibition some gray pictures,
altogether unlike my previous work."[31] But Moran does nothing to explain
the shift. I suggest two important and interrelated possibilities—economics
and interest in the exploration of contrasts. In terms of profitability, rep-
resentations of the New Jersey area seemed to appeal to Moran's patrons;
after barely a decade in the spotlight, his operatic, western style was al-
ready passing out of fashion, replaced by a vogue for smaller and more
intimate works. Although Moran lamented the commercialization of art in
the United States, complaining that "the bane of American art is that our
artists paint for money," he later confided to the *Denver Rocky Mountain
News* that "the Eastern people don't appreciate the grand scenery of the
Rockies. . . . It is much easier to sell a picture of a Long Island swamp than
the grandest picture of Colorado."[32] It seems that despite his philosophi-
cal objections, monetary success was in fact an important component of
Moran's artistic reckoning, and he may have viewed the industrial canvases
as a chance to exploit a new market of industrialists.[33]

My second proposition is that though Moran *was* an adherent of aes-
thetic theory, he had long shown an interest in exploring the relationship
between manmade and natural landscapes, and of the artificiality inherent

within those "natural" landscapes. Thomas S. Fern notes how the artist's sketches reveal a duality between fact and feeling, specifics and sensation, writing, "To reveal the essence of his subject, he maneuvered the elements in his landscapes until they expressed the right feelings. And when he did it well, he never lost touch with the visual truth, the plausible appearance of the place."[34] What Fern argues here is essential to understanding the dynamics of *Lower Manhattan:* Moran's works held within them a simultaneous urge toward two kinds of truth, the factual and the ineffable. *Lower Manhattan* points us to some answers to what it might have meant for an artist to make a scene of industry that used the visual language of *both* the factual and the picturesque, that embeds within itself *both* the idea of interconnected, systemic development and the more irrational side of industry.

## Painting the Picturesque

Communipaw was renowned for manufacturing; one local wrote in the *Newark Courier* of the city's "gigantic industries" and "black forest of smoking chimneys," effects Moran rendered in some of his sketches.[35] In particular, it was home to industries of sugar refining, butchering, glass, and pottery, and continues to house many companies first based there after the Civil War, including Dixon pencils, Colgate, and Lorillard Tobacco.[36] The periodical press had occasionally attacked the area as unsavory and polluted, yet Moran's images largely bypass any obviously negative elements. *Lower Manhattan* depicts the junk heaps, warehouses, and sludgy swamps of New Jersey in an aestheticized manner, with the ethereal smokestacks of sugar refineries and the skyline of New York City rising in the background. While *Lower Manhattan* utilizes the same expressive clouds and attention to natural details that characterized Moran's images of Yellowstone, the piece seems to mark a turning point in Moran's style. For the first time in his artistic career, reviewers praised not his oversized gestures and saturated colors but the "exquisitely delicate painting" technique and the "soft, tender" rendering of everyday life.[37] Such adjectives were rarely used to refer to Moran's earlier work, which was more likely to be described as spectacular though crude. It took the ugliness of Communipaw's waste dumps, not the airy majesty of Colorado's mountains, to make Moran a mature artist. Part of this growing maturity was Moran's increasingly sensitive and nuanced deployment of picturesque visual structures and the ability to understand the picturesque as a complex category that could be applied to an industrial scene.

The idea of the picturesque was one of several overlapping concepts used in the art world of the nineteenth century, whose members judged pictures using a variety of perceptual or experiential structures. Picturesque scenes were those that contained "irregularity of form, rough texture, [and] pleasing variety," which would arouse "curiosity and interest" in the viewer.[38] It took as one of its key models the work of the French landscape painter Claude Lorrain and was a category that should affect viewers with feelings of absorption and balance, though it could also excite interest through imperfection and irregularity. The picturesque served as an early model for Moran; the young artist traveled to England in 1861 to study the works of Claude, Turner, and John Constable in London's National Gallery.[39] The vogue for the picturesque had rather odd consequences within the worlds of art and tourism. Within artistic circles, it could lead to stagnation and lack of creativity as artists strove to fit their landscapes into a rigidly structured paradigm. In the realm of nature tourism, the picturesque had the paradoxical effect of forcing viewers to try and fit actual landscapes into their artistic notions of proper picturesqueness. Rebecca Bedell highlights the absurdity of this situation: viewers would now approach *actual* nature "by mentally composing it into pictures resembling well-known works by such artists as Claude Lorrain. . . . Was the image well framed? was the composition balanced? were the colors harmonious?"[40] Moran's early work certainly fit closely within this category, as might be expected from his youthful interest in Claude, Turner, and Constable. I argue, however, that a nineteenth-century shift in expectations allowed industry increasingly to be seen as compatible with picturesqueness, and that Moran captured this shifting, hybrid new picturesque mode in his industrial scenes.

Deploying the picturesque in an industrial image was a relatively new concept and could be somewhat tricky for artists to achieve successfully. Earlier in the century, British artists wishing to soften the effects of the Industrial Revolution had adopted the picturesque mode. It is likely that in his integration of picturesque elements into the urban industrial milieu, Moran relied on precedents from some of his artistic heroes. For instance, the art historians Caroline Arscott, Griselda Pollock, and Janet Wolff argue that Turner's early cityscapes merged picturesque elements of composition and subject matter with "a highly specific and knowable centre of a diversity of industrial activities."[41] In the American context, artists adopted the picturesque as a safe and ultimately unitary category that could instill in viewers a sense of comfortable pride in their nation. A collection of picturesque scenes from across the country was the basis for an artistic project, *Picturesque America*, resulting in two popular gift volumes packed

with illustrations. In her history of the publication, the art historian Sue Rainey notes that volume 2 of *Picturesque America* began to incorporate factories and mills as long as they were placed in semirural surroundings and did not include close-range examination of machine parts or those who handled them.[42]

Consonant with this new looseness in the definition of the category, reviewers often chose not to comment directly on *Lower Manhattan's* subject, focusing instead on the artist's adherence to picturesque conventions. For instance, the art critic Earl Shinn, writing under the pseudonym Edward Strahan, wrote, "Of picturesque elements existing on every hand without limit, those embraced in a view of Jersey City across the Morris Canal appear in a picture characterized by some of Thomas Moran's best qualities. It is a gray day . . . but the poetry of the air makes itself felt along that artificial water-course, about the depots beyond, and among those common scenes of commercial industry in a manner which the artist has perhaps never so forcibly realized before."[43] Reviews of *After a Thaw* and *Lower Manhattan* continually referenced the picturesque qualities of the scenes.

These reactions to Moran's industrial work include an insistence—surprising to the twenty-first-century viewer conditioned to think of factories as the epitome of unnatural sites—that scenes of industry could be pleasing in the same way as more traditional landscapes.[44] Despite how its subject matter may appear to current viewers, the stillness of the Communipaw scene; its removal from the actual factory site; its composition of orderly, receding space flanked by complementary but asymmetrical foreground elements; and the dramatic but light treatment of clouds and sky would place it squarely within the realm of the picturesque. Overwhelmingly positive reviews of *After a Thaw* and *Lower Manhattan* suggest that viewers were more than willing to accept industry as a part of the scenic American landscape. Shinn saw the refineries of *After a Thaw* as a "silver dazzle of sugar-baking palaces," while the *Atlantic Monthly* wrote of a "very luminous, pearly view towards New York across a surface of New Jersey shore, full of sparkling shallows," whose elements "lend themselves to the picturesque purpose easily."[45] Viewers were mesmerized and enchanted by the new forms of "dazzling" or "luminous" urban industry.

In 1880, the Hudson River seen in Moran's painting had been a touchstone for the picturesque for more than four decades. This iconic region changed and industrialized during these years, and according to Kenneth W. Maddox, late-nineteenth-century writers focused on the Hudson's "commercial activity" just as much as the "scenic beauty of the

landscape."[46] Robert Walter Weir seems to have assimilated these changes into his work by 1878 when he painted a similarly picturesque composition of New Jersey industry, *The Hudson River from Hoboken,* a scene on a waterfront only a couple of miles north of Communipaw (fig. 37). Taken at twilight, this view retains picturesque elements, such as the vibrant pink sky and dusky buildings on the opposite shore. Like Moran's image, how-

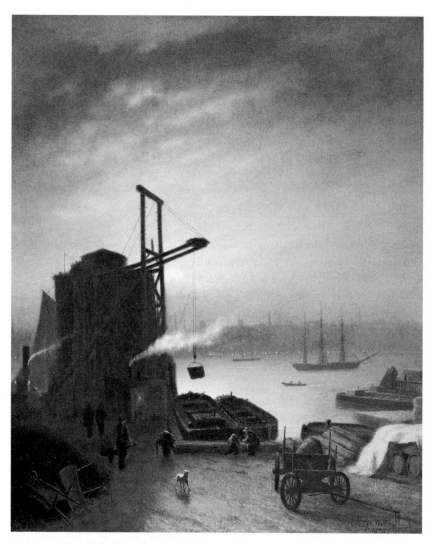

Figure 37.   Robert Walter Weir (American, 1803–89). *The Hudson River from Hoboken,* 1878.
Oil on panel, 30 x 25 in. Detroit Institute of Arts. Founders Society Purchase, Activities
Committee Fund / Bridgeman Images.

ever, the foreground depicts a more desolate scene. Silhouetted dramatically against the sky is a massive weighted crane of the type used to load ships. Nearby are two empty barges and some of the typical detritus of waterfront activities, including an empty wheelbarrow, horse cart, stacked barrels and lumber, and other evidence of shipping. This bold and modern composition highlights the rapid changes experienced in a single region of the country. Compared with the natural landscapes of the Hudson River School, Weir's interpretation of the picturesque demonstrates that in a period of less than forty years, the conceptualization of the Hudson River changed drastically. From its earlier depiction as a haven for nature tourists and transcendentalists—a business, but not an industry—the *idea* of the Hudson River had transformed into a center of industry and shipping.[47]

This notion that the idea of a place may be shaped by an accrual of references or implied connections relates to an influential theory of viewing defined by the Scotsman Archibald Alison in the late eighteenth century: that of association. Associationism is not a category of representation like sublimity or picturesqueness; rather, it is a theory of how the mind interprets and enjoys the impressions received through those visual strategies.[48] Associationism may be fruitfully applied to the picturesque mode through the operation of the viewer's memory, which forms "a train of thought" that swells out from details within the picture, creating linkages through iconographic symbols, personal observations or memories, and historical and literary references, and facilitates a fuller, richer, and personal reaction to a painting that is still framed by historical context.[49] Association allows the viewer to have an aesthetic experience that is based on building blocks of culturally specific knowledge. One key association that might have occurred to nineteenth-century viewers as they stood in front of Moran's commanding composition was the genre of popularly distributed cityscapes. *Lower Manhattan* bears certain resemblances to these cartographic or maplike views that were becoming common in the postwar United States. Moran's painting and the more popular engraved or lithographed cityscapes conform to the visual structures of what Albert Boime has termed the "magisterial gaze" in American painting.

## A "Preference for the Factual"

Beyond the Hudson River of Moran's and Weir's work, other regions of the country were developing similar industrial infrastructures, and artists found methods for representing these changes through what the art historian Marianne Doezema has called "an American preference for the

factual."[50] The city as an entity, especially the manufacturing city, was taking new form during these years. Often sponsored by local chambers of commerce or industrial leaders, lithographs and engravings expressed the geographical, topographical, and systemic peculiarities of America's great manufacturing centers. When it came to representing the urban scene, these reproducible images frequently utilized semi-cartographic techniques, tempting viewers to participate in exciting modern developments through apparently factual or neutral representations. The city view allowed illustrators to map out how systems interacted in specific parts of the country. These scenes were published in popular magazines or could be purchased by individuals as souvenirs. Lithographs were increasingly commissioned as publicity images for local industry and "placarded in railway waiting rooms, hotels, and other places of public resort."[51] The encyclopedic depiction of American cities testifies to a booster ideology and demonstrates an accompanying interest in precise recording of the fabric of urban spaces. City panoramas offered the city as part of a larger, interlinked network *and* as a miniature system itself, with factories as nodal points.

Whether large-format chromolithographs for public display or smaller engravings for publication in popular magazines, most of these images were intended for the mass dissemination of pro-business messages. Images tended to focus on emerging urban centers such as Cincinnati, Columbus, Chicago, Detroit, San Francisco, and Minneapolis as crucial locations where multiple systems converged. City views offered a way for spectators to pin down the location of important buildings and transportation conduits. In illustrated magazines, these were often minutely labeled with points of interest, whetting viewers' desire for "informational content."[52] This mode allowed artists to represent the system stripped of extraneous information, often omitting the human figure in an act of "symbolic depopulating."[53] While it made systems appear more legible and technical, such a strategy could also highlight the central tension of this book: when artists remove the people who make them work, technological systems appear to acquire a kind of autonomy. Charles Graham's foldout of New Orleans, discussed in chapter 3, provides the viewer with a powerful sense of being in motion over the city and the shifting perspectives that motion would give (see fig. 30). This skewed perspective heightens as the main avenues recede into incredibly deep space, while farther areas are seen almost as from above. The map highlights important buildings but is more concerned with the general layout of the city. Images like this bring a whole city under the viewer's scrutiny; they offer the scene to him

for surveillance and command, hinting at the interconnected highways of road, rail, and water that linked many regions of the United States. Here a virtual map of technological systems is displayed for comprehension and digestion; the links between the different areas of the city, and between this city and other urban areas, are made explicit.

The viewer is given a feeling of power, as if he is one of the manufacturing magnates or shipping tycoons who built the industrial structures seen. Such images were used to give viewers a vicarious journey to whatever city was being profiled; however, the essence of this type of imagery lies in the feeling of power it gives to a spectator who in reality is more likely to be a pawn within technology's vast and complex systems. Albert Boime has described such a surveying placement within the landscape, a subject position that emphasizes control and power, particularly over the land, and by extension promotes various forms of Manifest Destiny.[54] The *feeling* of power, control, and knowledge this gaze grants were important motivators for viewers, though such impressions were likely more illusory or misleading than Boime suggests. That feeling allowed ordinary Americans to try their hands at connecting the nodes of industrial and technological systems dispersed across the continent.

One of the most important technological systems to which many viewers could relate quite directly was the vast transportation nexus of American commerce. The ships docked at the Communipaw ferry terminal in *Lower Manhattan* suggest a connection with larger systemic networks. Communipaw was at this time in the process of becoming a major shipping center and lay only a brief ferry ride away from the New York docks, an even more important center of transportation and distribution. The Communipaw ferry dock was directly adjacent to a major terminal of the Central Railroad of New Jersey, completed in 1864.[55] In the right foreground, Moran includes a warehouse and a large crane for loading merchandise onto ships, and also implies the busy New York harbor in the background. The importance of the area Moran depicts in the burgeoning system of national and international shipping and distribution cannot be underestimated. His reference to the New York waterfront drove home the message of New York's centrality as a market for both incoming and outgoing products.

This traffic in commodities is emphasized in a *Harper's Weekly* composition illustrating a "map of the world . . . showing the geographical relationship of New York and the rest of the universe" (fig. 38). The map's composition forces the artist to cut out South Asia completely, with no indication that any countries exist between China and the Arabian

peninsula. New York is placed at the center, and by the map's somewhat misleading logic, "the reader will perceive that we are really in the centre of the universe, the 'half-way' house between either extreme of the same continent. . . . An examination of the map will suggest . . . that the present metropolis of the United States is destined to be the commercial centre of the world." By placing the United States at the center of the map, the artist reorients the traditional east-west binary in an American-centric fashion: the map is "showing at a glance the relation which New York bears in regard to distance and geographical position with the great commercial cities of *our* East, Europe, and West, Asia."[56] Reimagining the globe to suit New York by defining Europe as "*our* East" and Asia as "[our] West" powerfully dislocates centuries of learned cartographic relations, replacing them with a new conception of how the world is structured. The map also gives a schematic outline of the systems that linked New York with the rest of the world. Certain key relations—specifically those with East Asia—are emphasized, while other established trade networks, such as those with France, are left out. Britain (as the model to emulate), and the Caribbean, South America, and East Asia (as the Others ready to be dominated by the United States) are the prime locations featured in this conceptualization of New York's place in the world. The ships docked in the middle ground of *Lower Manhattan* thus contribute to a visual language of shipping and communication that centered around New York City and its environs in the decades following the Civil War.

Beyond its connection with shipping, the water in *Lower Manhattan* can be read in a different way: looking across the Hudson River from Communipaw, the city of Manhattan shines airily, bathed in a silvery glow. The viewer of the work is grounded solidly on the New Jersey waterfront but hopes, perhaps, to cross to the gleaming city beyond. In fact, when read from foreground to background, the scene implies just such a journey: the viewer crosses the calm, glassy water to the place where water and sky, cloud and building, become one. The city in the background is a place of desire, the preferred destination of the viewer, who transcends the materiality of the watery divide in an effort to reach the skyline. When and if we achieve this, we have, as Bryan J. Wolf puts it, "traveled only with our eyes."[57] This mode of imagined travel was celebrated as picturesque by E. L. Magoon in an essay on "Scenery and Mind," in which he claimed that the highest modes of transcendence are to be found "wherever thought is accustomed with unimpeded wing to soar from plains, or traverse opening vistas through towering hills, that it may hover over the azure waste of waters becalmed."[58] Throughout his career, Moran consistently explored

the possibilities of using water as a visual medium of transit. On one sketching trip to central Pennsylvania in 1865, he completed forty sketches, almost all of which contained representations of water.[59] One of his earliest major paintings, *Slave Hunt, Dismal Swamp* (1862), shows water more explicitly in terms of escape. This painting depicts a slave family fleeing through a murky pool in the lush green swamp, the opaque water tracing a narrative of hope and liberation. David Lubin discusses the relationship between water and emancipation, citing antebellum references to water in illustrations for Harriet Beecher Stowe's abolitionist novel *Uncle Tom's Cabin*.[60] In Moran's work, water often seems to signify a more incorporeal form of freedom, representing the ability of the viewer's eye to roam over landscapes in ways the body would not be able to do. Thus, while Anne Morand sees the expanse of water in *Lower Manhattan* as a "psychological barrier" between the viewer and the sugar refineries on the opposite shore, I interpret it in a more positive light. Rather than "expanses of water that distance the signs of industry from the viewer," I see Moran's vivid rendering of the river as an invitation to approach the far shore through an act of incorporeal traverse.[61] In this context, industrial sites are powerfully positive places that the viewer may grasp through the desire of a disembodied eye, participating in an "annihilation of space and time."[62]

A similar representational technique is used in the "Bird's-Eye View of the Pacific Railroad, from Chicago to San Francisco," an image from *Harper's Monthly* accompanying an article about the wealth of California and the increased ease of reaching the West Coast (fig. 39). A journey across the continent, which would have taken months at the beginning of the century, could now be completed in a few days. This illustration gives the viewer almost the entire western United States in a skewed combination of perspectives. The area around Chicago is carefully delineated, maplike, stressing the north-south axis of the city; the rail lines leading in or out of the city are carefully labeled. Far in the distance, San Francisco and Sacramento can be seen like minute El Dorados shimmering in a desert mirage. Although its perspective is fanciful and its geography not entirely accurate, this composition underscores the importance of "informational content" for viewers. It visually enacts the shrinking of the United States made possible by the development of the railroad. Thousands of miles could be grasped all at once, even down to the major mountain landmarks that might be passed on the journey. As if to emphasize this epic trip into the West, the sun is directly ahead, preparing to sink into the Pacific Ocean. Technological systems, disposed before the viewer in plain black and white lines stretching across the continent, made possible this vista

344

Figure 38. "Commercial and Geographical Relation of New York to Europe and Asia, with Views of Hong Kong, Honolulu, Aspinwall, Panama, and on the Pacific Railroad," *Harper's Weekly,* May 30, 1868, 544–45. Wood engraving, 14 x 20 in.

[Ⓕ BY R. B. LIVINGSTON.]

PANAMA, NEW GRANADA, CENTRAL AMERICA.

sing in population and developing in neral commerce, manufactures, and agriⓕⓔⓓ, it is becoming apparent that the ⓕ coast must soon become ours, thus exⓕⓔⓕⓝal territory. The immigration to the

Pacific coast of the United States from China and India bids fair to rival that to its Eastern borders from Europe; and at this moment there are 10,000 Chinese laborers actively engaged on the Pacific Railroad in bringing their country nearer to our own. In

two years more, it is safe to say, New York will be within 26 days of Hong Kong, thus establishing a route for trade and travel shorter by more than a fortnight than the swiftest route now existing, that by way of Aspinwall and Panama.

In view of the increasing importance of our new diplomatic arrangements and the revolutionizing of our commercial relations with China and the East, we have given on this page an outline map of a portion of the world, showing at a glance the relation

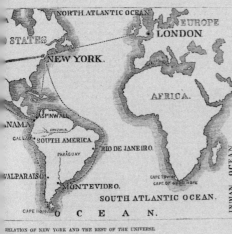

RELATION OF NEW YORK AND THE REST OF THE UNIVERSE.

SURVEYING FOR THE CENTRAL PACIFIC RAILROAD IN HUMBOLDT PASS.

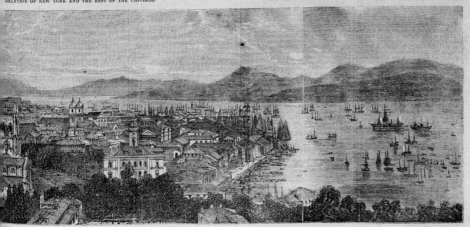

OF HONG KONG, HONOLULU, ASPINWALL, PANAMA, AND ON THE PACIFIC RAILROAD.

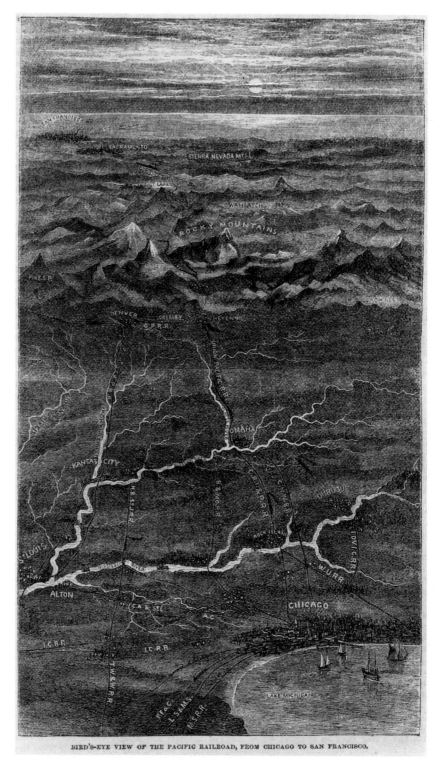

BIRD'S-EYE VIEW OF THE PACIFIC RAILROAD, FROM CHICAGO TO SAN FRANCISCO.

Figure 39. "Bird's-Eye View of the Pacific Railroad, from Chicago to San Francisco," *Harper's New Monthly Magazine,* May 1872, 867. Wood engraving, 7½ x 4½ in.

and this collapse of time and space. The depiction of urban scenes was intended to give the viewer a powerful position, one that enabled him to grasp vast and complex networks of technological systems, to survey and, at last, to understand the interconnected American continent.

## The System of Sugar

This interconnection was nowhere more evident than in the industry depicted in *Lower Manhattan:* sugar refining. The refineries in *Lower Manhattan* implicate the United States in a broader network, that of imperialistic projects on its own soil and abroad. This particular industry was related both to the desecration of the American landscape and to the increasingly successful imperialist thrust of the United States into Central America and the Caribbean. Both these issues are crucial to Communipaw and the greater Manhattan area, whose refineries supplied half of the nation's sugar by the 1880s.[63] Thirteen years after Moran's painting was completed, Moses King could write nonchalantly of the New York–New Jersey sugar industry that "no other single local industry begins to compare in magnitude or importance with that of sugar refining."[64] By the late nineteenth century, many American consumers took sugar for granted; it was a basic commodity that most used every day. Postwar Americans considered easy availability of sugar almost a birthright, something no advanced nation would do without. Writing in this vein, R. R. Bowker noted in *Harper's Monthly* in 1886, "It is almost impossible in these days of 'sweetness and light,' when the comfort and prosperity of a people are fairly tested by its consumption of sugar *per capita* . . . to imagine a sugarless world."[65] Despite earlier attempts by radical "free produce" abolitionists to boycott slave-grown sugar, by the postwar period it seems few Americans were giving a thought to the pedigree of cane sugar.[66] In his article, for instance, Bowker mentioned only American cane plantations employing freedmen, despite the fact that a majority of sugar sold in the United States was harvested elsewhere.[67] In the popular consciousness, sugar was no longer, as prominent black abolitionist Henry Highland Garnet had declared in 1851, a commodity "spread with the sweat of the slaves, sprinkled with their tears, and fanned by their sighs."[68] Rather, American appreciation of sugar in Moran's day involved a systematic forgetting of the often brutal conditions under which sugar was still produced on Cuban and Hawai'ian plantations. It is likely that even the parts of the sugar system based within the United States were largely invisible to those who lived beyond the range of the smoking refinery chimneys that "nearly encircled" lower Manhattan by 1856.[69]

Historically sugar had been, and continued to be in 1880, a key commodity that drove the early modern world economy and perpetuated its inequalities. The potential profitability of the Atlantic sugar trade was a primary motivator for European colonization in the West Indies, leading to the rise of the triangular trade. Western culture's "need" for sugar had been responsible for initiating and perpetuating slavery in the Americas, and at the time of Moran's effortlessly aestheticized painting, the industry remained complicit with continued slave systems in regions of Latin America.[70] In addition, according to the researches of the anthropologist Sidney W. Mintz, the increasing availability of inexpensive refined sugar in eighteenth-century Europe fueled the industrial revolution by providing a new, high-caloric diet to the working class.[71] An infinitely regressive loop of historical and industrial development springs to the surface in Moran's scene of sugar, shipping, and cityscapes: more shipping enabling more sugar production leads to greater industrial productivity from better-fed workers, leading to the need for more shipping, which can handle more sugar production, and so forth. It is not just Moran's painting that is built on the system of sugar. If we agree with Mintz, the whole of modern life, its industrial triumphs and its travails of inequality alike, were founded on a granular white substance we could no longer live without.

Already in 1880 sugar was recognized as a necessity, a hallmark of the industrialized nation, and an immense, systemic commodity. Moses King noticed something of this when he described the output of the American Sugar Refining Company in terms of its "collateral industries," which were both "vast and varied."[72] Corollary trades included barrel cooperage, the processing of animal charcoal for sugar purification (discussed below), coal for fueling the refineries, and transportation networks including trucks, trains, and ships. The historians Sara B. Pritchard and Thomas Zeller have analyzed the ways these systems were naturalized and obscured during the height of cane sugar production in the nineteenth century, noting that the details mentioned by King, as well as the considerable human toll of the sugar industry, were "all but invisible to the consumers of sugar thousands of miles away."[73] Moran's painting with its air of aestheticized and rarefied industry abetted this naturalization, but it is possible for the twenty-first-century viewer to pull out some of the contemporary references—both obvious and more deeply hidden—that viewers of *Lower Manhattan* might have associated with Moran's subject matter, New York's sugar refineries.

Sugar came from the Caribbean, specifically Cuba, about 80 percent of whose sugar crop was purchased by the United States at this time.[74] The historians Edwin G. Burrows and Mike Wallace estimate that by the end

of the nineteenth century, $350 million of American money was invested in Cuba, supporting U.S. interests in the mining, tobacco, and cane sugar farming industries.[75] As early as 1859, Cuba was one of America's most important trading partners, with a balance of trade exceeding that between the United States and France.[76] Beginning during the administration of President James K. Polk and continuing into the 1860s, American politicians debated the potential annexation of Cuba, a proposal many elite Cuban planters supported. Although this proposition had somewhat soured (on both sides) by the end of the Civil War, Cuba remained an important economic partner for the United States.[77]

American interest in acquiring Cuba was demonstrated in a cartoon by Frank Henry Temple Bellew showing the violent separation of Cuba from Spanish rule, foreshadowing the conflicts of the Spanish-American War (fig. 40). The primary motives for the proposed acquisition of Cuba, "in obedience to the laws of manifest destiny," were control over a number of important and lucrative commodities and the possibility to outmaneuver foreign powers.[78] Bellew's cartoon depicts Uncle Sam, dressed as a *vaquero* or ranchhand, using a threatening machete to cut off the tail of a weeping, shorn lion. With the loss of Mexico, Peru, and "Chili," which lie as if chopped from his luxuriant mane/main, the Spanish Lion suffers the final insult: forcible takeover of Cuba by the United States. This cartoon was primarily speculative and humorous, but the strategic importance of Cuba was stressed again and again in popular media. The connection between Cuba and sugar—and the fact that much of the sugar refined and sold in the United States had its origins in that island—clearly linked Moran's painting with American hopes for Manifest Destiny in the Caribbean and even Central and South America. Sugar was an encouraging symbol of American hemispherical domination and progress, promoting a new Manifest Destiny southward.

The sugar that did not come from Cuba was most likely from Louisiana. For climatological and soil reasons, the area suitable for sugar cultivation was restricted mainly to the Mississippi Delta and the coast of the Gulf of Mexico. Sugar had been one of the most profitable crops for southern planters before the Civil War, with antebellum sugar harvesting using many methods typically associated with later industrial production.[79] An image by A. R. Waud demonstrates that southern sugar cultivation had remained similar in structure to its antebellum precedents (fig. 41). The illustration shows sugar cane growing over 8 feet tall, which is hacked by hand and taken to the small-scale mill dominating the image, where it is put through the first stage of refining and prepared for transportation

to larger mills such as those at Communipaw. Of the approximately two dozen figures in the scene, all are African American except for the white overseer who, astride a black horse and dressed in a dashing white coat and hat, acts as a ghostly echo of the supposedly vanished planter class. The image enacts for viewers the racial power dynamic underlying the commodities that reached them: white overseers and black laborers, with the white male wielding absolute power, perhaps even smoking a valued Cuban cigar as he seems to admonish the lunching workers at right. If sugar did not rely on the labor of Cuban slaves (who were not officially emancipated until 1888), then it relied on the continuation of repressive and racialized agricultural structures, a vestigial holdover from the antebellum period.[80] And popular visual culture representing sugar production reinforced and naturalized these structures. Although these

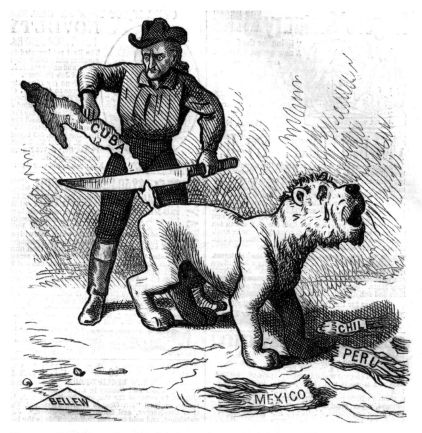

Figure 40. Frank Henry Temple Bellew (American, 1828–88). "That Noble Animal, the Spanish Lion," *Harper's Weekly*, December 20, 1873, 1144. Wood engraving, 5 x 4¾ in.

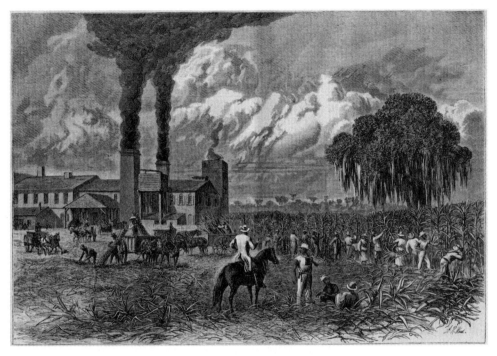

Figure 41.  A. R. Waud (American, 1828–91). "The Sugar Harvest in Louisiana," *Harper's Weekly*,
October 30, 1875, 884. Wood engraving, 9½ x 14 in.

connections may seem tenuous in Moran's painting, following the trail of
the sugar industry from its refining at Communipaw back to its sources
clearly leads us to Cuba and Louisiana.

Moran's canvas also gestures toward the West, an important region for
the representation of technological expansion. The connection between
the West and *Lower Manhattan* pertains to one of the primary materi-
als used for the refining of sugar, animal charcoal. Processed the correct
way, animal bones were made into a filter that would separate impurities
from raw sugar and impart the finished product with its characteristic
white color. For a period of approximately thirty years in the late nine-
teenth century, animal charcoal was obtained through a uniquely west-
ern trade, one that inextricably connected eastern sugar production to
Manifest Destiny and the destruction of traditional ways of life on the
Great Plains: buffalo bone gathering. "The Old Bone Man of the Plains" by
Rufus Fairchild Zogbaum shows an unlikely connection with the refiner-
ies of Communipaw (fig. 42). In a flat and desolate western landscape, a
middle-aged man cooks a meal over an open fire. He is dressed practically

Figure 42. Rufus Fairchild Zogbaum (American, 1849–1925). "The Old Bone Man of the Plains,"
*Harper's Weekly*, January 15, 1887, 36. Wood engraving, 9½ x 14 in.

and accompanied by four dogs and a horse to pull his Conestoga wagon.
Partial carcasses of two buffalo lie nearby, their bones picked clean by the
birds, black dots in the sky above. He is an improbable figure to be part
of a vast technological system that stretches across the globe, and yet this
solitary occupation of bone gathering was directly connected with certain
industries, sugar refining prominent among them. As the accompanying
text in *Harper's Weekly* reveals, the "unsportsmanlike" buffalo hunters of
the prewar years had all but extinguished the Plains giant, leaving rotting
carcasses and whitened bones scattered across the West. Consequently,
bone gathering became an industry in its own right, and thousands of tons
of buffalo bones were collected for use in "sugar refineries, bone-black
establishments, and carbon works."[81] While animal charcoal had been
used for refining sugar since the 1830s, the rapid extinction of the buffalo
by overhunting left a surplus of carbonaceous material that only had to
be collected and shipped east. The "miles of bleaching bones" left behind
by the buffalo hide industry of the antebellum period created the new
and more poignant industry of bone gathering, practiced mostly by poor

white settlers and displaced Native Americans.[82] Bone gathering tied East and West together in a symbiotic relationship of industrial production.

## Coda: Bone Black and White Gold

The "bone black" or animal charcoal industry has one further claim on our interest: it gestures toward the alchemical sublime. Moran's own interest in sublimity was clear from his grandiose western scenery, which many critics described as sublime in its scale, color, and atmospheric effects. His interest in the macabre or supernatural is less well-known, though it surfaced in minor works such as *The Haunted House* (1858) and *Macbeth and the Three Witches* (c. 1858–59). The bone black and sugar industries were tied through language, science, and contemporary perception to the alchemical. As early as the 1660s, alchemist Robert Boyle wrote appreciatively of sugar refining, while nineteenth-century sugar manufacturers hired chemists and other scientists to perfect their purification methods.[83] Even in the popular press of the 1880s, journalists like R. R. Bowker could write, while pondering the mysteries of sugar refining, "our rudest manufacturing processes" could transform "the same simple atoms," and yet "science has not yet reached below the surface of the mystery, and to the wisest eye the transformation is still a miracle."[84] The use of animal charcoal for purification might seem unclean, though evidently nineteenth-century consumers found it more palatable than the alternative purification technique, which used "disgusting material" like animal blood.[85] It was not the use of animal charcoal itself that was alchemical but what was done with it afterward. Charles F. Chandler's scientific entry on bone black in an 1877 general-interest encyclopedia reads more like an alchemical manual than a description of modern manufacturing: "By washing with warm water, and subjecting to a red heat in suitable retorts, the black is *revivified*, when it may be used again."[86] In the alchemical system, blackness or *nigredo* was associated with the most basic, impure materials and also with death. Within this schema, however, death represented something simultaneously negative and positive, the first step in the transformative process. The blackened bones of buffalo enabled a transcendent purification, an apotheosis of the whitened commodity, the "so-called white gold" of refined sugar.[87]

The alchemical properties of sugar suggest a strange, even uncanny underside to *Lower Manhattan* that was doubtless grasped by few, if any, of its viewers. Still, the associations were present in the visual, cultural, and political context, in the debates and ideas structuring Moran's world.

The canvas may hold this meaning while not sacrificing the triumphalist reading of aestheticized technology that many viewers gave it in the 1880s. Moran, whether consciously or not, activated a chain of connection, and of association, in his beautiful, sparkling evocation of modern industrial sugar production. Literally located on the boundary between New Jersey and New York, Moran's *Lower Manhattan* treads delicately along a whole series of boundaries: between manmade and natural, between humdrum and picturesque, between the "facts" of a gritty Communipaw waterside and the airy fantasies of a magical industrial realm. At the same time, and almost invisibly, his images of sugar refineries call up a number of striking connections among East, West, South, and the world beyond. *Lower Manhattan* seems to combine, in its picturesque yet specific representation of a single geographical area, the concurrent impulses toward clarity and obscurity. His striking visual representation of the industrial milieu suggests Communipaw as an attractive and misty realm while constantly reiterating the interconnectedness so important to the functional operation of technological systems.

Although Moran's painting references or relates to popular styles of illustration such as cityscapes, its existence within the art world freed it from needing to communicate specific messages. As American manufacturing grew increasingly complex and widespread in the postwar decades, however, certain forms of representation increasingly tried to pin down, rather than leave open, the meanings of images. Examining illustrations from pro-business magazines in the postwar years, it becomes clear that the carnivalesque atmosphere common in prewar publishing was increasingly supplanted by imagery that worked to promote business, educate readers, and define managerial techniques as the ideal structuring principles for an industrial America.

# Chapter 5

# Managing Visions of Industry

## The Managerial Eye

MOST OF us cannot even imagine entering a slaughterhouse. The mere thought of the smells and sights, the squeals of dying pigs and the sounds of their bodies being disassembled, is enough to turn the stomachs of the majority of twenty-first-century readers. And yet in 1867, James Parton wrote in the *Atlantic Monthly* that despite a "most horrid scene of massacre and blood," the operation of a Cincinnati pork slaughterhouse "claims the attention of the polite reader."[1] Just a few years later, a guidebook to American cities wrote that "*Pork-packing* is a highly-interesting process" and hoped that "a visit to one of the numerous *Pork-packing Houses* [of Cincinnati] will repay the tourist."[2] What could "polite" tourists want with the carnage of the abattoir? Nothing less than a whirlwind tour through the innovations in managerial organization and job specialization that characterized the emergence of industrial capitalism in the United States after the Civil War. Slaughterhouses—to many contemporary readers horrible reminders of truths we would rather not face—were put forward in the nineteenth century as trailblazers in new forms of efficient production, beacons of modernity, and bastions of organized, rational manufacturing.

Henry F. Farny's spectacular panoramic images, printed in *Harper's Weekly* in 1873, showed these modern forms of production in all their glory—and with a level of detail that still surprises (and possibly disgusts) today (fig. 43). Farny's dramatic scenes of hog butchering, laying

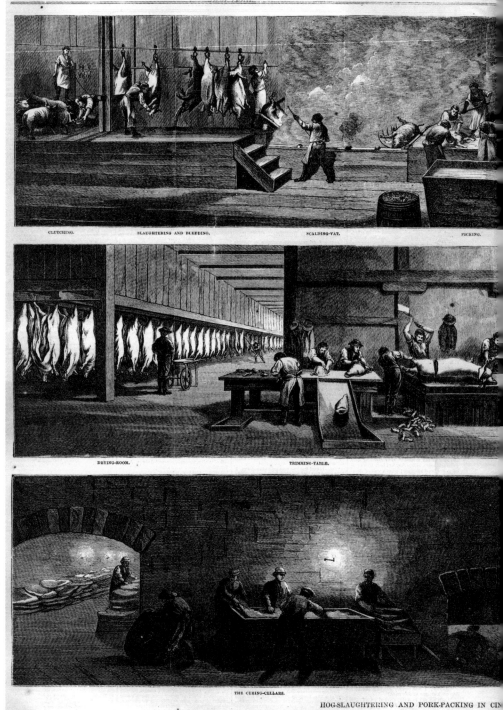

CLUTCHING.     SLAUGHTERING AND BLEEDING.     SCALDING-VAT.     PICKING.

DRYING-ROOM.     TRIMMING-TABLE.

THE CURING-CELLARS.

HOG-SLAUGHTERING AND PORK-PACKING IN CIN

Figure 43. Henry F. Farny (American, 1847–1916). "Hog-Slaughtering and Pork-Packing in Cincinnati," *Harper's Weekly*, September 6, 1873, 776–77. Wood engraving, 14 x 21 in.

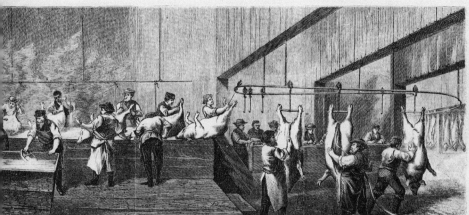

SCRAPING AND SHAVING.                    THE GAMBRELS.                    DISEMBOWELING AND WASHING.

UTTING-BLOCKS.                                    TRIMMING-TABLES.

LARD-RENDERING.                    PRESSING.                    "STEAM LARD" TANKS.

—FROM DRAWINGS BY H. F. FARNY.—[SEE PAGE 772.]

each segment of production open to the eye of the observer, comprise outstanding examples of a mode of visual representation that arose during the years following the Civil War, a style of illustration that I call the "managerial eye," a form of visual communication that helps the viewer understand at a single glance what a manager would have to know. Illustrations of the 1860s through 1880s demonstrate consistent interest in exploring the steps required to bring a commodity to the market and a desire to explicate visually the connectedness and interreliance of each phase of manufacture. Throughout the popular illustrated magazines of these years—though most markedly in *Harper's Weekly* and *Scientific American*—artists developed compositional methods designed to introduce viewers to a splendid and brave new world, the world of managerial wage capitalism and the concurrent developments of the assembly line and mass-production techniques.[3] This style of illustration takes the viewer inside the factory walls to observe the making of everyday consumer goods such as prepared foods and drinks, clothing, shoes, matches, sewing machines, and firearms.[4] A similar style was used to depict heavy industrial activities such as glass-blowing, iron and steel working, mining, and the manufacture of machine parts. Taken together, these images suggested a new interest in the minute details of all kinds of manufacturing. They also showed an editorial presumption that subscribers wished to have these industries explained to them and an artistic attention to the power of combined image and text for making step-by-step processes clear to viewers. Farny's panoramas are but one example of the dozens, if not hundreds, of visually innovative, factually informative compositions created by American illustrators to introduce their viewers to the exciting and changing world of manufacturing.

I have called this mode of representation the managerial eye, and in this chapter I explore how this style of viewing enabled readers of magazines to position themselves in relation both to the commodities they purchased every day and to the workers who made and distributed those products. Artists developed and expanded on three key compositional techniques— cut-aways, multi-paneled images, and panoramas—to give the viewer a sense of power, control, and knowledge over manufacturing. This attention to the details, sequence, and interdependent nature of proto–assembly line and proto–mass production techniques arose simultaneously with the emergence of a managerial class in the United States. A revolution in the way manufacturing structured its operations went hand in hand with a shift in the composition of images representing those manufactures. Illustrated magazines were a major venue for nineteenth-century observers to

learn about modern production techniques in a visual format that echoed the managerial focus on efficiency and rational organization.

It would be an oversimplification to approach these images as purely truthful or accurate depictions of industry in the nineteenth-century United States. Like magazine readers who enjoyed touristic images of the West, those who appreciated scenes of American manufacturing "came to feel as if they knew the places firsthand—unaware, in many cases, that what they saw was not necessarily what was there."[5] In one particular case, that of the *Scientific American* series "American Industries," which ran from 1879 to 1885, there is clear documentation that managerial images distorted the truth to make certain factories seem more modern than they actually were. These articles were, in essence, paid advertisements whose content was carefully controlled by the owners and managers of the factories they featured.[6] Their insistent focus on organization and efficiency, whether or not these were always a reality, reinforces the notion that the managerial eye was a blend of fact and fiction. But, as I argue, the purpose of this imagery was not to represent American industry in a literal and completely accurate way but instead to shape an idealized vision of a technologically advanced country that was emerging as the leader in modern techniques of commodity production. Illustrations offered a hybrid of reality and desire, based around the needs of the increasingly prevalent discourse of management and rationalization. Many of the engravings featured in this chapter presented a combination of facts and fantasies that contributed to the narratives that viewers and managers *wanted* to hear about industry in their country. Artists arranged their images to seem more authentic and accurate, presenting the public with a dream of cohesive and fully controlled industry.

This necessarily required manipulation on the part of illustrators, who worked actively to boost support for industrial capitalism—indeed, as examination of the structures of periodical publishing in the United States shows, magazine workers were intimately implicated within modern wage capitalism.[7] From editors and writers to wood engravers and artists, magazine employees operated within hierarchically structured factories that functioned exactly like the factories that made other mass-produced consumer goods. As Gerald J. Baldasty notes, American newspaper and magazine publishers at this time were well aware that their products were "a commodity that demanded attention to organizational and financial concerns."[8] Magazine illustrators were working explicitly to create a national atmosphere that was receptive and welcoming to the implementation of new managerial techniques—techniques that were being simultaneously

introduced into the very publishing trade that spread and publicized positive views of wage capitalism. Crucially, the wood engravings that boosted support for burgeoning mass production were themselves mass-produced objects.

Participating in the visual culture of technological systems, the managerial eye played a powerful role in the development of American attitudes toward industrial manufacturing. As systems became more complex, the managerial eye contributed to the increasingly unlikely notion that any single viewer could grasp a system's intricacies. The managerial eye invited viewers to explore vicariously, as tourists, the inner workings of American factories. This touristic mode of viewing would have been familiar to some readers. While regularly scheduled factory tours were uncommon before the end of the century, visitors could usually apply to the administrative offices of factories to request a tour. Guidebooks urged tourists to apply for entry to factories, foundries, waterworks, and, as mentioned above, slaughterhouses.[9] Yet the managerial approach also requires viewers to go beyond a simply superficial touristic gaze; as we see below, it visually focuses on techniques of rationalization and orderliness, asking viewers to solve problems, to follow raw materials through factories, and to oversee tasks just as a manager did.

Ironically, the apparently rational and straightforward viewpoint of the managerial eye was made possible only through artistic direction, which allowed viewers to access factories in ways they never could in real life. The managerial eye is not a literal manager's view but includes the many different kinds of knowledge an actual manager would be required to have: the situation of the site in relation to networks of production and distribution; the topography or important geographical features that might impact the industry; the different kinds of machinery operating within a single plant, factory, or mine; the many separate tasks that would have to be performed; and the architectural layout of the site's buildings. All these kinds of knowledge would have come under the purview of early managers, a powerful new class who arose in force after the end of the Civil War.

*Managerial Techniques and Ideologies*

The emergence of managerial capitalism in the nineteenth century was a complicated and gradual process that strove for nothing less than a complete revolution in American society and industry. As a group, managers tended to be educated, white, native-born men, people who did not neces-

sarily have skilled experience working in factories but who were instead trained to perform what we might characterize today as problem solving and profit maximization. Prior to the arrival of this new and specialized class of workers, most industries were managed by foremen or overseers, senior workers who had risen up the labor hierarchy through the development of specialized skills. They, too, tended to be white, native-born men with higher education levels than their underlings, but they differed from modern managers in both their training and their main purpose. The function of an overseer was primarily to ensure that workers did their jobs well and that machinery was operating properly, a kind of micromanagement that focused on individual problems rather than an overall program of operations. The white-collar managers who increasingly replaced these foremen during the late nineteenth century were, instead, expected to tackle macro problems such as flow of raw materials, organization of factory floor space, efficiency of job specialization, and integration of all parts of the labor process into a smooth and well-functioning whole. Where did these new managers come from? Why did they take such a tenacious hold on the American manufacturing scene, reshaping its outlines and contributing to the hegemonic dominance of the "efficiency expert" after the turn of the twentieth century?

Walter Licht, a labor historian, contends that the first appearance of a managerial class dates to the period of early railroad expansion in the 1830s.[10] Because of the complexity of the railroad network, as well as the clear danger disorganization could bring, there was a need for a small group of workers who could act as overseers across miles of track and interconnected routes. As Licht chronicles, the geographical spread of the railroad comprised a completely new form of business; their "complexity, diversity, and geographical range of operations" made railroads unique.[11] Because of their demand for a large labor force with diversified sets of tasks, railroads had particular need for a hierarchical structure of management and control, requiring owners to rethink older business models.[12] With the rise of larger and more geographically spread out businesses following the model of the railroads, the need for complex administrative structures grew rapidly. While the railroad's managerial organization had mostly to deal with questions of timing and personnel on a large geographical scale, early experiments in other fields, such as the textile industry, focused on the more circumscribed canvas of the factory site. Already in the antebellum period, wrote Richard D. Brown of the textile industry, "rational planning and calculations for optimum efficiency determined the locations of the machines, as well as the labor force, and

directed their interaction minutely."[13] This approach, which relied on the interaction among architecture, machines, and workers to regiment production, became increasingly hegemonic later in the century.

Management's development was uneven, differed widely across industries, and involved a process of trial and error. In the case of the railroad, for instance, managers were not a "cohesive class" with specialized training until the 1870s.[14] The emergence of managerial structures in American business was often "chaotic," especially during the turbulent years of the post–Civil War period, when managerial ideology was in its formative stages.[15] The tripartite structure of labor, management, and capital was by no means predetermined but evolved gradually throughout the century. From comprising a tiny minority of the workforce at midcentury, the "professional-managerial class" rose to around 1 million workers in 1880 and, Richard Ohmann estimates, approached 3.5 million people, or about 10 percent of the workforce, at the turn of the century.[16] This meteoric rise occurred in a context of postwar development and expansion.

While the roots of the shift clearly lay in the antebellum period, scholars attribute the postwar rise in management principles of organization and efficiency to political, ideological, and economic shifts, partially resulting from the massive mobilization of the war and the political need for order and control during Reconstruction.[17] In addition, the "robust administrative bureaucracy" required by the war had provided valuable object lessons in the power of organization for the efficient functioning of a large system.[18] Manufacturing companies, many of which were led or overseen by veterans, adopted elements of military administration as crucial models for effective operation.[19] By 1872, only seven years after the war, the economic theorist Amasa Walker was writing that traditional industries were fast disappearing: "Every different kind of boot and shoe is now produced in large manufacturing establishments, not by hand labor, as formerly, but by the most powerful and effective machinery. The trade is totally revolutionized. The same may be said of almost any other mechanical trade."[20] The new ideology, which focused around ideals of speed and efficiency, was made possible by expansion of production and transportation networks. Although this impulse would not reach its zenith until the turn of the twentieth century, with the efficiency experiments of Frederick Winslow Taylor and the implementation of scientific management, in the 1860s industries more uniformly began to implement organizational, technological, and architectural innovations to make production speedier, more efficient, and more cost effective. The preeminent historian of industrial management, Alfred D. Chandler, Jr., noted that the needs

of this new economy were "the development of new machinery, better raw materials, and intensified application of energy, followed by the creation of organizational designs and procedures to coordinate and control the new high-volume flows through several processes of production."[21] In Chandler's narrative, innovations in machinery and refinement of raw materials in turn fed further capabilities for streamlining production and increasing volume at lower price points.

In addition to innovations made to satisfy a growing philosophy of efficiency and profitability, the economic climate also had a profound impact on changes to manufacturing structures. Frequent depression cycles and stiff competition forced industrialists' hands. Bruce Laurie writes, "No employer . . . could withstand the frenetic competition and recurrent recessions without trimming costs and exercising more control of the labor process."[22] The desire for increased speed and control naturally tied in with the ideology of technological systems: the shifts in communication and transportation that spurred the growth of American manufactures posited the factory as merely one part, a link in the chain, of vast continental and international networks. At the same time, managers and capitalists worked together to redesign and restructure the factory itself as a system in miniature, with consistent flows of goods and materials through a series of processes linked together in a logical, orderly fashion.

The representation of factory interiors and other work sites in the years between the end of the Civil War and 1887 partook of the language of technological systems, attempting to clarify causal relations for viewers. At the same time, the images positioned the viewers as members of the powerful and educated new managerial class, providing them with apparently specialized knowledge about the inner workings of America's factories. Especially important was the fact that the industries profiled and illustrated in *Harper's* and *Scientific American*—including matches, cigarettes, clothing, canning, butchering, munitions, nails, and industrial and domestic machines—were also the industries Chandler identified as the earliest to adopt new managerial structures. Throughout the century, however, many industries still relied on custom or small batch production. These included furniture, jewelry, carriages, and specialized machinery, industries comparatively missing from attention in the mass periodicals.[23] This suggests that illustrators and journalists focused on those types of production that were using the newest and most advanced techniques, including the incorporation of de-skilling and managerial hierarchy. Viewers were receiving up-to-date, detailed visual representations of the most dynamic and modern industries, many of which were in the business of

producing everyday consumer goods. Anyone who viewed these images, then, could claim some degree of knowledge about the goods she used on a day-to-day basis and could imagine herself as a member of the emergent management structure.

## Development of a Management Aesthetic

The emergence of the stylistic traits that I group under the managerial eye occurred specifically in the pages of illustrated magazines during the years following the Civil War. In this sense, they developed alongside the innovations in commodity production that spurred the managerial revolution. As mentioned above, illustrators worked as managers of the visual realm but also as members of an industrialized workforce that produced mass commodities—graphic periodicals. In a longitudinal study of four decades' worth of images from the major American illustrated periodicals, I found a marked shift in illustration styles that corresponds to the emergence of managerial capitalism. From the typical half-page, single-frame illustrations that marked the earliest popular pictorial journalism in the United States, artists moved to increasingly intricate, multi-framed images that could relay the complex nature of modernized commodity production. These developments were spurred by competition for readership among magazines, with *Frank Leslie's* and *Harper's* as the major rivals among the weekly papers and *Scribner's* (*Century Magazine*) and *Harper's* scuffling for their share of the readership of illustrated monthlies. Pictorial journalism, however, was not unique to the United States, and industrial imagery in particular seems to have developed based on some specific European precedents. The key importance of these early precedents was the development of methods for representing time or sequence as it relates to labor.

There have always been representations of labor that were tied to time: medieval illuminators and stonemasons, for instance, liked to connect specific trades with the months or seasons of the year.[24] But this conception of time was one of the *longue durée,* God's time, which moved in an eternal cycle until the end of days. Visual depiction of any immediate chronological action posed a problem for artists prior to the invention of the motion picture camera in the late nineteenth century. Work is a tricky subject: choosing when to freeze the action, an artist must decide whether he wishes, foremost, to create drama or to make clear the processes and products of labor. As demonstrated earlier, John Ferguson Weir intentionally chose to highlight drama over informational content in his representations of the iron industry. But such a choice would not have worked for

Weir's contemporaries who were employed as magazine illustrators. When the legibility of a narrative was the most prominent rhetorical purpose of an image, composition and all other functions had to be subordinate to this goal. It seems that these artists may have turned for instruction to two kinds of precedents: popularly disseminated, inexpensive broadsheets and French and English technical illustrations, both forms which offered techniques for creating sequential pictorial statements that depicted temporal actions in two dimensions.

Scholars of the comic strip identify early modern books and broadsheets, containing both religious and satirical content, as an essentially modern mode of representation.[25] Their popular dissemination relied on what the print historian William M. Ivins, Jr., memorably dubbed "exactly repeatable pictorial statements."[26] Their popular impact depended on their relatively low expense and their immutability: every reader or viewer would experience the same images, multiplied as infinitely as the strength of the block and popular demand would allow. As Thierry Groensteen argues, the visual and narrative techniques that were later used for the comic strip had medieval origins, where "one finds page lay-outs, balloons for words or thoughts, onomatopoeia, movement lines, containment by frames or going outside them, fast movements split up into several images." But, he continues, it was the expansion of these techniques into a format—printing—that supported exactly repeatable pictorial statements which enabled average viewers to incorporate a new understanding of what it might mean to represent action over time into their vocabularies. Managerial imagery is too orderly to use most of the techniques outlined by Groensteen, but it does conform to his definition of a "visual narrative . . . conveyed by sequences of graphic, fixed images, together on a single support."[27] While most of the magazines originally published single, large images in quarter-, half-, or full-page sizes, by the mid-1860s, increasingly complex narrative techniques were appearing with greater frequency.

Perhaps a philosophically more similar counterpart to the managerial eye can be found in Enlightenment attempts to catalog and order the world. Denis Diderot's *Encyclopédie* (1751–72) is the most famous example of a large-scale project dedicated to depicting the mechanical arts, though Temple Henry Croker of the United Kingdom also provided extensive illustrations of production techniques.[28] Like images of the managerial eye, the engraved plates of the *Encyclopédie* and Croker's *Complete Dictionary of Arts and Sciences* (1764–65) often combine one or more views of a scene accompanied by texts explaining their content and order. In the case of Diderot's *Encyclopédie,* the text can be a means of establishing a narrative

between parts of the image that are "temporally discontinuous," a technique that was also used by nineteenth-century journalists to help viewers read images of factory labor.[29] As the art historian Randall C. Griffin notes, however, in most eighteenth-century examples, "the pictures act as a frame-by-frame narrative completely subservient to the text."[30] Indeed, the primary function of the encyclopedia images was to support the written content. In nineteenth-century examples of the managerial eye, the roles were reversed, and the text served to support and supplement the images. Typically authors would supply the reader with just enough information to reinforce the work of the images. These articles tended to be full of the kinds of information images could not provide—statistics about the scale of production or the size of facilities—rather than explicit descriptions of manufacturing techniques. The managerial eye relied almost entirely on visual cues to create a narrative and resolve the problem of temporality.

Under the instruction of Diderot and the head draftsman Louis-Jacques Goussier, artists for the *Encyclopédie* attempted to create an all-encompassing catalogue of industries, emphasizing "mechanical systematization."[31] But these eighteenth-century precedents did not employ the specialization and organizational clarity of images produced during the managerial revolution, and encyclopedias show skilled artisanal labor rather than de-skilled modern labor. Griffin writes that most of the nineteenth-century magazine illustrations "focus exclusively on the various stages of a worker's task, reminiscent of images in such books as Diderot's *Encyclopédie*."[32] While it is true that the encyclopedia entries focus on "stages of *a worker's* task," often appearing to show one man who can perform all the tasks depicted, this is less accurate in the case of nineteenth-century illustration. Managerial images are not of *a* worker's task but of *many* workers' tasks: the managerial eye represents the division of labor, the fragmentation of the labor force. It focuses on the twenty tasks of twenty men and thus is modern, specialized, and quite different from the encyclopedia entries that show groups of laborers working together. These eighteenth-century images suggest an ideology of collaborative effort rather than one of circumscribed movement, specialization, and separation from other workers.

## Human Chopping-Machines

Nineteenth-century illustrators were certainly aware of the long pictorial history of sequential, reproducible images of work, workers, and machines in the Western tradition. In the modern era of capitalized news illustration, they built rapidly on those foundations to create complex, narrative forms

of representation. It is possible to trace the development of the managerial eye through attention to the industry that opened this chapter: butchering. Technological advancements in transportation led to increased volume and acceleration of meatpacking in the 1840s through 1860s. Due to the speed allowed by the railroad, meat slaughtered in Midwestern centers, such as Cincinnati and Chicago, was quickly available to purchasers on the East Coast. Also, the development of a basic form of refrigerated car in the 1850s allowed for the safe transport of butchered and dressed meat from slaughterhouse to market.[33]

Quite remarkably, these innovations allowed the rapid extension of a pork-based technological system. One *Harper's Weekly* article of 1860 described Cincinnati as "Porkopolis," the hub of "a vast centralized and systematically established trade." Indeed, spectators marveled at the geographic breadth encompassed by the body of the hog itself: it is reared on "the beech-nuts, hickory-nuts, and acorns that abound in the forests of the luxuriant West," comes to the Midwest on its "reluctant pilgrimage," and from there its carcass and products are "distributed among the nations of the earth."[34] As Frederick Law Olmsted wrote, the parts of the hog "dispatch each to its separate destiny—the ham for Mexico, its loin for Bordeaux."[35] Even the Chinese were envisioned as a major new growth market for Cincinnati's products: "Now the eyes of dealers are expectantly turned westward, looking for a demand which they believe will be sure to come at no far-off day from the Celestial Empire. Chinamen learn to relish pork in California, and going home they bear testimony of its qualities to the teeming millions of China."[36] In the hog's brief lifespan, it took advantage of an entire network of systems, moving from West to Midwest and eventually into American, European, and even Asian markets. In other words, the destination of these products could be (almost) anywhere in the world. With business worth over $15 million annually in Cincinnati alone by the late 1870s, pork packing was an influential industry that demonstrated the value of exploiting technological systems of transportation nationally and internationally.[37]

More crucially, hog butchering was one of the earliest industries to adapt to proto–assembly line techniques. As early as the 1830s, American slaughterhouses had begun to develop efficient "disassembly lines," perfecting techniques for the well-organized mass killing, disemboweling, butchering, and packing of meat, particularly hogs.[38] Contemporary observers remarked on the spectacle as a wonder of the modern world, a highly specialized industry in which each man had his job, no matter how small or bloody. The routine disposal of over a thousand hogs in a day had

viewers aghast at the efficiency of organization within these factories for slaughter. James Parton of the *Atlantic* admired the swift artistry of the "gutters," men who, with no more than three or four cuts to the body of a scalded and de-bristled hog, removed the internal organs and prepared the animal for division into hams, chops, shoulders, and other edible cuts. The gutter's operation, Parton wrote, "performed in twenty seconds, and which is frequently done by the same man fifteen hundred times a day, takes an ordinary butcher ten minutes."[39] Another author, Willard Glazier, observed almost two decades later that fifty specialized workers "will unitedly dispose of a hog once in every twenty seconds," language similar to the way efficiency experts referred to the automotive industry in the twentieth century.[40] Olmsted described the scene in a Cincinnati slaughterhouse in vivid detail:

> Walking down to the vanishing point, we found there a sort of human chopping-machine where the hogs were converted into commercial pork. . . . No iron cog-wheels could work with more regular motion. Plump falls the hog upon the table, chop, chop; chop, chop; chop, chop, fall the cleavers. All is over. But, before you can say so, plump, chop, chop; chop, chop; chop, chop, sounds again. There is no pause for admiration. By a skilled sleight of hand, hams, shoulders, clear, mess, and prime fly off, each squarely cut to its own place. . . . Amazed beyond all expectation at the celerity, we took out our watches and counted thirty-five seconds, from the moment when one hog touched the table until the next occupied its place.[41]

Olmsted's prose captures the rhythmic and repetitive nature of the butchering table. His comparison of the workers to machines is a telling dehumanization of men whose tasks had been specialized down to the minutest movement. Regardless of the comparative inhumanity of this passage to a current reader, nineteenth-century observers were united in their admiration of the fact that "each man has his own special line of work," combined with the innovation of "overhead roadways" or continuous-process conveyors that easily moved the 600-pound carcasses through the building.[42] The innovations of management increased profits, but they also brought the stamp of modernity to a bloody and rather revolting business. As Parton wrote in his valedictory to the slaughterhouse, "There is a moral in all this. In such establishments, a business which in itself is disgusting, and perhaps barbarizing, almost ceases to be so."[43] Management and order could tame the blood and mayhem of the abattoir.

Hogs also proved quite versatile creatures, whose carcasses could be transformed into a litany of finished products, including many kinds of meat but also lard, candles, Prussian blue pigment, brushes, and mattresses; even bones were rendered into carbon fuel that could be used for sugar refining or other industrial processes. "Every scrap," one author recounted, "even the apparently most worthless, is saved and turned to account, either as an article of food or for use in the arts." So the "entire animal" was "consumed and converted, to the continued advantage and profit of innumerable economical and flourishing trades."[44] Much as Moran's *Lower Manhattan* sent out tentacles into Latin America and the West through its references to sugar refining, a single Cincinnati pork rendering plant could make possible the creation of a painting such as Moran's work, through the provision of blue pigment and brushes for artists. As the bones of the buffalo underlay the polite cup of tea with its lump of sugar, the highly processed bristles and blood of Cincinnati hogs reared in the states of the wild West provided artists with tools of their trade. Exploring the technological systems underpinning all these commodities allowed readers to trace the origins of the products they used, whether to savory or unsavory beginnings. Paired with the texts, illustrations performed the visceral work underscoring the interconnectedness of technological systems.

The representation of hog butchering in Cincinnati provides valuable examples that demonstrate a gradual transition to visual principles of rationality and management. In 1860, *Harper's Weekly* published a suite of five half-page illustrations to accompany an article about the successful spread of American pork products to new markets. The images show a visual style common to early issues of the *Weekly,* when the magazine typically ran single illustrations that stood alone in typeset pages relatively disconnected from other pictures accompanying the same story. The five images suggest an intermediate point between early, isolated images and more complex compositions encompassing a number of smaller, interlinked vignettes, which began appearing during the 1860s. The gruesome first image (fig. 44) depicts the slaughter of the animals as they are driven en masse through a chute and picked off one by one by a burly worker wielding a sledgehammer, "which done, [the hog] is immediately seized by the butchers inside, and stabbed, bled, scalded, scraped, and cleaned out. . . . He is converted into pork in about three minutes."[45] The river of blood running from the slaughtering table and the rows of slashed carcasses seen hanging behind the tableau give the image an air of realism compounded by the legible tasks of the vigorous workers. Reading from

Figure 44. "The Death Chamber," *Harper's Weekly,* February 24, 1860, 72.
    Wood engraving, 6 x 9½ in.

left to right, the viewer begins to put together a narrative of the process
for dealing with each carcass. The rhythm of the roof beams suggests that,
moving from left to right, a next step must appear just outside the frame
of the image to the right—and, in fact, this is the first of a series of such
images. The author noted how "the work is divided into several branches,
each demanding its separate squad of workmen."[46] An overall impression
of process can only be achieved by reading the text and images together,
and cannot be gleaned from a glance at the illustrations alone. This par-
ticular image suggests the interconnectedness and fluidity of the slaughter-
ing process but offers it to the viewer only obliquely. Thirteen years later,
however, another *Harper's Weekly* illustrator would unite these processes
in a more visually powerful layout.

The 1873 image by Henry Farny (see fig. 43) demonstrates the simulta-
neous modernizing of the pork-packing industry and of the techniques
artists used to represent it. Paula Young Lee writes that "the slaughter-
house only became 'modern' when it was re-imagined as a productive
place where meat was made . . . [and] no longer a symbolically 'dirty' site
where innocent animals were butchered."[47] Farny's clean, orderly, and logi-

cal series of images participate in this modernity, simultaneously removing the blood and gore of the earlier meatpacking scene and reimagining how best to represent the interior of a factory. In 1873, Farny had been doing illustrations for *Harper's Weekly* for eight years.[48] Yet this image was not originally created for publication in the magazine but reached its pages through more complex channels. The Pork-Packers Association of Cincinnati commissioned Farny's dramatic and detailed composition of hog butchering for a large-scale display at the 1873 Vienna World's Fair. The massive work, approximately 81 feet long, showed life-sized figures in what art critic John R. Tait called "the Odyssey of the Pig, from the period of his slaughter until his apotheosis as Pork."[49] The scenes were translated into a lithograph by the Cincinnati firm of Ehrgott and Krebs, possibly as a public relations image for the city.[50] Finally, *Harper's Weekly* translated the lithographs into illustrations for an in-depth article on pork processing. Through this entire process, Farny was working at all times within the structures of commercial representation, intended for viewing by mass audiences. And his prior years of work as an illustrator at *Harper's* no doubt infused even his painted work for the world's fair.

The images, whether displayed in life-size or dramatically shrunk to fit the pages of *Harper's Weekly,* demonstrate the major changes in representing factory interiors that had occurred during the previous thirteen years. Like the earlier images, these three panoramic vistas read from left to right, but instead of a disconnected series, they present a continuous process, with each step carefully labeled. Each man stands almost stationary at his task; instead of the men, the viewer follows the hog through each step of its disassembly. These men are differentiated through clothing, pose, and even race, as two darker-skinned men work alongside the rest. There is a sense that architectural space has been expanded to give an all-encompassing viewpoint. Indeed, the article notes, despite his careful attention to realistic detail, "the artist has taken liberties which were indispensable for the proper exhibition of this process."[51] Farny achieved this by placing the butchering tables in a single, straight line, rather than the actual layout, which is described as closer to a horseshoe. In other words, privileged readers of the magazine are given *more* information at a single glance than even the most competent manager could hope for. Farny subtly but crucially *restructured* the abattoir floor in order to provide a more detailed, informative perspective.

Another striking difference between this set of images and those from 1860 is that, rather than merely being *told* about the many products created from the single hog, the viewer witnesses the creation of those products

and can envision them making their way to her table. Chutes below each cutting block spill sausages, hams, heads, and sides of pork, each easily recognizable. We can read this section of Farny's image just as clearly as we read Glazier's textual description of the same event: "The different portions of his dissected body are slipping down wooden pipes, each to its appropriate apartment below," or, in Parton's slightly more lyrical words, "gently down their well-greased pipe slip the hams."[52] In fact, Farny's image is capable of giving a more direct and visceral representation of this moment than Glazier's matter-of-fact statement or Parton's florid description. Farny cleverly constructed his image to present the entire process at a glance in a way that the viewer easily comprehends, and he visually altered the space of the factory to communicate even more effectively.

Only in the lowest register of the composition is there a hint of anything outside the rational, straightforward visual impulse. In the curing cellar and the lard rendering station, the men toil no less diligently, but, especially on the left, they are enveloped in an atmosphere of murk and gloom, their faces invisible and their actions obscure. From below, two mysterious laborers arise from an even deeper cellar. This horizontal band hints at a mysterious netherworld of burly toilers, those "ghouls" described by John Ferguson Weir in relation to his industrial canvases. These men perform the dubious labor of rendering lard: "leaf lard, head, gut lard, and pork trimmings" along with "intestines, paunches, and all refuse from the slaughter house" are subjected to extreme heat until bones become a "bleached mass" and "even the teeth of the hog may be easily mashed between the fingers."[53] This repulsive underworld seems to be the only place where the irrational side of industry encroaches on the cogent, organized world above.

Most important for this discussion is the way Farny's illustration accomplishes what the earlier artist could not: it gives the viewer an explicit, detailed, and almost seamless representation of hog butchering, from live hog to edible and subsidiary products. The viewer sees not only the industrial processes that render the animals into usable commodities but can also imagine the potential global markets for American goods, delivered through continually expanding transportation systems.

Farny's panoramas were merely a single, fairly spectacular example of a kind of representation that was appearing with greater frequency and vigor throughout the 1870s and 1880s. In many other industries as well, the logic of management gave viewers a stake in the world of industrial production while naturalizing the idea that the middle class, in the figure of the factory manager, exercised a measure of control not only over the

means of production but also over the working class itself. Sophisticated viewers, like managers, could claim intimate knowledge of machines, tasks, and factories, all through experience gained from reading popular periodicals. By venturing inside the walls of the factory, refinery, or slaughterhouse, illustrators gave viewers a new, controlling perspective on technological systems. I have isolated three primary techniques that artists developed during these years in order to deal in a visually interesting and informative manner with the industries of nineteenth-century managerial capitalism. These modes, which constitute updated, reworked versions of historical attempts to represent sequential action, are the cutaway view, the multi-paneled image, and the panorama. While these three forms of representation developed from separate precedents, they were interconnected and often appeared within the same compositions. Artists incorporated increasingly complex permutations of these techniques as the art of newsmagazine illustration was reaching its heyday in the 1880s.

*Cut-Away Views*

The cut-away view was used both in the representation of commodity production and in the depiction of technological or engineering feats such as subways, tunnels, and bridges. The origins of this style of representation lie in technical drawings for architecture and engineering, but nineteenth-century illustrators gave the style more drama and popular appeal by doing away with dry elements like measurements and weights. Instead, they adapted the cut-away technique to the needs of the managerial eye: their key goal was not conveying structural integrity or even creating realistic, habitable interior spaces. Instead, they were concerned with communicating questions of organization that could help readers access new kinds of knowledge about developing industries. The cut-away view could be accomplished in several different ways, each of which allowed viewers a perspective virtually impossible to accomplish in real life or even through other reproductive methods such as photography. The side of a factory wall could be dramatically cut away, giving the spectator a direct view into the facility. Other images cut dramatically into mountains or hillsides, venturing through underwater tunnels or down mine shafts to expose otherwise unreachable scenes. Least dramatically, the illustrator could merely depict the interior of the factory, without calling direct attention to the cut-away effect. In this technique, the cut-away lacked drama but powerfully naturalized the viewer's assumptions about his ability to pierce the factory or mine and gain knowledge about the activities

that went on within. In many representations of industrial interiors, as with the 1860 account of pork butchering, viewers could gaze inside the factory without having to be reminded that they had burst through now-invisible walls. Occasionally half-built walls or framing structural supports reminded the viewer of the cut-away device, but most frequently these images naturalized this mode of viewing, presuming viewers would implicitly understand.

A representative example of a cut-away image is W. P. Snyder and Theodore R. Davis's representation of a grain elevator on the New York Central and Hudson River Railroad (fig. 45). The artists depict the inner workings of the massive structure by demolishing one of the building's short walls and peering inside the cavernous space within. Minute labels direct the viewer's attention to the grain pipes and bins, while the text treats the reader to an exhaustive catalog of dimensions and capacity.[54] This image not only captures the interior works of the grain elevator but also gives a detailed picture of its exterior, with grain chutes for loading and a large ship docked nearby. The image also provides the viewer with an impression of the busy New York harbor glimpsed from afar in Thomas Moran's *Lower Manhattan:* here a huge variety of ships—tugboats, barge, sailing ship, small sailboats, and even rowboats—create a bustle of activity on the wharf near the grain elevator. The careful attention to detail in the foreground gives the scene a sense of restless energy and a quality of immediacy as smoking rail cars come in and a tugboat crew throws a line to another craft. Looming over all these details is the hulking mass of the grain elevator itself, which begs the viewer to decipher and comprehend its inner workings. In this form of the cut-away image, the viewer senses the systemic connections—the boats, the railroad, the grain trucked probably from the Midwest—*and* a managerial glimpse at the local systems or processes of this particular site. In these kinds of cut-away images, the viewer is granted an impossible viewpoint assimilating many different kinds of knowledge into a single image. While earlier cut-away images felt the need to remind viewers in writing that "the front wall of the manufacturing building is supposed to be removed, so that the entire series of operations can be seen at a glance," that mode of vision had become naturalized in the intervening decades.[55]

## Multi-Paneled Images

Multi-paneled images developed quite quickly in the lifecycle of the popular illustrated magazines. *Harper's Weekly* began publication in 1857, and

Figure 45.  Composition by W. P. Snyder (American, 1853–c. 1930) from sketches by Theodore R. Davis. "Grain Elevator of the New York Central and Hudson River Railroad," *Harper's Weekly*, December 22, 1877, 1008. Wood engraving, 9½ x 14 in.

within ten years was commonly publishing at least one or two complex, multifaceted compositions in each issue. The motivating event for this diversification seems to have been the innovations of Civil War reporters such as Theodore R. Davis, Winslow Homer, and A. R. Waud, whose fragmented compositions, unified around a single theme or event, reflected the fractured feelings of the war years. This mode, however, quickly moved beyond representations of the battlefield due to its ability to offer quick and dramatic impact. Because of the large-size format of the weekly papers, a double page center spread could easily be split into multiple, yet interconnected, images. Not only were mass magazines available to a larger audience than ever before but their very design also incorporated the inherent distraction, multiplicity, and episodic nature of modern life. In the bustle of the modern city, or in the jolting in-between of a railway car, readers had to adjust to the syncopated rhythms of variously sized blocks of text and image. David Kunzle, a historian of the comic strip, writes of this new mode: "[Multiple images] on a page—all scanned in a moment. This

is in the logic of railway reading, which allowed for variety, distraction, and interruption, for superficial and momentary attention; for *looking,* in a shaking carriage, rather than sustained *reading.*"[56] Viewers' encounters with these images might be in the comfort of a middle-class parlor, but they might just as easily be in the more public, modern spaces suited to the distracted kind of viewing Kunzle describes—railways, newsstands, omnibuses, bars, or shift breaks. They needed to be able to absorb sequential narratives without "sustained reading." Images were called on to do more, and more difficult, work. Also part of this modern milieu was managerial capitalism, with its complexities, sequences, and cause and effect, all of which needed to be readily communicated to viewers.

The multi-paneled image was particularly apt for tracing sequential processes because it could represent various stages of production simultaneously, separated by frames yet implicitly legible as a single whole. One may also think of the multi-paneled image as a visual schematization of vertical integration, allowing observers to understand one of the key strategies of modern capitalism. In the earlier part of the century, most manufacturing was taking place in small-scale establishments, but with the new ability to ship raw materials, fuels, and finished products at high speeds, many larger factories began to, if hesitantly and incompletely, integrate vertically.[57] This meant that one could trace the source of a product from raw materials to finished commodity through a series of steps, often occurring at different facilities. In this sense, these images collapsed time and space, showing several steps as simultaneous and interconnected, even if they did not occur at the same time or in the same location. Nineteenth-century illustrators condensed these processes and gave viewers a snapshot of their sequence, often eliding the geographical moves a product might make in order to provide a more unified composition. Agricultural products made good subjects for illustrators interested in representing processes of production and distribution. Because products such as cotton, sugar, rice, fruits, meats, and shellfish were processed, preserved, and distributed to faraway purchase points, they provided illustrators with multiple stages on which to focus. Fish and shellfish—including lobsters, sardines, oysters, and clams—were a frequent topic of illustration. Granville Perkins's attractive multi-panel design of sardine fishing and canning organizes a narrative from raw materials to distribution while maintaining the special knowledge and in-depth approach typical to the managerial eye (fig. 46).

Perkins's images profile the American Sardine Company, a New Jersey–based venture that fished, cured, tinned, and distributed sardines. The

story promises that the illustrations will take the viewer through "the several processes through which the fish are passed after being taken," a procedure which takes about three days from start to finish.[58] The center of the composition is dramatically taken up by a marine scene of fishing, while just above, boats land their catch. Surrounding the central panels are a series of smaller scenes depicting the many stages, each with a specialized operative, required to clean, cook, and package the fish for shipping. Although the organization is not entirely self-evident from the image itself, a quick glance at the article on the next page suggests that the viewer should begin in the lower left corner, where three men sit hunched over a spiked, revolving scaling machine. Continuing around the central frame counterclockwise, readers may follow the next steps in the process: cleaning, washing, pickling, and steaming. In the frame representing steaming, it is interesting to note the dress of the main figure, who inexplicably wears the apron and square hat usually associated with mechanics, masons, or other skilled craftsmen. This man's hat and fine shoes differ markedly from the more typical brimmed hats and knee-high boots worn by the workers in the four lower frames, and ties him visually to the two solderers shown directly across the page from him. The overlarge tins they solder shut point to another visual technique that was frequently used in magazine illustration of manufacturing: a skewed sense of scale that amplifies the size of the products illustrated. While this gives the illustration a clunky look and disorienting sense of perspective, the frequency with which exaggeratedly sized products appeared in these kinds of illustrations suggests that it was an intentional choice made by the artist to give the viewer a better look at what is occurring. By magnifying the size of the product, the artist enabled minute details to be seen clearly.

Above the scene of soldering is the packing room, where a wall of tins, artfully stacked, give a nice diagonal thrust to the image. This is mirrored in the upper right-hand corner, the scene depicting workers filling tins with oil, and the only image that does not seem to fit comfortably into the natural flow of the composition. Instead, however, this panel, with its mirroring of the diagonal across the page, gives a hint at the technique of the cross-section view. Here the diagonal is created not through a pile of fancifully stacked cans but through a cut-away that leaves part of the wall intact, denoting that the viewer is peering into a private space with a penetrating gaze. Throughout the exploration of sardine canning, the viewer has clearly attained a privileged view of the factory, but in this panel it is made most explicit. A final scene hints at the future of the sardines: at the bottom of the composition, they are ready to be "shipped in

Figure 46. Granville Perkins (American, 1830–95). "American Sardine Fishery," *Harper's Weekly*, April 18, 1874, 332. Wood engraving. 9½ x 14 in. Reproduced by permission from HarpWeek.

large quantities to every part of the country."[59] This image presumes to inform the viewer about a comprehensive set of processes that allowed her sardines to sit on the Saturday morning breakfast table, right next to her issue of *Harper's Weekly.*

Besides illustrating daily commodities, the managerial eye could take viewers deep beneath the earth, combining the informative qualities of multi-paneled images with the thrill of burrowing underground, a different manifestation of the cut-away view. The specter of industrial disaster always hung over representations of mining, as collapses and floods were often sensationalized in the press. Any representation of conditions in the mines would be especially revealing for readers, who would probably never themselves venture into such a space. In Paul Frenzeny's multi-frame image, the viewer gets an intimate glimpse inside a coal mine, supplementing a larger cover image and story about the history of American mining (fig. 47). Here the reader experiences visually "the various processes by which the coal is worked out from its bed in the mountain and prepared for the market."[60] This text prepares the reader for his examination of the many different types of jobs required to extract the valuable ore, in these years a commodity that most readers would come into contact with on a daily basis.

In the central image of his composition, Frenzeny uses a striking example of the cut-away technique when he blends into a single seamless frame the aftermath of a "blasting" and a scene of miners going "up the airhole." The jagged edge of the recently blasted rock provides the image with picturesque irregularity, while the three miners in the lower right-hand corner form a link between the viewer's space and the central vignette. Just beyond the blasted "breast," a miner, haloed by the light emanating from his helmet, emerges from a tunnel. He almost forms a mirror image of the men going up the airhole; all are simultaneously about to emerge into the large central cavern. Around this main image, the viewer gets glimpses of several specialized trades within the mine, such as the fire boss, whose job is to check for dangerous fire damp, and the surveyors, who decide the best way to approach the vein. All these scenes, along with the dark atmosphere of the overall composition, give a sense of tunneling through the rock. Rough edges and tunnel walls surround almost all the vignettes, reinforcing the enclosed nature of the mine. A final panel is worth close inspection because it depicts actual managerial control over the miners—the counting board, shown in the upper right corner of the composition. This board served as a means for the manager to keep track of the productive output of each employee:

Figure 47. Paul Frenzeny (French, 1840–1902). "Down among the Coal Mines—Inside the Mine," *Harper's Weekly,* February 22, 1873, 148. Wood engraving, 9½ x 14 in.

Going down to work, the miners have to pass the "counting board," on which are a number of pegs bearing the names of the workmen, and on each peg a number of wooden checks marked with corresponding names, each check representing a car-load of coal. These are distributed to the men as they pass in. When the trains come up with their loads of coal they have to pass this same point, and as they do so the drivers hand the checks to the counting boss, who returns them to the pegs, and at the end of the day there is the record of each man's labor, about which there can be no dispute.[61]

In this system, the counting boss represents the economic interests of the mine owners and points to an important aspect of the mining industry. Alfred Chandler wrote that as early as the 1840s, mining establishments began expanding and professionalizing their operations as well as employing greater numbers of men. By the time Frenzeny's images were made, many railroads and other manufacturing interests were purchasing shares in coal mines, thus reinforcing the ideology of vertical monopoly.[62] Coal mining served as an important locus of control over workers and as an example of the increasingly corporate, managed nature of the U.S. economy in the nineteenth century.

## Panoramas

The final visual form, that of the panorama, was adapted from another realm of popular visual culture, that of spectacular entertainment. The pre-cinematic forms of panoramas and cycloramas had long provided artists with one method of solving the temporal problems of representation. The incorporation of movement and sound effects made these attractions into all-encompassing spectacles for entertainment and education, marking what Tom Gunning has described as a nineteenth-century obsession with "an ever progressive and always elusive total and complete illusion."[63] In the postbellum era, panoramas and cycloramas were one of the few successful forms of artistic entertainment to depict the war openly.[64] While the brash display of one of these massive painted tableaux seems difficult to reconcile with the quiet, contained medium of magazine illustration, recall Henry Farny's successful distillation of his own panoramic paintings into managerial wood engravings. Other artists used some of the same techniques found in real-life panoramas—most commonly, the sensation of an unusual or elevated perspective or the broadening of the field of vision.

Figure 48. "The Manufacture of Power Printing Presses," *Scientific American,* March 27, 1880, 191 (detail). Wood engraving, 4½ x 9 in. Image courtesy of Harvard College Library, Cabot Science Library.

In this technique, which might better be called pseudo-panoramic, the illustrator adapts certain elements of panoramic representation to communicate quick and complete information with a single glance. Just as the panorama's presentation of "'realistic' effects in mass visual culture" relied on a constructed notion of the naturalness of vision and its ability to convey knowledge, so too did managerial panoramas provide magazine readers with naturalized, though wholly artificial, views into rational factory spaces.[65]

This technique may be seen in *Scientific American*'s representation of the Cottrell and Babcock machine works in Westerly, Rhode Island, where power printing presses were manufactured (fig. 48). Here viewers are able to oversee the entire manufacturing floor at a single glance. The room appears to recede into almost endless space, conjuring up visions of the 1876 Centennial or other vast, shedlike exposition buildings in which thousands of machines and products were collected for display. The raised perspective and the extremely wide angle of the view suggest an impossible vantage point, the imaginative creation of an artist desiring to give a representation that is both informational and aesthetically pleasing; this elevated perspective is the one "best view" that could be achieved from

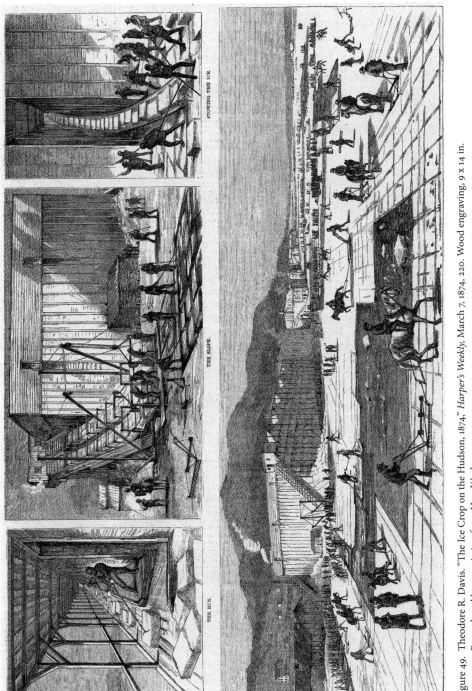

Figure 49. Theodore R. Davis. "The Ice Crop on the Hudson, 1874," *Harper's Weekly*, March 7, 1874, 220. Wood engraving, 9 x 14 in. Reproduced by permission from HarpWeek.

a single viewpoint.[66] Although its details recede into shadows, the image nevertheless gives an impression of mastery and control—the *viewer's* imagined control—over a printing press factory, an establishment whose products enabled the multiple reproductions of the very image the viewer was looking at.

An even broader panorama is granted in Theodore R. Davis's representation of ice harvesting on the Hudson River, a scene that gives the viewer an apparently unmediated glance over a large and complex operation (fig. 49). Its very naturalness belies its constructed nature, which is organized to communicate specific types of information. The lower panel, powerfully horizontal, shows a vast expanse of river ice being measured by horse-drawn sledges, cut, and floated down a water channel to the huge, factory-like ice house on the left. All different stages of the cutting are shown simultaneously, and despite the stillness of the scene, the masses of men, who show up as black blobs against the ice in the middle ground, give an effect of quiet industriousness. An estimated "three thousand men and boys" were employed at the seasonal work of harvesting a commodity that was, by 1874, "an article for household use which is no longer a luxury, but a necessity."[67] Richard D. Brown supported this observation, writing that technological and organizational improvements pioneered by the Boston industrialist Frederick Tudor around 1850 shifted ice from a "luxury of minor commercial significance" to "a national industry exercising a major influence on the American diet" with an intricate distribution and storage system.[68] Ice's essential role in other mutually reinforcing industries such as brewing and meatpacking contributed to its rapid rise from indulgence to necessity.[69] The lower panel also repeats a stage of the process from the middle scene above, which shows men loading the cut ice onto an external conveyor belt for ease of transport into the ice house. From there, the viewer travels up the ramp with the ice blocks and down again into the house, where a dozen men are "stowing the ice" in the upper right corner of the composition. In this series of scenes, it is the lower panorama that offers the most striking and informative vista; the other frames merely serve as enlarged details of the overall process.

What makes these scenes "managerial"? Images of this kind, whether or not they depict any scene that could actually be viewed by a real human being (as many clearly could not), operate to provide the viewer with a particular kind of knowledge, however inaccurate, manipulated, or optimistic. Over time, ways of representing the systems of managerial capitalism evolved into a rational, clear-cut visual language. Cut-away, multi-paneled,

and panoramic images gave viewers certain kinds of information about manufacturing and industrial processes. The managerial eye's impossible stance allowed the viewer to be exposed to the many concerns and responsibilities of the manager.

## Scenes of Managerial Control

It is crucial to recall, however, that the managerial class served an explicitly disciplinary and surveilling function. Instituting management structures designed for the regulation of workers was a source of constant resentment and resistance into the twentieth century.[70] I have argued that, in these images, viewers stand in for managers and may be led to believe that they possess both the managers' knowledge and their power over the workers depicted. But despite rapid growth of the professional-managerial class during the post–Civil War years, managers still made up a quite small percentage of the workforce in the 1880s and thus an even smaller percentage of the likely readership of a periodical like *Harper's Weekly*. Even considering that the *Weekly* was a magazine targeted toward the middle class and the upwardly mobile skilled working class, most viewers of these images, statistically speaking, were unlikely ever to enter a factory in the managerial role.[71] The feeling of control granted by the managerial eye was often misleading, even patently false, giving viewers an inflated sense of their access to knowledge. Representations that depict actual managerial figures allow analysis of the ways that power dynamics were expressed within the sphere of the factory. The managerial position heightened middle-class white males' authority over workers, particularly those already socially disenfranchised by their age, race, or gender. The control of the manager was expressed through his status as a mature white male, as well as his explicit representation as a figure of domination and supervision.

Managers frequently held power over their workers by virtue of a difference in age: managers of middle age might oversee workers as young as eight or ten years old in certain industries. In Theodore R. Davis's "The Coal-Mines of Pennsylvania—Preparing the Coal for the Market," the well-dressed, bearded manager with one hand on his hip appears as a paternal or, more aptly, paternalistic, figure dramatically surveying the labor of young mine workers (fig. 50). Standing with body language that exudes confidence, he holds a switch, particularly disturbing to the twenty-first-century viewer as it becomes evident that many, if not most,

Figure 50.   Theodore R. Davis. "The Coal-Mines of Pennsylvania—Preparing the Coal for the Market," *Harper's Weekly,* September 11, 1869, 581 (detail). Wood engraving, 4¼ x 9¼ in.

of the workers over whom he presides are children. Davis provides a vision of disciplinary and even violent managerial oversight in a scene that places the viewer in a similar position of power over the young laborers, described as "smutty young blackbirds" or "urchins."[72] The manager stands on a ledge, elevated above the vast and undifferentiated sea of operatives. Except for a row in the immediate foreground, most of these youths are delineated with a few strokes and merely add a sense of scale to the scene. Surprisingly for a journal that was already expressing concern over child welfare, the plight of these young boys makes no emotional appeal to the spectator; almost all of them, even the closest, are shown either turned away or in profile, disabling an affective relationship between viewer and worker. Instead, the obvious person with whom to identify, given the image's visual organization, is the manager.

Such compositional strategies were also mobilized to reinforce unequal racial relations between workers and managers. While representations of mixed-race labor forces were rare, when they did appear, the viewer was always asked to ally himself with the manager or boss through a compositional parity that related power to skin color. An image of Civil War engineering work demonstrates how both perspectival composition and race combined to create an image of white management and black labor (fig. 51). Not only are middle-class viewers divided from the African American workers by race but they also clearly stand above them on a shelf of earth 5 or 6 feet high. A single black soldier is also shown on

this level, but sitting, so as not to obscure the view of the two white men overseeing the digging, one in an officer's uniform. The proud officer and his companion are the ones who are shown as, literally, on the viewer's "level." They are also some of the only people who, like the viewer, avoid being cast under the slanting shadow that obscures many details within the earthwork. Images such as this used compositional techniques to reinforce both class and racial dominance in the mind of the viewer. There

Figure 51.  "View of General Butler's Dutch Gap Canal before the Explosion of the Bulk-Head," *Harper's Weekly*, January 21, 1865, cover. Wood engraving, 11 x 9¼ in.

are no statistics available on the racial makeup of the *Harper's* reading audience, but throughout its run, it was ambivalent, if not overtly hostile, toward African Americans, publishing frequently racist assumptions about their abilities. Its reportage consistently reinforced the assumption of a white reading audience, if a Republican one that in certain circumstances was sympathetic to African Americans' needs. By assuming the viewer as white, the maker of the image expected him to identify with the authoritative central figure. Managerial imagery implicitly reinforced the racial and economic power dynamic of the United States, assuring the reader of continued control both over African Americans and the working class.

Women constituted another traditional segment of the manufacturing economy, especially in the textile industry. A thread works in Willimantic, Connecticut, employed young female operatives at spinning and weaving, much as the earliest New England textile factories had done (fig. 52). A *Scribner's Monthly* profile of the factory noted its adherence to an ideology of efficiency. The laborious work of thread spooling was done by machines that rolled "exactly 200 yards of thread"; the spools then "slide down their appointed path" smoothly and regularly.[73] One of the earliest money-saving innovations connected with the thread and textile industry was the use of women and young boys as less expensive, unskilled labor, pioneered as early as the eighteenth century at sites like Lowell, Massachusetts. By the 1870s, the Willimantic works added other efficient labor practices, and the *Scribner's* artist showed these processes conducted by female operatives under the watchful eye of a manager. In this image, the working women appear fixed under the vigilant gaze and authoritative body language of the manager. In this specific industry, where many workers were traditionally female, the presence of a male controlling figure strengthened the power relations between labor and management. As with the young boys in the mines and the African American laborers on Civil War engineering works, an already unequal dynamic between worker and manager was compounded and magnified by a social inequity as well. Viewers were constantly reminded of the privileged class and educational status of managers in relation to the workers they oversaw.

Overt representations of managerial figures such as these began appearing in the 1860s, and by the following decades, visual imagery could attest to the ever-presence of the manager in the realm of commodity production. In these illustrations, the superiority of the managerial class over the working class, women, children, and racial minorities was constantly

"WARRANTED 200 YARDS."

Figure 52. "Warranted 200 Yards," *Scribner's Monthly,* September 1878, 708. Wood engraving, 3½ x 5 in. Image courtesy of Harvard College Library, Widener Library.

reinforced, and the viewer was asked over and over again to identify himself with those figures who straddled the line between labor and capital.

## Coda: Managing Money

In a final composition, the viewer is taken inside the Philadelphia Mint to see the minting of silver currency (fig. 53). The drawings of the mint use several techniques, including a modified version of the cut-away, panorama and spatial distortion, the inclusion of middle-class spectators (if not actual managerial figures), and the careful leading of the viewer through several stages required to produce the finished commodity. In these images, it is clear that the mint welcomed and was perhaps even designed for the touristic visits of middle-class citizens, several of whom are shown perusing its various departments. Stretching a point a bit, it could be argued that this industry was particularly open to "management" from everyday Americans, since it was a federal service in this government of, by, and for the people. This image is, I believe, unique for showing not one but four separate tourist couples, which could be construed as support for a reading that this particular "product" was even more susceptible

Figure 53. "Coining Silver Dollars at the Philadelphia Mint," *Harper's Weekly*, June 19, 1880, 388. Wood engraving, 9¼ x 14 in.

to outside managerial involvement from non-specialist citizens. Other than that detail, there is nothing particularly striking about this series of scenes; it merely gives, once again, a familiar arsenal of visual strategies of vicarious management. Yet this apparently dull composition brings us, in a way, full circle. Representations of the minting of money serve as a potent reminder that all the images seen in this chapter rested on the proper operation of commerce. That money itself was, in a way, a mass produced commodity, is important to consider in the technological system of production and exchange conjured up by images classified under the managerial eye. That even a basic unit of currency had to be manufactured—and broken down into specialized steps in a similar way to the commodities that money would be used to purchase—is a compelling reminder of the interconnectedness of all these seemingly disparate images.

Through many different means of visual framing, then, illustrators throughout the later part of the nineteenth century successfully communicated to periodical readers the complexities and details of commodity production in the growing economy of the United States. During these same years, American businesses were expanding and implementing new techniques of management that were constantly evolving throughout the century. A startling concurrence between the industries that were early adopters of managerial systems and those depicted in periodicals indicates that the illustrators were employed to showcase the new ideas of efficiency, linear narrative, job specialization, and integrated production which were an integral part of the ideology of management. These industries included those that have been examined in depth here, as well as others that were also covered in the periodicals, such as iron and steel production, glassmaking, and the manufacture of canned foods, beverages, and other consumer articles. Talented magazine illustrators developed the visual vocabulary best suited to the representation of manufacturing, allowing viewers to construct a fantasy of complete managerial knowledge. Viewers were also expected to ally themselves with the emergent management class through these visual means.

Lest we think that the only connecting thread between these images is their use of shared visual techniques, the scenes of the Philadelphia Mint remind us that we, and nineteenth-century viewers, must think more broadly than that. The managerial eye was not only a means for understanding the workings of a particular factory or mine. Instead, it was a powerful set of visual tropes that allowed readers of *Harper's Weekly* and other popular magazines to situate individual manufacturers, products, and services within the larger, and ever-present, matrix of technological

systems, and to carve out a privileged site for themselves in that nexus. The power of the managerial eye has much in common with the emergence of a proto–Progressive Era shift toward a more structured, straightforward, "managed" society seen through images' attempts to intervene in and govern the worlds of American education and social life.

# Chapter 6

# Laziness and Civilization

## Picturing Sites of Social Control

DURING THE years that managerial ideology was on the rise in American industry, it was also growing in the social realm. Perhaps it was building neither as quickly nor as powerfully, but nevertheless the language of efficiency and systems was restructuring social relations. How else to explain Reverend D. O. Kellogg's March 1880 address to the American Social Science Association (ASSA), in which he explicitly outlined the ethos of technological systems in order to compare it to the goals and structures of social welfare:

> The industrial world has grown into a marvellously complex organization, of which the rapid expansion predicts the day when the entire globe will be but one gigantic factory. The farmer of Minnesota sows his grain in coöperation with the factory hands of Lowell, who spin and weave his clothing, and with the meat-packer of Cincinnati or Chicago, who feeds him . . . and the process ends, perhaps, in the tea brought from China to his table. At each stage of the series of transactions, a number of distinct interests are focussed, the influence of which is felt over continents and hemispheres.

Kellogg continued with an argument in favor of "studious, systematic work" toward the alleviation of the social ills of poverty, crime, and lack of proper education.[1]

Kellogg, as a member of the ASSA, was one of a growing cadre of postwar middle-class reformers who arose to attack the problems of American social life using the tools of industrial management. This chapter addresses

institutions of social control in the 1870s and 1880s and their embrace of the bureaucratic structures of managerial capitalism that were revolutionizing the worlds of business and industry. Specifically, it analyzes representations of sites where people were taught to be laborers, including the school, workhouse, and penitentiary.

The kind of philanthropic, middle-class imperative represented by Kellogg's address to his fellow social scientists is primarily associated with the Progressive Era, which began in the mid-1890s and extended into the early twentieth century. This ideology, however, was already manifesting decades earlier. Beginning in the late 1860s, Americans increasingly encountered visual imagery and textual sources calling for the creation of organizational structures to deal with the widening social gaps of the Gilded Age. Key areas of focus, as with the settlement houses and educational institutions favored by later Progressives, were systematic investigation of inequality and structured eradication of poverty. I interpret this systematic focus as a concerted attempt to apply the language of technological systems and the logic of management in the social realm as energetically as they were deployed in the factory. Images, primarily in the popular press, dictated the proper standards for citizenship in the United States through a visual vocabulary that stressed the centrality of labor as a core American value and a prerequisite for proper citizenship. During this era, representations of social systems, from the public school to the workhouse and prison, constructed an ideal worker in viewers' minds. Just as artists had manipulated representations of railroads, telegraphs, and cityscapes to stress the role of technological systems in creating an ideal, modernized nation, postwar representations of social systems used mechanistic and managerial metaphors to envision an ideal workingman who had been shaped by a powerful set of social organizations. My analysis of these organizations progresses from the most benign and normative to the most severe, moving from the rise in public education after the Civil War to debates over convict labor in the 1880s. All the sites I examine were conceptualized as places where citizens could be taught the value of labor and could be shaped into properly productive workers.

These institutions were in flux during the volatile postwar years, before the government began seriously to intervene in both industry and the social realm during the 1890s. The upheavals of the Civil War created changes that led to growing professionalization in many walks of life, including education, social welfare, and criminology. Charitable, educational, and penal institutions were increasingly created with an eye to

solving social problems through rigidified systems of organization and regulation.[2] Social life was now overseen by teachers, wardens, reformers, and government civil service workers. In the areas of art and culture, too, the postwar "enthusiasm for institutional development flourished" with increased attention to artistic and didactic organizations, schools, and publications, as the art historian J. M. Mancini notes.[3] This growing atmosphere of social control implicitly overlapped with productive labor: being a good, and normative, citizen was often expressed using various metaphors of "work." In fact, the historian Michael B. Katz notes a specific link between the emergence of corporate capitalism and changes in the organization of schools and other institutions, which "reflected the drive toward order, rationality, discipline, and specialization inherent in capitalism."[4] Alternately, deviance of various kinds was an expression of the *failure* to work properly. Advocates for universal, required education suggested it as the most effective way to socialize children and ensure their productive capacities, but for those who slipped through the cracks, workhouses and prisons operated as sites of forced utility and retraining. The "cure" for social deviance, as the historian James B. Gilbert stated, "often meant nothing more than the ability to return to the job."[5] Popular imagery avidly declared the uplifting moral, economic, and personal rewards of work during the same years that technological reforms were transforming traditional notions of what "work" looked like. Illustrators seized on the visual vocabulary of the managerial eye to depict work that occurred in key sites of social training and control.

Like contemporary imagery of factory interiors, representations of social structures helped viewers to visualize their country in terms of process, organization, and system. These images appeared in similar venues, the illustrated magazines, and were implicitly allied with the normative middle-class messages those publications tended to promote. While industrial images taught viewers to see the world like managers, representations of the social order showed them how to think like reformers. As suggested by guidebooks from the 1870s listing Philadelphia's Eastern Penitentiary and New York's Workhouse as sites of interest, middle-class travelers were accustomed to viewing penitentiaries and other institutional structures as places of spectacle for touristic enjoyment.[6] Increasingly, they were also asked to enter those institutions with an eye to reform. Just as industrial imagery had coached viewers in the tactics of the managerial eye, illustrators asked their audiences to "manage" questions of poverty, social fitness, and labor.

*The Rise of Social "Management"*

During the early republic, there was a marked rise in charitable and restrictive organizations intended to control, survey, and define the population. David J. Rothman argued in *The Discovery of the Asylum* that the usefulness of these institutions for categorizing and monitoring the population was "discovered" as part of the country's process of modernization. One of the ways to make the population conform to standards of normality—often defined just as clearly by what was aberrant as by what was desirable—was to place people in institutions designed to create social order. Often these institutions locked away and segregated certain types of people, submitting them to forced regimes of homogeneity and attempting to educate them about how they "should" behave. Rothman contended that the ideological importance of prisons, asylums, poorhouses, and schools grew during the early republic, in contrast with their relative unimportance during the colonial period. Incidence of such institutions increased during the early years of the nineteenth century as relief of various conditions—whether poverty, criminality, illness, or insanity—moved outside the home and became part of a public mandate of order and control.[7] This was apparent in the earliest factory systems, such as those at Lowell, Massachusetts, which were part of this impulse toward regulation and organization. Working in one of the early factories in Massachusetts or Rhode Island was intended as an experience that would impress young, usually female employees with a sense of organization, punctuality, discipline, and self-control.[8] But despite the rise in charitable and penal organizations in these years, most were administered haphazardly and without any unifying philosophy.

After the Civil War, unofficial civil-service reform shaped a second wave of institutional restructuring. Many of these changes were as a direct consequence of the war. An army of clerks arose to oversee administration of relief for newly freed slaves and to process benefits for wounded veterans and the families of the deceased.[9] Tasks previously performed by volunteers were consolidated under state and federal control; for example, between 1863 and 1886, twelve states formed State Boards of Charity, which oversaw poor relief and also held educational and penal responsibilities.[10] When, in 1869, *Frank Leslie's Illustrated Newspaper* called for "more systematic benevolent attention" to those still suffering from the war's aftermath, it foreshadowed the greater institutional changes to come in the following decades.[11] Managerial ideology permeated the language of charitable and penal institutions alike during these years.[12] B. K. Pierce, chaplain of New York's House of Refuge, a reformatory for criminal boys, wrote proudly

in 1869 that "the institution . . . has increased from year to year in its efficiency," explicitly connecting the mission of the house with the keyword of managerial capitalism.[13] Similarly, George J. Luckey, president of the Pennsylvania State Teachers' Association, spoke in 1874 of the importance of developing an "all-comprehensive, symmetrical system" of education, a systematic approach to any task being a hallmark of the developing management ideology.[14] Such attention to efficiency and systems provided a way of thinking about society as a business: well-organized structures could keep track of many bodies and provide formulaic means of dealing with those bodies.

The earliest roots of the Progressive ideology of middle-class social work arose during this period—though it was not yet called social work. The *Journal of Social Science* was founded in 1869, and its articles covered topics ranging from urban poverty and education to immigration, social justice, and penal corrections.[15] It was later followed by the *Publications of the American Statistical Association* (1888), the *Annals of the American Academy of Political and Social Science* (1890), and the *American Journal of Sociology* (1895), all of which mandated scientific examination of social and economic problems.[16] As is evident from these dates, professionalization of sociology did not strongly take hold until the 1880s and later. Still, earlier private and amateur charitable groups embraced a proto-professional outlook on dealing with poverty, education, and other social concerns. Professionalization in other fields dealing with the management and control of the social realm was also growing during the same years: organizations for the professional development of public school teachers, artists, and even physical educators were in constant growth during the two decades following the end of the war.[17]

The rise in "scientific charity" following reunification was an attempt to impose managerial-style control on the social realm. Reverend S. Humphreys Gurteen, an advocate of scientific charity, phrased the movement as a battle against "concentrated and systematized pauperism," implying that structured conditions of poverty required structured responses from reformer-managers.[18] So-called Charity Organization Societies were designed to rationalize and conglomerate preexisting philanthropic organizations to "bring order to their charitable work."[19] In the social realm, the language of industrial management could also be applied to the management of the self, calling for the well-ordered regulation and shaping of a citizenry through work. The rhetorical language of many charities explicitly linked factory management and philanthropy. In the 1880s and later, social scientists urged philanthropists "to do in charity what is done

in commerce and industry—so to arrange its different agencies, and so to coördinate its different forces as to attain a certain end with the least possible waste of energy."[20] This focus on the efficiency of charitable work and the managerial qualities of philanthropic organizers reinforced the intimate connection between the industrial and the social. Scientific charity marked the beginnings of a move away from the Victorian culture of sentimentality while still remaining moored to many of sentimentality's tropes for depicting the poor.[21] Images not only taught viewers to think like philanthropists; they also powerfully worked to shape public opinions of deviance and its cure. Representations of schools, workhouses, and prisons began to mirror the visual constructions of the managerial eye. The structures themselves were put before the viewer, made visible to clarify what went on within them. Images cut into these sites the way the managerial eye cut through factories to reveal inner workings beneath brick exteriors.

## Schools as Sites of Training

Education was a cornerstone of the movement to standardize and control labor. Government provision of public schools and legislators' increasing insistence that children attend them marked an important turning point in the conception of education. There are two general strands important for this analysis: public elementary education and technical education. Common to both modes was a dual purpose: helping place students in various employments and simultaneously instilling in them the values of application, diligence, and self-reliance. The power of general elementary schooling as a tool for establishing uniform morals and values was central to debates about education during the Gilded Age. School attendance had tripled between 1800 and 1860, when measured by average number of days per annum spent in school.[22] According to Michael B. Katz, promoters of general elementary education argued that structured learning environments were ideal sites for "the inculcation of modern habits of punctuality, regularity, docility, and the postponement of gratification," lessons that would make students into able and compliant workers later in life.[23] A historian of American education, John L. Rury, concurs with this, writing that nineteenth-century reformers saw universal elementary education as good training for an economic system that foregrounded the "rule of the clock and efficiency."[24] Scholars of American education generally argue that "popular education" and "democratic capitalism" were ideologically intertwined during the late nineteenth century.[25] Sherri Broder,

however, notes that the reformers' focus on "compulsory schooling" was an attempt "to impose on society a middle-class construction of childhood as a period of innocence, vulnerability, and parental protection."[26] Many working-class children could not afford to forego a paycheck to attend school. Clearly, questions of education and children's labor were intimately connected, particularly among the children of the poor.

Reformers who condemned the lack of public education in the United States were prone to attack impoverished parents for failing to bring their children to school, sending them out to work instead. In an article with the saccharine title "The Little Laborers of New York City," the founder of the Children's Aid Society, Charles Loring Brace, decried what he saw as a short-sightedness among the poorer classes of New York, adversely comparing middle-class and working-class family structures: "With the children of the fortunate classes there are certain years of childhood which every parent feels ought to be freed from the burdens and responsibilities of life. The 'struggle for existence,' the labor of money-making, the toil for support, and all the cares and anxieties therewith, will come soon enough. And the parent is glad that the first years at least should be buoyant and free from care." By contrast, Brace argued, the parents of the working class or the working poor could "indulge in no such sentiments." He insisted that their children were compelled to enter the workforce at an early age, mainly because parents were "indifferent to the child's natural growth and improvement." Unlike middle- or upper-class parents, who understood the value of education for future success, "the laborer sees the daily earnings, and does not think much of the future advantages which the child may win by being educated now."[27] Brace's bias comes out strongly when he characterizes the working class as lacking long-term problem-solving skills, imagining them as more concerned with profiting from their children than cultivating those children as future citizens.

Brace's conclusions were challenged from the left by the economist of poverty Henry George, who opposed child labor in all forms, claiming that the pernicious system of poverty in the United States "condemned children yet unborn to the brothel and the penitentiary."[28] George was one of the earliest authors to shift the blame for poverty away from the working class and onto the immoral practices of American manufacturing. But the mainstream of American society seemed to accept Brace's claims, including the president of Brown University and treasurer of the ASSA, the moral philosopher Francis Wayland. Wayland wrote in his tome *The Elements of Moral Science* about children "forced to labor before they are able to endure confinement and fatigue, or to labor vastly beyond their strength;

so that the vigor of their constitution is destroyed even in infancy." Who was to blame for this evil situation? Wayland argued that guilt was "shared between the parent who thus sells his child's health and life for gold, and the heartless agent who thus profits by his wickedness," but the violence of Wayland's language against the "parent's selfishness" and "love of gain" suggests that he believed the blame lay most powerfully with working-class parents who allowed their children to enter the workforce too early.[29]

Brace focused on New York as a representative example of the problems with child labor, where children were often submitted to work schedules as grueling as those of adults. "How intense and wearying is their daily toil," Brace wrote, "and how much of their health and education is sacrificed in these early years and premature labor!" To correct what reformers saw as a coming political and industrial crisis, the Children's Aid Society offered education as the solution for poverty and child labor. At the society's schools, Brace continued, children "of the working classes are taught habits of industry, order, and cleanliness, together with common-school lessons and [skills of] some industrial branch."[30] Both educational and industrial systems required children to behave in a restrained, compliant manner and to take direction from adult authorities who supervised and regulated their efforts. The difference was that the children in the workforce had entered that space too early, before learning the values of "industry, order, and cleanliness" that might have been gained by attending school. They lacked the proper educational grounding to make them efficient and trustworthy workers. What Brace's argument did *not* do was suggest a means to lift these children out of poverty; instead, he offered a censorious analysis of the working class as opportunistic and short-sighted, while re-inscribing the importance of education to mold children into well-prepared workers. The pupils of the Children's Aid Society enacted their own future as "little laborers."

The connection Gilded Age society saw between childhood education and later utility to society is apparent in a pair of illustrations sketched by Charles Stanley Reinhart from designs by the painter Percival De Luce, published in *Harper's Weekly* in December 1874 (figs. 54 and 55). Through their juxtaposition, both illustrations convince the viewer of the need to regard teachers as public servants no less important than policemen for upholding social order. The illustration titled "Children Who Do Not Go to Our Public Schools" (fig. 54) takes the viewer through a litany of social disorder, laziness, violence, and vice. Without a proper education, it implies, children will grow up to participate in socially destructive activities such as theft, gambling (and cheating at gambling), drunken debauchery,

CHILDREN WHO DO NOT GO TO OUR PUBLIC SCHOOLS.—From a Design by Percival De Luce.—[See Page 1046.]

Figure 54. Percival De Luce (American, 1847–1914) and Charles Stanley Reinhart (American, 1844–96). "Children Who Do Not Go to Our Public Schools," *Harper's Weekly,* December 19, 1874, 1045. Wood engraving, 14 x 9½ in.

CHILDREN WHO GO TO OUR PUBLIC SCHOOLS.—From a Design by Percival De Luce.—[See Page 1046.]

Figure 55. Percival De Luce and Charles Stanley Reinhart. "Children Who Go to Our Public Schools,"
*Harper's Weekly,* December 19, 1874, 1044. Wood engraving, 14 x 9½ in.

rioting, prostitution, and murder. The likely endpoints for these activities are the gallows or the Tombs Prison, whose grim Egyptian Revival facade forms the base of the composition. The other, smaller vignettes surrounding the central oval depict acts of violence and desperation to which the uneducated may turn. The only slightly obscure panel is at the lower left, showing two well-dressed women walking through the street, with two men looking back at them. The inclusion of a lit gas lamp with radiating beams exposes the women as "loose" females walking unescorted at night and the appreciative men as potential customers. Most of these surrounding images are representations of future repercussions, but the central scene demonstrates the immediate effects of neglecting education. Six children are playing in the courtyard of a large tenement block. The boys quarrel and smoke cigars; the central boy may be preparing to throw the brick he holds in his left hand. A young girl pokes disconsolately at a toy ship floating in a puddle of gutter muck. A dead cat lying nearby may be evidence either of the boys' cruelty or of the disease and filth of the tenements. A slightly older girl cares for a baby, elaborating on Brace's opinion that the poorer classes were unable to tend to their children. Surmounting the entire scene is a smashed ballot box, the culmination of these children's failures: not only will they not grow up to be useful workers, this image implies, but they will also be susceptible to election fraud, bribery, or uninformed decision making.

The pendant image titled "Children Who Go to Our Public Schools" (fig. 55) is a fervent plea in support of education. Although the central image depicts a country schoolmistress and five well-dressed, genteel children, the margins are filled with representations of manual labor and industry. Beginning at the top left and moving clockwise, the professions depicted include printing, carpentry, reaping, working for the railroad, middle-class motherhood, shipbuilding, blacksmithing, and literary endeavors. Seventy-five percent of the occupations depicted would typically be held by members of the working class. The other two represent "brain work" and childrearing, occupations concerned with reproducing education in coming generations. To the right and left of the central oval, as well as directly above it, "tools of the trade" for three major sectors of society—agriculture, industry, and the arts—dominate, like heraldic blazons. At the base of the composition, where the Tombs could be seen on the contrasting image, the ballot box, here whole and undisturbed, is accompanied by the book of "law and order." The message to viewers is clear: not only is having education preferable to having none (fairly self-evident), and not only is education a prerequisite for an orderly and productive society, but

industrial and agricultural work form the backbone that allows middle-class leisure. In this formulation, members of the working class must be educated in order to maintain the standards of society held dear by members of the middle and intellectual classes. Labor is visually imagined as the means by which the working class may be used to uphold the status quo. At the same time, the images suggest the positive power of education as a tool enabling the attainment of, if not gentility, at least self-sufficiency by members of the working class.

Work and education were bound together even more inextricably in the case of technical education, which began to be standardized after the Civil War and gradually replaced the apprenticeship system that had characterized earlier periods of industrial development. While the informal master-apprentice structure was dwindling due to a decrease in artisanal production, institutionally based technical education was growing in influence. Formalized degree requirements increasingly shaped the educational experiences of skilled laborers. Even for certain unskilled or semi-skilled jobs, technical training became an important part of workplace preparedness. The acceptance of technical education—which prestigious schools such as Harvard University originally frowned on as counter-intellectual—was greatly helped by the Morrill Act, passed by Congress in 1862. The act allowed for federal financial support to allow the foundation of state universities to teach engineering and the "mechanic arts."

The Morrill Act directly contributed to a huge postwar outgrowth of trained engineers and technicians as major colleges began to incorporate technical education into their curricula and added graduate programs in engineering.[31] One of the most striking examples is that of the Pratt Institute of Brooklyn, opened in 1887 and specifically dedicated to training in the industrial arts. The businessman Charles Pratt founded the school for the "industrial classes" on the principle that "the value of intelligent handicraft and skilled labor" should grant the mechanical arts "like dignity with the liberal pursuits." Pratt's goal was to "secure . . . the symmetrical development, moral, mental, and physical, of its pupils," and thus it conformed to "the radical idea of the 'new education' in attempting to develop all the powers symmetrically, instead of endeavoring to train a single set of faculties merely."[32] The courses of instruction at Pratt included, for boys, woodworking, chemistry, mechanical drawing, metallurgy, and machine work, and, for girls, sewing, hygiene, nursing, and cooking. While segregated by gender, these trades showed a clear bias, at least among the male occupations, toward sets of knowledge that would be required for working in modern industry and the sciences.

Not all students received such specialized training, however. The foundation of technical colleges for the education of African Americans began directly after the Civil War with the intention of preparing emancipated slaves for the workforce. The goal of these colleges, chief among them the Hampton Normal and Agricultural Institute, was primarily to educate young people in technical skills and middle-class normative behavior. According to an 1873 profile of the school, Hampton's "primary object should be a thorough training for future usefulness and the creation of a respect for labor."[33] Modern historians, however, have contended that Hampton's educational program re-inscribed restrictive notions of racial ability, including arguments that certain subjects like mathematics would be irrelevant to the future lives of African American students.[34] In addition, art historians have examined how images of the school communicated those ideas to the public. The relationship between industry and education at Hampton was neither straightforward nor simple.

General Samuel Chapman Armstrong, first principal of Hampton, was concerned that after Emancipation, "the freedmen would slip back into the inert contentment with ignorance that belongs to slavery."[35] Hampton was partially founded on this assumption that former slaves needed to be *taught* self-reliance and diligence; Armstrong wrote of the necessity for a "routine of industrious habit" to better acclimate nonwhite students to working.[36] Male students worked in the printing office and farm, while women were put to work sewing and laundering clothes. Thus the program of study at Hampton, as at Pratt, was segregated according to ideas about work and gender. Laura Wexler argues, however, that the tasks most students learned at Hampton were not preparing them for the cutting-edge technological world but instead for "a second-class career at best and more likely for domestic service or low-level, nonunion labor."[37] A comparison of representations of students in training at the two schools demonstrates this.

W. A. Rogers's illustrations of Pratt give an excellent cross-section of the skills offered there (fig. 56). Women are shown learning to cook and type, and are given instruction in "treatment for apparent drowning" not by performing resuscitation themselves but rather by watching a demonstration by an older male teacher. The cluster of women sit upright on their chairs, taking careful notes. In the background, a framed picture of a mother and child and a folding bed hint at possible applications for their knowledge of "Hygiene and Home-nursing." By contrast, images of Hampton show black women engaged in a more distinctly domestic craft (fig. 57). In "Girls' Industrial Room," a white instructor oversees four

THE PRATT INSTITUTE, BROOKLYN, NEW YORK—THE PUPILS AT WORK.—Drawn by W. A. Rogers.—[See Page 214]

Figure 56. W. A. Rogers (American, 1854–1931). "The Pratt Institute, Brooklyn, New York—The Pupils at Work," *Harper's Weekly*, March 21, 1891, 213. Wood engraving and process line engravings, 9½ x 14½ in.

female students who are seated at sewing machines. They are dressed demurely but fashionably, engaging in a domestic activity seen as appropriate to the sphere of nineteenth-century womanhood but also preparing them for careers as seamstresses or laundresses. By contrast with the semi-professional pursuits implied in Rogers's illustration of Pratt, "Girls' Industrial Room" suggests a role for African Americans that is different and less modern than the place afforded many whites.

Male occupations are more clearly the focus in images of both Pratt and Hampton; however, the division between modern, industrialized labor and more outmoded methods of production remains. At Pratt, men are shown conducting scientific experiments, turning wood on mechanical lathes, and learning blacksmithing in the "Forge-shop." Pratt provided

Figure 57. "Girls' Industrial Room," *Harper's New Monthly Magazine,* October 1873, 680. Wood engraving, 3½ x 3½ in.

Hampton (vs. Pratt — white)

Figure 58. "The Printing-Office," *Harper's New Monthly Magazine,* October 1873, 679.
        Wood engraving, 3½ x 3½ in.

technical training in the broadest sense: it taught a wide range of useful skills with the aim of instilling in students "habits of thrift . . . self-reliance, and . . . personal character" while giving them a broad grounding in different types of work.[38] While Pratt's ethos valued specific skills, one Hampton student wrote more vaguely that, through education and hard work, he hoped "to make myself a good and useful man."[39] This sentiment echoed Armstrong's argument that African American students needed "less of mathematics, but more manhood," a claim made at the 1872 meeting of the National Education Association.[40] Imagery of the school's printing room bears out this less ambitious relationship to the world of modern industry (fig. 58). Male students are shown typesetting,

printing, and binding copies of the *Southern Workman,* a monthly periodical aimed at former slaves and dedicated to articles on racial issues, agriculture and science, and good housekeeping. The techniques of printing and binding used by these students are somewhat outmoded compared to the technologies that were current in the printing trades; in addition, a large proportion of jobs in printing and binding (though not typesetting) were low paying and typically held by women and young boys, not grown men. Like the young black women who were learning sewing and laundering, Hampton's male students look less prepared and less modern than their white counterparts at Pratt. Education remained highly segregated throughout the nineteenth century, despite attempts to improve technical training for African American students. Nevertheless, both Pratt and Hampton used technical education as a means of continuing the social training begun in public schools: the inculcation of a respect for labor for its own sake and the formation of mentally, morally, and physically able workers.

## On-the-Job Education

While schools such as Pratt and Hampton were developing programs of technical training, reformers expected those who were already gainfully employed to continue their education. Programs of industrial paternalism, such as that practiced by the Cheney Brothers silk company, emphasized an agenda of enforced temperance, aesthetic and sanitary modern housing, and programs to help their workers gain "the material conditions of self-respect."[41] Among these resources were educational programs, schools, and libraries, where workers could have access to books and periodicals. A similar setup existed in other industrial complexes throughout the country, including in Richmond, Virginia, one of many southern cities profiled by Kirk Munroe for the *Harper's Weekly* series "The New South."

John Durkin's images of the Allen and Ginter cigarette factory demonstrate that industrialists and perhaps workers believed in the benevolence of corporate educational programs (fig. 59). The largest image in the composition "Richmond—A Cigarette Factory" shows seemingly endless rows of women and girls engaged in rolling cigarettes by hand. The few males in the scene, all standing, suggest a gendered hierarchy evident in many other industries, where managers tended to be white males. Most of the women are dressed simply in shirtwaists and long skirts; none wears

Figure 59. John Durkin (American, 1868–1903). "Richmond—A Cigarette Factory," *Harper's Weekly*, January 15, 1887, 50–51. Wood engraving, 14 x 20 in.

protective gloves to shield her skin from the poisoning effects of the nico-tine in the tobacco. Each woman bends over her workstation like a student at a school desk, which the work surfaces resemble. Little interaction oc-curs among the operatives, in contrast to their more animated behavior in "Quitting Time," the small horizontal image above the factory scene. Here, the employees move off in small clusters, some accompanied by husbands or sweethearts.

It is the upper left illustration, "The Library," however, that focuses on the factory's desire to educate its employees. In it, eight female workers and a male librarian take advantage of one of the "beneficent schemes for their mental improvement." The library is "filled with the best stan-dard literature, from which every employée is entitled to take, and keep for two weeks at a time, such books as she chooses."[42] Such educational programs served to displace other kinds of knowledge that might pose a threat to managerial hegemony. Access to the novels of Charles Dickens and Anthony Trollope was substituted for the technical knowledge that could have "allowed the skilled worker . . . to maintain control over the work process by retaining control over his own labor and the decisions that governed it."[43] While some might see this as educating workers to gain social capital, the texts allowed were primarily harmless, sentimental, and politically neutral. The *kinds* of knowledge distributed in such lending libraries served to reinforce the power relations of corporate capitalism.

The juxtaposition of the two settings also reinforces the difference be-tween the airless space of the factory, with its gray gloom, hatched by the engraver with diagonal lines across almost the entire surface, and the light, airy room of the library, whose execution has the freeness of a line drawing. The workers appear more stylishly dressed here, two with fashionable bonnets and one, second from the right, in a two-toned gown with a modish apron drapery across the skirt. The clothes and setting sug-gest genteel, middle-class aspirations, but when contrasted with the scene below, the unlikeliness of these ambitions is emphasized. Nevertheless, it is clear that the factory owners wish them to continue their education, to shape them into well-read, civic-minded workers. Academic critiques of corporate paternalism, such as those leveled by Charles Francis Adams, Jr., and Henry George, failed to reach readers in sufficient numbers to combat the unabashed boosterism of *Harper's*.[44] In the Allen and Ginter factory, literacy was connected with labor and responsible citizenship—as long as workers did not become so educated that they began to question the system. The intertwining of work and education was a manifestation of the social and industrial need for order.

*Painting Craft / The Craft of Painting*

Despite the strides made in both education and commerce, many observers believed that the United States was entering a period of crisis brought on by the de-skilling of labor and the eradication of some traditional industries. Jobs "calling for the highest skill . . . ceased altogether," the *Harper's Weekly* editors complained, in an echo of rhetoric that had been appearing since at least the beginning of the nineteenth century and that continues into the early twenty-first.[45] Part of the blame for this was placed on young people who were said to prefer "the comparative ease and gentility of the counting-room to the more manly occupation of a trade or the farm."[46] The focus on "manly" occupations, as opposed to the effeminate labor of the brain worker, echoed a well-documented post–Civil War belief in a crisis in masculinity, which led to a widespread attempt to re-instill traits of manliness.[47] Ironically, the very changes that had allowed "manly" manual laborers to do their jobs more efficiently were brought on by the interventions of white-collar workers, and the zealous drive for order perpetuated and exponentially increased the need for such managers.

The once central class of skilled mechanics was shrinking, and with it, the traditional master-apprentice relationship as the primary means of obtaining industrial education and training. Apprenticeship was usually associated with small-scale skilled trades that were not utilizing processes of industrialization. Therefore, it is not surprising that recording this decline occurred not in the pages of pro-business magazines, with their forward-looking impetus, but rather within the more traditional realm of the art world. By the 1870s, paintings frequently depicted skilled craftsmanship as a disappearing aspect of preindustrial life.[48] In compositions showing craftsmen with young apprentices, American artists such as Henry Ossawa Tanner, Theodore Robinson, and Charles Frederick Ulrich reinforced a sense of passing. Tanner's *Young Sabot Maker* (1895), Robinson's *The Forge* (1886), and Ulrich's *The Village Printing Shop, Haarlem, Holland* (fig. 60) situate their youthful laborers in clearly European settings, contrasting Continental continuities of craft production with modernized American educational systems. The most enigmatic and quiet of these paintings, *The Village Printing Shop* presents evasion rather than explicit labor. The two adults working the press turn away from the artist, their faces obscured; even the central boy, taking a cup of tea rather than laboring, does not address the viewer, instead giving a partial profile. This oblique composition suggests an unwillingness to address spectators. Turning away from

viewers, these figures seem mournful, suggesting the passing of an era. Europe's retention of the apprenticeship system marked it as a place of stagnation and nostalgia.

Some industries did continue to uphold the system of informal education; one of the most notable was the iron industry. Until the widespread adoption of the Bessemer steel process in the 1880s, iron puddling was one of the most dangerous but also the most lucrative jobs available in the metalworking industries. Iron puddlers were an elite class of laborers

Figure 60. Charles Frederick Ulrich (1858–1908). *The Village Printing Shop, Haarlem, Holland*, 1884. Oil on panel, 21¼ x 22¹⁵⁄₁₆ in. Daniel J. Terra Collection, 1992.137. Photo credit: Terra Foundation for American Art, Chicago / Art Resource, NY.

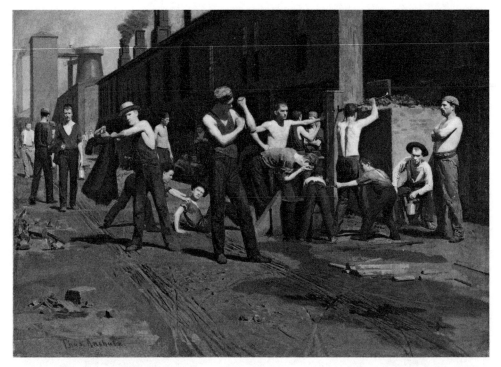

Figure 61.   Thomas Pollock Anshutz (American, 1851–1912). *The Ironworkers' Noontime*, 1880.
Oil on canvas, 17 x 23⅞ in. (43.2 x 60.6 cm). The Fine Arts Museums of San Francisco,
Gift of Mr. and Mrs. John D. Rockefeller, 3rd, 1979.7.4.

who maintained apprenticeship structures. As they required assistants
who were small and nimble, young boys often became apprentice pud-
dlers. Most were under thirty and would "retire" to other, less demand-
ing jobs within an ironworks, ceding their spots to their apprentices. As
such, it was a position with a short lifespan but one that required intense
training and experience.[49] One of the most famous images of industry in
the nineteenth-century United States is Thomas Pollock Anshutz's *The
Ironworkers' Noontime* (fig. 61). Anshutz completed only a single work on
the theme of industry, but it has come to figure as an icon of Gilded Age
masculinity and a rare precursor to the social realism of the Ashcan artists,
many of whom were Anshutz's students.

There is something valuable to be learned by considering Anshutz's
painting in the context of social systems, especially of the relationship be-
tween work and education. Completed in 1880, *The Ironworkers' Noontime*
came after the violence of 1877 and just before the Bessemer process was
adopted, replacing the jobs of many of the workers it depicts.[50] The scene

is packed with figures, many shirtless or wearing sleeveless undershirts, who hold a variety of poses. At the right gapes the cavernous black entry to the foundry, while its smokestacks loom in the background. Although the factory wall is punctuated by many small windows, the shadow over it gives the sense of a monochrome, solid backdrop against which the puddlers are arrayed and stand, almost friezelike, overlapping but each distinctly legible. At least four young boys are shown—and two or three young men of fourteen to eighteen—two roughhousing in the center and others washing themselves at the pump. Although they are meant to be at rest from their labors, they do not approach the sense of comradely relaxation seen in contemporary images of break time, such as John George Brown's *Longshoremen's Noon* (1879) and the British painter Eyre Crowe's *The Dinner Hour, Wigan* (1874). While Brown's interracial, motley crew all relax convincingly, and Crowe's diners seem rapt in sisterly conversations, Anshutz's men are full of tension, unable to detach their bodies from the discipline of the work they have just finished.

The work of iron puddlers had ties to the worlds of both craft and mechanized labor. Melissa Dabakis argues that puddlers were "decidedly *not* victims of industrialization," describing them as forcefully modern, valiant, and secure in their position within labor's hierarchy.[51] But closer attention to the status of ironworking around 1880 challenges Dabakis's reading, suggesting that what appears to be a heroic and contemporary image of American industry in fact depicts an occupation in peril.[52] One of the tensions underlying this image was the threat to traditional ironworking from the Bessemer process, which would wipe out the jobs of many of these men within the next decade. Patented by a British industrialist, Sir Henry Bessemer, in 1856, the Bessemer process for making inexpensive steel from pig iron appeared in the United States around 1870 and entirely reshaped the industry by the mid-1880s.[53] While some puddlers remained on the job well into the twentieth century, the Bessemer steel process's capacity—almost ten times that of the average iron mill—and more durable product eliminated many ironworkers' jobs.[54] Thomas H. Pauly also notes that the painting probably depicts a factory for making cut iron nails; Wheeling, West Virginia, where Anshutz made the sketches and observations for *The Ironworkers' Noontime* was the national center of nail production from the 1840s onward.[55] Iron nails, however, were made obsolete by the invention of a simpler and cheaper method for making steel wire nails, a process that increasingly forced out highly paid skilled puddlers and their apprentices.[56] Thus, in some ways, despite its apparent modernity, this image represents a transitional moment in the status of

master-apprentice relations and may contain a nostalgic message similar to paintings depicting European craft.

Even its form reinforces its kinship with the world of skilled craft rather than repetitive industry. At 17 by 24 inches, the painting does not have the tiny, jewel-like precision of a gem like Winslow Homer's *Snap the Whip* (1872), but it is surprisingly small. Its very smallness is a shock to the viewer, as the subject, with its focus on the manly bodies of the workmen, seems to beg for the large-scale treatment of a history painting. Instead, Anshutz chose an intimate format that forces the viewer to focus on its *made* quality. Rough cart tracks running through the middle of the painting seem scored into its surface; bars of iron on the ground in front of the pump are coated with powdery rust. Every detail of the image is finely wrought, each brushstroke carefully applied. Its small size would also seem to preclude the kind of "threatening confrontation" between viewer and worker described by Randall C. Griffin in his analysis of what he characterizes as *The Ironworkers' Noontime*'s "disconcerting" qualities.[57] Instead, within its technique and unusual size, the painting encodes a commonality between ordinary viewers and workers whose situation in the changing world of industrial production was uncertain, and between Anshutz himself and the puddlers he depicts.

Anshutz's painting also offers another connection with the world of skilled craft production: a parallel between the industrial master-apprentice relationship and the master-pupil relationship of the art world. As a student at the Pennsylvania Academy of the Fine Arts, Anshutz studied under the controversial tutelage of Thomas Eakins. Earlier in the century, the process of education at the academy was scattershot. In the late 1860s, a "system was introduced" including broader instruction and set curricula.[58] Two of the primary components of the new systematic curriculum included figure drawing and anatomy. Eakins also introduced the use of photography, a tool Anshutz may have employed to aid his composition. The frieze-like arrangement of *The Ironworker's Noontime* constantly reminds the viewer that, under Eakins, Anshutz would have trained by sketching sculptures of classical antiquity as well as taking classes in life drawing; the variety and tense grace of the figures serve as a visual mark of his schooling.[59] On first seeing the canvas displayed in Pennsylvania, the art critic Mariana Griswold van Rensselaer wrote of Anshutz as one of the best of "the pupils who are being trained under Mr. Eakins at the Academy schools [and] already show an inclination to follow his example."[60] *The Ironworkers' Noontime*, with its contorted and heroic poses, marks Anshutz as a student of Eakins

and the product of a process of artistic education. Anshutz's artwork, like the iron nails that would have come out of the Wheeling mill, had been submitted to a tempering process, shaped by the hand of a master but passed on to an apprentice.

In another bizarre twist, however, Eakins's idiosyncratic approach to art education became increasingly unpopular with the authorities at the academy. His obsession with the teaching of anatomy was at odds with a "developing idea of the art school as the source of all artistic training."[61] Around the same time that the Bessemer process was displacing traditional methods of iron production—that is, in the years immediately surrounding the completion of *The Ironworkers' Noontime*—the academy's Committee on Instruction was gradually forcing Eakins out. His resignation in 1886 coincided almost exactly with the complete ascendance of Bessemer steel. Although Anshutz would later pass on elements of his training—and his interest in daily life and industrial technology—to his students Robert Henri, George Luks, William Glackens, John Sloan, Everett Shinn, and Charles Sheeler, his apprenticeship was, like that of the puddlers' apprentices he painted, part of a tradition in decline. Traditional master-student relationships in the arts were increasingly being replaced by comprehensive training at art academies such as the Pennsylvania Academy and the National Academy of Design, where students followed a strict course of study under a set of specialized teachers. *The Ironworkers' Noontime*, then, sits precariously between the norms of modern industry and the traditions of craft production.

The complicated relationship among art, industry, and education that this painting enacts was also present in debates about general public education. The need for artistic training was pressing among young people of all classes; even those destined to become "shoemakers, tailors, coppersmiths, iron-founders, tin-smiths, the masons, carpenters, cabinet-makers, weavers, potters, gardeners, will all find their account in knowing how to wield the pencil."[62] The importance of artistic education could help shape better workers, wrote a San Francisco newspaper in 1871: "Our system of public education will be defective until it regards some knowledge and skill in art as a necessity for all, instead of a luxury for a few—as a public need, instead of merely a private enjoyment."[63] As the Boston School Committee's *Annual Report* argued when it called drawing "a most desirable discipline both for the eye and the hand," basic artistic skills could contribute to future success. Such skills were necessary both in the parlor, locus of the leisured "eye," *and* the workplace, where the "hand" held sway.[64] Artistic

training was both a specialized result of one of the last remaining master-apprentice relationships and an important element in general elementary education.

The school—whether elementary school, technical school, factory library, or art school—was a crucible that forged citizens who defined themselves through their work: industrial, intellectual, or artistic. Although it was cast as a benevolent institution during this period, the school was in fact a disciplinary site, one in which pupils were inculcated with pre-selected values and bestowed with those skills deemed most likely to be useful given their class, race, and gender. Schools were important sites of social authority in which the ideals of the well-managed factory and well-organized society were impressed on their students.

## When Education Fails

What if these avenues of social and industrial training failed? What happened to those who could not learn to conform to the modern standards of life? They were usually subjected to more drastic measures, ranging from the workhouse or reform school to, as a last resort, prison. Being forced into one of these institutions usually meant that traditional methods of education had failed, but attempts to shape proper laborers did not stop once a subject was incarcerated. In fact, if anything, labor became an even more crucial topic in these locations. If reformers of the era are to be believed, many prisoners had their first experience with an institution of social control in a reform school. B. K. Pierce, chaplain of one of the most prominent examples, the New York House of Refuge, wrote that many young offenders would "be returned two or three times to the Refuge, and ultimately revolve between the Penitentiary and State-prison."[65]

Completed in 1854, the House of Refuge was located on Randall's Island in the East River off Manhattan. The island contained a complex of institutions designed to segregate and rehabilitate the poor. As Peter Bacon Hales argues, however, poor relief in this period relied on separating the "worthy" from the "unworthy" poor, a doctrine influenced by Herbert Spencer's theories of social evolution that caused many organizations to "withhold all aid from those potentially capable of work."[66] Reverend S. Humphreys Gurteen of the charity organization movement argued that support to the able-bodied poor was "render[ing] pauperism a permanent institution, a positive profession."[67] During the 1860s, the journalist W. H. Davenport took readers on tours of New York's reformatories and workhouses in a series of articles illustrated with sketches by the author.[68] His key themes

were poverty, social training, and work. Davenport's illustration of the House of Refuge shows boys who had been arrested for criminal behavior at work making wire, hoop skirts, and shoes (fig. 62).[69]

The layout of the multi-paneled page is similar to representations of manufacturing, though the central panel depicts the playground of the institution with dozens of boys at lively games. This shows boys burning off excess energy through recreation, set up as a proper outlet for their vigor in opposition to squandering it at drinking, cards, or other forms of dissipation. Exercise, like labor, was fixed on as a means of disciplining the body.[70] Surrounding this central vignette are ten scenes of industrious children, all boys of widely varying ages, reinforcing Pierce's claim that "every child, from the oldest to the youngest, has a daily task wisely adapted to its age and ability," a less structured version of the task specialization that was being instituted in the factory setting. This diversity of tasks and ages is evident in Davenport's illustration: though the young men in "Nailing the Soles" are probably in their teens, a boy seated on the floor in "Hoop Skirt Factory" appears to be in diapers, while only one figure in the background of that image is actually *taller* than the skirt hoops being constructed. Davenport presents young boys who both embody and play-act the role of the responsible male laborer. The image frames the boys as workers in miniature, readying themselves for eventual entrance into the workforce as rehabilitated members of society. Here they merely act out—as if practicing—the labors they will soon assume.[71]

The overall routine at the House of Refuge was intended to teach the inmates a threefold lesson in the intimately connected arenas of intellectual, moral, and industrial development. In the prayer book printed for the house's daily and Sabbath worship, inmates were expected to ask God to help them labor well; each morning they would intone, "Thou hast appointed to each of us our work in life: O Lord, enable us all diligently to perform every duty falling to our lot. Let us not waste our time in idleness. . . . Let us remember that thine eye is upon us."[72] The timetable contained eight hours of work and four of schooling each day, excepting Sundays, a schedule of "exacting" employment that would help children strengthen their "minds and moral faculties."[73] The philosophical organization of the House of Refuge attempted to address all three facets of the individual in a rigorous and methodical way.

Although it was not as beneficial as attending school, a stay at the House of Refuge was thought to imbue the young man or woman with an idea of the nobility and necessity of labor. It might also give him or her skills that would be useful in finding a job in the outside world, ranging from

Figure 62. W. H. Davenport (American, active 1860s). "New York House of Refuge on Randall's Island," *Harper's Weekly*, May 23, 1868, 332. Wood engraving, 9½ x 14 in.

the specific and technical, such as "Making Sieves," to the more abstract, such as self-control, punctuality, and a strong work ethic. As he presided over the laying of the building's cornerstone in 1852, New York Mayor A. C. Kingsland hoped that "habits of industry and discipline" would accompany its inmates "into the world and render them good and useful citizens."[74] But if they came from impoverished families, they might be forced to continue their petty criminal activities, particularly if they were not old enough to work in the industrial realm. Pierce advocated training in the trades as the most effective way to combat this recidivism.[75]

On a more sinister note, one could also read these young men as prefiguring their future roles as inmates of more serious penal institutions. The inmates of a workhouse were seen as redeemable, able to be trained with the republican values so important to fostering a strong and lasting work ethic. Prisons, however, seem to have been viewed as a last resort for those who could not be trusted to live their lives according to principles of honesty, self-reliance, and effort. Commentators blamed both the prisoners themselves and the structural failures of education and industrial training that had ill-prepared inmates for life in the modern world. In an 1883 *Harper's Weekly* article, sociologist F. B. Sanborn suggested that "the convict, even more than the free man, needs constant labor, which will occupy both his hands and his thoughts, and keep him from those forms of self-destruction and moral death which idleness in prison invites. He needs also, for he has seldom had it, a training in some useful pursuit, and in those habits of industry which will enable him to avoid crime when he goes out into the world again."[76] Prison reformers made similar arguments, as one attendee of the 1886 National Prison Congress noted: "We are here to-day as scientists, and reformers, and as business men. . . . We are agreed, that physical employment by criminals is essential to their health, happiness, and reform."[77] In these estimations, criminal behavior represented a breakdown of the social systems that were intended to produce responsible citizens, particularly in the latter quotation with its threefold focus on scientific management, reform, and economics. Prisons were sites for dealing with those members of society who failed to learn the lessons of the schoolhouse, workhouse, or workshop, and who sought means of profitmaking outside the accepted structures of American society.

Debates raged about the role of labor within penal institutions. Traditionally, prisoners had been expected to pay for the costs of their incarceration through forced labor, a system that dated back to the colonial period. As corporate capitalism became more entrenched in American society, companies used prison contracts as sources of inexpensive labor. Contrary

Figure 63.   Albert Berghaus (American, c. 1831–1901). "Convicts Working under Contractors in the Ironing Department of the Prison Laundry," *Frank Leslie's Illustrated Newspaper,* March 2, 1878, 452. Wood engraving, 6 x 9 in.

to the stereotypical images of prisoners engaged in stone-breaking, in fact prisoners were often contracted to make such everyday commodities as stoves, hats, hosiery, shoes, and other leather goods.[78] Coming to a head in the 1880s, a debate about the morality of this practice pushed for the abolition of the contract labor system. Arguments ranged from the humane (noting the brutal conditions of prison work) to the economic (stating that contracted convicts competed directly with "honest" working men).[79] Supporters of the system considered forced labor a necessary means of crime deterrence, while reformers agreed that second offenses would decline if convicts learned skills they could use after their release.[80] As the reformer George Washington Cable reported hearing from one southern warden, "Send a man out from here with knowledge of a trade, and may be he will come back, but the chances are he will not."[81] Residents of New York State voted overwhelmingly in favor of abolishing the contract system in

1883, while arguments about prison labor were ongoing in other states throughout the 1880s.[82]

Artists treated convict labor with direct, almost managerial, detail. The structure of prison labor quite literally replicated the systems of industrial order, often lifted wholesale from the private sector and implemented in the penitentiary.[83] In 1878, *Frank Leslie's* showed the ironing department of New York's Sing Sing Prison as a regimented workplace (fig. 63). Albert Berghaus depicted the convicts at work as ordinary men, almost automatically going about their tasks. The ordered rows of workers recall the images of modernized workplaces from chapter 5. This representation of prisoners suggests that they are fully implicated in a system of contracted commodity production. The accompanying article was explicit about the systematic, industrialized nature of prison life: "As the machinery, so the prisoners."[84] In a similar vein, Cable referred to prison administration as "the management of a State's convicts."[85] Prison and factory overlapped in the explicit language of management and control that structured both systems.

### Coda: Prison Factories and Factory Prisons

In closing, consider two images from *Harper's Weekly* that seem to conflate prisoners and laborers visually, suggesting both groups as parts of the new, highly structured social realm in which people were organized, kept track of, and processed by social institutions. In a March 1876 issue, two illustrations by Félix Regamey showed aspects of life inside the prison at Blackwell's Island (fig. 64). Lines of prisoners are shown before and after a meal, in the first place queuing for bread and in the second returning their spoons after the meal is finished. Behind them is clearly visible the long, tall hall of the prison itself, with cell doors standing open and small, narrow windows providing light. The prisoners are dressed in their striped uniforms and supervised by two men wearing white straw hats and dark suits. In the far background of the left image stands another figure, presumably a warden who will ensure that the meal occurs in an orderly, controlled fashion. On the right, the prisoners line up to return their spoons, still overseen by the three men. The empty rows of tables and stools speak of the meal that has just finished. In this engraving, the prison interior looks even higher and more cavernous, the tiny windows, barred, barely let light into the gloom. Little, or immaterial, light is given from the globe-shaped oil lamp at the upper right corner of the composition, a peculiar fixture whose form echoes that of a ballot box but here set high

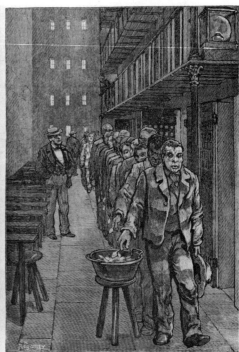

Figure 64. Félix Regamey (French, 1844–1907). "Blackwell's Island—Prisoners' Meals," *Harper's Weekly,* March 11, 1876, 217. Wood engraving, 9 x 14 in.

prison ⟵⟶ labor (conflation) ⟶

and out of reach of the inmates below. Their uniform clothing and the cell doors, slightly ajar in the background, mark these men as prisoners, but their demeanor and bearing seems unashamed and orderly. The high ceiling and interior structure of the prison seem recognizable from the dozens of engravings of factory workspaces that had already appeared in *Harper's Weekly* by the mid-1870s. The orderliness of the men, who stand calmly in their ranks, reminds the viewer of a familiar scene: the industrial realm.

Paul Frenzeny's "A Nevada Silver Mine—Changing the Shift" shows a similar moment in the life of miners, who, like the prisoners in New York City, wait in orderly ranks to record their arrival at the proper shift (fig. 65). Although the four figures in the foreground wear very different costumes—perhaps meant to illustrate ethnic difference—the remainder of the men boast a strikingly similar uniform of hat, shirt, and trousers rolled up or tucked into boots. Like the prisoners, they line up for their trip down into the mine, standing in organized rows, ready to be processed by the system. The four men at the right are on their way home from an eight-

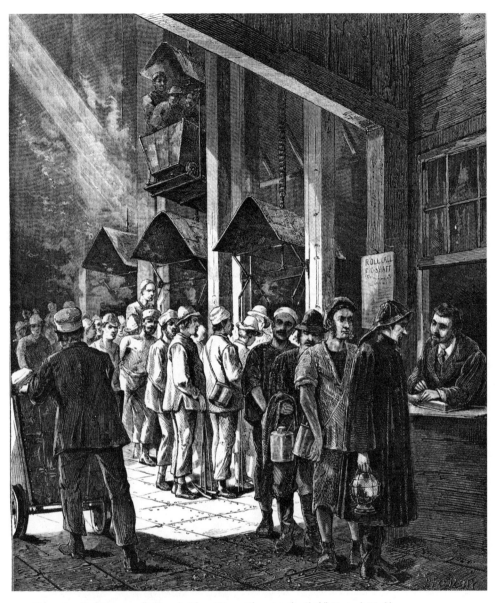

Figure 65. Paul Frenzeny. "A Nevada Silver Mine—Changing the Shift," *Harper's Weekly*, August 25, 1877, cover. Wood engraving, 11¼ x 9½ in.

hour shift, and their clothes, perhaps darkened by their toil underground, are gray. At the window, whose sign reads "Roll Call," they give their names to the brain worker at the controller's office who keeps track of the daily attendance and uses it to calculate wages. The vast ceiling of the "hoisting house" and the elevators that take carloads of men and ore to different parts of the mine are familiar in sense if not in detail to the massive cranes

of John Ferguson Weir's *The Gun Foundry* and Giovanni Batista Piranesi's *Carceri*. Factories that resemble prisons, prisons that echo mines and factories: both are large and complex institutions designed to keep track of their inmates and to regulate their behavior while profiting from their labor. Whether a man becomes a worker through his own volition—through toil in a Nevada silver mine—or is forced to learn the virtues of industry through punitive labor in one of the country's many prisons, the desired result is similar. Both institutions are factories for processing people, for forging "citizens." Whether a citizen is forged at the crucible of a foundry or excavated from the depths of a mine, whether he is conditioned through a lengthy process of education or led through disciplinary programs of rehabilitation, his fitness to be engaged with the body politic is judged primarily by his willingness and efficiency as a laborer.

As the century drew to a close, the ideology of Progressivism took a more tenacious hold. Both in the realm of labor, with the advent of scientific management, and in the social arena, with the increasing professionalization of social work and education, the 1890s was a decade of aggressive incorporation, structure, and system. The growing desire to organize, catalog, and gather data on all elements of life in the United States phased out many visual modes of representation that did not fit with this imaginary, rationalized nation. Yet both strands of representation traced in this book served as important precursors to the ongoing tension over how to represent technology and industry, which continued into the first decades of the twentieth century.

# Conclusion

## Twentieth-Century Echoes

DESPITE THEIR vibrancy and relevance throughout the nineteenth century, the images in this book began to appear, by comparison, outdated and even obsolete by the turn of the century due to major changes in both illustration and the art world. To consider the afterlife of nineteenth-century America's visual obsession with labor and technology, it may be worth briefly turning to the Progressive Era and beyond. In so doing, we may rehabilitate these images, many of which are now relatively unknown even within the history of American art, as crucial precursors to fields of representation from art photography and avant-garde painting to social documentary and Precisionism. All of these movements and moments had strong roots in nineteenth-century ideas about efficiency, technological progress, and national identity, though their responses to these questions diverged often quite markedly from the concerns of nineteenth-century artists.

One of the most crucial shifts from nineteenth- to twentieth-century representational strategies lay in what the intellectual historian Neil Harris calls the "technological innovation" and "iconographical revolution" of the turn to halftone reproduction in the 1890s.[1] By the turn of the century, almost all the major illustrated periodicals had begun using halftone printing for the reproduction of both original artwork and photographs. The halftone process had been refined by a Philadelphia-based inventor, Frederic Ives, in 1881; it constituted a less expensive and supposedly more faithful form of reproduction than wood engraving.[2] Where once artists and engravers had given free interpretation to the news, the supposed

rationalism and impartiality of the photographic medium now dominated. Despite these advantages, however, major illustrated periodicals were fairly slow to embrace halftone technology, probably because, as *Harper's Weekly's* political cartoonist W. A. Rogers later put it in his autobiography, while a wood engraving "at its best follows the mood and the method of the artist," the halftone process rolls over original artwork "with the crushing effect of a steam roller."[3] Flattening tonal varieties and blurring sharp lines, early halftone reproductions, from the perspective of many artists, were far from satisfactory.

Two representations of iron production from the 1890s forcibly demonstrate the shortcomings of early halftone photographic reproduction (figs. 66 and 67). A representation of a Birmingham, Alabama, iron foundry displays a spectacular and sublime scene of industry but one that also conforms to the panoramic urges of the managerial eye. The viewer sees the scene from one end of a vast hall: almost twenty laborers are clearly visible with their long rabbles, prodding and stirring the iron, which emits fantastic sparks, rendered as pure white gouge marks in the center of the image. The perspectival construction of this interior is fanciful. In the foreground, a car track, clearly straight, curves to be accommodated into the composition. The viewer's position is an impossible one, almost as if he were dangling halfway down from the ceiling, a point of view that allows him to look just slightly down on the scene. These elements combine to give a sense of panorama, as if the setting had been captured with a wide-angle lens (the apparent distortion or curvature of several structures also gives this effect), and the large-size format of *Harper's Weekly* gave this double-page spread even more visual impact. Only a few figures overlap one another, and each performs his appointed task. Details of the composition lend a sense of realism one might expect from a journalistic representation; a resting man in the foreground mops his brow with a handkerchief, for instance. These small gestures all convey an image of truthful reportage, while at the same time, the compositional distortions lend the familiar sense of power and control.

By contrast, a photograph from only six years later demonstrates the disappointing initial implementation of halftone photography. "A View of a Great Smithy" presents such an unrelenting grayness that at first it is difficult to tell what is being depicted at all. Once viewers adjust to the flatness of tone and begin to examine the details of the scene, they can make out a bit more, but there is no instantly graspable message from this image. Instead, it presents a jumble of workers, tools, and products without any overriding logic or lesson. On a table in the center foreground sits an

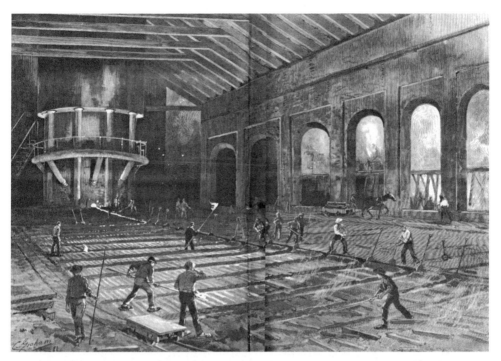

Figure 66. Charles Graham. "The Great Industry of Birmingham, Alabama—A Pig-Iron Furnace," *Harper's Weekly,* March 26, 1887, 214–15. Wood engraving, 14 x 20 in. " managerial eye," fanciful perspectiv

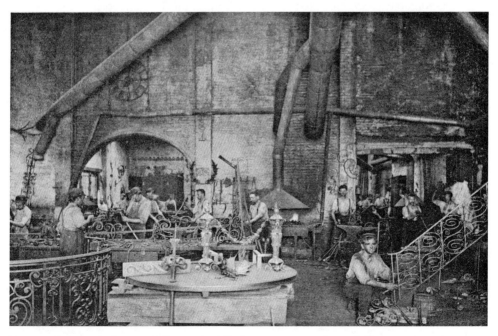

Figure 67. "A View of a Great Smithy," *Harper's Weekly,* January 14, 1893, 35. Process halftone engraving of a photograph, 5¼ x 8 in.

assemblage of items, including what look like firedogs and wall sconces but are impossible to identify definitively. Behind this display and to the left, three workmen bow over a long table but, again, the work they do is unclear; they *seem* to be working on a long decorative wrought iron grille, but the flatness of the photograph vaguely suggests that these objects are *closer* to the picture plane than the workers are. The illegibility of the workers' hands in this straight-on perspective demonstrates why a slightly elevated viewpoint and enlarged size of objects, which could have given clearer views of the tasks performed, were so often used in illustration. On the whole, the photograph leaves the viewer in confusion. Most interesting about this article and image pairing is the way the author, Charles De Kay, dealt with the absolute visual failure of the photograph.

While articles accompanying illustrations of industry occasionally included vivid descriptions of the work processes, this was rare. More typically, the author would include certain types of information that could not reliably be conveyed by the images, such as specific facts and figures. Impressionistic descriptions of the factory or mine interior were usually rendered unnecessary by the detailed visual language of the imagery. In the case of De Kay, however, the photograph is so lacking in information that he seemed driven to do with his pen what the photographer could not with his camera. De Kay wrote, evoking a magical and dramatic scene completely lacking in the published photograph:

> In darkish corners under the high sheds glow the fires, in which bars of all sizes and shapes are roasting. Bare-armed men drag various pieces of metal in and out of the coals, place them on the anvils, and stand serene while the hammers of their fellows, wielded by muscular arms, dash cascades of sparks over them from the white-hot ends. Under the picturesque light and shade the smithy has that exhilarating din when labor which is heard fashions shape out of shapelessness. . . . A great smithy, such as the one I am thinking of—the reader can get a glimpse of one part of it in the illustration—is a place where all kinds of things are fabricated. . . . Singular to see how resistless is the power of these hammers when the material has been properly roasted. Through the Japanese fireworks of sparks the trio of smiths look grim and determined.[4]

With the visual failure of the managerial eye, the article presents a literary attempt to evoke the same kind of drama evident in images such as Charles Graham's "Great Industry of Birmingham" (see fig. 66). De Kay's description bears no resemblance at all to the photograph of a "Great Smithy."

Instead, it tries to complete for the viewers of the photograph what they expect to see and desire to know about the production of wrought iron, compensating for the flatness and illegibility of the halftone.

By comparison with engraved images of similar industries, early half-tone photographs fell short on almost every front: detail, clarity, and ability to use physically impossible perspectives to give readers more information about a particular site or industry.[5] But despite the higher quality of engraving technology, the indexicality of the photograph made it a more convincing source of visual journalism, leading to the eventual phasing-out of laborious and expensive wood engravings.[6] This shift, which now seems inevitable, was in fact closely tied to larger ideological shifts within American culture. Neil Harris argues of the Progressive Era that "the single generation of Americans living between 1885 and 1910 went through an experience of visual reorientation that had few earlier precedents." The year 1885, which Harris chooses as the start of the halftone era, or "the modern world of visual reproduction," coincides roughly with the end of my own study, which I have chosen to locate in 1887.[7] Harris and the esteemed print scholar William Ivins both have argued that by the turn of the twentieth century, Western society "stopped talking about photographic distortion, and . . . adopted the photographic image as the norm of truthfulness in representation." This interest in truthfulness seems to predicate the disappearance, or at least decay, of the earlier, more irrational forms of interpreting work and industry. Ivins went on to suggest that photography facilitated a large-scale recognition of a difference "between pictorial expression and pictorial communication of statements of fact."[8]

And yet, most of the illustrators discussed in this book did not see themselves simply as pictorial communicators. Nor did even the most managerial of images appear to their readers *merely* as statements of fact. There was a broad spectrum of visual reactions to industry and technology and a wide field of potential interpretations to those varied reactions. Nonetheless, the shift that both Ivins and Harris have described maps onto larger arguments about the general development of American society at the turn of the twentieth century.

## The Progressive Era and Beyond

The dominance of order and control that post–Civil War American society seemed to privilege and reward was a precursor to the Progressive Era, which lasted from approximately 1893 through America's entry into World War I in 1917. The fairly informal, nonprofessional structures of pictorial

journalism, which had dictated the content of the nineteenth-century magazines discussed here, were superseded by increased interest in facts, charts, and statistics; the necessity of professional training; and emphasis on organizational structures. Pictures—increasingly photographs reproduced and disseminated using process halftone engraving—were more often used not as primarily positive depictions of American exceptionalism but as critical documents that sought to uncover the social ills of modernity.[9] The roots of this ideology may be found in the images studied throughout this book, particularly as managerial wage capitalism became ever more firmly entrenched through time and motion studies, "industrial psychology," and other practices designed to survey local and holistic productivity.[10] The practices developed in the years following the Civil War had a powerful effect on early twentieth-century life.

The managerial eye had looked dramatically forward to the focus on efficiency, economy, and process that marked American industry during the first decades of the twentieth century. The newer mass-circulation magazines—*McClure's, Cosmopolitan, The Ladies' Home Journal, The Saturday Evening Post,* and others—carried on the celebration of American industry while relying more and more heavily on advertising that could help sustain that industry. As Richard Ohmann notes, after 1893 the magazine itself increasingly became like a department store.[11] Twentieth-century magazines, including specialist business periodicals like *Forbes* (1917), relied on photo-spreads, rather than wood engravings, to promote the goals of American managers, manufacturers, inventors, and industrial designers. Despite their changing audiences and the vast visual and communicative differences from the wood engravings of the nineteenth century, however, these popular representations of contemporary industry could not have existed without the groundwork laid by illustrators and engravers in Civil War–era America.

In these same first decades of the twentieth century, dramatic changes disrupted the function, circulation, and stylistic identity of American painting and fine arts. Throughout this book, I have tried to be precise about the circumstances of an object's creation, though I noted at the beginning that more overlap existed between fine art and illustration than might have been expected. But in the later part of the nineteenth century, as J. M. Mancini argues, artistic modernism arose from "a *critical* environment that was itself being transformed by the pressures of modernization." Superseding a midcentury atmosphere in which "easily circulated, reproducible images" might be considered forms of high art production,

this new ethos assumed "irreducible originals as the only 'true' art."[12] Such restriction of the art world also, as Mancini and Sarah Burns argue, privileged the aesthetic experimentation of the avant-garde over the more traditional forms of artistic discovery practiced by John Ferguson Weir and Thomas Moran.[13] Both of those artists died in 1926, by which time several avant-garde movements, from Aestheticism to New York Dada and Precisionism, lay between the heights of their careers and contemporary practice. Within that nearly half-century, new forms and reasons for representing technology emerged within the art world. The Romantic tenor of Weir's and Moran's canvases was superseded by a different form of irrationality, while their adherence to the eighteenth-century aesthetic conventions of sublimity and picturesqueness seemed stuffy and retrograde in comparison with the increasing abstraction and conceptual nature of American art in the first two decades of the twentieth century. Artists including Alfred Stieglitz, Paul Strand, Charles Sheeler, Charles Demuth, Joseph Stella, and Georgia O'Keeffe interpreted American industry and modernization in a variety of visual forms and media, but all privileged Modernist formal experimentation and abstraction over the emotional and experiential responses created in *The Gun Foundry, Forging the Shaft,* and *Lower Manhattan from Communipaw, New Jersey.* Still, some of the tensions that existed in nineteenth-century visions of industry continued, albeit in different forms, into the twentieth century.

One of the most famous evocations of the rationalist ideology in art, Precisionism, seems an obvious legacy of the managerial eye. And yet, as scholars have reminded us over the past twenty years, those apparently rational and precise images are imbued with all kinds of unruly undercurrents. These persistent challenges to the norm—from shared myths and symbols of an alternative America to hidden queer desires—suggest something subtle, shifting, and strange that lay always beneath American reactions to industry.[14] By contrast, New York Dada and its closely connected movement, Surrealism, would seem to be the apotheosis of irrationality, irreverence, and occultism emerging in the second decade of the twentieth century. But even here, all is not as it seems. The rational structures of science and technology were deeply embedded within the knowledge bases and artistic practices of artists like Marcel Duchamp and Joseph Cornell.[15] Although these artists approached their work with a more whimsical sense of irrationality than the dark, sometimes threatening interpretation given in some nineteenth-century images, the Dada and Surrealist artists, too, engaged in references to occult philosophy and even

alchemy.[16] Even within products of the twentieth century that seem purely rational—or resolutely irrational—no synthesis of responses to technology was ever reached.

While they appear far-removed from the world of the early twentieth century, the images discussed throughout this book serve as essential precursors to both the popularly disseminated magazines and the Modernist works of the early twentieth century. From the immediate antebellum years to the dawn of the Progressive Era, artists and illustrators across media created the first large-scale focus on American industry within U.S. visual culture. These images forever changed American viewers' ideas about the roles of technology, labor, and industry within a diverse and constantly shifting nation.

## Finale

What does it mean to "represent" work? The painters discussed in this book both represented the labor of others and *presented* their own labor as an important component in the meaning of their artistic production. For-hire illustrators and wood engravers also recognized the parallels between themselves and the workers and technologies they depicted, perhaps even more forcefully than painters, as they were implicated in a structure of wage capitalism that painters largely avoided.[17] The labor of the creator often factors into our understanding of what it means to represent anything. But taking "work" as one's subject creates an additional layer of commentary on the very nature of image-making itself. What about "representing" technology? Many of the images discussed in this book were parts of technological systems; they contain within them, or embody, the startling expansion of the technological in the United States during the nineteenth century.

In the end, the images discussed here used vision to shape, or manage, different audiences' responses to the roles of work and technology in nineteenth-century life. At the same time, many of the images explicitly envisioned management (and self-management), whether in the factory itself or in the social realm. These questions interacted with larger concerns about the changing nature of labor and industry in the nineteenth-century United States. Although the most spectacular event of the century—the Civil War—shaped conceptions of national identity and values, more mundane, everyday changes also worked powerfully to mold people's lives. The advents of managerial capitalism and structured systems of education, charity, and punishment were gradual and uneven; there was no single

moment or originating event that determined the shape of contemporary life. While images might seem like a peripheral category when compared with the massiveness of the structural, political, and industrial changes that occurred in the years between 1857 and 1887, they were in fact powerful actors in shaping *how* viewers envisioned and thought about labor and technology during some of the most complex decades of the century.

# Notes

## Introduction

1. "Columbia Welcoming the Nations," *Harper's Weekly,* May 20, 1876, 410.

2. "Thousands" may seem like an exaggeration. I found and catalogued, however, nearly a thousand such images in *Harper's Weekly* alone. I also browsed *Harper's Monthly, Scientific American,* and *Frank Leslie's Illustrated Newspaper,* finding hundreds more. I looked only tangentially into other forms of visual culture, including photography, chromolithography, and engravings on steel or copper. Within the fine arts, many notable though little-known images are cataloged in nineteenth-century exhibition reviews, the Smithsonian Institution Research Information System (SIRIS) database, and art historical texts, including Marianne Doezema, *American Realism and the Industrial Age* (Cleveland: Cleveland Museum of Art, 1980); Patricia Hills, *The Working American* (Washington, DC: District 1199 National Union of Hospital and Health Care Employees, Smithsonian Institution Traveling Exhibition Service, 1979); Hills, "The Fine Arts in America: Images of Labor from 1800 to 1950," in *Essays from the Lowell Conference on Industrial History, 1982 and 1983,* ed. Robert Weible (North Andover, MA: Museum of American Textile History, 1985), 120–64; Elizabeth Kennedy and Katharine M. Bourguignon, *The People Work: American Perspectives, 1840–1940* (Giverny, France: Musée d'Art Américain, Terra Foundation for the Arts, 2003); Susan G. Larkin, *American Impressionism: The Beauty of Work* (Greenwich, CT: Bruce Museum of Arts and Science, 2005); and Kenneth W. Maddox, ed., *In Search of the Picturesque: Nineteenth Century Images of Industry along the Hudson River Valley* (Annandale-on-Hudson, NY: Art Institute of Bard College, 1983).

3. On visitors' contradictory responses to the Corliss, see Marianne Doezema, "The Clean Machine: Technology in American Magazine Illustration," *Journal of American Culture* 11.4 (Winter 1988): 82, 87; John F. Kasson, *Civilizing the Machine: Technology and Republican Values in America, 1776–1900* (New York: Grossman, 1976), 161–65; David E. Nye, *American Technological Sublime* (Cambridge: MIT Press, 1994), 120–23; Robert W. Rydell, *All the World's a Fair: Visions of Empire at American*

*International Expositions, 1876–1916* (Chicago: University of Chicago Press, 1984), 15–16; and Julie Wosk, *Breaking Frame: Technology and the Visual Arts in the Nineteenth Century* (New Brunswick, NJ: Rutgers University Press, 1992), 73–74.

4. T. J. Jackson Lears, *No Place of Grace: Antimodernism and the Transformation of American Culture, 1880–1920* (New York: Pantheon Books, 1981), 7–26.

5. Thomas Parke Hughes, "The Evolution of Large Technological Systems," in *The Social Construction of Technological Systems: New Directions in the Sociology and History of Technology,* ed. Wiebe E. Bijker et al. (Cambridge: MIT Press, 1987), 51–82; Hughes, *Networks of Power: Electrification in Western Society, 1880–1930* (Baltimore: Johns Hopkins University Press, 1983); Bernward Joerges, "Large Technical Systems: Concepts and Issues," in *The Development of Large Technical Systems,* ed. Renate Mayntz and Thomas Parke Hughes (Boulder, CO: Westview, 1988), 9–36.

6. Ruth Schwartz Cowan, *A Social History of American Technology* (New York: Oxford University Press, 1997), 149. See also Melvyn Dubofsky, *Industrialism and the American Worker, 1865–1920,* 3rd ed. (Wheeling, IL: Harlan Davidson, 1996), 36–38.

7. Alfred D. Chandler, Jr., *The Visible Hand: The Managerial Revolution in American Business* (Cambridge: Belknap Press of Harvard University Press, 1977), 79–205.

8. On governmental interest in creating a telegraphic network, see Paul Israel, *From Machine Shop to Industrial Laboratory: Telegraphy and the Changing Context of American Invention, 1830–1920* (Baltimore: Johns Hopkins University Press, 1992), 24–57.

9. For some texts that explore this complexity in the art world, see Richard J. Boyle, *Double Lives: American Painters as Illustrators, 1850–1950* (New Britain, CT: New Britain Museum of American Art, 2008); Jo Ann Early Levin, "The Golden Age of Illustration: Popular Art in American Magazines, 1850–1925" (Ph.D. diss., University of Pennsylvania, 1980), 94–96; and J. M. Mancini, *Pre-Modernism: Art-World Change and American Culture from the Civil War to the Armory Show* (Princeton: Princeton University Press, 2005), 37. For a European comparative perspective, see Tom Gretton, "Difference and Competition: The Imitation and Reproduction of Fine Art in a Nineteenth-Century Illustrated Weekly News Magazine," *Oxford Art Journal* 23.2 (2000): 143–62.

10. Cecelia Tichi, *Shifting Gears: Technology, Literature, Culture in Modernist America* (Chapel Hill: University of North Carolina Press, 1987), 19. For a nineteenth-century case study, see John Gladstone, "Working-Class Imagery in *Harper's Weekly,* 1865–1895," *Labor's Heritage* 5.1 (Spring 1993): 42–61.

11. On some of the technological changes that made this possible, see William S. Pretzer, "The Quest for Autonomy and Discipline: Labor and Technology in the Book Trades," in *Needs and Opportunities in the History of the Book: America, 1639–1876,* ed. David D. Hall and John B. Hench (Worcester, MA: American Antiquarian Society, 1987), 13–59; Vanessa Meikle Schulman, "Making the Magazine: Visuality, Managerial Capitalism, and the Mass Production of Periodicals, 1865–1890," *American Periodicals* 22.1 (2012): 1–28; and Ronald J. Zboray, "Antebellum Reading and the Ironies of Technological Innovation," *American Quarterly* 40.1 (March 1988): 65–82. On antebel-

lum print culture in the United States and United Kingdom, see Patricia Anderson, *The Printed Image and the Transformation of Popular Culture, 1790–1860* (Oxford: Clarendon Press, 1991); Isabelle Lehuu, *Carnival on the Page: Popular Print Media in Antebellum America* (Chapel Hill: University of North Carolina Press, 2000); Michael Schudson, *Discovering the News: A Social History of American Newspapers* (New York: Basic Books, 1978), 1–60; and Peter W. Sinnema, *Dynamics of the Pictured Page: Representing the Nation in the "Illustrated London News"* (Aldershot, UK: Ashgate, 1998). As may be deduced from my mention of a "unified national audience" for print culture, I am influenced by the theories of Benedict Anderson, which I discuss more in chapter 1. Anderson, *Imagined Communities: Reflections on the Origin and Spread of Nationalism* (1983; rev. ed., London: Verso, 1991), esp. 9–46.

12.  Circulation numbers are in John Tebbel, *The American Magazine: A Compact History* (New York: Hawthorn, 1969), 116, 110. Estimates of readership are discussed in Levin, "Golden Age of Illustration," 39–40.

13.  Mark J. Noonan, *Reading "The Century Illustrated Monthly Magazine": American Literature and Culture, 1870–1893* (Kent, OH: Kent State University Press, 2010), 12–15; David Paul Nord, *Communities of Journalism: A History of American Newspapers and Their Readers* (Urbana: University of Illinois Press, 2001), 227–31; Barbara Sicherman, "Ideologies and Practices of Reading," in *A History of the Book in America*, vol. 3, *The Industrial Book, 1840–1880*, ed. Scott E. Casper et al. (Chapel Hill: University of North Carolina Press and American Antiquarian Society, 2007), 295–97. Although Nord's statistics come from the 1890s (due to the unavailability of earlier data), he proposes high levels of working-class readership throughout the post–Civil War era, particularly among those readers associated with "the modern industrial community." Nord, *Communities of Journalism*, 241.

14.  Matthew Schneirov, *The Dream of a New Social Order: Popular Magazines in America, 1893–1914* (New York: Columbia University Press, 1994), 28.

15.  Richard Benson, *The Printed Picture* (New York: Museum of Modern Art, 2008), 22, 24. For a more evocative description of the wood-engraver's art, see Gerry Beegan, *The Mass Image: A Social History of Photomechanical Reproduction in Victorian London* (Basingstoke, UK: Palgrave Macmillan, 2008), 47–50.

16.  Joshua Brown, *Beyond the Lines: Pictorial Reporting, Everyday Life, and the Crisis of Gilded Age America* (Berkeley: University of California Press, 2002), 35–40.

17.  Rhetorical choices in captions are analyzed in Andrea G. Pearson, "*Frank Leslie's Illustrated Newspaper* and *Harper's Weekly*: Innovation and Imitation in Nineteenth-Century American Pictorial Reporting," *Journal of Popular Culture* 23.4 (Spring 1990): 93.

18.  Jacob Abbott, *The Harper Establishment; or, How the Story Books Are Made* (New York: Harper and Brothers, 1855), 110.

19.  William M. Ivins, Jr., *Prints and Visual Communication* (Cambridge: Harvard University Press, 1953), 61.

20.  Neil Harris, "Iconography and Intellectual History: The Half-Tone Effect," in *New Directions in American Intellectual History*, ed. John Higham and Paul K. Conkin

(Baltimore: John Hopkins University Press, 1979), 199. See also Beegan, *The Mass Image,* 7–16, 186–88.

21. Doezema, "The Clean Machine," 73–92; Harris, "Iconography and Intellectual History," 205–9; Estelle Jussim, *Visual Communication and the Graphic Arts: Photographic Technologies in the Nineteenth Century* (1974; reprint, New York: R. R. Bowker, 1983), 69.

22. "The Centennial Celebration," *Georgia Weekly Telegraph and Journal and Messenger,* May 25, 1875, 4.

23. Rydell, *All the World's a Fair,* 10.

24. "Our Centennial," *Harper's Weekly,* May 27, 1876, 422.

25. William Dean Howells, "A Sennight of the Centennial," *Atlantic Monthly,* July 1876, 96.

26. "Our Centennial," 422.

27. "The Multitude Admitted," *The Press* [Philadelphia], May 11, 1876, 2, quoted in Rydell, *All the World's a Fair,* 13.

28. "Our Philadelphia Letter," *Daily Arkansas Gazette,* July 27, 1876, 2.

29. Howells, "A Sennight of the Centennial," 96.

30. Charles T. Porter, *Engineering Reminiscences: Contributed to "Power" and "American Machinist"* (New York: John Wiley and Sons, 1908), 248.

31. Porter, *Engineering Reminiscences,* 248.

32. John Arvid Hertzman, "Sources of the Technological Aesthetic: The Architecture of the Reciprocating Engine in the Eighteenth and Nineteenth Centuries" (Ph.D. diss., University of North Carolina, Chapel Hill, 1976), 311–18.

33. Nye, *American Technological Sublime,* 43.

34. Bayard Taylor, "The Centennial: Survey of the Buildings and Grounds, Comparison with the Other Great World's Fairs," *St. Louis Globe-Democrat,* April 18, 1876, 2.

35. Doezema, "The Clean Machine," 82.

36. Jacob Bigelow *Elements of Technology, Taken Chiefly from a Course of Lectures Delivered at Cambridge, on the Application of the Sciences to the Useful Arts,* 2nd ed. (Boston: Hilliard, Gray, Little, and Wilkins, 1831), 4–5.

37. Howells, "A Sennight of the Centennial," 96.

38. Henry Nash Smith, *Popular Culture and Industrialism, 1865–1890* (Garden City, NY: Anchor Books, 1967), 80.

39. "Characteristics of the International Fair, III," *Atlantic Monthly,* September 1876, 358.

40. Howells, "A Sennight of the Centennial," 96.

41. On the theme of blackness in visual culture, see Sarah Burns, *Painting the Dark Side: Art and the Gothic Imagination in Nineteenth-Century America* (Berkeley: University of California Press, 2004), 101–27.

42. C. A. N., "The Centennial: Another Glance at the World's Workshop," *Georgia Weekly Telegraph and Journal and Messenger,* November 7, 1876, 3.

43. "Characteristics of the International Fair, III," 359.

44. C. A. N., "The Centennial," 3.

45. William H. Rideing, "At the Exhibition, II: Glimpses of Machinery Hall and the Government Building," *Appletons' Journal,* June 10, 1876, 759.

46. "Characteristics of the International Fair, III," 358.

47. The narrative of "incorporation" that I am attempting to challenge and supplement is the central argument in Alan Trachtenberg's seminal book on nineteenth-century American culture, *The Incorporation of America: Culture and Society in the Gilded Age* (1982; reprint, New York: Hill and Wang, 1995).

## 1. Between Materiality and Magic

1. The relationship between the telegraph and the journalistic profession is clear: 14 percent of messages on the first telegraphic line were press communications. Menahem Blondheim, *News over the Wires: The Telegraph and the Flow of Public Information in America, 1844–1897* (Cambridge: Harvard University Press, 1994), 35.

2. "The Oceanic Telegraph," *North American Review,* October 1858, 533; Charles F. Briggs and Augustus Maverick, *The Story of the Telegraph, and a History of the Great Atlantic Cable* (New York: Rudd and Carleton, 1858), 14.

3. Barbara Young Welke, *Recasting American Liberty: Gender, Race, Law, and the Railroad Revolution, 1865–1920* (Cambridge: Cambridge University Press, 2001), 139.

4. Stephen Salsbury, "The Emergence of an Early Large-Scale Technical System: The American Railroad Network," in *The Development of Large Technical Systems,* ed. Renate Mayntz and Thomas Parke Hughes (Boulder, CO: Westview, 1988), 37–68.

5. On the standardization of time, see Lennart Lundmark, "The Mechanization of Time," in *The Machine as Metaphor and Tool,* ed. Hermann Haken et al. (Berlin: Springer-Verlag, 1993), 45–65; and Michael O'Malley, *Keeping Watch: A History of American Time* (1990; reprint, Washington, DC: Smithsonian Institution Press, 1996), esp. 55–98. For a consideration of how the railroad-telegraph complex worked to "create" time, see James A. Ward, *Railroads and the Character of America, 1820–1887* (Knoxville: University of Tennessee Press, 1986), 106–15.

6. Ebenezer Hiram Stedman, *Bluegrass Craftsman: Being the Reminiscences of Ebenezer Hiram Stedman, Papermaker, 1808–1885,* ed. Frances L. S. Dugan and Jacqueline P. Bull (Lexington: University of Kentucky Press, 1959), 105–6; Alexander Jones, *Historical Sketch of the Electric Telegraph: Including Its Rise and Progress in the United States* (New York: George P. Putnam, 1852), v.

7. Jones, *Historical Sketch of the Electric Telegraph,* 4.

8. Here "myth" refers *not* to the meaning developed by Roland Barthes, the naturalization of certain ideological concepts, but actual myths from classical antiquity. My thinking, however, is influenced by the idea that images work to reinforce and "mythify" concepts of race, class, nation, and gender. Barthes, "Myth Today," in *Mythologies,* trans. Annette Lavers (New York: Hill and Wang, 1972), 109–59.

9. "The Magnetic Telegraph—Its Contemplated Extension—Its National Importance," *Albany Argus,* December 13, 1844, quoted in Peter West, *The Arbiters of*

*Reality: Hawthorne, Melville, and the Rise of Mass Information Culture* (Columbus: Ohio State University Press, 2008), 104. A similar claim was made in relation to the railroad, which had the power to unite "the citizens of one common country, brethren of the same political family." *Proceedings of the Citizens of Charleston, Embracing the Report of the Committee and the Address and Resolutions Adopted at a General Meeting in Reference to the Proposed Rail-Road from Cincinnati to Charleston* (Charleston: A. E. Miller, 1835), 13, quoted in Aaron W. Marrs, *Railroads in the Old South: Pursuing Progress in a Slave Society* (Baltimore: Johns Hopkins University Press, 2009), 16.

10. Benedict Anderson, *Imagined Communities: Reflections on the Origin and Spread of Nationalism* (1983; rev. ed., London: Verso, 1991), 9–46.

11. Trish Loughran, *The Republic in Print: Print Culture in the Age of U.S. Nation Building, 1770–1870* (New York: Columbia University Press, 2007), 5–15.

12. Anderson, *Imagined Communities*, 11.

13. Sue Rainey, *Creating "Picturesque America": Monument to the Natural and Cultural Landscape* (Nashville: Vanderbilt University Press, 1994), 219.

14. On the impact of the railroad on communications and commodity production, see Wolfgang Schivelbusch, *The Railway Journey: The Industrialization of Time and Space in the 19th Century* (1977; reprint, Berkeley: University of California Press, 1986), 1–15; and Alan Trachtenberg, *The Incorporation of America: Culture and Society in the Gilded Age* (1982; reprint, New York: Hill and Wang, 1995), 57–60.

15. Jennifer Clark, "The American Image of Technology from the Revolution to 1840," *American Quarterly* 39.3 (Autumn 1987): 438–42; John F. Kasson, *Civilizing the Machine: Technology and Republican Values in America, 1776–1900* (New York: Grossman, 1976), 3–51; Merritt Roe Smith, "Technological Determinism in American Culture," in *Does Technology Drive History? The Dilemma of Technological Determinism*, ed. Merritt Roe Smith and Leo Marx (Cambridge: MIT Press, 1994), 1–35.

16. Charles Caldwell, "Thoughts on the Moral and Other Indirect Influences of Rail-Roads," *New-England Magazine*, April 1832, 293.

17. Susan Danly and Leo Marx, eds., *The Railroad in American Art: Representations of Technological Change* (Cambridge: MIT Press, 1988), 1–112; John Gladstone, "The Romance of the Iron Horse," *Journal of Decorative and Propaganda Arts* 15 (1990): 7–37; Ian Kennedy, "Crossing Continents: America and Beyond," in *The Railway: Art in the Age of Steam*, ed. Ian Kennedy and Julian Treuherz (New Haven: Yale University Press, 2008), 119–53.

18. Marvin M. Fisher, "The Iconology of Industrialism, 1830–60," *American Quarterly* 13.3 (Autumn 1961): 360.

19. There is a lengthy bibliography discussing art and Manifest Destiny. Two key examples include Angela Miller, *The Empire of the Eye: Landscape Representation and American Cultural Politics, 1825–1875* (Ithaca, NY: Cornell University Press, 1993); and William H. Truettner, "The Art of History: American Exploration and Discovery Scenes, 1840–1860," *American Art Journal* 14.1 (Winter 1982): 4–31.

20. These stylistic choices are consistent with those found in contemporary European images. Jane E. Boyd, "Adorning the Landscape: Images of Transportation

in Nineteenth-Century France," in *Visions of the Industrial Age, 1830–1914: Modernity and the Anxiety of Representation in Europe,* ed. Minsoo Kang and Amy Woodson-Boulton (Aldershot, UK: Ashgate, 2008), 21–41; Matt Thompson, "Modernity, Anxiety, and the Development of a Popular Railway Landscape Aesthetic, 1809–1879," in *Trains, Literature, and Culture: Reading/Writing the Rails,* ed. Steven D. Spalding and Benjamin Fraser (Lanham, MD: Lexington Books, 2012), 119–56.

21. Leo Marx, *The Machine in the Garden: Technology and the Pastoral Ideal in America* (1964; reprint, Oxford: Oxford University Press, 1967), 226, emphasis added. Marx expanded on the symbol of the "garden" developed in Henry Nash Smith, *Virgin Land: The American West as Symbol and Myth* (Cambridge: Harvard University Press, 1950): 123–261. Klaus Benesch critiques Marx by arguing for "a more encompassing concept of technology as both a value system and a system of variegated technological applications." Such a complex understanding of technology is similar to the one I am seeking in this chapter. Benesch, *Romantic Cyborgs: Authorship and Technology in the American Renaissance* (Amherst: University of Massachusetts Press, 2002), 8.

22. "Starrucca Viaduct, on the New York and Erie Railroad," *Scientific American,* February 7, 1852, 161.

23. "The Starrucca Viaduct, on the New York and Erie Railroad," *Holden's Dollar Magazine,* February 1850, 67.

24. "Pictures in New York," *New York World,* January 1, 1866, quoted in Kennedy, "Crossing Continents," 124–26.

25. "Scenery on the Erie Railroad," *Harper's New Monthly Magazine,* July 1850, 213.

26. A. C. Wheeler, "On the Iron Trail," *Scribner's Monthly,* August 1876, 532.

27. Smith's *Virgin Land* is the earliest analysis to address this sexualization, which is continued in Marx's *The Machine in the Garden* and Ronald Takaki, *Iron Cages: Race and Culture in 19th-Century America* (1979; rev. ed., New York: Oxford University Press, 2000), 148–54.

28. "Rail-road to the Pacific," *United States Democratic Review,* November 1848, 405.

29. Henry George, "What the Railroad Will Bring Us," *Overland Monthly,* October 1868, 298. For a general history of the transcontinental railroad, see David Haward Bain, *Empire Express: Building the First Transcontinental Railroad* (New York: Viking, 1999).

30. Recent scholarship on periodical readership has supported the notion that one target audience was the upwardly mobile, whose "genteel" aspirations were both created and urged along by the programming of publishing houses like Harper's. Analyses of periodical audiences tend to be specialized by publication. On the role of gentility in the Harper publications, particularly the *Monthly,* see Michael Epp, " 'Good Bad Stuff': Editing, Advertising, and the Transformation of Genteel Literary Production in the 1890s," *American Periodicals* 24.2 (2014): 186–205; and Thomas Lilly, "The National Archive: *Harper's New Monthly Magazine* and the Civic Responsibilities of a Commercial Literary Periodical, 1850–1853," *American Periodicals* 15.2 (2005): 142–62. On *The Century* (*Scribner's Monthly*), see J. Arthur Bond, "Elevating

American Culture: Realism, Refined Taste, and the Print Artifact in the *Century Magazine* during the 1880s" (Ph.D. diss., Indiana University, 1999), 26–84; and Arthur John, *The Best Years of the "Century": Richard Watson Gilder, "Scribner's Monthly," and the "Century Magazine," 1870–1909* (Urbana: University of Illinois Press, 1981). See also Richard Ohmann, *Selling Culture: Magazines, Markets, and Class at the Turn of the Century* (London: Verso, 1996), 21–64.

31. On the "vanishing American," see Vivien Green Fryd, "Rereading the Indian in Benjamin West's *Death of General Wolfe*," *American Art* 9.1 (Spring 1995): 72–85. Indian removal was a central goal of the transcontinental railroad according to Robert G. Angevine, *The Railroad and the State: War, Politics, and Technology in Nineteenth-Century America* (Stanford: Stanford University Press, 2004), 168–73.

32. On the iconography of kneeling African Americans in the post–Civil War period, see Kirk Savage, *Standing Soldiers, Kneeling Slaves: Race, War, and Monument in Nineteenth-Century America* (Princeton: Princeton University Press, 1997), 52–88.

33. Bruce Dain, *A Hideous Monster of the Mind: American Race Theory in the Early Republic* (Cambridge: Harvard University Press, 2002); Adam Dewbury, "The American School and Scientific Racism in Early American Anthropology," *Histories of Anthropology Annual* 3 (2007): 121–47; Takaki, *Iron Cages*, 28–35; Brian Wallis, "Black Bodies, White Science: Louis Agassiz's Slave Daguerreotypes," *American Art* 9.2 (Summer 1995): 38–61.

34. Henry T. Williams, *The Pacific Tourist: Williams' Illustrated Trans-Continental Guide of Travel, from the Atlantic to the Pacific Ocean* (New York: Henry T. Williams, 1876), 166.

35. Richard V. Francaviglia, *Over the Range: A History of the Promontory Summit Route of the Pacific Railroad* (Logan: Utah State University Press, 2008), 102.

36. Jennifer L. Roberts, *Mirror-Travels: Robert Smithson and History* (New Haven: Yale University Press, 2004), 115.

37. For the concept of punctuality as it related to the railroad, see Marrs, *Railroads in the Old South*, 87–97; and Mark M. Smith, *Mastered by the Clock: Time, Slavery, and Freedom in the American South* (Chapel Hill: University of North Carolina Press, 1997), 79–92.

38. Roberts, *Mirror-Travels*, 114.

39. Francaviglia, *Over the Range*, 104.

40. Wood-engraved reproductions included "Completion of the Pacific Railroad," *Harper's Weekly*, June 5, 1869, 356; and "The Completion of the Union Pacific Rail Road," *Frank Leslie's Illustrated Newspaper*, June 5, 1869, cover. Discussion of the stereographs and their dissemination appears in Susan Danly, "Andrew Joseph Russell's *The Great West Illustrated*," in Danly and Marx, eds., *The Railroad in American Art*, 100, 109.

41. This also included a self-authored and self-published pamphlet, *"The Last Spike": A Painting by Thomas Hill, Illustrating the Last Scene in the Building of the Overland Railroad* (San Francisco, 1881).

42. Quoted in Angevine, *The Railroad and the State*, 189.

43. Quoted in Ronald Takaki, *Strangers from a Different Shore: A History of Asian Americans* (Boston: Little, Brown, 1989), 84.

44. Jack Chen, *The Chinese of America* (San Francisco: Harper and Row, 1980), 67; Roger Daniels, *Asian America: Chinese and Japanese in the United States since 1850* (Seattle: University of Washington Press, 1988), 36.

45. Quoted in Takaki, *Strangers from a Different Shore*, 85.

46. Nayan Shah, *Contagious Divides: Epidemics and Race in San Francisco's Chinatown* (Berkeley: University of California Press, 2001), esp. 1–76; Takaki, *Iron Cages*, 217–19; John Kuo Wei Tchen, *New York before Chinatown: Orientalism and the Shaping of American Culture, 1776–1882* (Baltimore: Johns Hopkins University Press, 2001), 260–83.

47. The xenophobia of this back matter was in stark contrast to more ethnographic depictions of Chinese American life found in the sections of the papers dedicated to news. Mary M. Cronin and William E. Huntzicker suggest that stories on Chinese life in *Frank Leslie's*, with illustrations by Joseph Becker, presented a primarily sympathetic interpretation of Chinese Americans. Cronin and Huntzicker, "Popular Chinese Images and 'The Coming Man' of 1870: Racial Representations of Chinese," *Journalism History* 38.2 (Summer 2012): 86–99.

48. Edward Forster, *The Arabian Nights Entertainments* (New York: D. Appleton, 1868), 30, 31.

49. Leslie Fiedler, *Love and Death in the American Novel* (1960; rev. ed., 1966; reprint, Normal, IL: Dalkey Archive Press, 1997), esp. 391–429. For recent reinterpretations of the American gothic, see Justin D. Edwards, *Gothic Passages: Racial Ambiguity and the American Gothic* (Iowa City: University of Iowa Press, 2003); Lesley Ginsberg, "Slavery and the Gothic Horror of Poe's 'The Black Cat,'" in *American Gothic: New Interventions in a National Narrative*, ed. Robert K. Martin and Eric Savoy (Iowa City: University of Iowa Press, 1998), 99–128; and Teresa A. Goddu, *Gothic America: Narrative, History, and Nation* (New York: Columbia University Press, 1997).

50. Edwards, *Gothic Passages*, 55.

51. For American reactions to *Frankenstein* and its relationship to technology, see Glen Scott Allen, *Master Mechanics and Wicked Wizards: Images of the American Scientist as Hero and Villain from Colonial Times to the Present* (Amherst: University of Massachusetts Press, 2009), 33–39; Sarah Burns, *Painting the Dark Side: Art and the Gothic Imagination in Nineteenth-Century America* (Berkeley: University of California Press, 2004), 114–77; Peter K. Garrett, *Gothic Reflections: Narrative Force in Nineteenth-Century Fiction* (Ithaca, NY: Cornell University Press, 2003), 87–94; and Julie Wosk, *Breaking Frame: Technology and the Visual Arts in the Nineteenth Century* (New Brunswick, NJ: Rutgers University Press, 1992), 68–69.

52. Though, as J. Adam Johns reminds us, it is a machine that does not act either "predictably or mechanically." Johns, *The Assault on Progress: Technology and Time in American Literature* (Tuscaloosa: University of Alabama Press, 2008), 37.

53. H. L. Malchow, *Gothic Images of Race in Nineteenth-Century Britain* (Stanford: Stanford University Press, 1996), 9–40. On the relationship between blackness and

death in nineteenth-century American visual culture, see Burns, *Painting the Dark Side*, 101–27.

54. Mark Aldrich, *Death Rode the Rails: American Railroad Accidents and Safety, 1828–1965* (Baltimore: Johns Hopkins University Press, 2006), 38–40; Marrs, *Railroads in the Old South*, 127–33.

55. Theodore E. Keeler, *Railroads, Freight, and Public Policy* (Washington, DC: Brookings Institution, 1983), 19–42; Welke, *Recasting American Liberty*, 28–31.

56. "Death on the Rail," *Harper's Weekly*, March 25, 1865, 178; "The Horrors of Travel," *Harper's Weekly*, September 23, 1865, 594.

57. Aldrich, *Death Rode the Rails*, 18–21.

58. Matthew Beaumont, "The Railway and Literature: Realism and the Phantasmagoric," in Kennedy and Treuherz, eds., *The Railway*, 37.

59. Joshua Brown, *Beyond the Lines: Pictorial Reporting, Everyday Life, and the Crisis of Gilded Age America* (Berkeley: University of California Press, 2002), 68–74.

60. "The Horrors of Travel," *Harper's Weekly*, January 4, 1868, 2.

61. Goddu, *Gothic America*, 10.

62. Henry Nash Smith, *Popular Culture and Industrialism, 1865–1890* (Garden City, NY: Anchor Books, 1967), 71.

63. Transmitted May 24, 1844, on an experimental line from Baltimore to Washington, DC. Paul Israel, *From Machine Shop to Industrial Laboratory: Telegraphy and the Changing Context of American Invention, 1830–1920* (Baltimore: Johns Hopkins University Press, 1992), 41. Most histories cite the message in this way, though Lewis Coe claims the punctuation used was an exclamation point, not a question mark, in order to comply with the biblical source, Numbers 23:23. Coe, *The Telegraph: A History of Morse's Invention and Its Predecessors in the United States* (Jefferson, NC: McFarland, 1993), 32.

64. David E. Nye, *American Technological Sublime* (Cambridge: MIT Press, 1994), 62. Nye uses "dislocating" to refer both to a sense of disorientation in the face of new technology and a literal dislocation of the voice from the body, an ability to "sever language from human presence."

65. Morse promised "instantaneous communication" in a February 15, 1838, letter to F. O. J. Smith, chairman of the House Committee on Commerce, reprinted in Alfred Vail, *The American Electro Magnetic Telegraph with the Reports of Congress, and a Description of All Telegraphs Known, Employing Electricity or Galvanism* (Philadelphia: Lea and Blanchard, 1845), 81. Semaphore telegraphs provided little improvement on military warning beacon systems, which had been in use for thousands of years; see Coe, *The Telegraph*, 1–13.

66. Paul Gilmore, *Aesthetic Materialism: Electricity and American Romanticism* (Stanford: Stanford University Press, 2009), 52, 54.

67. Briggs and Maverick, *The Story of the Telegraph*, 13. For more background on the relationship between spiritualism and telegraphy, see Jeffrey Sconce, *Haunted Media: Electronic Presence from Telegraphy to Television* (Durham, NC: Duke Univer-

sity Press, 2000), 21–58; and Linda Simon, *Dark Light: Electricity and Anxiety from the Telegraph to the X-Ray* (Orlando, FL: Harcourt, 2004), 28–47.

68. Jones, *Historical Sketch of the Electric Telegraph*, 4; "Submarine Telegraph to Europe," *United States Magazine*, August 1855, 93.

69. Henry Caswall, *The Western World Revisited* (Oxford: John Henry Parker, 1854), 276. The historian Gregory J. Downey weds the two apparently contradictory poles by describing the telegraph infrastructure as an "internetwork" that occupied both actual and virtual space. Downey, *Telegraph Messenger Boys: Labor, Technology, and Geography, 1850–1950* (New York: Routledge, 2002), 127–28.

70. "The First Words Sent by Telegraph," *Cincinnatus* 1.2 (February 1, 1856): 76.

71. Henry M. Field, *The Story of the Atlantic Telegraph* (New York: Charles Scribner's Sons, 1893), 68.

72. Chester G. Hearn, *Circuits in the Sea: The Men, the Ships, and the Atlantic Cable* (Westport, CT: Praeger, 2004), 24–26. Huntington later painted a group portrait, discussed in Karl Kusserow, "Technology and Ideology in Daniel Huntington's *Atlantic Cable Projectors*," *American Art* 24.1 (Spring 2010): 94–113. For a popular history of the cable, see John Steele Gordon, *A Thread across the Ocean: The Heroic Story of the Transatlantic Cable* (New York: Walker, 2002).

73. W. H. Russell, *The Atlantic Telegraph* (1866; reprint, Stroud, UK: Nonsuch, 2005), 15.

74. Barbara A. Wolanin, "Mythology, Allegory, and History: Brumidi's Frescoes for the New Dome," in *American Pantheon: Sculptural and Artistic Decoration of the United States Capitol*, ed. Donald R. Kennon and Thomas P. Somma (Athens: Ohio University Press, 2004), 193; Francis O'Connor, "Constantino Brumidi as Decorator and History Painter," in Kennon and Somma, eds., *American Pantheon*, 204–19.

75. Whitman quoted in Virgil Barker, *American Painting: History and Interpretation* (New York: Macmillan, 1950), 559.

76. *Daily National Intelligencer*, January 17, 1866, 2, quoted in Wolanin, "Mythology, Allegory, and History," 195.

77. Field, *Story of the Atlantic Telegraph*, 188.

78. For Doezema's reading of the image, see "The Clean Machine: Technology in American Magazine Illustration," *Journal of American Culture* 11.4 (Winter 1988): 74.

79. Field, *Story of the Atlantic Telegraph*, 52.

80. William Shakespeare, *The Tempest* (1610–11), Act I, scene 2, lines 400–406.

81. John Gillies, "The Figure of the New World in *The Tempest*," in *"The Tempest" and Its Travels*, ed. Peter Hulme and William H. Sherman (Philadelphia: University of Pennsylvania Press, 2000), 180–200; Stephen Greenblatt, introduction to *The Tempest*, in *The Norton Shakespeare*, ed. Stephen Greenblatt (New York: Norton, 1997), 3047–54; Marx, *The Machine in the Garden*, 34–72. More cautious views are given in William M. Hamlin, *The Image of America in Montaigne, Spenser, and Shakespeare: Renaissance Ethnography and Literary Reflection* (New York: St. Martin's Press, 1995), 97–130; and Leo Salingar, "The New World in *The Tempest*," in *Travel and Drama*

*in Shakespeare's Time,* ed. Jean-Pierre Maquerlot and Michèle Willems (Cambridge: Cambridge University Press, 1996), 209–22.

82. B. J. Sokol, *A Brave New World of Knowledge: Shakespeare's "The Tempest" and Early Modern Epistemology* (Madison, NJ: Fairleigh Dickinson University Press, 2003), 32.

83. "First Words Sent by Telegraph," 76.

84. For racial interpretations of Caliban, see Tommy L. Lott, *The Invention of Race: Black Culture and the Politics of Representation* (Malden, MA: Blackwell, 1999), 9; and Takaki, *Iron Cages,* 11–13. On parallels between Caliban and *Frankenstein,* see Malchow, *Gothic Images of Race,* 32–33.

85. Dionysius Lardner, with contributions from Edward B. Bright, *The Electric Telegraph* (new ed., London: James Walter, 1867), 4–5.

86. "Map of the World, Showing the Telegraphic Systems for Encircling the Entire Globe," *Harper's Weekly,* August 12, 1865, 508.

87. Quoted in Dwayne R. Winseck and Robert M. Pike, *Communication and Empire: Media, Markets, and Globalization, 1860–1930* (Durham, NC: Duke University Press, 2007), 46.

88. C. G. Ferris, Report to the House Committee on Commerce, December 30, 1842, reprinted in Vail, *The American Electro Magnetic Telegraph,* 85.

89. William Shakespeare, *A Midsummer Night's Dream* (1594–96), Act II, scene 1, lines 175–76.

90. Lardner, *The Electric Telegraph,* 6. The line is also quoted on the masthead of the short-lived *American Telegraph Magazine* (October 1852–July 1853) and the frontispiece of Jones, *Historical Sketch of the Electric Telegraph.*

91. Even at the start of the Civil War, approximately half the tracks were still in some gauge other than that which would become "standard." Frank Dobbin, *Forging Industrial Policy: The United States, Britain, and France in the Railway Age* (Cambridge: Cambridge University Press, 1994), 60.

92. Estimates of the distance vary. *Harper's Weekly* estimated 9,000 miles of track in four days, Stephen Salsbury and Douglas J. Puffert both give the figure as 13,000 miles in two days, and Edward L. Ayers estimates that those 13,000 miles were converted in *one* day. "The Standard Gauge," *Harper's Weekly,* June 5, 1886, 364; Salsbury, "Emergence of an Early Large-Scale Technical System," 55; Puffert, *Tracks across Continents, Paths through History: The Economic Dynamics of Standardization in Railway Gauge* (Chicago: University of Chicago Press, 2009), 149–52; Ayers, *The Promise of the New South: Life after Reconstruction* (New York: Oxford University Press, 1992), 13.

93. This is an error on Nast's part. Standard gauge is 4 feet, 8.5 inches.

94. Brown, *Beyond the Lines,* 90–93; L. Perry Curtis, Jr., *Apes and Angels: The Irishman in Victorian Caricature* (Washington, DC: Smithsonian Institution Press, 1971).

## 2. "Where Vulcan Is the Presiding Genius"

1. "The National Academy of Design," *Round Table,* April 25, 1868, 262, from Weir's scrapbook of press cuttings, reel 530.815, Weir Family Papers, Archives of Amer-

ican Art, Smithsonian Institution. Originals housed in Manuscripts and Archives, Sterling Memorial Library, Yale University.

2. For a biography of R. W. Weir, see William H. Gerdts, *Robert Weir: Artist and Teacher of West Point* (West Point, NY: Cadet Fine Arts Forum of the U.S. Corps of Cadets, 1976), 9–22. For complete biographical information on J. F. Weir, see Betsy Fahlman, *John Ferguson Weir: The Labor of Art* (Newark: University of Delaware Press, 1997).

3. "The Forging of the Shaft," *Frank Leslie's Illustrated Newspaper*, September 4, 1869, 387.

4. John Ferguson Weir, "American Art: Its Progress and Prospects," *Princeton Review*, May 1878, 822.

5. I am not the first to notice a similarity between Piranesi's etchings and industrial imagery. Tim Barringer compares the *Carceri* to *The Forge* (c. 1844–47) by the British artist James Sharples, while Hermann Warner Williams, Jr., made passing reference to the *Carceri* in his description of *Forging the Shaft*, though I did not come across this until after forming my own conclusions. Barringer, *Men at Work: Art and Labour in Victorian Britain* (New Haven: Yale University Press and Paul Mellon Centre for Studies in British Art, 2005), 155–56; Williams, *Mirror to the American Past: A Survey of American Genre Paintings: 1750–1900* (Greenwich, CT: New York Graphic Society, 1973), 210.

6. Fahlman, *John Ferguson Weir*, 98–102; Randall C. Griffin, *Homer, Eakins, and Anshutz: The Search for American Identity in the Gilded Age* (University Park: Pennsylvania State University Press, 2004), 55–57. For additional previous interpretations of *The Gun Foundry* and *Forging the Shaft*, see Melissa Dabakis, *Visualizing Labor in American Sculpture: Monuments, Manliness, and the Work Ethic, 1880–1935* (Cambridge: Cambridge University Press, 1999), 25–27; Richard S. Field, "Passion and Industry in the Art of John Ferguson Weir," *Yale University Art Gallery Bulletin* (1991): 49–67; and John F. Kasson, *Civilizing the Machine: Technology and Republican Values in America, 1776–1900* (New York: Grossman, 1976), 168–71.

7. "Art Items," *New York Mail*, 1867, quoted in Fahlman, *John Ferguson Weir*, 102. Another article inadvertently made this comparison, describing *Forging the Shaft* as "a striking peace of realism [*sic*]." "National Academy of Design: Fifty-Fourth Annual Exhibition," *New-York Daily Tribune*, April 1, 1879, 5.

8. "National Academy of Design: First Article," *American Art Journal*, May 2, 1866, 20, from Weir's scrapbook of press cuttings, reel 530.809, Weir Family Papers.

9. "Notes on Art," *New York Herald*, May 1868, from Weir's scrapbook of press cuttings, reel 530.814, Weir Family Papers.

10. Weir to Mary French, January 29, 1866, reel 531.304 (typescript) and 531.300–303 (MS), Weir Family Papers.

11. On the sublime as an aesthetic category, see Peter de Bolla, *The Discourse of the Sublime: Readings in History, Aesthetics, and the Subject* (Oxford: Basil Blackwell, 1989), 27–58; and Morton D. Paley, *The Apocalyptic Sublime* (New Haven: Yale University Press, 1986).

12. Edmund Burke, *A Philosophical Enquiry into the Origin of Our Ideas of*

*the Sublime and Beautiful* (1757; reprint, Oxford: Basil Blackwell, 1987), 95, 100, 110–24.

13. Kasson, *Civilizing the Machine*, 139–80; Leo Marx, *The Machine in the Garden: Technology and the Pastoral Ideal in America* (1964; reprint, Oxford: Oxford University Press, 1967), 145–226; Perry Miller, *The Life of the Mind in America: From the Revolution to the Civil War* (New York: Harcourt, Brace, and World, 1965), 269–312; Miller, "The Responsibility of Mind in a Civilization of Machines," *American Scholar* 31.1 (Winter 1961–62): 51–69; David E. Nye, *American Technological Sublime* (Cambridge: MIT Press, 1994). More recently, Chandos Michael Brown has explored the importation of theoretical texts on sublimity in the colonial and early republic periods, defining an early American sublime that is a hybrid of cartographic, natural, and industrial elements. Brown, "The First American Sublime," in *The Sublime: From Antiquity to the Present*, ed. Timothy M. Costelloe (Cambridge: Cambridge University Press, 2012), 147–70.

14. Nye, *American Technological Sublime*, 32–43.

15. Immanuel Kant, *The Critique of Judgment*, trans. J. H. Bernard (1790; reprint, Amherst, NY: Prometheus, 2000), 109, 110.

16. These encounters are described in Weir, *The Recollections of John Ferguson Weir, Director of the Yale School of the Fine Arts, 1869–1913*, ed. Theodore Sizer (New Haven: Associates in Fine Arts at Yale University, 1957), 70, 74, 77. As can be gleaned from their writings, both Porter and McCosh may be described as roughly Kantian in their affiliation, while James grappled rather antagonistically with Kant's writing in his discussion of Swedenborgian philosophy. Noah Porter, *The Human Intellect; with an Introduction upon Psychology and the Soul*, 4th ed. (New York: Charles Scribner's Sons, 1883); James McCosh, *The Intuitions of the Mind Inductively Investigated* (New York: Robert Carter and Brothers, 1860); Henry James, *Substance and Shadow; or, Morality and Religion in Their Relation to Life: An Essay upon the Physics of Creation* (Boston: Ticknor and Fields, 1863).

17. Kant, *The Critique of Judgment*, 120.

18. Marek Kulisz, "Sublime, the Unclear," in *The Most Sublime Act: Essays on the Sublime*, ed. David Jarrett et al. (London: University of North London Press, 1996), 101.

19. Nye, *American Technological Sublime*, 4. In modern chemistry, the term is still used. It refers to an endothermic process in which a substance transitions directly from the solid to the gaseous state, though "cooling it down to a refined product" is not part of the definition.

20. Nicholas Goodrick-Clarke, *The Western Esoteric Tradition: A Historical Introduction* (Oxford: Oxford University Press, 2008), 71–85; Trevor H. Levere, *Transforming Matter: A History of Chemistry from Alchemy to the Buckyball* (Baltimore: Johns Hopkins University Press, 2001), 1–31; Bruce T. Moran, *Distilling Knowledge: Alchemy, Chemistry, and the Scientific Revolution* (Cambridge: Harvard University Press, 2005), 99–156; William R. Newman and Lawrence M. Principe, *Alchemy Tried in the Fire: Starkey, Boyle, and the Fate of Helmontian Chymistry* (Chicago: University of Chi-

cago Press, 2002), 38–47; F. Sherwood Taylor, *The Alchemists: Founders of Modern Chemistry* (New York: Henry Schuman, 1949). While recent studies have done much to revive alchemy's scientific credentials, metaphysical concerns coexisted with material goals throughout the alchemical era. Recent discussions of this complexity include Jonathan Hughes, *The Rise of Alchemy in Fourteenth-Century England: Plantagenet Kings and the Search for the Philosopher's Stone* (London: Continuum, 2012), 35–52; and Pamela O. Long, *Openness, Secrecy, Authorship: Technical Arts and the Culture of Knowledge from Antiquity to the Renaissance* (Baltimore: Johns Hopkins University Press, 2001), 144–48.

21. Lyndy Abraham, *A Dictionary of Alchemical Imagery* (Cambridge: Cambridge University Press, 1998), 84–85; Moran, *Distilling Knowledge*, 17–31; Charles Nicholl, *The Chemical Theatre* (London: Routledge and Kegan Paul, 1980), 25–31; Gareth Roberts, *The Mirror of Alchemy: Alchemical Ideas and Images in Manuscripts and Books from Antiquity to the Seventeenth Century* (London: British Library, 1994), 50–54. The strict nature of the science even extended to the structural organization of alchemical workshops, which were highly ordered and systematic in their chain of command and physical layout. Newman and Principe, *Alchemy Tried in the Fire*, 96–99; Tara Nummedal, *Alchemy and Authority in the Holy Roman Empire* (Chicago: University of Chicago Press, 2007), 129–40.

22. On the alchemists' spiritual motives, see Randall A. Clack, *The Marriage of Heaven and Earth: Alchemical Regeneration in the Works of Taylor, Poe, Hawthorne, and Fuller* (Westport, CT: Greenwood, 2000), 5; Goodrick-Clarke, *The Western Esoteric Tradition*, 77; Nye, *American Technological Sublime*, 4; and Taylor, *The Alchemists*, 158.

23. Walter W. Woodward, *Prospero's America: John Winthrop, Jr., Alchemy, and the Creation of New England Culture, 1606–1676* (Chapel Hill: University of North Carolina Press, 2010), 19–20.

24. John Winthrop, "A Model of Christian Charity," in *The Journal of John Winthrop, 1630–1649*, ed. Richard S. Dunn and Laetitia Yeandle (Cambridge: Harvard University Press, 1996), 10, 7.

25. Woodward, *Prospero's America*, 76. Woodward discusses Winthrop's involvement in metallurgic development at length, 75–159. See also William R. Newman, *Gehennical Fire: The Lives of George Starkey, an American Alchemist in the Scientific Revolution* (1994; reprint, Chicago: University of Chicago Press, 2003), 39–52; and Newman and Principe, *Alchemy Tried in the Fire*, 156–61.

26. Woodward, *Prospero's America*, 12.

27. Clack, *Marriage of Heaven and Earth*, 1–47; Herbert Leventhal, *In the Shadow of the Enlightenment: Occultism and Renaissance Science in Eighteenth-Century America* (New York: New York University Press, 1976).

28. Articles included E. K. Olmsted, "Gold in All Ages—Gold Seekers," *DeBow's Review*, December 1860, 739–51; "The Elixer of Life," *Ladies' Repository*, July 1872, 32; "The Knowledge of Chemistry in Antiquity," *Appleton's Journal*, September 25, 1869, 177–78; and John Denison Champlin, Jr., "The Philosopher's Stone," *Appleton's Journal*, November 9, 1872, 509–12.

29. Dr. Henry Draper, "Delusions of Medicine," *Harper's New Monthly Magazine,* February 1873, 394.

30. Alan Trachtenberg, "The Emergence of a Keyword," in *Photography in Nineteenth-Century America,* ed. Martha A. Sandweiss (New York: Abrams, 1991), 16–45; Chris Webster, "Dark Materials: The Chemical Wedding of Photography and the Esoteric," in *Esotericism, Art, and Imagination,* ed. Arthur Versluis et al. (East Lansing: Michigan State University Press, 2008), 251–66. For a contrary view, see Laurie Dahlberg, "The Material Ethereal: Photography and the Alchemical Ancestor," in *Art and Alchemy,* ed. Jacob Wamberg (Copenhagen: Museum Tusculanum Press, 2006), 83–100.

31. Clack, *Marriage of Heaven and Earth,* 49–132; Jeffrey L. Meikle, "Hawthorne's Alembic: Alchemical Images in *The House of the Seven Gables,*" *ESQ: A Journal of the American Renaissance* 26.4 (1980): 172–83.

32. Weir, "American Art," 817, 822.

33. David Bjelajac, *Washington Allston, Secret Societies, and the Alchemy of Anglo-American Painting* (Cambridge: Cambridge University Press, 1997).

34. Abraham, *A Dictionary of Alchemical Imagery,* 212–13; Matilde Battistini, *Astrology, Magic, and Alchemy in Art,* trans. Rosanna M. Giammanco Frongia (Los Angeles: J. Paul Getty Museum, 2007), 308; Nicholl, *The Chemical Theatre,* 61–62. Research by archaeometallurgists Paul Budd and Timothy Taylor suggests the link between magic and metallurgy is found in prehistoric European societies. Budd and Taylor, "The Faerie Smith Meets the Bronze Industry: Magic versus Science in the Interpretation of Prehistoric Metal-Making," *World Archaeology* 27.1 (June 1995): 133–43.

35. "Die Figur des Schmiedes ist um typische Binärkodes herum gebildet: Mann-Frau, hässlich-schön, Krieg-Liebe, ratio-libido, Arbeit-Kunst, Ausgestoßensein-Dazugehörigkeit; dies alles vor dem Hintergrund einer Arbeit der Stoffmetamorphose" (author's translation). Klaus Türk, *Bilder der Arbeit: Eine ikonografische Anthologie* (Wiesbaden, Germany: Westdeutscher Verlag, 2000), 73.

36. Abraham, *A Dictionary of Alchemical Imagery,* 35–39; Battistini, *Astrology, Magic, and Alchemy,* 253, 273, 279; Nicholl, *The Chemical Theatre,* 92–96, 136–41; Roberts, *The Mirror of Alchemy,* 82–91.

37. Michael Fried, *Menzel's Realism: Art and Embodiment in Nineteenth-Century Berlin* (New Haven: Yale University Press, 2002), 120–21, 243–44; Abraham, *A Dictionary of Alchemical Imagery,* 35.

38. On Weir's interest in Bonhommé, see Field, "Passion and Industry," 59–60; and Fahlman, *John Ferguson Weir,* 105. On Bonhommé, see Michelle Evrard and Patrick Le Nouëne, *La représentation du travail: Mines, forges, usines* (Le Creusot, France: Centre National de Recherche d'Animation et de Création pour les Arts Plastiques, 1977); and Gabriel P. Weisberg, "François Bonhommé and Early Realist Images of Industrialization, 1830–1870," *Arts Magazine* 54.8 (April 1980): 132–35. On Wright's industrial scenes, see Francis D. Klingender, *Art and the Industrial Revolution* (London: Noel Carrington, 1947), 47–50.

39. Stephen Daniels, "Loutherbourg's Chemical Theatre: *Coalbrookdale by Night*," in *Painting and the Politics of Culture: New Essays on British Art, 1700–1850*, ed. John Barrell (Oxford: Oxford University Press, 1992), 220–24; David Fraser, "Fields of Radiance: The Scientific and Industrial Scenes of Joseph Wright," in *The Iconography of Landscape: Essays on the Symbolic Representation, Design and Use of Past Environments*, ed. Denis Cosgrove and Stephen Daniels (Cambridge: Cambridge University Press, 1988), 119–41; Klingender, *Art and the Industrial Revolution*, 48; David H. Solkin, "Joseph Wright of Derby and the Sublime Art of Labor," *Representations* 83.1 (Summer 2003): 167–94. For an analysis specifically focused on Wright's paintings of scientific phenomena, see Paul Duro, " 'Great and Noble Ideas of the Moral Kind': Wright of Derby and the Scientific Sublime," *Art History* 33.4 (September 2010): 660–79. Weir was doubtless aware of these images, as was his father, who in 1849 created a scene of scientific discovery, *The Microscope*. Betsy Fahlman discusses the painting in relation to nineteenth-century microscopy in "Engaging Science and Industry: Tradition, Modernity, and the Weirs," in *The Weir Family, 1820–1920: Expanding the Traditions of American Art*, ed. Marian Wardle (Provo, UT: Brigham Young University Museum of Art, 2011), 111–20.

40. "The King of Hammers," *Harper's Weekly*, August 1, 1874, 647, 646.

41. Quoted in Laura Rigal, *The American Manufactory: Art, Labor, and the World of Things in the Early Republic* (Princeton: Princeton University Press, 1998), 181.

42. Dabakis, *Visualizing Labor in American Sculpture*, 12; Rigal, *The American Manufactory*, 181–82.

43. Bjelajac, *Washington Allston*, 69.

44. Ransom R. Patrick, "John Neagle, Portrait Painter and Pat Lyon, Blacksmith," *Art Bulletin* 33.3 (September 1951): 192; Robert W. Torchia, *John Neagle: Philadelphia Portrait Painter* (Philadelphia: Historical Society of Pennsylvania, 1989), 85–86. For more on Freemasonry in the early republic, see Steven C. Bullock, *Revolutionary Brotherhood: Freemasonry and the Transformation of the American Social Order, 1730–1840* (Chapel Hill: University of North Carolina Press, 1996), 137–273.

45. David Montgomery, *Workers' Control in America: Studies in the History of Work, Technology, and Labor Struggles* (Cambridge: Cambridge University Press, 1979); Montgomery, "The Working Classes of the Pre-Industrial American City, 1780–1830," *Labor History* 9.1 (Winter 1968): 3–22; Rigal, *The American Manufactory*, 191–96; Sean Wilentz, *Chants Democratic: New York City and the Rise of the American Working Class, 1788–1850* (New York: Oxford University Press, 1984), 107–16.

46. Quoted in Long, *Openness, Secrecy, Authorship*, 62. For more on masterapprentice relationships, see Battistini, *Astrology, Magic, and Alchemy*, 358.

47. Weir, *Recollections*, 38.

48. Weir, "American Art," 819.

49. Weir, "American Art," 819, 825.

50. *A New Royal and Universal Dictionary of Arts and Science; or, Complete System of Human Knowledge* (London: J. Cooke, 1770–71), quoted in Solkin, "Joseph Wright of Derby and the Sublime Art," 174.

51. Karl Marx and Friedrich Engels, "Manifesto of the Communist Party" (1888 English ed.), in *The Marx-Engels Reader,* ed. Robert C. Tucker, 2nd ed. (New York: Norton, 1978), 476.

52. Karl Marx, *Capital,* vol. 1, trans. Ben Fowkes (1867; reprint, London: Penguin Books, 1990), 206, 198. For reference to the "magician," see Marx and Engels, "Manifesto of the Communist Party," 478.

53. Karl Marx, "The Economic and Philosophic Manuscripts of 1844," trans. Martin Milligan, in Tucker, ed., *The Marx-Engels Reader,* 104 (". . . die Verwandlung aller menschlichen und natürlichen Eigenschaften in ihr Gegenteil, die allgemeine Verwechslung und Verkehrung der Dinge") and 96 (". . . es *mag* nichts als sich selbst schaffen").

54. Weir to Jervis McEntee, July 22, 1867, box 1.45, Jervis McEntee Papers, Archives of American Art.

55. Weir to Jervis McEntee, August 4, 1867, box 1.45, McEntee Papers.

56. Weir, "The Architect and His Art," *Princeton Review,* January 1882, 72.

57. "Fine Arts: National Academy of Design," *New York Times,* May 1, 1866, 5.

58. "The Forging of the Shaft," 387.

59. Cennino Cennini, *The Craftsman's Handbook,* trans. Daniel V. Thompson, Jr. (c. 1390; New York: Dover, 1933), 24.

60. Pamela H. Smith, *The Body of the Artisan: Art and Experience in the Scientific Revolution* (Chicago: University of Chicago Press, 2004), 140–42. On modern experiments, see, for example, Sarah Lowengard, "Prussian Blue: Transfers and Trials," in *The Materiality of Color: The Production, Circulation, and Application of Dyes and Pigments, 1400–1800,* ed. Andrea Feeser et al. (Farnham, UK: Ashgate, 2012), 167–81.

61. Weir, "The Painter's Art," *Princeton Review,* May 1882, 315–16. There is no solid evidence either for or against Weir's active involvement in chemistry, other than his suggestion that it was a necessary skill for young artists. An 1872 article notes that, in his capacity as a public lecturer on art, Weir projected images "by means of the hydro-oxygen lantern," but it is unclear whether he had any knowledge of how to operate the lantern himself. "Brooklyn Art Association," *New York Evening Post,* October 4, 1872, 2.

62. Giorgio Vasari, *The Lives of the Artists,* vol. 1, trans. Julia Conaway Bondanella and Peter Bondanella (1550/1568; Oxford: Oxford University Press, 1998), 186. Weir was familiar with Vasari as the source of this legend about Van Eyck. In fact, much of Weir's article "The Painter's Art" is cribbed from Vasari.

63. Bjelajac, *Washington Allston,* 31.

64. James Elkins, *What Painting Is: How to Think about Oil Painting, Using the Language of Alchemy* (New York: Routledge, 1999), 19, 125, 122. For more on the alchemical ontology of painting, see Smith, *The Body of the Artisan,* 129–51.

65. Susan Nichols Carter, "The Spring Exhibition at the Academy of Design," *Appleton's Journal,* May 27, 1871, 620; Weir, *Recollections,* 45.

66. Weir, "The Architect and His Art," 73. The second part of the quotation is unattributed by Weir but its source is Eugène Emmanuel Viollet-le-Duc, *Discourses on Architecture,* trans. Henry Van Brunt (Boston: James R. Osgood, 1875), 189.

67. Weir, *Recollections*, 51–52. George Inness, artistic contemporary of Weir and a known Spiritualist and Swedenborgian mystic, conceptualized his art-making process in a similarly revelatory way. Charles Colbert, *Haunted Visions: Spiritualism and American Art* (Philadelphia: University of Pennsylvania Press, 2011), 165–69; Rachael Ziady DeLue, *George Inness and the Science of Landscape* (Chicago: University of Chicago Press, 2004).

68. Elkins, *What Painting Is*, 175.

69. Ethan Allen Hitchcock, *Remarks upon Alchemy and the Alchemists, Indicating a Method of Discovering the True Nature of Hermetic Philosophy; and Showing that the Search after the Philosopher's Stone Had Not for Its Object the Discovery of an Agent for the Transmutation of Metals* (Boston: Crosby, Nichols, 1857), 102–3.

70. Weir to Mary French, January 29, 1866.

71. Weir to Jervis McEntee, July 22, 1867.

72. Weir to Julian Alden Weir, July 22, 1875, reel 529.1064–67, Weir Family Papers.

73. Weir, "American Art," 823.

74. Weir to Mary French, November 21, 1865, reel 529.933–38, Weir Family Papers.

75. For this letter's similarity to "The Raven," see Fahlman, *John Ferguson Weir*, 82–83; and Field, "Passion and Industry," 56–57. For "The Raven" as a touchstone of the Gothic in American visual culture, see Sarah Burns, *Painting the Dark Side: Art and the Gothic Imagination in Nineteenth-Century America* (Berkeley: University of California Press, 2004), 146–48.

76. Field, "Passion and Industry," 56.

77. Weir to Mary French, November 21, 1865.

78. Taylor, *The Alchemists*, 149.

79. "The Academy Pictures: Further View of More Prominent Works," *New York Evening Telegram*, April 22, 1879, 3.

80. Weir to Jervis McEntee, January 28, 1867, box 1.45, McEntee Papers.

81. For an extended analysis of *An Artist's Studio*, see Fahlman, *John Ferguson Weir*, 42–63.

82. Weir to Mary French, November 21, 1865.

83. Weir's sketchbooks, 1862, reel 530.665, Weir Family Papers. The image is also reproduced in Fahlman, *John Ferguson Weir*, 42.

84. Fahlman, *John Ferguson Weir*, 63. In the recent catalog on the work of the Weir family, *His Favorite Model* receives only the disappointing interpretation of a dance between "pre-war nationalism and post-war cosmopolitanism." Marian Wardle, "Introduction: The Weir Family at Home and Abroad," in Wardle, ed., *The Weir Family*, 20.

85. Weir, "American Art," 815–16.

86. Mircea Eliade, *The Forge and the Crucible*, 2nd ed., trans. Stephen Corrin (Chicago: University of Chicago Press, 1978), 47. For evidence of late-nineteenth-century interpretations of alchemy as a metaphor for spiritual formation, see Alex Owen, *The Place of Enchantment: British Occultism and the Culture of the Modern* (Chicago: University of Chicago Press, 2004), 124–25.

87. Weir, *The Way: The Nature and Means of Revelation* (Boston: Houghton, Mifflin, 1889), vi.

88. Kant, *The Critique of Judgment*, 116.

89. Weir, *The Way*, 280.

## 3. Swords into Ploughshares

1. The "noble worker" appears in *Frank Leslie's Illustrated Newspaper, Harper's Weekly, Harper's Monthly*, and *Vanity Fair*, and clearly derives from British models discussed in Mary Cowling, *The Artist as Anthropologist: The Representation of Type and Character in Victorian Art* (Cambridge: Cambridge University Press, 1989), 170–75. On the blacksmith in nineteenth-century visual culture, see James C. Boyles, "'Under a Spreading Chestnut-Tree': The Blacksmith and His Forge in Nineteenth-Century American Art," *IA: The Journal of the Society for Industrial Archaeology* 34.1–2 (2008): 9–24. On the persona of the Yankee in popular culture, see Elizabeth Johns, *American Genre Painting: The Politics of Everyday Life* (New Haven: Yale University Press, 1991); Deborah J. Johnson, *William Sidney Mount: Painter of American Life* (New York: American Federation of Arts, 1998), 32–33; and William T. Oedel and Todd S. Gernes, "'The Painter's Triumph': William Sidney Mount and the Formation of a Middle-Class Art," *Winterthur Portfolio* 23.2–3 (Summer–Autumn 1988): 111–27.

2. Charles D. Shanly, "After the War," *Harper's New Monthly Magazine*, August 1865, cover.

3. Isaiah 2:4 (King James Version).

4. Examples include C. K. W., "New Occasions Teach New Duties," *The Liberator*, May 26, 1865, 83; "The Opening of the Tenth Mechanics' Fair Today," *Boston Daily Advertiser*, September 20, 1865, 2; "Peaceful Times," *Harper's Weekly*, March 6, 1875, 198; "The Thanksgiving of 1865," *Frank Leslie's Illustrated Newspaper*, December 23, 1865, 221; and John Greenleaf Whittier, "The Peace Autumn," *Atlantic Monthly*, November 1865, 545–46.

5. Boston Mountain (pseud.), "Letter from the South," *Daily National Intelligencer*, March 16, 1866, 1.

6. Richard D. Brown, *Modernization: The Transformation of American Life, 1600–1865* (New York: Hill and Wang, 1976), 183.

7. Richard Slotkin, *The Fatal Environment: The Myth of the Frontier in the Age of Industrialization, 1800–1890* (New York: Atheneum, 1985), 282.

8. For an overview of the southern regions, see Edward L. Ayers, *The Promise of the New South: Life after Reconstruction* (New York: Oxford University Press, 1992), 3–33; and James C. Cobb, *Industrialization and Southern Society, 1877–1984* (Lexington: University Press of Kentucky, 1984), 5–26.

9. Matilde Battistini, *Astrology, Magic, and Alchemy in Art*, trans. Rosanna M. Giammanco Frongia (Los Angeles: J. Paul Getty Museum, 2007), 308.

10. Lois Dinnerstein, "The Iron Worker and King Solomon: Some Images of Labor in American Art," *Arts Magazine* 54.1 (September 1979): 115.

11. Winifred Morgan, *An American Icon: Brother Jonathan and American Identity* (Newark: University of Delaware Press, 1988), 21–23, 64.

12. Edwin Forbes, "Battle of Antietam . . . Brilliant and Decisive Bayonet Charge of Hawkins's Zouaves . . . Utter Rout of the Rebels," *Frank Leslie's Illustrated Newspaper,* October 11, 1862, 40–41; Winslow Homer, "A Bivouac Fire on the Potomac," *Harper's Weekly,* December 21, 1861, 808–9; "Uniforms of United States Volunteers and State Militia," *Harper's Weekly,* August 31, 1861, 552–53; "The Wounded Zouave in the Hospital at Washington," *Harper's Weekly,* August 17, 1861, cover.

13. Roy T. Matthews, "Britannia and John Bull: From Birth to Maturity," *Historian* 62.4 (Summer 2000): 809.

14. Morgan, *An American Icon,* 22.

15. James Kirke Paulding, *The Diverting History of John Bull and Brother Jonathan* (Philadelphia: Robert DeSilver, 1827), 4–8.

16. Morgan, *An American Icon,* 73.

17. Morgan, *An American Icon,* 21, 64.

18. Morgan suggests that Sam's ascendancy was based on his universal, rather than sectional, appeal—Jonathan and Yankee Doodle were, after all, Yankees, and it was harder for them to represent an entire nation. Morgan, *An American Icon,* 118. Thanks, however, are due to Jeffrey L. Meikle for his suggestion that the shift *also* reflects a certain fading of optimism. I agree with this, as the United States certainly felt weary and chastened throughout the Reconstruction era, due to traumatic events including frequent economic recessions, race riots, the 1877 strikes, and governmental corruption in the administrations of Presidents Andrew Johnson and Ulysses S. Grant.

19. Ayers, *Promise of the New South,* 106–8; Mabel O. Wilson, *Negro Building: Black Americans in the World of Fairs and Museums* (Berkeley: University of California Press, 2012), 42–43.

20. Ayers, *Promise of the New South,* 111–12.

21. David H. Hill, *The Land We Love,* May 1866, 3, quoted in Harold S. Wilson, *Confederate Industry: Manufacturers and Quartermasters in the Civil War* (Jackson: University Press of Mississippi, 2002), 272.

22. Ayers, *Promise of the New South,* 105; Wilson, *Confederate Industry,* 272.

23. Charles C. Eldredge, *Tales from the Easel: American Narrative Paintings from Southeastern Museums, circa 1800–1950* (Athens: University of Georgia Press, 2004), 20.

24. A Roman nose was highly desirable: British illustrator Charles Bennett wrote that "such noses frequently belong to persons of superior intellect and high moral sentiment, and are often found indicative of great strength of mind and decision of character." Bennett, "Notes on Noses," *Illustrated London News,* May 28, 1842, 36, quoted in Cowling, *The Artist as Anthropologist,* 148.

25. See, for instance, Vivian Green Fryd, *Art and Empire: The Politics of Ethnicity in the United States Capitol, 1815–1860* (1992; reprint, Athens: Ohio State University Press, 2001), 62–87.

26. *Atlanta Constitution,* November 11, 1881, quoted in Eldredge, *Tales from the Easel,* 66n44.

27. Barbara Wolanin suggests that Brumidi probably saw a print of Terry's *Allegory* prior to composing this image for the Capitol. Wolanin, *Constantino Brumidi: Artist of the Capitol* (S. Doc. No. 103-27; Washington, DC: Government Printing Office, 1998), 162.

28. This cartographic approach to representing slavery was not unique to *Harper's Weekly*. Trish Loughran analyzes an 1854 map in similar terms, suggesting that slavery was figured as a black "stain" that threatened to encroach on the free soil of the West and Northwest. Loughran, *The Republic in Print: Print Culture in the Age of U.S. Nation Building, 1770–1870* (New York: Columbia University Press, 2007), 367.

29. "Georgia," *Harper's Weekly*, May 12, 1866, 302.

30. J. R. Hamilton, "Rocketts Landing, Richmond, Virginia," *Harper's Weekly*, September 23, 1865, 596.

31. Richard Nixon, "Open Letters: The World's Exposition at New Orleans: Its Scope and Expected Results," *The Century*, December 1884, 313. For more on the proposed role to be played by New Orleans in the national and international economies, see Kevin Fox Gotham, *Authentic New Orleans: Tourism, Culture, and Race in the Big Easy* (New York: New York University Press, 2007), 45–68.

32. Gotham, *Authentic New Orleans*, 57.

33. "The Tredegar Iron-Works," *Harper's Weekly*, August 5, 1865, 490.

34. J. R. Dennett, "The South as It Is" (series, published intermittently), *The Nation*, July 20, 1865, through April 19, 1866; Edward King, "The Great South" (series, published monthly), *Scribner's Monthly*, November 1873 through December 1874; Charles Dudley Warner et al., "The New South" (series, published intermittently), *Harper's Weekly*, December 4, 1886, through August 13, 1887.

35. Edward King, *The Great South: A Record of Journeys in Louisiana, Texas, The Indian Territory, Missouri, Arkansas, Mississippi, Alabama, Georgia, Florida, South Carolina, North Carolina, Kentucky, Tennessee, Virginia, West Virginia, and Maryland* (Hartford: American Publishing Company, 1875).

36. J. Henry Harper, *The House of Harper: A Century of Publishing in Franklin Square* (New York: Harper and Brothers, 1912), 550.

37. Harper, *The House of Harper*, 550, 551.

38. Charles Dudley Warner, "The New Lynchburg," *Harper's Weekly*, December 4, 1886, 791.

39. Warner, "The New Lynchburg," 791.

40. Horace Bradley, "Atlanta, Georgia—Manufacture of Cotton-Seed Oil," *Harper's Weekly*, February 12, 1887, 123; Bradley, "Atlanta, Georgia—The Manufacture of Gossypium Phosphate," *Harper's Weekly*, February 26, 1887, 160; Bradley, "The Great Industries of Birmingham, Alabama: Coke Ovens," *Harper's Weekly*, March 26, 1887, 216.

41. Nixon, "Open Letters," 312.

42. "A Southern Exhibition," *Manufacturer and Builder* 15.3 (March 1883): 54.

43. "The World's Work: The Atlanta Cotton Exposition," *The Century*, January 1882, 476.

44. Nixon, "Open Letters," 312.

45. Nast, "The Georgetown Election—The Negro at the Ballot Box," *Harper's Weekly*, March 16, 1867, 172; Nast, "This Is a White Man's Government," *Harper's Weekly*, September 5, 1868, 568.

46. Luke 2:13–14: "And suddenly there was with the angel a multitude of the heavenly host, praising God, and saying, Glory to God in the highest, and on earth peace, good will toward men" (King James Version).

47. Edward Atkinson, "Significant Aspects of the Atlanta Cotton Exposition," *The Century*, February 1882, 564.

48. While Nast's image promotes racial inclusivity, blacks were excluded from the 1881 Exposition. The horrible irony is that the African American man Nast used as a symbol of brotherhood would, in reality, only have been welcome on "Freedman's Day." This pattern of exclusion continued in both southern and northern exhibitions until the 1895 Atlanta Cotton States and International Exposition, which held the first exclusively African American exhibition in the history of American fairs. Wilson, *Negro Building*, 44–53.

49. Atkinson, "Significant Aspects of the Atlanta Cotton Exposition," 563.

50. Eugene Lawrence, "Republicanism, Past and Future: The Good Time Come," *Harper's Weekly*, November 23, 1872, 910.

51. "The World's Work," 475.

52. "Governors at Atlanta," *Harper's Weekly*, November 12, 1881, cover.

53. Atkinson, "Significant Aspects of the Atlanta Cotton Exhibition," 570.

## 4. Sugar, Shipping, and Cityscapes

1. A ride on the New Jersey Hudson-Bergen light rail line still affords some vistas surprisingly similar to the one rendered in *Lower Manhattan*, as the author noticed in the summer of 2013. Further verification of Moran's location was attempted through synthesis of Google Maps and nineteenth-century descriptions of the painting.

2. The adjective "fantastic" was used to refer to *After a Thaw—Communipaw Ferry*, an 1879 work similar to *Lower Manhattan*. "Academy of Fine Arts: Characteristics Which Make the Present Exhibition a Good One," *New York Evening Telegram*, April 14, 1879, 3.

3. Ruth Schwartz Cowan, *A Social History of American Technology* (New York: Oxford University Press, 1997), 149–65.

4. Thurman Wilkins with Caroline Lawson Hinkley, *Thomas Moran: Artist of the Mountains*, 2nd ed. (Norman: University of Oklahoma Press, 1998), 9.

5. Fritiof Fryxell, *Thomas Moran: Explorer in Search of Beauty* (East Hampton, NY: East Hampton Free Library, 1958), 11–13; Joni Louise Kinsey, *Thomas Moran and the Surveying of the American West* (Washington, DC: Smithsonian Institution Press, 1992), 79–92; Kinsey, *Thomas Moran's West: Chromolithography, High Art, and Popular Taste* (Lawrence: University Press of Kansas, 2006); J. M. Mancini, *Pre-Modernism: Art-World Change and American Culture from the Civil War to the Armory Show* (Princeton: Princeton University Press, 2005), 82–87; Wilkins, *Thomas Moran*, 209–11.

6. Quoted in George W. Sheldon, *American Painters: With One Hundred and Four Examples of Their Work Engraved on Wood* (New York: D. Appleton, 1881), 124.

7. Some of Ruskin's letters to Moran are quoted at length in Wilkins, *Thomas Moran,* 364n29.

8. "Sketchings: Our Commercial Explosion," *The Crayon* 4.11 (November 1857): 344.

9. William James Stillman and John Durand, "The Art of the Present," *The Crayon* 1.19 (May 9, 1855): 289. For additional commentary, see "Manufacturing Interests," *The Crayon* 2.9 (August 29, 1855): 136. On Ruskin's influence on the *Crayon,* see Roger B. Stein, *John Ruskin and Aesthetic Thought in America, 1840–1900* (Cambridge: Harvard University Press, 1967), 101–23. On Moran's philosophical involvement with the American Pre-Raphaelites and Ruskinian thought, see Nancy K. Anderson, ed., *Thomas Moran* (Washington, DC: National Gallery of Art, 1997), 24–27; and Kinsey, *Moran and the Surveying of the American West,* 13–18.

10. Kinsey, *Moran and the Surveying of the American West,* 43–58; Wilkins, *Thomas Moran,* 78–80. For general discussion of the survey parties and Manifest Destiny, see Albert Boime, *The Magisterial Gaze: Manifest Destiny and American Landscape Painting c. 1830–1865* (Washington, DC: Smithsonian Institution Press, 1991), 137–58.

11. Fryxell, *Thomas Moran,* 9; Wilkins, *Thomas Moran,* 5.

12. Kinsey, *Moran and the Surveying of the American West,* 22–24; Angela Miller, *The Empire of the Eye: Landscape Representation and American Cultural Politics, 1825–1875* (Ithaca, NY: Cornell University Press, 1993), 265–71; Raymond J. O'Brien, *American Sublime: Landscape and Scenery of the Lower Hudson Valley* (New York: Columbia University Press, 1981), 218–28.

13. Barbara Novak, *Nature and Culture: American Landscape and Painting, 1825–1875,* 3rd ed. (New York: Oxford University Press, 2007), 15.

14. [Richard Watson Gilder], "The Old Cabinet," *Scribner's Monthly,* June 1872, 242, quoted in Anderson, ed., *Thomas Moran,* 89.

15. [Richard Watson Gilder], "The Old Cabinet," *Scribner's Monthly,* May 1876, 125.

16. Kinsey, *Moran and the Surveying of the American West,* 24–29.

17. On Moran's interest in Romantic contemplation of ruins, see Wilkins, *Thomas Moran,* 25–26. On the "geological" qualities of his work, see Rebecca Bedell, *The Anatomy of Nature: Geology and American Landscape Painting, 1825–1875* (Princeton: Princeton University Press, 2001), 125–35.

18. "Culture and Progress," *Scribner's Monthly,* June 1872, 251.

19. Anne Morand, *Thomas Moran: The Field Sketches, 1856–1923* (Norman: University of Oklahoma Press, 1996), 53.

20. F. V. Hayden, "The Wonders of the West II: More about Yellowstone," *Scribner's Monthly,* February 1872, 396.

21. F. V. Hayden, "Wonders of the Rocky Mountains: The Yellowstone Park: How to Reach It," in *The Pacific Tourist: Williams' Illustrated Trans-Continental Guide of Travel, from the Atlantic to the Pacific Ocean,* ed. Henry T. Williams (New York: Henry T. Williams, 1876), 305.

22. S. Weir Mitchell, "Through the Yellowstone Park to Fort Custer," *Lippincott's Magazine*, June 1889, 701, quoted in Cecelia Tichi, *Embodiment of a Nation: Human Form in American Places* (Cambridge: Harvard University Press, 2001), 113.

23. Mancini, *Pre-Modernism*, 11. See also Margaret C. Conrads, "'In the Midst of an Era of Revolution': The New York Art Press and the Annual Exhibitions of the National Academy of Design in the 1870s," in *Rave Reviews: American Art and Its Critics, 1826–1925*, ed. David B. Dearinger (New York: National Academy of Design, 2000), 94–97; and Randall C. Griffin, *Homer, Eakins, and Anshutz: The Search for American Identity in the Gilded Age* (University Park: Pennsylvania State University Press, 2004).

24. John Ferguson Weir, "American Art: Its Progress and Prospects," *Princeton Review*, May 1878, 816.

25. William Mackay Laffan, "The Material of American Landscape," *American Art Review* 1 (November 1879): 32.

26. Wilkins, *Thomas Moran*, 190.

27. "The National Academy," *New York Sun*, May 4, 1879, 3. *After a Thaw* is currently owned by a private collector and images of it are unavailable for publication. I am grateful to Steve Good from the Thomas Moran Catalogue Raisonné Project for this information.

28. Thomas Moran, "American Art and American Scenery," in *The Grand Canyon of Arizona: Being a Book of Words from Many Pens, about the Grand Canyon of the Colorado River in Arizona* (Chicago: Passenger Department of the Santa Fe Railway, 1902), 86.

29. "Pictures: The Art Association Reception at the Academy," *Brooklyn Union-Argus*, December 7, 1880, 3.

30. S. G. W. Benjamin, "A Pioneer of the Palette: Thomas Moran," *Magazine of Art* 5 (February 1882): 92.

31. Quoted in Sheldon, *American Painters*, 124. The identification of these "gray pictures" as *After a Thaw* and *Lower Manhattan* is my own speculation. Examination of Moran's work during the late 1870s and early 1880s shows that he exhibited no other paintings with such a color scheme. This suggests that he was explicitly referring to his industrial paintings as part of an artistic search for novelty and innovation. An 1879 review described *After a Thaw* as "a little black in color," seeming to complement Moran's description. "The Academy Pictures: What Can Be Seen by a Second Glance at the Collection," *North American*, November 20, 1879, 1.

32. Quoted in Sheldon, *American Painters*, 124; "A Mountain Painter," *Denver Rocky Mountain News*, June 18, 1892, quoted in Anderson, ed., *Thomas Moran*, 127.

33. Appealing to this demographic was not necessarily a bad choice. Among nineteenth-century industrialists, Thomas B. Clarke and William T. Evans were enthusiastic collectors of art depicting the modern American scene. While Moran's two industrial paintings were critically successful, however, they did not draw eager buyers. *Lower Manhattan* sold in 1886 at an Ortgies and Company auction for $400. This was not a particularly high sum; by contrast, the critically panned *Ponce de Leon* went

for $2,000 at the same sale. I have not found any sale information for *After a Thaw*. Anderson, ed., *Thomas Moran*, 245.

34. Thomas S. Fern, *The Drawings and Watercolors of Thomas Moran (1837–1926): An Exhibition* (Notre Dame, IN: University of Notre Dame Art Gallery, 1976), 13.

35. *Newark Courier*, May 1, 1874, quoted in Wilkins, *Thomas Moran*, 95.

36. Fern, *Drawings and Watercolors*, 90; Nancy Siegel, *The Morans: The Artistry of a Nineteenth-Century Family of Painter-Etchers* (Huntingdon, PA: Juniata College Press, 2001), 30–31.

37. "Academy of Fine Arts," 3; "The National Academy," 3.

38. Sue Rainey, *Creating "Picturesque America": Monument to the Natural and Cultural Landscape* (Nashville: Vanderbilt University Press, 1994), 27.

39. Morand, *Thomas Moran*, 18; Wilkins, *Thomas Moran*, 37–44.

40. Bedell, *The Anatomy of Nature*, 91.

41. Caroline Arscott and Griselda Pollock with Janet Wolff, "The Partial View: The Visual Representation of the Early Nineteenth-Century City," in *The Culture of Capital: Art, Power and the Nineteenth-Century Middle Class*, ed. Janet Wolff and John Seed (Manchester, UK: Manchester University Press, 1988), 227.

42. Rainey, *Creating "Picturesque America*," 201, 266. See also Cowan, *Social History of American Technology*, 205.

43. Edward Strahan [Earl Shinn], "Art News: New York Notes," *Art Amateur*, February 1880, 52.

44. In 1940, when the painting was acquired by the Washington County Museum of Fine Arts (WCMFA), it was still referred to in picturesque language as a "grandiose revelation of naturalistic phenomena." On a 2013 visit to the WCFMA, however, the author overheard museum guests referring to the painting's subject as "ugly" and "unattractive," suggesting our decreased ability to appreciate the industrial picturesque. "Public Picks Moran," *Art Digest*, November 15, 1940, 17. For the WCMFA's official language on *Lower Manhattan*, see its catalogue entry in Elizabeth Johns, ed., *One Hundred Stories: Highlights from the Washington County Museum of Fine Arts* (Hagerstown, MD: Washington County Museum of Fine Arts, 2008), 168–69.

45. Edward Strahan [Earl Shinn], "The National Academy of Design," *Art Amateur*, June 1879, 4; "The Two New York Exhibitions," *Atlantic Monthly*, June 1879, 783. Nancy Anderson has done an excellent job of tracing the exhibition history of *After a Thaw* and *Lower Manhattan*, though she erroneously includes Shinn's 1879 review of *After a Thaw* in the catalogue entry for *Lower Manhattan*. I have attempted to pair the correct reviews with the paintings based on what is known of their exhibition histories. Anderson, ed., *Thomas Moran*, catalogue entry, 115; exhibition record, 223–54 passim.

46. Kenneth W. Maddox, ed., *In Search of the Picturesque: Nineteenth Century Images of Industry along the Hudson River Valley* (Annandale-on-Hudson, NY: Art Institute of Bard College, 1983), 63. On the Hudson in the work of R. W. Weir, see Leo G. Mazow, "Robert Walter Weir and the Sense of Place," in *The Weir Family, 1820–1920:*

*Expanding the Traditions of American Art,* ed. Marian Wardle (Provo, UT: Brigham Young University Museum of Art, 2012), 29–53.

47. Maddox, ed., *In Search of the Picturesque,* 65–69. On the business of touring the Hudson, see Frances F. Dunwell, *The Hudson: America's River* (New York: Columbia University Press, 2008), 67–83; and O'Brien, *American Sublime,* 86–87. Contrary to my interpretation, Betsy Fahlman describes R. W. Weir's *Hudson River from Hoboken* as a "softly romantic" scene that downplays industrialization. Fahlman, "Engaging Science and Industry: Tradition, Modernity, and the Weirs," in Wardle, ed., *The Weir Family,* 120.

48. Bedell, *The Anatomy of Nature,* 93–94, 103–5; Rachael Ziady DeLue, *George Inness and the Science of Landscape* (Chicago: University of Chicago Press, 2004), 118–24, 134–36; O'Brien, *American Sublime,* 120–23.

49. Archibald Alison, *Essays on the Nature and Principles of Taste,* ed. Abraham Mills (1790; rev. ed., New York: Harper and Brothers, 1853), 20. This edition of Alison's work was intended for a popular American audience, as editor Abraham Mills included marginal questions for discussion, rather like a modern book club readers' guide. His introduction suggests that his audience was well-educated readers who were not specialists in aesthetics or philosophy.

50. Marianne Doezema, *American Realism and the Industrial Age* (Cleveland: Cleveland Museum of Art, 1980), 21.

51. D. J. Kenny, *Illustrated Cincinnati: A Pictorial Hand-Book of the Queen City* (Cincinnati: Robert Clarke, 1875), 147, quoted in Peter C. Marzio, *The Democratic Art: Pictures for a 19th-Century America, Chromolithography 1840–1900* (Boston: Godine, 1979), 131. In addition to Marzio's focus on lithographic representation, Peter Bacon Hales has discussed the rise of photographic panoramas with a particular focus on the techniques of camera angles and, increasingly, composite images. Such images served similar roles of boosting industry, celebrating major landowners, and underscoring narratives of control. Hales, *Silver Cities: Photographing American Urbanization, 1839–1939* (1984; rev. ed., Albuquerque: University of New Mexico Press, 2005), 133–48.

52. Doezema, *American Realism and the Industrial Age,* 21.

53. For this phrase, I am thankful to Edward Slavishak, who helped me to work through this point in his comments on a very early version of this chapter, presented at the Hagley Fellows Conference in March 2007.

54. Boime, *The Magisterial Gaze,* esp. 21–22, 117–21.

55. *Appletons' Hand-Book of American Travel: Northern and Eastern Tour* (New York: D. Appleton, 1873), 188; Charles Hardenbury Winfield, *History of the County of Hudson, New Jersey, from Its Earliest Settlement to the Present Time* (New York: Kennard and Hay, 1874), 236–37.

56. "Commercial Relations of New York," *Harper's Weekly,* May 30, 1868, 345–46.

57. Bryan J. Wolf, "Seeing the Nineteenth Century through Twenty-First Century Eyes," public lecture at the University of California, Irvine, June 6, 2005.

58. E. L. Magoon, "Scenery and Mind," in *The Home Book of the Picturesque; or, American Scenery, Art, and Literature,* facsimile ed., with an introduction by Motley F. Deakin (1852; Gainesville, FL: Scholars' Facsimiles and Reprints, 1967), 27.

59. Discussed and catalogued in Morand, *Thomas Moran,* 27–29, 122–31. Thurman Wilkins also suggests some atavistic relationship to water, perhaps prompted by Moran's crossing of the Atlantic as a young immigrant. As Wilkins imaginatively writes, on this 1844 voyage, young Tom "spent long hours watching the waves, fixing their forms and colors in his memory." Wilkins, *Thomas Moran,* 12.

60. David Lubin, *Picturing a Nation: Art and Social Change in Nineteenth-Century America* (New Haven: Yale University Press, 1994), 116–57.

61. Morand, *Thomas Moran,* 53.

62. Leo Marx discusses the nineteenth-century popularity of this phrase, from a minor satirical work by Alexander Pope, in reference to travel and communication. Marx, *The Machine in the Garden: Technology and the Pastoral Ideal in America* (1964; reprint, Oxford: Oxford University Press, 1967), 194.

63. Edwin G. Burrows and Mike Wallace, *Gotham: A History of New York City to 1898* (New York: Oxford University Press, 1999), 1211.

64. Moses King, ed., *King's Handbook of New York City: An Outline History and Description of the American Metropolis* (Boston: Moses King, 1893), 918.

65. R. R. Bowker, "A Lump of Sugar," *Harper's New Monthly Magazine,* June 1886, 72.

66. Lawrence B. Glickman, *Buying Power: A History of Consumer Activism in America* (Chicago: University of Chicago Press, 2009), 61–89.

67. Bowker, "A Lump of Sugar," 73, 78–79.

68. Quoted in Glickman, *Buying Power,* 79.

69. "The Refineries of New York," *Hunt's Merchants' Magazine* 35 (October 1856): 500, quoted in Deborah Jean Warner, *Sweet Stuff: An American History of Sweeteners from Sugar to Sucralose* (Washington, DC: Smithsonian Institution Scholarly Press, 2011), 7.

70. Sidney W. Mintz, *Sweetness and Power: The Place of Sugar in Modern History* (New York: Viking, 1985), 37–58.

71. Mintz, *Sweetness and Power,* 158–99; Sara B. Pritchard and Thomas Zeller, "The Nature of Industrialization," in *The Illusory Boundary: Environment and Technology in History,* ed. Martin Reuss and Stephen H. Cutcliffe (Charlottesville: University of Virginia Press, 2010), 69–100.

72. King, ed., *King's Handbook,* 918.

73. Pritchard and Zeller, "The Nature of Industrialization," 84. See also Warner, *Sweet Stuff,* 17–18.

74. Gillian McGillivray, *Blazing Cane: Sugar Communities, Class, and State Formation in Cuba, 1868–1959* (Durham, NC: Duke University Press, 2009), 30. Other major suppliers were Louisiana, Texas, and Hawai'i. Bowker, "A Lump of Sugar," 73.

75. Burrows and Wallace, *Gotham,* 1211.

76. "Notes on Cuba," *Harper's Weekly,* January 29, 1859, 72.

77. Louis A. Pérez, Jr., *Cuba: Between Reform and Revolution,* 3rd ed. (New York: Oxford University Press, 2006), 81–83.

78. "The Purchase of Cuba Pictorially Considered," *Harper's Weekly,* March 26, 1859, 200.

79. Richard Follett, "Slavery and Technology in Louisiana's Sugar Bowl," in *Technology, Innovation, and Southern Industrialization from the Antebellum Era to the Computer Age,* ed. Susanna Delfino and Michele Gillespie (Columbia: University of Missouri Press, 2008), 73–83.

80. On emancipation in Louisiana and Cuba, see Rebecca J. Scott, *Degrees of Freedom: Louisiana and Cuba after Slavery* (Cambridge: Belknap Press of Harvard University Press, 2005), 37–60; and Scott, "Explaining Abolition: Contradiction, Adaptation, and Challenge in Cuban Slave Society, 1860–1886," in *Between Slavery and Free Labor: The Spanish-Speaking Caribbean in the Nineteenth Century,* ed. Manuel Moreno Fraginals et al. (Baltimore: Johns Hopkins University Press, 1985), 25–53.

81. "Bone-Hunting on the Plains," *Harper's Weekly,* January 15, 1887, 39.

82. *Annual Report of the Board of Regents of the Smithsonian Institution* (Washington, DC: Government Printing Office, 1889), 445. See also Andrew C. Isenberg, *The Destruction of the Bison: An Environmental History, 1750–1920* (Cambridge: Cambridge University Press, 2000), 160–62.

83. Warner, *Sweet Stuff,* 1, 19–20.

84. Bowker, "A Lump of Sugar," 75.

85. From an unidentified 1834 source, quoted in Warner, *Sweet Stuff,* 8.

86. Charles F. Chandler, "Bone-Black, or Animal Charcoal," in *Johnson's New Universal Cyclopaedia: A Scientific and Popular Treasury of Useful Knowledge,* ed. Frederick A. P. Barnard and Arnold Guyot (New York: A. J. Johnson and Son, 1877), 1:551.

87. John Michael Vlach, *The Planter's Prospect: Privilege and Slavery in Plantation Paintings* (Chapel Hill: University of North Carolina Press, 2002), 103.

## 5. Managing Visions of Industry

1. James Parton, "Cincinnati," *Atlantic Monthly,* August 1867, 242, 241.

2. *Appletons' Illustrated Hand-Book of American Cities; Comprising the Principal Cities in the United States and Canada, with Outlines of Through Routes, and Railway Maps* (New York: D. Appleton, 1876), 95, 106.

3. The focus on *Harper's* and *Scientific American* is due to their major roles in developing visual techniques for managerial representation. Although *Frank Leslie's Illustrated Newspaper* also printed the kinds of images discussed here, it tended to focus more on sensational images of technology, such as train crashes. While *Scientific American* began as a technical periodical, it became more widely read and popular during these years. *Scribner's Monthly* produced imagery similar to *Harper's Monthly* but more sporadically. Robert J. Scholnick, "*Scribner's Monthly* and the 'Pictorial Representation of Life and Truth' in Post–Civil War America," *American Periodicals* 1.1

(Fall 1991): 46–69; Edward W. Stevens, Jr., "Technology, Literacy, and Early Industrial Expansion in the United States," *History of Education Quarterly* 30.4 (Winter 1990): 523–44.

4. Among dozens of other images, see "American Industries, No. 8—Ale Brewing," *Scientific American,* March 15, 1879, 159, 162; "American Industries, No. 29 The Manufacture of Revolvers," *Scientific American,* January 24, 1880, 53; "American Industries, No. 42—A Shirt and Collar Factory," *Scientific American,* May 15, 1880, 303, 309; "Fresh Beef from Chicago," *Harper's Weekly,* October 28, 1882, 697; "How Matches Are Made," *Harper's Weekly,* June 22, 1878, 488, 490; "A Lobster Factory," *Harper's Weekly,* August 8, 1868, 509; Howard Mudge Newhall, "A Pair of Shoes," *Harper's New Monthly Magazine,* January 1885, 273–91; and "Salt-Works at Syracuse," *Harper's Weekly,* November 13, 1886, 735.

5. Floramae McCarron-Cates, "The Best Possible View: Pictorial Representation in the American West," in *Frederic Church, Winslow Homer, and Thomas Moran: Tourism and the American Landscape,* ed. Gail S. Davidson and Floramae McCarron-Cates (New York: Cooper Hewitt, 2006), 77.

6. David A. Hounshell, "Public Relations or Public Understanding? The American Industries Series in *Scientific American,*" *Technology and Culture* 21.4 (October 1980): 589–93, written as a response to Carroll W. Pursell, "Testing a Carriage: The 'American Industry' Series of *Scientific American,*" *Technology and Culture* 17.1 (January 1976): 85–91.

7. Eugene Exman, *The House of Harper: One Hundred and Fifty Years of Publishing* (New York: Harper and Row, 1967); Vanessa Meikle Schulman, "Making the Magazine: Visuality, Managerial Capitalism, and the Mass Production of Periodicals, 1865–1890," *American Periodicals* 22.1 (2012): 3–9; Ronald J. Zboray, "Antebellum Reading and the Ironies of Technological Innovation," *American Quarterly* 40.1 (March 1988): 69–71.

8. Gerald J. Baldasty, *The Commercialization of News in the Nineteenth Century* (Madison: University of Wisconsin Press, 1992), 81.

9. William Littmann, "The Production of Goodwill: The Origins and Development of the Factory Tour in America," in *Constructing Image, Identity, and Place: Perspectives in Vernacular Architecture IX,* ed. Alison K. Hoagland and Kenneth A. Breisch (Knoxville: University of Tennessee Press, 2003), 71–84; David E. Nye, *American Technological Sublime* (Cambridge: Cambridge University Press, 1994), 127–29. For some examples from a guidebook, see *Appletons' Illustrated Hand-Book,* 78, 94–95, 116, 130.

10. Walter Licht, *Working for the Railroad: The Organization of Work in the Nineteenth Century* (Princeton: Princeton University Press, 1983). See also Alfred D. Chandler, Jr., *The Visible Hand: The Managerial Revolution in American Business* (Cambridge: Belknap Press of Harvard University Press, 1977), 81–121.

11. Licht, *Working for the Railroad,* 5.

12. Stephen Salsbury, "The Emergence of an Early Large-Scale Technical System: The American Railroad Network," in *The Development of Large Technical Systems,* ed. Renate Mayntz and Thomas Parke Hughes (Boulder, CO: Westview, 1988), 37–68.

Chandler also makes this point: "Safe, regular, reliable movement of goods and passengers, as well as the continuing maintenance and repair of locomotives, rolling stock, and track, roadbed, stations, roundhouses, and other equipment, required the creation of a sizable administrative organization." Chandler, *The Visible Hand,* 87.

13. Richard D. Brown, *Modernization: The Transformation of American Life, 1600–1865* (New York: Hill and Wang, 1976), 128. The classic case study is of the changes in shoe production in Lynn, Massachusetts: Alan Dawley, *Class and Community: The Industrial Revolution in Lynn,* 25th anniv. ed. (Cambridge: Harvard University Press, 2000). See also Daniel Nelson, *Managers and Workers: Origins of the Twentieth-Century Factory System in the United States, 1880–1920,* 2nd ed. (Madison: University of Wisconsin Press, 1995), 10–19.

14. Licht, *Working for the Railroad,* 25.

15. Glenn Porter, *The Rise of Big Business, 1860–1910* (1973; reprint, Arlington Heights, IL: Harlan Davidson, 1992), 19.

16. Richard Ohmann, *Selling Culture: Magazines, Markets, and Class at the Turn of the Century* (London: Verso, 1996), 119.

17. Lindy Biggs, *The Rational Factory: Architecture, Technology, and Work in America's Age of Mass Production* (Baltimore: Johns Hopkins University Press, 1996), 8–35; Richard Slotkin, *The Fatal Environment: The Myth of the Frontier in the Age of Industrialization, 1800–1890* (New York: Atheneum, 1985), 281–300.

18. Mark R. Wilson, *The Business of Civil War: Military Mobilization and the State, 1861–1865* (Baltimore: Johns Hopkins University Press, 2006), 191.

19. Wilson, *Business of Civil War,* 208–16.

20. Amasa Walker, "Labor and Capital in Manufactures," *Scribner's Monthly,* August 1872, 461.

21. Chandler, *The Visible Hand,* 244. See also David A. Hounshell, *From the American System to Mass Production, 1800–1932: The Development of Manufacturing Technology in the United States* (Baltimore: Johns Hopkins University Press, 1984). For a comparison with the United Kingdom, see H. J. Habakkuk, *American and British Technology in the Nineteenth Century: The Search for Labour-Saving Inventions* (Cambridge: Cambridge University Press, 1962).

22. Bruce Laurie, *Artisans into Workers: Labor in Nineteenth-Century America* (New York: Hill and Wang, 1989), 120.

23. Philip Scranton, *Endless Novelty: Specialty Production and American Industrialization, 1865–1925* (Princeton: Princeton University Press, 1997), 3–24.

24. Alison M. Kettering, "Men at Work in Dutch Art; or, Keeping One's Nose to the Grindstone," *Art Bulletin* 89.4 (December 2007): 696–98; Francis D. Klingender, *Art and the Industrial Revolution* (London: Noel Carrington, 1947), 52.

25. David Kunzle, *The Early Comic Strip: Narrative Strips and Picture Stories in the European Broadsheet from c. 1450 to 1825* (Berkeley: University of California Press, 1973), 1–5; Patricia Vansummeren, "From 'Mannekensblad' to Comic Strip," in *Forging a New Medium: The Comic Strip in the Nineteenth Century,* ed. Pascal Lefèvre and Charles Dierick (Brussels: Vrije Universiteit Brussel University Press, 1998), 39–48.

26. William M. Ivins, Jr., *Prints and Visual Communication* (Cambridge: Harvard University Press, 1953).

27. Thierry Groensteen, "Töpffer, the Originator of the Modern Comic Strip," in Lefèvre and Dierick, eds., *Forging a New Medium*, 109, 108.

28. Many of Croker's images were plagiarized from the *Encyclopédie*, which had itself plagiarized around 150 plates from the French Royal Academy of Science's *Descriptions des Arts et Métiers* (1761–88). Werner Hupka, *Wort und Bild: Die Illustrationen in Wörterbüchern und Enzyklopädien* (Tübingen, Germany: Max Niemeyer Verlag, 1989), 108, 105.

29. Olivier Lavoisy, "Illustration and Technical Know-How in Eighteenth-Century France," *Journal of Design History* 17.2 (June 2004): 148.

30. Randall C. Griffin, "Thomas Anshutz's 'The Ironworkers' Noontime': Remythologizing the Industrial Worker," *Smithsonian Studies in American Art* 4.3–4 (Summer–Autumn 1990): 131–32.

31. John R. Pannabecker, "Representing Mechanical Arts in Diderot's *Encyclopédie*," *Technology and Culture* 39.1 (January 1998): 48.

32. Griffin, "Thomas Anshutz's 'The Ironworkers' Noontime,'" 131.

33. Chandler, *The Visible Hand*, 299. See also Wilson J. Warren, *Tied to the Great Packing Machine: The Midwest and Meatpacking* (Iowa City: University of Iowa Press, 2007), 12–16.

34. "The Hog Trade of Cincinnati," *Harper's Weekly*, February 4, 1860, 72, 73.

35. Frederick Law Olmsted, *A Journey through Texas; or, A Saddle-Trip on the Southwestern Frontier* (New York: Dix, Edwards, 1857), 9.

36. "Pork-Packing," *Harper's Weekly*, September 6, 1873, 778.

37. *King's Pocket-Book of Cincinnati* (Cincinnati: John Shillito, 1879), 68.

38. Biggs, *The Rational Factory*, 24–27; Paula Young Lee, "Siting the Slaughterhouse: From Shed to Factory," in *Meat, Modernity, and the Rise of the Slaughterhouse*, ed. Paula Young Lee (Durham: University of New Hampshire Press, 2008), 46–70; Dominic A. Pacyga, "Chicago: Slaughterhouse to the World," in Lee, ed., *Meat, Modernity, and the Rise of the Slaughterhouse*, 153–66.

39. Parton, "Cincinnati," 242.

40. Willard Glazier, *Peculiarities of American Cities* (Philadelphia: Hubbard Brothers, 1885), 133.

41. Olmsted, *A Journey through Texas*, 9.

42. Glazier, *Peculiarities of American Cities*, 133; Charles L. Flint et al., *One Hundred Years' Progress of the United States* (Hartford, CT: L. Stebbins, 1871), 66.

43. Parton, "Cincinnati," 243.

44. "The Hog Trade of Cincinnati," 74.

45. "The Hog Trade of Cincinnati," 74.

46. "The Hog Trade of Cincinnati," 74.

47. Lee, conclusion, in Lee, ed., *Meat, Modernity, and the Rise of the Slaughterhouse*, 238–39.

48. Denny Carter, *Henry Farny* (New York: Watson-Guptill, 1978), 16.

49. John R. Tait, "On Picture Hanging," *Art Review* 2.1 (1887): 15, quoted in "Henry Farny," in *Artists in Ohio 1787–1900: A Biographical Dictionary*, ed. Mary Sayre Haverstock et al. (Kent, OH: Kent State University Press, 2000), 280.

50. Peter C. Marzio, *The Democratic Art: Pictures for a 19th-Century America, Chromolithography 1840–1900* (Boston: Godine, 1979), 146.

51. "Pork-Packing," 778.

52. Glazier, *Peculiarities of American Cities*, 133; Parton, "Cincinnati," 243.

53. Flint et al., *One Hundred Years' Progress*, 66.

54. "A Grain Elevator," *Harper's Weekly*, December 22, 1877, 1010.

55. A. H. Guernsey, "Making the Magazine," *Harper's New Monthly Magazine*, December 1865, 29.

56. David Kunzle, *Father of the Comic Strip: Rodolphe Töpffer* (Jackson: University Press of Mississippi, 2007), 149, emphasis added.

57. Chandler, *The Visible Hand*, 240–49.

58. "Sardine Fishery," *Harper's Weekly*, April 18, 1874, 333.

59. "Sardine Fishery," 333.

60. "Down among the Coal Mines," *Harper's Weekly*, February 22, 1873, cover.

61. "Down among the Coal Mines," cover.

62. Chandler, *The Visible Hand*, 52, 153.

63. Tom Gunning, "'Animated Pictures': Tales of Cinema's Forgotten Future," *Michigan Quarterly Review* 34.4 (Fall 1995): 481.

64. Harold Holzer and Mark E. Neely, Jr., *Mine Eyes Have Seen the Glory: The Civil War in Art* (New York: Orion, 1993), 171–206.

65. Jonathan Crary, *Techniques of the Observer: On Vision and Modernity in the Nineteenth Century* (Cambridge: MIT Press, 1992), 9.

66. The idea of the "best view"—a composite view from a number of viewpoints and thus an impossible view—was more famously used by artists in touristic renderings of nature. McCarron-Cates, "The Best Possible View," 75–117.

67. "The Ice Crop on the Hudson," *Harper's Weekly*, March 7, 1874, 222.

68. Brown, *Modernization*, 132. See also Joseph C. Jones, Jr., *America's Icemen: An Illustrative History of the United States Natural Ice Industry, 1665–1925* (Humble, TX: Jobeco Books, 1984).

69. Henry Hall, *The Ice Industry of the United States, with a Brief Sketch of Its History and Estimates of Production in the Different States* (1888; reprint, Northampton, MA: Early American Industries Association, 1974), 5.

70. Mike Davis, "The Stopwatch and the Wooden Shoe: Scientific Management and the Industrial Workers of the World," *Radical America* 9.1 (January–February 1975): 68–95; Barbara Ehrenreich and John Ehrenreich, "The Professional Managerial Class," in *Between Labor and Capital*, ed. Pat Walker (Boston: South End Press, 1979), 5–45; David Montgomery, *Workers' Control in America: Studies in the History of Work, Technology, and Labor Struggles* (Cambridge: Cambridge University Press, 1979), 10–15.

71. According to Richard Ohmann, managers made up 6–7 percent of the

workforce in 1880. The audience of an illustrated magazine could be far larger than the size of the workforce, as middle-class women and older juveniles were frequent readers of what Matthew Schneirov describes as "family house magazines." There may have been a significant upper-working-class readership who found managerial images aspirational. Ohmann, *Selling Culture,* 119; Schneirov, *The Dream of a New Social Order: Popular Magazines in America, 1893–1914* (New York: Columbia University Press, 1994), 29–61. See also Mark J. Noonan, *Reading "The Century Illustrated Monthly Magazine": American Literature and Culture, 1870–1893* (Kent, OH: Kent State University Press, 2010), 12–15; David Paul Nord, *Communities of Journalism: A History of American Newspapers and Their Readers* (Urbana: University of Illinois Press, 2001), 227–41; Barbara Sicherman, "Ideologies and Practices of Reading," in *A History of the Book in America,* vol. 3, *The Industrial Book, 1840–1880,* ed. Scott E. Casper et al. (Chapel Hill: University of North Carolina Press, 2007), 295–97.

72. "Coal-Mining and the Coal Market," *Harper's Weekly,* September 11, 1869, 583.

73. Charles H. Clark, "A Spool of Thread," *Scribner's Monthly,* September 1878, 708.

## 6. Laziness and Civilization

1. Rev. D. O. Kellogg, "The Objects, Principles and Advantages of Association in Charities," *Journal of Social Science* 12.1 (December 1880): 85, 87.

2. George M. Fredrickson, *The Inner Civil War: Northern Intellectuals and the Crisis of the Union* (1965; reprint, New York: Harper and Row, 1968), 98–112; William G. Staples, *Castles of Our Conscience: Social Control and the American State, 1800–1985* (New Brunswick, NJ: Rutgers University Press, 1990), 66–72; Walter I. Trattner, *From Poor Law to Welfare State: A History of Social Welfare in America,* 5th ed. (New York: Free Press, 1994), 79–105.

3. J. M. Mancini, *Pre-Modernism: Art-World Change and American Culture from the Civil War to the Armory Show* (Princeton: Princeton University Press, 2005), 46. See also Paul DiMaggio, "Cultural Entrepreneurship in Nineteenth-Century Boston: The Creation of an Organizational Base for High Culture in America," in *Rethinking Popular Culture: Contemporary Perspectives in Cultural Studies,* ed. Chandra Mukerji and Michael Schudson (Berkeley: University of California Press, 1991), 374–97; Lawrence W. Levine, *Highbrow/Lowbrow: The Emergence of Cultural Hierarchy in America* (Cambridge: Harvard University Press, 1988), 171–242; and Alan Wallach, "Long-Term Visions, Short-Term Failures: Art Institutions in the United States, 1800–1860," in *Art in Bourgeois Society, 1790–1850,* ed. Andrew Hemingway and William Vaughan (Cambridge: Cambridge University Press, 1998), 297–313.

4. Michael B. Katz, "The Origins of Public Education: A Reassessment," in *The Social History of American Education,* ed. B. Edward McClellan and William J. Reese (Urbana: University of Illinois Press, 1988), 102.

5. James B. Gilbert, *Work without Salvation: America's Intellectuals and Industrial Alienation, 1880–1910* (Baltimore: Johns Hopkins University Press, 1977), 138.

6. *Appletons' Illustrated Hand-Book of American Cities; Comprising the Principal Cities in the United States and Canada, with Outlines of Through Routes, and Railway Maps* (New York: D. Appleton, 1876), 27; Robert Ogden, *Boston to Washington: A Complete Pocket Guide to the Great Cities and the Centennial Exhibition* (New York: Hurd and Houghton, 1876), 94–95.

7. David J. Rothman, *The Discovery of the Asylum: Social Order and Disorder in the New Republic* (Boston: Little, Brown, 1971). Rothman's work preceded Michel Foucault's *Discipline and Punish* by four years and includes similar observations about institutions and social control. Foucault, *Discipline and Punish: The Birth of the Prison,* trans. Alan Sheridan (1975; reprint, New York: Vintage, 1995).

8. David E. Nye, *American Technological Sublime* (Cambridge: MIT Press, 1994), 112–13; Bryan Jay Wolf, "The Labor of Seeing: Pragmatism, Ideology, and Gender in Winslow Homer's *The Morning Bell,*" *Prospects* 17 (1992): 284–86.

9. Trattner, *Poor Law to Welfare State,* 82–87.

10. Robert Hamlett Bremner, *From the Depths: The Discovery of Poverty in the United States* (1956; reprint, New York: New York University Press, 1967), 48; Trattner, *Poor Law to Welfare State,* 88–89.

11. "Consequences of the Civil War, and Our Duties," *Frank Leslie's Illustrated Newspaper,* December 4, 1869, cover. See also Bremner, *From the Depths,* 43.

12. Fredrickson, *Inner Civil War,* 183–216; Richard Slotkin, *The Fatal Environment: The Myth of the Frontier in the Age of Industrialization, 1800–1890* (New York: Atheneum, 1985), 282–86; Mark R. Wilson, *The Business of Civil War: Military Mobilization and the State, 1861–1865* (Baltimore: Johns Hopkins University Press, 2006), 191–209.

13. B. K. Pierce, *A Half Century with Juvenile Delinquents; or, The New York House of Refuge and Its Times* (New York: D. Appleton, 1869), 133.

14. George J. Luckey, Inaugural Address of the 21st Annual Session of the Pennsylvania State Teachers' Association, *Pennsylvania School Journal* 23.3 (September 1874): 67. Similarly, in the 1880s, Boston school reformer John D. Philbrick noted that in the field of school administration, "the tendency is towards a greater centralization and permanency of authority." Quoted in William J. Reese, *America's Public Schools: From the Common School to "No Child Left Behind,"* updated ed. (Baltimore: Johns Hopkins University Press, 2011), 59.

15. Frank Luther Mott, *A History of American Magazines,* vol. 3, *1865–1885* (Cambridge: Belknap Press of Harvard University Press, 1957), 313.

16. Frank Luther Mott, *A History of American Magazines,* vol. 4, *1885–1905* (Cambridge: Belknap Press of Harvard University Press, 1957), 191–92.

17. Mancini, *Pre-Modernism,* 99–131; Roberta J. Park, "Healthy, Moral, and Strong: Educational Views of Exercise and Athletics in Nineteenth-Century America," in *Fitness in American Culture: Images of Health, Sport, and the Body, 1830–1940,* ed. Kathryn Grover (Rochester, NY: Margaret Woodbury Strong Museum, 1989), 129–33.

18. Rev. S. Humphreys Gurteen, *Phases of Charity* (Buffalo: Haas, Nauert and Klein, 1877), 5. For additional background on the scientific charity movement, see

Bremner, *From the Depths,* 51; James Leiby, *A History of Social Welfare and Social Work in the United States* (New York: Columbia University Press, 1978), 111–27; and Trattner, *Poor Law to Welfare State,* 93–95.

19. Trattner, *Poor Law to Welfare State,* 94.

20. Rev. Oscar C. McCulloch, "General and Specific Methods of Operation in the Association of Charities," *Journal of Social Science* 12.1 (December 1880): 91.

21. Sherri Broder, *Tramps, Unfit Mothers, and Neglected Children: Negotiating the Family in Nineteenth-Century Philadelphia* (Philadelphia: University of Pennsylvania Press, 2002), 36–45; Leo G. Mazow, "Taxing Visions and the 'Decent Distance,'" in Leo G. Mazow and Kevin M. Murphy, *Taxing Visions: Financial Episodes in Late Nineteenth-Century American Art* (University Park: Pennsylvania State University Press, 2010), 11–15.

22. Richard D. Brown, *Modernization: The Transformation of American Life, 1600–1865* (New York: Hill and Wang, 1976), 138.

23. Katz, "The Origins of Public Education," 105.

24. John L. Rury, *Education and Social Change: Contours in the History of American Schooling,* 3rd ed. (New York: Routledge, 2009), 62. On punctuality, see David Nasaw, *Schooled to Order: A Social History of Public Schooling in the United States* (New York: Oxford University Press, 1979), 36–39; and Reese, *America's Public Schools,* 38–39.

25. Katz, "The Origins of Public Education," 111. Katz continues, "Schools reflected, legitimated, and sustained the social order." See also Reese, *America's Public Schools,* 22–27; Rury, *Education and Social Change,* 61–90; and Joel Spring, *The American School, 1642–2004,* 6th ed. (Boston: McGraw-Hill, 2005), 206–24.

26. Broder, *Tramps, Unfit Mothers, and Neglected Children,* 104.

27. Charles Loring Brace, "The Little Laborers of New York City," *Harper's New Monthly Magazine,* August 1873, 321.

28. Henry George, as cited in *Tocsin,* October 23, 1886, quoted in Broder, *Tramps, Unfit Mothers, and Neglected Children,* 48.

29. Francis Wayland, *The Elements of Moral Science* (1856; rev. ed., Boston: Gould and Lincoln, 1870), 321.

30. Brace, "The Little Laborers," 327. In addition to technical education, Brace offered another solution, that of country holidays geared toward turning urban urchins into socially useful persons. Sarah Burns suggests that rural imagery of mischievous boys by Winslow Homer, Eastman Johnson, and John George Brown served as a powerful comparative with the cramped urban context. Brace's final solution to urban poverty was more shocking: he orchestrated an exodus to foster families in New England and the West. Historians have interpreted this plan as a systematic attempt to purge New York of the children of the Irish, Italians, and other immigrants, whom Brace considered unruly and undesirable. Burns, "Barefoot Boys and Other Country Children: Sentiment and Ideology in Nineteenth-Century American Art," *American Art Journal* 20.1 (1988): 24–50; Stephen O'Connor, *Orphan Trains: The Story of Charles Loring Brace and the Children He Saved and Failed* (Boston: Houghton Mifflin, 2001).

31. Glen Scott Allen, *Master Mechanics and Wicked Wizards: Images of the American Scientist as Hero and Villain from Colonial Times to the Present* (Amherst: University of Massachusetts Press, 2009), 20; David F. Noble, *America by Design: Science, Technology, and the Rise of Corporate Capitalism* (New York: Knopf, 1977), 22–24.

32. S. Giffard Nelson, "The Pratt Institute," *Harper's Weekly,* March 21, 1891, 214.

33. Helen W. Ludlow, "The Hampton Normal and Agricultural Institute," *Harper's New Monthly Magazine,* October 1873, 673. For similar statements about another African American educational institution, see *Lincoln Institute: Centennial Exhibit 1876* (Jefferson City, MO: Lincoln Institute, 1876).

34. Ronald E. Butchart, *Schooling the Freed People: Teaching, Learning, and the Struggle for Black Freedom, 1861–1876* (Chapel Hill: University of North Carolina Press, 2010), 123–31.

35. Ludlow, "Hampton Normal and Agricultural Institute," 674.

36. Samuel Chapman Armstrong, *Lessons from the Hawaiian Islands* (Hampton, VA: n.p., 1884), quoted in Robert Francis Engs, *Educating the Disfranchised and Disinherited: Samuel Chapman Armstrong and Hampton Institute, 1839–1893* (Knoxville: University of Tennessee Press, 1999), 74. For an outline of Armstrong's educational and political beliefs, see William H. Watkins, *The White Architects of Black Education: Ideology and Power in America, 1865–1954* (New York: Teachers College Press, 2001), 47–61.

37. Laura Wexler, *Tender Violence: Domestic Visions in an Age of U.S. Imperialism* (Chapel Hill: University of North Carolina Press, 2000), 149. See also Engs, *Educating the Disfranchised and Disinherited,* 78–79.

38. Nelson, "The Pratt Institute," 214.

39. Ludlow, "Hampton Normal and Agricultural Institute," 678.

40. Samuel Chapman Armstrong, "Normal-School Work among the Freedmen," *Addresses and Proceedings of the National Education Association, 1872* (Washington, DC: National Education Association, 1872), 179, quoted in Butchart, *Schooling the Freed People,* 123.

41. Edward Howland, "An Industrial Experiment at South Manchester," *Harper's New Monthly Magazine,* November 1872, 836–44, 841 (quotation). On corporate paternalism in this era, including an analysis of Cheney Brothers in South Manchester, Connecticut, see Margaret Crawford, *Building the Workingman's Paradise: The Design of American Company Towns* (London: Verso, 1995), 29–40; and Hardy Green, *The Company Town: The Industrial Edens and Satanic Mills That Shaped the American Economy* (New York: Basic Books, 2010).

42. Kirk Munroe, "Richmond, Virginia," *Harper's Weekly,* January 15, 1887, 42.

43. Wolf, "The Labor of Seeing," 298.

44. On the critique of paternalism as a literary genre, see David Leverenz, *Paternalism Incorporated: Fables of American Fatherhood, 1865–1940* (Ithaca, NY: Cornell University Press, 2003), 123–40.

45. "Technical Art Education," *Harper's Weekly,* January 24, 1885, 59.

46. "Our Rising Generation," *Harper's Weekly,* October 14, 1871, 970.

47. Gail Bederman, *Manliness and Civilization: A Cultural History of Gender and Race in the United States, 1880–1917* (Chicago: University of Chicago Press, 1995); Leverenz, *Paternalism Incorporated*, 33–40.

48. Emily Dana Shapiro, however, suggests that this was not always the case. She makes an argument for the ways some images of handcraft negotiated between the artisanal and the industrial in "J. D. Chalfant's *Clock Maker*: The Image of the Artisan in a Mechanized Age," *American Art* 19.3 (Fall 2005): 40–59.

49. David Montgomery, *The Fall of the House of Labor: The Workplace, the State, and American Labor Activism, 1865–1925* (Cambridge: Cambridge University Press, 1987), 14–29; Randall C. Griffin, *Homer, Eakins, and Anshutz: The Search for American Identity in the Gilded Age* (University Park: Pennsylvania State University Press, 2004), 57–68.

50. Although it is not a central focus of this study, it is important to note that images of labor violence—such as those made in the "strike year" of 1877—were an important category of visual imagery in the nineteenth century. Ross Barrett, *Rendering Violence: Riots, Strikes, and Upheaval in Nineteenth-Century American Art* (Oakland: University of California Press, 2014), esp. 127–54; Philip S. Foner and Reinhard Schultz, *The Other America: Art and the Labor Movement in the United States* (West Nyack, NY: Journeyman Press, 1985); Troy Rondinone, " 'History Repeats Itself': The Civil War and the Meaning of Labor Conflict in the Late Nineteenth Century," *American Quarterly* 59.2 (June 2007): 397–419; Edward Slavishak, *Bodies of Work: Civic Display and Labor in Industrial Pittsburgh* (Durham, NC: Duke University Press, 2008), 64–88.

51. Melissa Dabakis, *Visualizing Labor in American Sculpture: Monuments, Manliness, and the Work Ethic, 1880–1935* (Cambridge: Cambridge University Press, 1999), 28.

52. Griffin, *Homer, Eakins, and Anshutz*, 62–63; Griffin, "Thomas Anshutz's 'The Ironworkers' Noontime': Remythologizing the Industrial Worker," *Smithsonian Studies in American Art* 4.3–4 (Summer–Autumn 1990): 128–43; Montgomery, *Fall of the House of Labor*, 27–29.

53. For some sources on early use of the Bessemer process in the United States, see "Bessemer Steel," *Harper's Weekly*, March 25, 1876, 253–54; "Bessemer Steel in This Country," *Scientific American*, May 6, 1865, 295; "The Manufacture of Bessemer Steel," *Manufacturer and Builder* 3.12 (December 1871): 277; and S. Waterhouse, "The Natural Adaptation of St. Louis to Iron Manufactures," *DeBow's Review*, September 1869, 745.

54. "The average Bessemer mill had a capacity of 114,000 tons per year, as compared with 12,000 tons for the average iron-rolling mill." Montgomery, *Fall of the House of Labor*, 28.

55. Thomas H. Pauly, "American Art and Labor: The Case of Anshutz's *The Ironworkers' Noontime*," *American Quarterly* 40.3 (September 1988): 347.

56. Amos J. Loveday, Jr., *The Rise and Decline of the American Cut Nail Industry: A Study of the Interrelationships of Technology, Business Organization, and Management Techniques* (Westport, CT: Greenwood, 1983), 113–25.

57. Griffin, *Homer, Eakins, and Anshutz*, 68.

58. William C. Brownell, "The Art Schools of Philadelphia," *Scribner's Monthly*, September 1879, 739. See also Louise Lippincott, "Thomas Eakins and the Academy," in *In This Academy: The Pennsylvania Academy of the Fine Arts, 1805–1976* (Philadelphia: Pennsylvania Academy of the Fine Arts, 1976), 166.

59. On Eakins's teaching with photography and Anshutz's use of photographs, see Ruth Bowman, "Nature, the Photograph, and Thomas Anshutz," *Art Journal* 33.1 (Fall 1973): 32–40; and Lippincott, "Thomas Eakins and the Academy," 170–73. On similarities between Anshutz's and Eakins's sketching and composition, see Griffin, "Thomas Anshutz's 'The Ironworkers' Noontime,'" 138–39.

60. Mariana Griswold van Rensselaer, "Picture Exhibitions in Philadelphia II," *American Architect and Building News*, December 31, 1881, 311.

61. Lippincott, "Thomas Eakins and the Academy," 178.

62. "Art in the Public Schools," *Frank Leslie's Illustrated Newspaper*, July 30, 1881, 358. See also Ellen Mazur Thomson, *The Origins of Graphic Design in America, 1870–1920* (New Haven: Yale University Press, 1997), 107–8.

63. "Technical and Art Education," *Daily Evening Bulletin* [San Francisco], January 27, 1871, 2.

64. *Annual Report of the School Committee of the City of Boston, 1866* (Boston: Alfred Mudge and Son, 1867), 107, quoted in Mancini, *Pre-Modernism*, 55.

65. B. K. Pierce, "New-York House of Refuge," *Appletons' Journal*, March 18, 1871, 306.

66. Peter Bacon Hales, *Silver Cities: Photographing American Urbanization, 1839–1939* (1984; rev. ed., Albuquerque: University of New Mexico Press, 2005), 276. On the distinction between "deserving" and "undeserving," see Broder, *Tramps, Unfit Mothers, and Neglected Children*, 15–16; and Michael B. Katz, *In the Shadow of the Poorhouse: A Social History of Welfare in America* (New York: Basic Books, 1986), 86–91.

67. Gurteen, *Phases of Charity*, 8.

68. W. H. Davenport, "The Workhouse at Blackwell's Island," *Harper's New Monthly Magazine*, November 1866, 683–702; "The Nurseries on Randall's Island," *Harper's New Monthly Magazine*, December 1867, 8–25; "The House of Refuge on Randall's Island," *Harper's Weekly*, May 23, 1868, 333. Almost all of Davenport's journalistic career focused on these institutions. In one article, he claimed to be a former patient of the insane asylum. Davenport, "Blackwell's Island Lunatic Asylum," *Harper's New Monthly Magazine*, February 1866, 273.

69. The offenses were usually minor, though Pierce wrote of more serious crimes committed by inmates, such as drug addiction, prostitution, and violent theft. Pierce, "New-York House of Refuge," 303.

70. On physical exertion and self-discipline, see Harvey Green, *Fit for America: Health, Fitness, Sport and American Society* (New York: Pantheon, 1986), 87–94; and Park, "Healthy, Moral, and Strong," 125–35.

71. These included, for boys, cooking and baking, agriculture, shoemaking,

making wire sieves and rodent traps, and hoop-skirt construction. Girls would practice laundry and sewing. Pierce, "New-York House of Refuge," 305–6.

72. *A Manual of Devotion and Hymns for the House of Refuge, City of New York* (New York: Carlton and Porter, 1867), 63.

73. Pierce, *Half Century with Juvenile Delinquents*, 80, 176.

74. A. C. Kingsland, "Mayor Kingsland's Address," quoted in Pierce, *Half Century with Juvenile Delinquents*, 192.

75. Pierce, "New-York House of Refuge," 307.

76. F. B. Sanborn, "The Labor of Sentenced Prisoners," *Harper's Weekly*, November 17, 1883, 727.

77. *Proceedings of the National Prison Congress* (Chicago: R. R. Donnelley and Sons, 1887), 217, quoted in Staples, *Castles of Our Conscience*, 27–28.

78. Rebecca M. McLennan, *The Crisis of Imprisonment: Protest, Politics and the Making of the American Penal State, 1776–1941* (Cambridge: Cambridge University Press, 2008), 100–106; Staples, *Castles of Our Conscience*, 28–29.

79. McLennan, *The Crisis of Imprisonment*, 137–92. Articles and editorials on convict labor began appearing in *Harper's Weekly* in 1878, with "Working-Men and Convict Labor," *Harper's Weekly*, April 13, 1878, 287. Eighteen stories about labor and prisons appeared in the *Weekly* between 1878 and 1887.

80. "Working-Men and Convict Labor," 287.

81. George Washington Cable, "The Convict Lease System in the Southern States," *The Century*, February 1884, 582.

82. McLennan, *The Crisis of Imprisonment*, 172.

83. Staples, *Castles of Our Conscience*, 38–39.

84. "Sing Sing State Prison," *Frank Leslie's Illustrated Newspaper*, March 2, 1878, 452.

85. Cable, "The Convict Lease System," 583.

## Conclusion

1. Neil Harris, "Iconography and Intellectual History: The Half-Tone Effect," in *New Directions in American Intellectual History*, ed. John Higham and Paul K. Conkin (Baltimore: John Hopkins University Press, 1979), 198.

2. Wood engraving was incredibly expensive. Only paper was a larger expense in an illustrated magazine's budget. By the time halftone reproduction was already possible for large print runs, *Harper's Weekly* was still spending a huge portion of its budget on engraving. For instance, in the final six months (July–December) of 1888, the *Weekly* spent an average of $716.46 per issue on engraving, compared with $640.04 per issue on artist/illustrator fees and $228.22 per issue on author fees. Of the total six-month budget for the magazine during these months, 18 percent of its cost went toward engraving. Harper and Brothers Records, 1817–1929, reel 25, frames 16–96 *passim*, Butler Library, Columbia University.

3. W. A. Rogers, *A World Worth While: A Record of "Auld Acquaintance"* (New York: Harper and Brothers, 1922), 167.

4. Charles De Kay, "Iron in Decorative Design," *Harper's Weekly,* January 14, 1893, 35.

5. This is a primary argument of Marianne Doezema, "The Clean Machine: Technology in American Magazine Illustration," *Journal of American Culture* 11.4 (Winter 1988): 73–92. See also Estelle Jussim, *Visual Communication and the Graphic Arts: Photographic Technologies in the Nineteenth Century* (1974; reprint, New York: R. R. Bowker, 1983); and Jo Ann Early Levin, "The Golden Age of Illustration: Popular Art in American Magazines, 1850–1925" (Ph.D. diss., University of Pennsylvania, 1980), 66–69.

6. Harris, "Iconography and Intellectual History," 209. Peter Bacon Hales also discusses the preference for photography in social exposé imagery. Hales, *Silver Cities: Photographing American Urbanization, 1839–1939* (1984; rev. ed., Albuquerque: University of New Mexico Press, 2005), 272–74.

7. Harris, "Iconography and Intellectual History," 199.

8. William M. Ivins, Jr., *Prints and Visual Communication* (Cambridge: Harvard University Press, 1953), 94, 136.

9. For the most comprehensive study of the photographic realm, see Elspeth H. Brown, *The Corporate Eye: Photography and the Rationalization of American Commercial Culture, 1884–1929* (Baltimore: Johns Hopkins University Press, 2005). Even photographic still images could only convey production efficiency "imperfectly." Some motion study experts, such as Frank and Lillian Gilbreth, shifted to recording with the moving image, presaged by the chronophotographs of Etienne-Jules Marey. Marta Braun, *Picturing Time: The Work of Etienne-Jules Marey, 1830–1904* (Chicago: University of Chicago Press, 1992), 320–48; Brown, *The Corporate Eye,* 69–81. See also Sharon Corwin, "Picturing Efficiency: Precisionism, Scientific Management, and the Effacement of Labor," *Representations* 84 (Autumn 2003): 139–65; and David Clayton Phillips, "Art for Industry's Sake: Halftone Technology, Mass Photography and the Social Transformation of American Print Culture, 1880–1920" (Ph.D. diss., Yale University, 1996).

10. David Montgomery, *Workers' Control in America: Studies in the History of Work, Technology, and Labor Struggles* (Cambridge: Cambridge University Press, 1979), esp. 1–30; Daniel Nelson, *Managers and Workers: Origins of the Twentieth-Century Factory System in the United States, 1880–1920,* 2nd ed. (Madison: University of Wisconsin Press, 1995).

11. Richard Ohmann, *Selling Culture: Magazines, Markets, and Class at the Turn of the Century* (London: Verso, 1996), 223–30. See also Susan Strasser, *Satisfaction Guaranteed: The Making of the American Mass Market* (Washington, DC: Smithsonian Institution Press, 1989), 3–28.

12. J. M. Mancini, *Pre-Modernism: Art-World Change and American Culture from the Civil War to the Armory Show* (Princeton: Princeton University Press, 2005), 114.

13. Mancini, *Pre-Modernism*, 82–90, 125–31; Sarah Burns, *Inventing the Modern Artist: Art and Culture in Gilded Age America* (New Haven: Yale University Press, 1996), 311–27.

14. Debra Bricker Balken, *Debating American Modernism: Stieglitz, Duchamp, and the New York Avant-Garde* (New York: American Federation of Arts, 2003); Andrew Hemingway, *The Mysticism of Money: Precisionist Painting and Machine Age America* (Pittsburgh: Periscope, 2013); Karen Lucic, *Charles Sheeler and the Cult of the Machine* (Cambridge: Harvard University Press, 1991); Miles Orvell, *After the Machine: Visual Arts and the Erasing of Cultural Boundaries* (Jackson: University Press of Mississippi, 1995); Jonathan Weinberg, "I Want Muscle: Male Desire and the Image of the Worker in American Art of the 1930s," in *The Social and the Real: Political Art of the 1930s in the Western Hemisphere,* ed. Alejandro Anreus et al. (University Park: Pennsylvania State University Press, 2006), 115–34.

15. Wanda Corn, *The Great American Thing: Modern Art and National Identity, 1915–1935* (Berkeley: University of California Press, 1999), 3–89; Linda Dalrymple Henderson, *Duchamp in Context: Science and Technology in the "Large Glass" and Related Works* (Princeton: Princeton University Press, 1998); Kirsten Hoving, *Joseph Cornell and Astronomy: A Case for the Stars* (Princeton: Princeton University Press, 2009).

16. Tessel M. Bauduin, "Science, Occultism, and the Art of the Avant-Garde in the Early Twentieth Century," *Journal of Religion in Europe* 5.1 (January 2012): 23–55; Michael Leja, *Looking Askance: Skepticism and American Art from Eakins to Duchamp* (Berkeley: University of California Press, 2004), 221–47; Celia Rabinovitch, *Surrealism and the Sacred: Power, Eros, and the Occult in Modern Art* (Boulder, CO: Westview, 2002).

17. Rogers, *A World Worth While*, 12–14, 38, 247.

# Index

periodization (of our course) — post-CW?
    when was the "Gilded Age" or the
"prog Era" — historiography of those
terms?

VANESSA MEIKLE SCHULMAN received an A.B. in American Civilization and History of Art at Brown University and an M.A. and Ph.D. in Visual Studies at the University of California, Irvine. Her research, focused on nineteenth-century American art and visual culture, has been published in the journals *American Periodicals, inVisible Culture,* and *Early Popular Visual Culture.* She taught art history at Elon University and writing and composition at Wheelock College and currently teaches art and architectural history at Illinois State University. She is now pursuing additional research on the art and literature of the Civil War and on representations of British history in American visual culture between 1812 and 1917.